THE MORAL MIRROR OF ROMAN ART

This interdisciplinary study explores the meanings of mirrors and reflections in Roman art and society. When used as metaphors in Roman visual and literary discourses, mirrors had a strongly moral force, reflecting not random reality but rather a carefully filtered imagery with a didactic message. Focusing on examples found in mythical narrative, religious devotion, social interaction, and gender relations, Rabun Taylor demonstrates that reflections served as powerful symbols of personal change. Thus, in both art and literature, a reflection may be present during moments of a protagonist's inner or outer transformation.

Rabun Taylor is an assistant professor in the Department of Classics at the University of Texas, Austin. He is the author of *Public Needs and Private Pleasures: Water Distribution, the Tiber River, and the Urban Development of Ancient Rome* and *Roman Builders: A Study in Architectural Process.*

THE MORAL MIRROR
OF ROMAN ART

RABUN TAYLOR
University of Texas, Austin

Published with the assistance of
The Getty Foundation

CAMBRIDGE
UNIVERSITY PRESS

CAMBRIDGE UNIVERSITY PRESS
Cambridge, New York, Melbourne, Madrid, Cape Town, Singapore, São Paulo, Delhi

Cambridge University Press
32 Avenue of the Americas, New York, NY 10013-2473, USA

www.cambridge.org
Information on this title: www.cambridge.org/9780521866125

First published 2008

Printed in the United States of America

A catalog record for this publication is available from the British Library.

Library of Congress Cataloging in Publication Data

Taylor, Rabun M.
 The moral mirror of Roman art / Rabun Taylor.
 p. cm.
 Includes bibliographical references and index.
 ISBN 978-0-521-86612-5 (hardback)
 1. Mirrors in art. 2. Mirrors in literature. 3. Art and morals. 4. Arts and
society – Rome. I. Title.
NX650.M536T39 2008
700′.453 – dc22 2007041285

ISBN 978-0-521-86612-5 hardback

To Betsey and Kathy
fontibus comitatis, <u>speculis sapientiae</u>

CONTENTS

LIST OF FIGURES

ACKNOWLEDGMENTS

VARIOUS IDEAS PRESENTED IN THIS BOOK DEVELOPED THROUGH LIVELY discussions with friends and colleagues, most notably Bettina Bergmann, Elaine Gazda, and Barbara Kellum, during a summer's week at Pompeii. I am grateful to Ann Kuttner for reading an early draft, at the time in the form of a long article, and responding – as only she can – with commentary of such passion and erudition that it served as a kind of reference volume for the duration of the project. Much of the subsequent research and writing was accomplished with the assistance of a Charles A. Ryskamp Fellowship of the American Council of Learned Societies during the academic year 2004–5. Shadi Bartsch, Nancy de Grummond, Martha Ross Taylor, and Natalie Kampen read and commented on various chapters of the manuscript. Kathleen Coleman read and copyedited the entire book. To all of them, to two anonymous readers, and to the editor at Cambridge University Press, Beatrice Rehl, I offer my deepest thanks. Many institutions and museums in the United States, Africa, and Europe generously granted permission to reproduce images; these are acknowledged individually in the captions. And finally, special honors go to Melissa Haynes, who labored tirelessly over two years to secure images and reproduction rights.

INTRODUCTION

S EVERAL YEARS AGO, WHEN THE IDEA OF WRITING A BOOK ON THIS TOPIC first occurred to me, I fixed upon a puzzling little mystery. Why, in Roman art and story, is there virtually no such thing as a *casual* reflection? Instead, the phenomenon of reflectivity is clustered within a few special genres or myths, each of which imposes upon it a special and sometimes profound significance. On the other hand, many artistic genres – even those known for their traditions of naturalism – avoid the realistic rendering of liquid surfaces. To be sure, there are a few exceptions to this rule: a drinking goat on the painted Odyssey landscape in Rome poised symmetrically over its counter-image in the water comes immediately to mind, and lesser analogues can be found here and there. But for the most part, the vast expanses of water represented in Roman seascapes and riverine landscapes – though these are thick with boats, humans, gods, and marine creatures – transmit little more than random static. Reflection, it would seem, was too meaningful a phenomenon in received culture, and too valuable a discursive tool, to be left to chance.

On further consideration, I concluded that none of this should come as a surprise. The topic of reflection was heavily freighted with moral meaning and haunted by half-remembered ghosts of very ancient magico-religious beliefs. The whole point of avoiding reflectivity in the world of art was to safeguard its metaphorical potency in a few special preserves of meaning. When

reflections or mirrors do appear in Roman art, they seem to convey – variably and inconstantly – a range of meanings corresponding to such words and phrases as femininity, beauty, eros, self-absorption, self-knowledge, divination, *metanoia* (change of heart), entrapment, liminality, spirit world, alterity, and death. These concepts can be divided roughly along two paths: toward the self, constructions of personhood, and one's place in society; or toward the Other and the strange other-world it inhabits.

In his essay "On Mirrors", Umberto Eco concludes that a mirror image is not a sign of the thing it reflects.[1] It is merely a *prosthesis*, a tool for augmenting the ordinary human faculty of vision – useful enough in many circumstances, but devoid of any semantic content apart from what pertains to its referent. Although mirrors can transmit signs, he contends, they never engender them. However, it may appear in the mirror, a sign always exists apart from its reflection. Such is the clinical perspective of modernity, and even (arguably) of the ancient Stoics, whose semiotic theories Eco adduces to make his argument. But as Eco would be first to concede, things are quite different in the realm of human imagination and folk belief. Around the world, the disembodied verisimilitude of mirror images has led naturally to thoughts of the uncanny – of gods and ghosts, doppelgangers and monsters. If we could plunge through the textual surface of myth into the world of its protagonists, we would inhabit a realm where reflections were the antithesis of Eco's neutral organs of transmission.

In story and ritual around the world, reflections signify – and in many ways. Some act autonomously. Some have memories; they capture, preserve, and transmit truths. Other mirrors ensnare with falsehoods or ambiguities (for instance, the *speculum fallax* adduced by medieval moralists).[2] Others still can be oracular ("Mirror, mirror, on the wall . . ."). Mirrors may enclose a world unto themselves (Alice's adventures through the looking glass), or protect a reservoir of knowledge that the phenomenal world denies us: St. Paul's vision of heaven as "through a glass, darkly" is only the most famous of a long line of mystical speculations on the divine by way of the mirror metaphor.[3] Reflected images may be seen as the captured spirits of the living or dead or as malicious demons intent on stealing the soul; hence Sir James Frazer's archetype of the primitive "mirror-soul."[4] A mirror can enclose one's double (for example, the Egyptian *Ka*),[5] or be a channel to phenomena that would destroy the viewer if seen directly (Medusa's face, the Lady of Shalott's Camelot). It can even be the very antithesis of Eco's neutral tool of observation, denying entry of certain beings (e.g., vampires) into its own sphere. In the mid-second century C.E. Pausanias described a mirror, fixed to a wall of the temple of Demeter and Kore at Lycosura in Arcadia, that deleted all reflections of people milling about in front of it, and capturing only the images of the cult statues (8.37.7). It is hard to know whether he thought this was genuinely magical, or just a trick

mirror of the sort devised by Hero of Alexandria to raise the image of a cult
statue above its actual position.[6] In either case, as Françoise Frontisi-Ducroux
and Jean-Pierre Vernant have observed in their important study of reflection in
antiquity, this mirror subverted the function of mirrors in general "by opening
a breach in the scenery of 'phenomena,' manifesting the invisible, revealing
the divine, making it seen in the flash of a mysterious epiphany."[7]

Whereas Eco focuses on the "content" of mirrors that are mere passive agents
to observation in the phenomenal world, in works of the imagination the mir-
rors are themselves content; and so they and the images they contain are under
no such constraints. Reflection as a cosmos of the world beyond emerges in
many mythologies.[8] Storytellers and mythmakers over the ages, influenced as
much by magic and folklore as by the intellectual currents of classical antiquity,
could not resist the allure of the looking glass, particularly if it was attached to a
famous king or savant. The Egyptian alchemist Zosimus, writing in the third or
fourth century C.E., speaks of a mirror of electrum commissioned by Alexan-
der the Great in which any viewer could see his own future. One perceived
in its orb not just images, but the perfect divine spirit itself, in whose sway
everything resides up to the instant of our death.[9] According to Ibn al-Zubayr,
God gave Adam a magical mirror that allowed its owner to see anything on
earth. This was not merely a fiction of the distant past, he reports, for it had
come down, by way of King Solomon, to the Umayyad dynasty and ultimately
the Abbasid treasuries closer to his own time.[10] In Spenser's *The Faerie Queene*
Merlin possessed a "wondrous myrrhour" (or a crystal ball, an invention of the
poet's day). "It vertue had, to shew in perfect sight,/ What ever thing was in the
world contaynd,/ Betwixt the lowest earth and heavens might,/ So that it to
the looker appertaynd" (3.2.19).[11] Chaucer's squire tells of a strange knight
"upon a steede of bras,/ and in his hand a brood mirour of glas" which allegedly
could impart full knowledge of one's foes and lovers. Its powers incite specu-
lation among the skeptics in his audience:

> And somme of hem wondred on the mirour
> That born was up into the maister tour,
> Hou men myghte in it swiche thynges se.
> Another answerde and seyde it myghte wel be
> Naturelly, by composiciouns
> Of anglis and of slye reflexiouns,
> And seyden that in Rome was swich oon.
> They speken of Alocen, and Vitulon,[12]
> And Aristotle, that writen in hir lyves
> Of queynte mirours and of perspectives,
> As knowen they that han hir bookes herd (*Canterbury Tales* 5.225–35).

Living at a time when magic and science coexisted comfortably, medieval and
Renaissance writers often ascribed the lore of magic mirrors to great thinkers

of the past. Aristotle and Alhazen are likely candidates for Chaucer; both were men of science and authorities on optics, but their remoteness in time and the difficulty of their texts cast a haze of legend over their mechanical theories. Spenser compares his glass to the legendary creations of King Ptolemy II, whose reputation for wizardry emerged from the nonpareil feat of his architects in Alexandria: the Pharos lighthouse, itself perceived as a tour de force of optical engineering.

In the post-Enlightenment world, surrounded by reflections of every kind, we are apt to dismiss the mirror as a passive medium unselectively reflecting anything and everything transmissible by light. But even we, who have reached a cultural "mirror stage" brought on by scientific consensus and universal famil-iarity with casual reflection, must admit that certain aspects of reflection remain uncanny, even unnerving. Consider the absolute reversal of left and right pro-duced by a single planar mirror. My body extends into three dimensions. I imagine these dimensions to correspond to three bipolar axes extending out from my center: front-back, top-bottom, left-right. From the cognitive per-spective of the seeing organism, one would expect each of these oppositions to be undifferentiated and interchangeable, like the x–y–z axes in mathematics; but surprisingly, this is not the case. When I look at myself frontally in a mirror on the wall, I am aware of reversals along two, but not all three, of these axes. My image is reversed from front to back and left to right – but not from top to bottom. If I stand on top of a mirror and look down into it, or hold it directly above my head, the configuration changes. Now the image is inverted vertically and laterally, but not from front to back. The beginnings of a pattern seem to emerge. There are three axes. Both axes I have tested suggest a rotating ratio of 2:1: two dimensions inverted, one not. So there should be a *third* mirror position from which front–back and top–bottom will be inverted – but not left–right. Yet try as I might, I can find no such position.[13] In a single mirror, the left–right reversal is absolute, but the others are not.

Less puzzling, but still not intuitive, is the nature of reflection in a world without metals. Any flat, highly glossy *nonmetallic* surface, including water, is completely reflective only at very oblique angles. On water and on polished stone walls, we easily and clearly make out the reflection of things that lie dis-tant from us but only slightly removed from the plane of the surface – objects that glance at a slight angle off the surface on their way to the eye. But direct, perpendicular reflection is at best partial, and at worst unintelligible, for it contends with the interference of the medium's nonreflective properties, such as transparency (water) or color and texture (ice or stone). From underwater, there are no partial reflections on the surface whatever. A broad cone of non-reflectivity extends up from the eye to the surface. Within its boundaries there is no coherent reflection, only the transitory scribbles generated by turbulence

on the surface. Beyond the cone's boundaries the surface is transformed into a completely silvered mirror, like the rippling surface of mercury (again, mitigated by some dappling generated by turbulence). A striking conclusion, then: in the prehistory of reflectivity, no visual image of the self was ever fully realized. A glossy surface was far more effective at capturing the Other (which lay at some distance) than at constructing the self.

And so we must suppress our Lacanian inclination to put self-construction at the center of every mirror. The interest in remotest antiquity was surely directed toward the tendency of reflections to create another world, not a confronting face. The earliest human encounters with reflections were on water, and water was always a numinous realm. The fact that images on liquids are not absolute reflections, but are partially transparent, and that the region beneath their surface is distorted, refracted, and in every way alien to our own, must have influenced ancient thinking about all mirrors: they are not just distinct boundaries, but receptacles; they contain an alternate reality.[14] The infinitude of the world beyond seems an apt metaphor for death and its attendant spirit world.

Roman culture was well advanced into the "mirror stage." Far removed from Neolithic life, Romans came as close as any ancient people to taking mirrors for granted. They were not spooked by the ordinary and predictable reflections on the metallic surfaces they encountered in their everyday lives. But they did inherit longstanding traditions of myth and religious belief. For example, writing in the late second century C.E., Apollodorus of Athens articulates a common perception of antiquity when he compares Homer's *eidola*, the flitting shades of dreams and the dead, to waterborne reflections.[15] More importantly, Romans understood the rich potential of the mirror for metaphor. Like the shadow, the mirror image is an incorporeal replica of a body whose movements it dutifully mimics; it seems only reasonable that both phenomena, from time immemorial, should have been interpreted as surrogates of the soul.[16] But the reflection, unlike the shadow, appears only within a suitable medium that frames it, and presents the naturalistic illusion of depth. This surrogate comes with its own world.

There was, of course, another approach to reflectivity in antiquity, informed by the rationalism of scientific inquiry. Ancient optics in general, and catoptrics (the science of mirrors) in particular, were never conceived as phenomena entirely independent of cognition.[17] From the perspective of Greek theory, especially as propounded by Ptolemy, sight is "nothing but *that which makes seeing*, and thus first and primordially a *gaze*. So the reification, so curious to us, of this gaze – simultaneously a thing among things and sensation among things sensible – may be explained as a quasi-organ projected geometrically out from our bodies."[18] A robust corpus of scientific and philosophical discussions

of mirrors survives from antiquity, including discourses on catoptrics attributed to Euclid, Ptolemy, and Hero of Alexandria as well as an atomistic treatment of reflection by Lucretius.[19] Reflectivity was understood as a derivative of optical mechanics, and was thus subsumed under the larger question of how we see.[20] Beginning with the Presocratics, various scientific theories of vision emerged, most of them favoring the eye either as an active agent of vision, emitting rays of illumination, or as a receptor of emanations from the object. Writing in the mid-first century C.E., Seneca recognized two dominant theories of catoptrics. One was an extension of atomistic optical theory, which regarded the eye as the passive receptor of *eidola* ("images" or "shadows") issuing from the seen objects. Here the mirror was perceived as an agent not in duplicating the image, but in changing its path. The other theory, closer to Seneca's own Stoicism, regarded a mirror as a deflector of rays emanating from the eye.[21] In both cases, then, the mirror merely took the impact of the visual act and redirected it; the mirror did not initiate the act or manipulate the content of the image, except to frame it. As such, it was essentially passive.

MIRRORS AS METAPHOR IN ANTIQUITY

But mirrors are paradoxical; opposites reside in them. Self and the Other, same and different, true and false, positive and negative, surface and depth – these and other oppositions inhere in the interplay of human cognition and real mirrors.[22] So too do active and passive; for although most would regard a mirror as optically passive, it is actively involved in a cognitive event: it splits off the subject from the object, arousing sensibilities in the act of self-regard that might not otherwise come to pass.[23] Hence the interesting evolution of the Greek word *klan*, "break," "shatter," to denote deflection or reflection.[24] It is this very real capacity for mirrors to participate in a psychological phenomenon, I believe, that helped to preserve their symbolic complexity in spite of the agnostic advances of Greek science.

In the ancient vernacular imagination, grounded in myth and preserved particularly in the visual tradition, a powerful attitude persisted that the metaphorical mirror of art and story is a kind of machine – a semiautonomous organ of conversion. When a mirror transmits reality on the rebound, it does so as a cognitive filter. The background noise of chaotic reality is stripped away, and the specular image, sometimes baneful, sometimes beneficial, returns with concentrated force – or diminished force, if the original phenomenon, such as Medusa's face or the glory of God,[25] is too intense to be seen. By subtracting from the object, mirrors augment the subject – though not necessarily in a positive or improving way. So when Aeschylus and Alcaeus claim that wine is the mirror of the soul, they are ascribing to the mirror an editorial faculty.[26] What

you see reflected is *essence*, truer and more concentrated than the original: *in vino veritas* implies a corollary, *sine vino vanitas*. The action of a mirror does not end at the reflection. It is carried back to the viewer and changes him (Plato *Phaedr.* 255b–d). When I "reflect" or "speculate" on an object of thought I am projecting upon it an idea. The idea rebounds, and I receive it and process it in a clarified, concentrated form. The mirror therefore is not a strictly optical, or objective, device; it processes the moral, psychological, and intellectual faculties of the subject.[27]

It is the mirror as I have just characterized it — active, semiautonomous — that constitutes the subject of this book. The principles of the active mirror, I believe, can be laid out as a series of simple mnemonic associations:

The mirror is magical. Folklorists and anthropologists have long known that reflections, probably because of their timeless presence on the surface of water (and thus of the nether world), have been used as implements of magic and symbols for magical phenomena. The mirror as soul-catcher, as portal to the dead, as an oracular window on the future — all of these elemental attributions are present, or at least vestigial, in Roman culture. With some notable exceptions (Pliny the Elder's encyclopedic *Natural History*, for example, or Artemidorus' *The Interpretation of Dreams*), ideas of this kind are not accorded much attention in the literature of the educated Roman elite; but they are embedded in ancient folk belief, leaving many traces in art, myth, and ritual.

The mirror is metamorphic. There is often a fascinating correlation between a reflective act (i.e., the perception of a reflection in art, story, or ritual) and personal transformation. Sometimes the change is a bodily metamorphosis driven by external forces (the youth Actaeon, for example, who sees himself as a dying stag reflected in the water), but even more interesting are shifts in personal identity. Because the mirror is a gendered thing, reflections may be featured in stories of gender ambivalence and vacillation. The metamorphosis may be helpful (e.g., to Achilles on Skyros) or baneful (to Narcissus). In the ritual sphere, it may accompany an altered state of mind (as in the cult of Dionysus), or even apotheosis (as in the rebirth of Dionysus himself). Particularly in literature and narrative, the represented mirror in Greco-Roman art and literature can be understood as a permeable, absorbent medium that offers entry into another world or another state of being. As such it is a threshold; and like all magical thresholds it filters the person in transit. This filtering effect may be cleansing or it may be drastically reductive. The object-self returns to the subject only if the mirror is truly reflexive; that is, if the beholder sees him- or herself. In Roman art, the mirror (reflexive or not) is often the vertex of an open

triangle in which the viewer (i.e., you or I) spies the reflection. This has the effect of forcing the viewer into the subjectivity of the protagonist.

The mirror is metaphorical. Anything that is an *agent* in a phenomenon may eventually become a *metaphor* of it, the sign vehicle of its own function. In essence the Roman mirror becomes, among other things, a signifier of metamorphosis – whether it be the banality of blossoming beauty, the pathos of loss, or the secret ways of achieving ecstasy in mystery cults.

The mirror is magnetic. Reflection in ancient art is not a neutral, value-free simulation of reality; it is an autonomous, powerfully captivating force. The mirror creates a protagonist. Whoever is reflected therein, explicitly or implicitly, is meant to be the principal object of the viewer's attention. Together with its referent (i.e., the thing mirrored), the represented mirror tends to form an asymmetrical diptych in which the reflection pulls inexorably at the viewer and dominates the referent – which may also be subject to its pull. It does not necessarily represent the most psychologically satisfying state (as witness the mirror images of Thetis or the dying Persian in chapter 4), but it has the force of inevitability. This imbalance in favor of the image is undoubtedly tied to the ancient and enduring mythology of the double – an entity that, "free from all inhibition and molded to escape various frustrations, wields so much energy that it eclipses its model and absorbs its vitality."[28]

The mirror is moral. I return to the question I began with. There are no casual reflections in Roman art, I think, because reflection more than almost any other visual phenomenon was bound up with necessity. It is moral because it reveals what must be. Its framing of the referent, its status as a magnet of the gaze and a concentrator of meaning, privileges it. Here, the word *moral* is meant to encompass both the positive and the negative. Reflections may provide assistance in the accomplishment of a desirable or necessary task, the nature of which has almost infinite permutations. Socrates and Seneca extol the mirror as a path to self-knowledge; it is also used this way in myth. Most commonly, it is the channel by which femininity defines itself and masculinity improves itself – which, when approached in the prescribed way, reinforces the worth of its user. But a mirror may too be a dangerous and even an insidious thing; its associations with black magic have survived to this day. In the possession of a man it can lead him to the ruinous state (or so Roman moralists assessed it) of self-absorption. Even a virtuous woman must beware of its corrupting powers.

When used as a metaphor, the Roman mirror is always in some sense moral. Thus the term "moral mirror," as it is used in this book, refers to the mirror

as a coded device, whether in art or literature, and not just an artefact in every-day life.

REFLECTIONS IN REAL LIFE

How did Romans interact with reflection in everyday life? Certainly there were fewer opportunities to encounter casual reflections in antiquity than we have today, except as vague, fugitive shadows. Vitruvius observes that stucco can be polished to a mirror surface (7.3.11). Polished stone wall revetment became common in public buildings in the Julio-Claudian era, but its reflective properties were relatively feeble, despite Suetonius' picturesque report that the emperor Domitian insisted on polished surfaces throughout his palace so that he could spy assassins approaching from behind (*Dom.* 14.4). On the other hand, in the mid-first century C.E. Seneca complained that even in quite ordinary bathing establishments the walls were "resplendent with large and costly mirrors" (*Ep.* 86.6, my transl.), probably of the full-length kind he so deplored in the homes of the rich. He also attested to the newfangled trend of installing large glass windows in baths (*Ep.* 86.4, 8; 90.25), which would have had some limited reflective value. We may reasonably surmise that almost everyone owned, or had access to, some kind of hand mirror for personal grooming.

Bronze mirrors, once popular among the elite in the Aegean of the palatial period, disappeared from the Greek record thereafter before emerging in the early sixth century B.C.E. They came to Italy at about the same time.[29] Personal mirrors were ubiquitous in the Roman world; extant examples surely number in the thousands. They are far too scattered, and too poorly cataloged, to be studied as a body, but fortunately there are enough dedicated collections and specialized publications to allow some general assessments of their history, types, and distribution.[30] Roman mirrors were made of silver, bronze (itself often silvered or tinned), or glass with metallic backing. From the first century B.C.E., simple rectangular and disk mirrors of bronze, without handles of any kind, seem to have enjoyed widespread popularity.[31] With the invention of transparent glass in Syria at the beginning of the first century B.C.E., small glass mirrors with a variety of metallic backings, usually set into frames of contrasting materials, also became a widespread accessory in Roman households.[32] Often these were much smaller (they could have a diameter as tiny as 2.5 cm), and so in order to be useful their surfaces were made convex. Natural convexity was achieved by blowing a globe of glass and coating its interior with molten lead or some other metal, and then carefully sectioning the globe and working its segments into disks.[33]

Humble mirrors of this kind almost never appear in Roman art. The dignity of representation is granted only to the more prestigious forms, which fall into

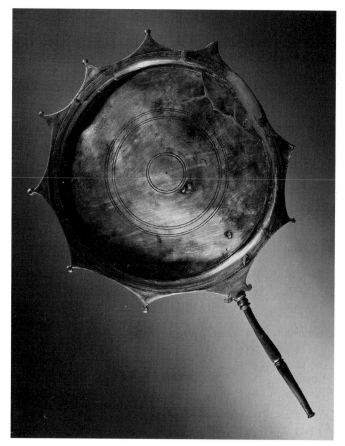

1. Bronze mirror from Pompeii. Naples, Museo Nazionale 13519. Scala/Art Resource, NY.

a few general categories. First and foremost, the classic grip mirror: a disk of silver, bronze, or silvered bronze, usually slightly smaller than a face, to which is attached a separate upright handle at the bottom.[34] Its surface may be flat or even concave, but much more commonly it is slightly convex. The backs of Roman grip mirrors rarely carry figural decoration but often are incised with concentric circles; the rim may be smooth or decorated with perforations or scalloping (Fig. 1). Two other common "prestige" types are the lid mirror and the box mirror.[35] The lid mirror, derived from a more elaborate Hellenistic prototype, consists of a thin disk and a separate lid that fits snugly over it. It seems to have been a specialty of workshops in southern Gaul.

The term *box mirror* (or *mirror box*) refers loosely to a number of subtypes. One consists of a wafer-thin reflective disk inserted into a separately made circular metal box with a removable lid. On a popular Gallic type, both sides of the box are decorated with Neronian coins from the imperial mint in Lugdunum. The classic hinged subtype (the *Klappspiegel*), looking much like a modern compact, was a Greek invention beloved also of Etruscan aristocratic women from the third to the first century B.C.E. – particularly those of Volterra, whose sculptural

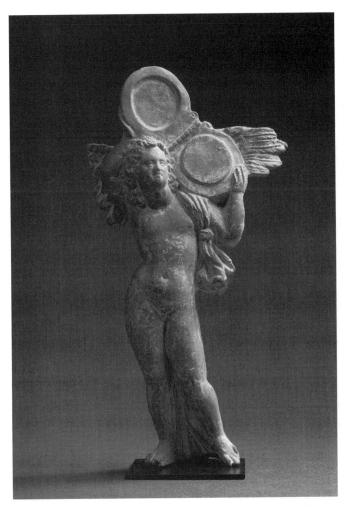

2. Terracotta statuette from Myrina. Late first century B.C.E. Paris, Louvre Myr 94. Photo: Réunion des Musées Nationaux/Art Resource, NY.

portraits reclining atop cinerary urns often included it as an attribute.[36] Circular or square, the mirror's frame and lid could be made of bronze, wood, or bone. Many charming late-Republican or early-Imperial statuettes from Myrina in Asia Minor (Fig. 2) portray a little Eros hoisting an oversize circular mirror of this type. One of the most familiar scenes in all of Roman art features a rectangular version. This is the hairdressing episode from the Mysteries Frieze at Pompeii, in which (again) the implement is borne by an Eros (Fig. 3). It is uncertain whether this is a hinged model, or the rarer sliding variety, of which two examples in bone have been preserved at Taranto (Fig. 4).

The popularity of box mirrors seems to have waned toward the end of the first century C.E. Around the middle of that century there emerged a new design, known as the "Simpelveld" type (after a well-known exemplar from the eponymous site in the Netherlands) or the *miroir à poignée*.[37] It consists of

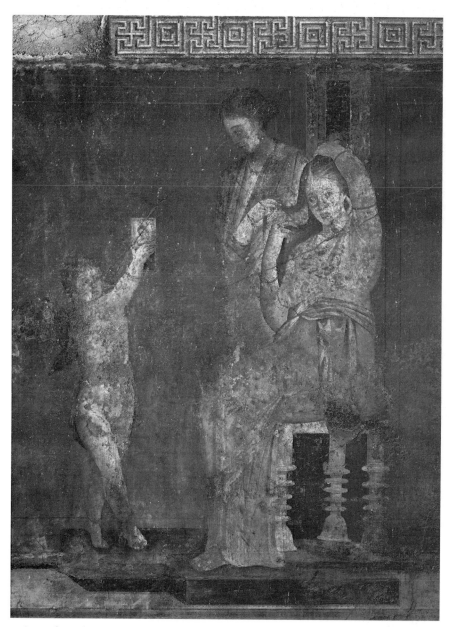

3. Scene from the Frieze of the Mysteries in the Villa of the Mysteries, Pompeii. Mid-first century B.C.E. Photo: Scala/Art Resource, NY.

a circular disk with a diametral "drawer handle" soldered to its rear. A mirror of this kind has been found at Pompeii; another was represented in a now-lost fresco from Pompeii, preserved in a drawing from the nineteenth century (Fig. 5).[38] The type simply disappears from the record for a century and a half after Vesuvius, only to return in third-century Gaul and to maintain its popu-larity well into the fourth century. It has been suggested that a woman holding a

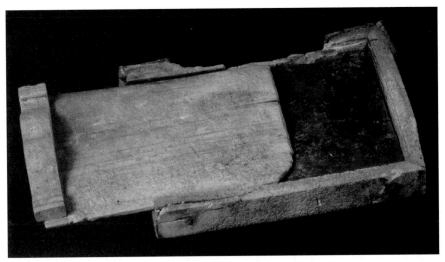

4. Sliding mirror from Contrada S. Lucia at Taranto. Silvered bronze and bone. Taranto, Museo Nazionale Archeologico 12048.

5. Drawing by G. Abbate of a wall painting from the House of the Postumii/M. Holconius Rufus (8.4.4, 49) at Pompeii. Photo: Naples, Museo Nazionale.

mirror of this type in a reconstructed fresco vignette from the imperial palace at Trier is a member of the Imperial court, or perhaps an allegory of an imperial virtue (Fig. 6).[39] Whatever her identity, this crowned and haloed woman is clearly at the top of the social and spiritual scale. There can be little doubt that in late antiquity a large *miroir à poignée* represented the standard against which all other mirrors were measured.

THE LITERATURE

Fascination with mirrors and reflections seems as inexorable today as ever. Several museum exhibits and catalogs in recent years have been formulated around the topic of the mirror both as artefact and as metaphor, usually with a significant nod to ancient beliefs and practices as well as to modern theory.[40] Studies of reflection as a cultural conceit and a scientific tool have proliferated since Gustav Friedrich Hartlaub's penetrating study of 1951, *Zauber des Spiegels: Geschichte und Bedeutung des Spiegels in Kunst*.[41] Jurgis Baltrusaitis' *Le Miroir*, for example, presents an entertaining illustrated tour through the history of catoptrics from antiquity to the modern period. Sabine Melchior-Bonnet's *The Mirror: A History* also takes as its canvas the length and breadth of Western civilization, but hers is principally a literary survey with a long excursus on the development and reception of silvered glass mirrors in seventeenth- and eighteenth-century Venice and France. Mark Pendergrast, by contrast, has focused on the history of mirrors in science and technology.

Within the ambit of ancient studies, mirrors and reflections have been studied from many perspectives. Most elementally, there are the catalogs of mirrors themselves: Eduard Gerhard's five-volume *Etruskische Spiegel* (1843–97) and the ongoing *Corpus Speculorum Etruscorum*, along with several monographs that treat Etruscan mirrors as objects in themselves, not just the vehicles of iconography;[42] a monograph on Praenestine mirrors;[43] several studies or catalogs of Greek mirror types;[44] and a few (too few!) on Roman mirrors as well.[45] A. de Ridder's and Ada von Netoliczka's authoritative encyclopedia entries from three quarters of a century ago still serve as useful general surveys of Greek and Roman mirrors, but their individual parts have been superseded by subsequent scholarship.[46]

Our understanding of the Greek sciences of optics and catoptrics, both of which had profound implications for philosophical theory, has advanced considerably, thanks to a small but vigorous cadre of specialists.[47] For the most part, however, recent interest has focused on the mirror as a cultural artefact. Philosophy itself, which seized upon the mirror metaphor in elaborating everything from the Platonic and Epicurean theories of sense perception to Stoic ethics and late-antique cosmology, has inspired fruitful investigation on several

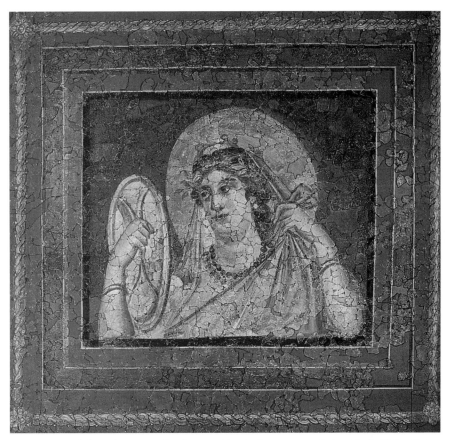

6. Fresco panel from the imperial palace at Trier. Before 326 C.E. Trier, Bischöfliches Dom-
und Diözesanmuseum.

fronts.[48] I have already mentioned the evocative mirror metaphors of St. Paul,
which despite their brevity have inspired a robust scholarship.[49] The resonance
of Paul's model of indirect vision extended at least as far back as Plato, with
his convictions that reflections are among the most debased of all expressions
of reality, and forward to the Neoplatonists and patristic thinkers.[50]

The explosion of interest in ethnography and folklore in the nineteenth
century, often expressed as an anthropology of magic and ritual, inspired a
number of studies on the magical uses of mirrors, punctuated by Géza Róheim's
Spiegelzauber in 1919, a curious blend of ethnography and psychoanalytic theory
characteristic of its time.[51] In the twentieth century, a number of scholars
turned their energies toward the investigation of mystery and hermetic cults
in which mirrors were used for divination and hallucinatory rituals.[52] Chapter
3 of this book, *pari passu* with Nancy de Grummond's work on Etruscan art
and divination, will bring the issue back into focus.[53]

The mirror as metaphor in Greek and Latin literature has inspired some excellent work of late, notably an important essay by Willard McCarty; monographs by Einar Jónsson and Shadi Bartsch; a dissertation by Moritz Schuller; and a number of publications by Jean-Pierre Vernant and Françoise Frontisi-Ducroux, culminating in their collaborative book, *Dans l'oeil du miroir*.[54] McCarty's brilliant little article probes the principles of polarity underlying the Greco-Roman metaphor of the mirror – its tendency to embody alternately identity and separation, correspondence and opposition, self and the Other, positive and negative, ecstasy and entrapment, female and male, sexual attraction and amuletic repulsion. In its fascination with binary oppositions McCarthy's essay has much in common with the French structuralism of Vernant and Frontisi-Ducroux. An inventive and idiosyncratic approach to reflection in antiquity, their book takes the form of a series of more or less loosely related essays probing the psychology of the mirror in Greek and Roman society, particularly as it pertains to gender and religious mysticism. Jónsson, taking a more direct approach to the history of philosophy, traces catoptric symbolism in the Greco-Roman intellectual tradition through three stages: first, the development of metaphors of direct and indirect reflection within epistemological theory, particularly in Plato and the Stoics; second, the reelaboration of this symbolism in the ontology of Neoplatonism; and finally, its adoption into early Christianity, whose patristic fathers advanced competing notions of the soul as the imperfect mirror of God. Drawing upon several important sources of mirror imagery in Greek and Roman literature (the Narcissus and Medusa stories, Euripides' *Hippolytus*, Plato's *Symposium* and *Phaedrus*), Schuller traces the development of the mirror as a cultural tool of self-knowledge – an implement that allows one to move beyond mere introspection to the objectification of the self. Just recently Shadi Bartsch has examined the philosophical metaphor of the mirror afresh in an astute study of visuality and visual theory in ancient concepts of the self.

As this book will attest, art itself has much to contribute to the discussion too. Others have preceded me in examining reflections and mirrors in Greek and Roman art, notably Hartlaub, who includes a highly competent chapter on ancient art; and especially Lilian Dreger and Lilian Balensiefen, both of whom have attempted broad surveys of the material from the Classical period to late antiquity. I am particularly indebted to Balensiefen, who herself builds upon Dreger's 1940 dissertation. She takes a traditionally empirical approach to her subject matter, which she organizes according to broad categories of "real" and "unreal" reflections in art and myth. Her work is particularly strong in the category of reflection-myths that are also well represented in art, such as those of Actaeon, Perseus and Medusa, and Narcissus. My own approach, which often diverges sharply from Balensiefen's, in no sense seeks to diminish

her achievement or subvert her conclusions; it is instead a tribute to her careful and diligent scholarship.

THE ROMAN VIEWER

My book periodically invokes the Roman viewer as if he or she were not so different from you and me. This strategy may seem facile to readers who feel that such bridging of cultural divides merely retrojects the author's own norms and prejudices upon a too distant subject. The problem of how to simulate a long-defunct viewing experience is hardly a trivial one; it is, for example, the central issue in Jaś Elsner's monograph of a decade ago, *Art and the Roman Viewer*.[55] There are few, if any, cultural absolutes that bind all peoples, times, and places. Nevertheless, there is much that the modern *educated* viewer has in common with the educated Roman viewer; if this were not the case, and if in fact I could not approximate the perspective of my ancient counterparts, then there would be no point in studying their culture at all. We are capable of digesting a good deal of the raw material upon which a Roman would have formulated a response to art: myths, literature, rhetorical training, philosophical reasoning, movement and gesture, and even – thanks to such compilers as Varro, Ovid, Pliny the Elder, Plutarch, and others – folk beliefs and customs. And it hardly needs to be said that our own visual vocabulary and symbolism owe a tremendous debt to the Greco-Roman tradition.

So I make no apologies for the occasional attempt to invoke the Roman viewer, though I am fully aware of the pitfalls. I cannot, for example, say much about the uneducated Roman, who in many cases would have brought a more representative perspective to bear on much of the material presented in this book. But it is important to be reminded, in this postmodern, postpositivist, postprocessual age of anxiety, that cultural divides are far from absolute; that there are good reasons why we still find value, and some measure of cultural kinship, in very old things – and why we still seek a better understanding of them. Gilles Sauron, I think, took the proper middle way in his 1998 study of the Mysteries Frieze at Pompeii:

> It is only right to observe that if we are to view this pictorial work correctly, we must progress to a veritable archaeology of the gaze, which takes away our visual customs and permits us to see this document, more than twenty centuries old, with the eyes of its contemporaries. An impossible undertaking, perhaps? I would say rather that this undertaking, though certainly difficult, is theoretically indispensable for a correct understanding of those things that are given us to see – and that we at the close of the twentieth century, while certainly claiming no ability to recover the gaze of the Romans of the mid-first century B.C.E., must seek all the means at

our disposal at least to try to understand how the visual perception of the ancients was conditioned by a number of customs that are no longer our own, through the vision of public and private decorative schemes that are no longer familiar to us – quite apart from the particular conventions used in this particular pictorial genre.[56]

Sauron, in brief, is seeking not a direct, empathic relationship to the ancient viewer but rather a better understanding of the iconographic artefacts of the gaze and the codes by which they operate. It is in this archaeological spirit that I introduce, for example, such coded pictorial devices as the flexed gaze (chapter 1), lamination of signifiers (chapter 3), the ecstatic head-toss (chapter 3), and the chastising mirror-shield (chapter 4).

ONE

THE TEACHING MIRROR

THE MIRROR AND MASCULINITY

> Mirrors were invented in order that man may know himself, destined to attain many benefits from this: first, knowledge of himself; next, in certain directions, wisdom. The handsome man, to avoid infamy. The homely man, to understand that what he lacks in physical appearance must be compensated for by virtue. The young man, to be reminded by his youth that it is a time of learning and of daring brave deeds. The old man, to set aside actions dishonourable to his grey hair, to think some thoughts about death. This is why nature has given us the opportunity of seeing ourselves.
>
> A clear fountain or a polished stone returns to each man his image. . . . What sort of refined life do you think those people led who groomed themselves at this kind of mirror? That was a simpler age, content with what chance offered, and it had not yet twisted benefits into vice nor seized upon inventions of nature for the purpose of lust and extravagance.[1]

Thus wrote Seneca in his reflections upon Socrates' famous dialogue with Alcibiades about the meaning of the Delphic slogan "know thyself."[2] The mirror was, in Seneca's Stoic scheme, a double-edged sword. Enhanced self-observation, even self-knowledge, did not guarantee a path to wisdom; it could, in the wrong hands, lead to a perverse pleasure in one's error. But in the hands of the well-intentioned, philosophic man, it was a powerful tool in the struggle of the transcendent soul over the base materiality of the body.[3]

Roman society has been called a panopticon of spectatorship[4] – a landscape of ubiquitous, perpetual, and ever-adaptive theater in which all of society must participate. To most Romans, regardless of rank, everyday life was a sequence of performances, rehearsed or extemporaneous. Even the ordinary and the obscure found themselves on both ends of the public gaze in the controlled spectacle of Roman life.[5] In such circumstances both men and women found a place for the mirror in their rituals of self-actualization or self-discovery – but in very distinct, asymmetrical ways. The mirror as a cultural construct, whatever its applications in real life, remained a strictly gendered thing. Writers as diverse as Phaedrus, Seneca, Plutarch, and Apuleius stipulated that a man should resort to a mirror only on the ground of philosophical self-improvement.[6] Although it would be absurd to presume that ordinary Roman men believed their manliness was somehow compromised when they used a mirror in their personal grooming,[7] or that all men slavishly endorsed the value judgments of the cultural elite,[8] the differences in the social, and indeed *moral*, value of male and female specularity remained profound. Punctuating this distinction was a fear of a moral recidivism of the male if he consorted with reflections too ardently. "Nothing to excess," a Socratic dictum, was at the core of this value system.[9] In her new monograph on the Roman philosophy of the self, Shadi Bartsch says,

> although the idea of "self-knowledge" suggests, for us, a romantic intro-
> spection into the hidden depths of the soul, or a Freudian uncovering
> of the unconscious desires ⬛⬛⬛⬛⬛⬛⬛⬛⬛⬛⬛⬛⬛⬛⬛⬛⬛⬛ *rosyne* was
> directed toward moderatio⬛⬛⬛⬛⬛⬛⬛⬛⬛⬛⬛⬛⬛⬛⬛⬛⬛⬛of the indi-
> vidual, toward the approb⬛⬛⬛⬛⬛⬛⬛⬛⬛⬛⬛⬛⬛⬛⬛⬛⬛owering of
> an inner potential. This p⬛⬛⬛⬛⬛⬛⬛⬛⬛⬛⬛⬛⬛⬛⬛⬛ *phrosyne* as
> a set of practices and the r⬛⬛⬛⬛⬛⬛⬛⬛⬛⬛⬛⬛⬛⬛y, and also
> explains why, for us, the er⬛⬛⬛⬛⬛⬛⬛⬛⬛⬛⬛⬛⬛those ends
> might seem empty or supe⬛⬛⬛⬛⬛⬛⬛⬛⬛⬛⬛⬛ writers it
> provides a significant view

To the extent that the use of mirrors was necessary or desirable, the cultural gender gap could be characterized by a simple dichotomy that extends from the sexual norms of the time. The ideal Roman woman was reflected *being*; the ideal Roman man, if be reflected he must, was reflected *doing*.[11] In neither case, I hasten to emphasize, was the object of reflection strictly the inner self of the mind or the soul; rather, it was a construction of the self as an animated body on display before the world.[12] Masculine speculation transcended the self-enclosed economy of the mirror; it was an aid to agency in the broader world of affairs. For men, the moral mirror might take one of two forms: *reflexive*, in which the subject would see himself, along with (it was hoped) his faults and virtues, and adjust his life accordingly; or *triangulative*, whereby he might be

instructed by the virtues and faults of others, reflected in some metaphorical mirror such as a literary or theatrical account of their deeds.[13] This metaphor proved so potent that the Latin noun *speculum* acquired the special meaning of "model" or "standard."[14] The triangulative mirror differs from the reflexive mirror in one crucial way: it reflects the ideal to be emulated rather than the reality in need of improvement.[15]

Socrates' mirror was reflexive; but for others, the triangulative mirror provided the moral ideal. Paul's famous paradigm, "For now we see through a glass, darkly, but then face to face: now I know in part; but then shall I know even as also I am known," presumed a human triangulation to the divine on the tarnished or imperfect mirror of mortal existence. Plutarch also drew upon the mirror as a catoptric channel to the divine, the Platonic realm of higher reality that is prior to material things.[16] Plutarch in fact was particularly fond of the metaphor of reflection, and used it often. In one sense, history itself was his mirror, teaching him to put his life in order and conform to manly virtues; his actions should reflect those of great m[en . . . He found] that writing history and biography – "using h[istory as a mirror and try]ing in a manner to fashion and adorn my life i[n conformity with the virtues the]rein depicted" – was beneficial to the author[. . .] [He also accep]ted a popular conceit that a person's words [were the image, the mirror imag]e, of the inner self. One's outer presence was [a reflective conduit to] the world: more a lens, really, than a pure re[flector, a mi]ddle point in an oblique optical trajectory.[18]

In the introduction to his *De clementia*, Seneca found a middle way between the reflexive and the triangulative by proposing himself – or more accurately, his treatise – as a moral mirror to his patron Nero, "so that . . . I might show you to yourself as one who will attain the greatest pleasure (*voluptatem*)."[19] The metaphor of the mirror acknowledged that manly virtue called upon a split subjectivity, a "master and servant" within the self to control and shape mere impulse.[20] The process presents an interesting exchange of power roles: the simple self, the master, chastened by the didactic self, the helpful servant. The relationship has been given life in innumerable literary pairings, from Horace and his imaginary slave Davus (*Sat.* 2.7) to Lear and his fool. It is this dynamic of reversal, perhaps, that lies at the heart of the principle of the magnetic mirror.

The man at the mirror perfected himself as an agent, the subject of an active proposition; women and effeminate men perfected themselves as the patients, or recipients, in a passive or reflexive action. Because of the perceived danger that the active could too easily relax into the passive – a danger that Stoicism and Epicureanism, which dominated the cultural airwaves of Hellenized Rome, took feverishly to heart – art and literature scarcely ever presented a *neutral* encounter between a male and a mirror. If an encounter was to be admitted at all, it had to be explained either as a salutary draft of philosophical

self-adjustment or – much more commonly – as a despicable wallow in enfee-
bling *voluptas*.[21] Seneca best defined both of these male types: on the one hand,
the man who sought to see himself as the world saw him, and to adjust his
persona accordingly; on the other, the self-absorbed pervert Hostius Quadra,
who indulged in his sexual abominations in a room full of magnifying mirrors:

> He was vile in relation not to one sex alone but lusted after men as well as
> women. He had mirrors made of the type I described (the ones that reflect
> images far larger) in which a finger exceeded the size and thickness of an
> arm. These, moreover, he so arranged that when he was offering himself
> to a man he might see in a mirror all the movements of his stallion behind
> him and then take delight in the false size of his partner's very member
> just as though it were really so big. . . . Go on now and say that the mirror
> was invented for the sake of touching up one's looks [*munditiarum causa*]!
> The things that monster said and did (he ought to be torn apart by his
> own mouth) are detestable to talk about. Mirrors faced him on all sides
> in order that he might be a spectator of his own shame. . . . Sometimes
> shared between a man and a woman, and with his whole body spread in
> position for submitting to them [*toto corpore patientiae expositus*], he used to
> watch the unspeakable acts. . . . Even among prostitutes there exists some
> sort of modesty, and those bodies offered for public pleasure draw over
> some curtain by which their unhappy submission [*infelix patientia*] may
> be hidden. Thus, towards certain things even a brothel shows a sense
> of shame. But that monster had made a spectacle of his own obscenity
> and deliberately showed himself acts which no night is deep enough to
> conceal.[22]

This strange character portrait, which continues on in the same vein
at length, has been carefully examined from a theoretical standpoint only
recently.[23] Here the word *patientia*, the passive sexual role, is applied not only
to prostitutes but (derisively) to Hostius himself. His bold sexual initiatives may
seem to be feverishly active, but according to the dominant cultural formu-
lation his lust is of a strictly pathic, effeminate nature. Even more interesting
is Hostius' morbid fascination with his physiology to the complete exclusion
of his *physiognomy*. His transactions are bizarre, quasi-triangulative affairs in
which the face, which is the rightful occupant of a man's mirror, is displaced
by bloated genital phantasms flashing about on the silvered walls of his den.
Hostius' feverish reinvention of the body, although it enlarges scale, reduces
scope; his mirrors fragment and depersonalize the whole to the point where
he celebrates an essentially disembodied, mechanical process, strictly confined
to bestiality. Seneca's stark choice between (in this case) a "good" reflexivity
and a "bad" triangulation presents a classic example of the double-edged moral
mirror. That which can draw man's attention upward to the realm of pure soul
can also be used in the opposite way, dragging it downward to his soulless
nether parts.

The life of the Roman man of affairs – and to a great extent, his Greek predecessor too – was a paradox. Such a man must simultaneously invite the public gaze and beware of it.[24] And so the single most charged, and ethically ambiguous, category of male catoptric encounter was the rehearsal before a mirror. The dying Augustus, it was said, arranged his hair and face in a mirror; then, as his last act, he called for applause, like a comic actor leaving the stage.[25] By choosing a histrionic analogy, the historian Dio Cassius betrays a certain disapproval, perhaps feeling that the great emperor had compromised his reputation by staging his own exit in such a crudely self-interested and theatrical way. Suetonius reports that Caligula perfected his terrifying persona in front of a mirror (*Calig.* 50.1) – not a condemnation of male specularity per se, but consistent with the perception that when philosophy is absent, mirrors and monstrosity consort together.

More generally, if a public figure was found to have used a mirror to adjust his public image, he opened himself to charges of effeminacy. Demosthenes owned a full-length mirror in which he practiced his rhetorical gestures; not surprisingly, his archrival Aeschines denounced him as a debauched girly-man.[26] According to Macrobius, the notoriously effeminate orator Hortensius used a mirror (a large one, I surmise) to check the appearance of his toga (*Sat.* 3.13.4–5). Seneca, although praising manly Socratic mirrors, proceeds to condemn the fashion for full-length mirrors and other expressions of self-absorption (*QNat.* 1.17.8–9). With his attack on Hostius Quadra still fresh (it appears only a few pages earlier), the reader may be tempted to conjecture that this author is opposed not so much to the expense of such mirrors (the stated grounds for his criticism) as to their capacity to reveal the whole body for appraisal, not just the face alone, thereby eroticizing his philosophical tool. Among the evidence adduced against Apuleius in his celebrated trial for sorcery was the fact that he possessed a mirror. The orator defended his ownership of it by citing, among its other defensible uses, the philosophic function propounded by Socrates and its performative function as exemplified by Demosthenes.[27] In the latter case, he argued, the mirror served for a teacher (*ante speculum quasi ante magistrum causas meditatum*), thereby formulating what Molly Myerowitz has called the didactic of the mirror.[28] But the wily defendant did not press his case too far: he noted that his hair remained matted and unruly. His was a true philosopher's mirror, he implied – a tool for self-improvement, but hardly complicit in effeminate self-admiration. No other passage in Roman literature so clearly establishes the carefully drawn divide between physiognomic (masculine) and cosmetic (feminine) uses of reflection.

Couched in such ambiguous terms, it is no surprise that mirrors were hardly ever presented in Roman art or literature as attributes of men who made claims to civic gravitas. There is one class of men, however, who seem to have coexisted comfortably with their own reflections. These were actors, men of

humble origins (often in slavery) with no prospect of a direct role in civic life. They were under no philosophic compulsion to know themselves, but made it their business to know the characters they played; for if we follow Aristotle's precepts, their efforts, like those of historians, projected upon the audience, as if by a mirror, noble and ignoble deeds to which the audience would respond on the basis of their own life experiences.[29] In short, actors used *reflexive* reflection to improve their ability to project *triangulative* reflection – the mimetic character that would be mirrored upon the audience. The reputations of actors in the Roman era were notoriously uneven, and acting in general was redolent of *infamia*;[30] but in the golden age of Roman theater an A-list actor such as the comedian Q. Roscius Gallus could command not only a knighthood and enough wealth that he could refuse income in his later years,[31] but the admiration, friendship, and advocacy of Sulla and Cicero. Roscius "was said never to have used a gesture on stage which he had not rehearsed and tested at home, and according to an anecdote would contest with Cicero to see which could best express the same thought with greatest variety; Cicero through language, or Roscius through his movements."[32]

Thus, a scrupulous actor such as an orator, was exquisitely aware of his own bodily persona on stage; and given the availability of technology to grind and polish large sheets of bronze, there is little doubt that some actors, at least, used body-length or half-length mirrors to master their craft. Because they were usually masked in performance (Roscius, who customarily went without a mask, is an exception[33]), this involved no facial expression whatever but depended entirely on subtleties of delivery, gesture, stance, and movement. In Roman mural art the oversize mirror makes an appearance among the backstage attributes of actors in at least two cases. The better-known of these is a fresco panel from Herculaneum (Fig. 7). The scene represents two actors preparing for a performance while a female attendant kneels beside a tragic mask. Behind the principal actor, who sits dressed for his role, stands a large rectangle framed in white. The vague pink and buff wash across its surface, rendered in diagonals, adopts the same convention for conveying reflectivity without reflection as advertising art today. A second, fragmentary fresco panel from Pompeii also represents a tragic actor, this time idealized and at rest in his Greek chiton as he contemplates a tragic mask held before him by an attendant (Fig. 8). Behind his right knee rests, at an angle, a framed panel. Though this type of frame, with projecting corners, often adorns small portable paintings represented in Roman art (especially votive *pinakes* at shrines), the actor's prop has a surface rendered in a uniform grayish-white wash more appropriate for a mirror.

Was the actor's use of the mirror a distinctively male attribute, an accessory to *doing?* From a sociological perspective, Roman actors lived in a permanently liminal condition that tempered genuine popularity with the status of a social outcast. In terms of gender too they were ambiguous, and therefore deviant:

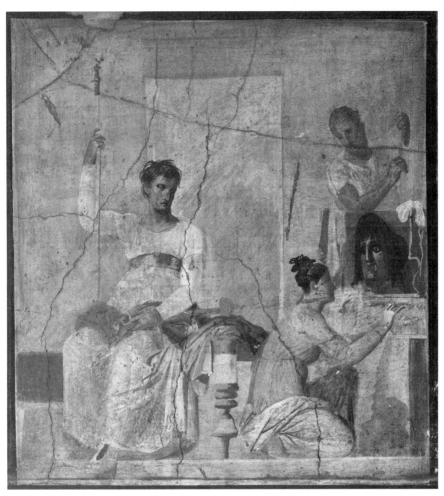

7. Third-style wall painting, probably from the "palaestra" at Herculaneum. Naples, Museo Nazionale 9019. Photo: Erich Lessing/Art Resource, NY.

many played roles of both men and women. In Michel Foucault's formulation, they would have inhabited a heterotopia – a place where persons reside when they cannot be accepted into the real space of social normalcy.[34] The theater and the mirror are both classic heterotopias. As it happens, both allow the self to project another by a kind of intersubjectivity, or (to use Lacan's characterization of the mirror stage) a dialectic of identification with the Other.[35] On stage and in rehearsal, the actor is simultaneously (or alternately) himself, the persona of the Other, and the critical audience of both. In rehearsal, the mirror assists this multitasking by clarifying the distinction of roles. The actor's simple self and self-as-audience inhere in real space, scrutinizing the persona that appears across the metallic threshold in virtual space. But in ancient practice there is no reciprocation of the "critical eye" across the divide, for the mask

is unidirectional. When reflected, it does not convey back into real space the identity of an *audience* off in virtual space: the mirror's sphere is strictly performative. The theatrical mask, then, disrupts the cycle of hyperreflexivity – the pleasure of being seen even as one sees – that characterizes the archetypal Roman effeminate in front of the mirror.

MINERVA, MARSYAS, AND GENDERED STANDARDS OF PERFORMANCE

Whatever else can be said about the "masculine" mirror in its Greco-Roman formulation, its proper didactic function was always essentially epistemological: the subject learned from the experience. Such self-knowledge, as philosophers preached it, was the privilege of men. Women were schooled in something quite different, self-consciousness. Their business was product development, where they were the product and men the consumers. When, in Greco-Roman myth, a particular female – even an extraordinarily masculine one – tries to do something "performative" before a reflection, her efforts end in shambles. A popular Greek myth recounts how Athena/Minerva invented the double pipe and the strange, skirling music played on it; but when she saw her reflection in the water of a river, and the ugly distortion that her playing brought to her face, she cast the pipes away in horror and refused to play ever again.[36] According to a Classical verse formulation of the tale, of which a couple of fragments are preserved in Plutarch, the satyr Marsyas berated the goddess for her unbecoming hobby:

> In fact, those who delight in pleasant fables tell us that when Athena played the pipes, she was rebuked by the satyr and would give no heed:
>
> > That look becomes you not; lay by your pipes
> > And take your arms [*hopla*] and put your cheeks to rights;
>
> but when she saw her face in a river, she was vexed and threw her pipes away. Yet art makes melody some consolation for unsightliness. And Marsyas, it seems, by a mouth-piece and cheek-bands repressed the violence of his breath and tricked up and concealed the distortion of his face:
>
> > He fitted the fringe of his temples with gleaming gold
> > And his greedy mouth he fitted with thongs bound behind.[37]

In most other versions of the story, it seems that Marsyas was not even present while Athena played, but came upon the pipes accidentally after she discarded them. This is the version Ovid chooses to tell in his *Fasti*.[38] But already by about 480 B.C., Melanippides of Melos was confirming the strange central detail, the shame of personal appearance, that prompted a goddess to pass the legacy of pipe playing to the Phrygian satyr: "Athena hurled the instruments from her sacred hand and said, 'To perdition with you, shameful things, an outrage to my body. I yield me not to such baseness.'"[39]

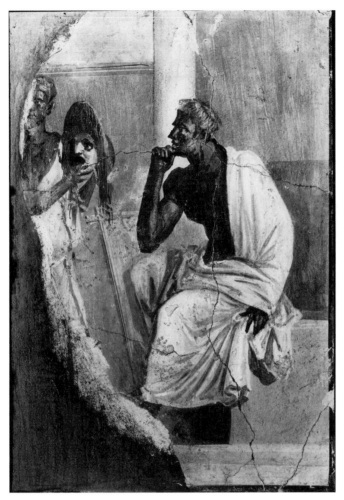

8. Fragment of a wall painting from the House of M. Lucretius Fronto (5.4.A) in Pompeii. First century C.E. Naples, Museo Nazionale. Photo: Alinari/Art Resource, NY.

Athena/Minerva is a goddess of determinate sex but of ambiguous gender: female patroness of the male pursuits of wisdom and war. In keeping with her ambiguity, this act of abjuration can be interpreted in radically different ways. On the one hand, it may be seen as the purifying, masculine expedient advanced by Seneca: consulting a mirror to eliminate unseemly distortions in one's appearance, thereby taming the irrationality and inner passions that engendered them. This is how Jean-Pierre Vernant, following Franz Cumont, sees it: the double pipe "contributes nothing to the perfection of intelligence; . . . it has an orgiastic, not an ethical, character."[40]

On the other hand, it can be argued that invention is necessarily an act of the intellect, and that the goddess is intentionally choosing the option most apt for a subaltern femininity: to *be* in the reflection, rather than to *do*. Such behavior is not usually in the nature of this goddess, to whose formidable

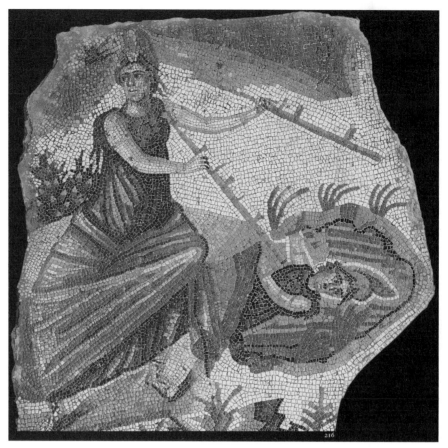

9. Fragment of a triclinium mosaic from a residence at Dougga. Fourth century c.e. Photo courtesy of the Museum of Utica, Tunisia.

intelligence was credited the invention of many useful things. But there is something about the mirror that vitiates even her invincible persona; it is for this reason, perhaps, that no parlor mirror is ever seen in her presence, even (so Callimachus claims) when she prepares for the Judgment of Paris.[41] (Her famously reflective shield, we shall see, was purely tactical ordnance with no reflexive function or meaning.) The reflective water on which she has her chance encounter becomes her philosophic *praeceptor*, her teacher – but paradoxically it *teaches her to be untaught*. The didactic reflection is simultaneously antididactic. In a flash she becomes her own audience and is appalled by the comical ugliness of her face. Mere subjectivity, absorbed in the simple pleasure of accomplishment and creativity, is no match for the wave of feminine shame that washes over her when she spies her distended face, rendered – as Vernant would have it – nothing less than a gorgon mask.[42] The gendered dyad of vanity and modesty, reinforced by Marsyas' criticism, fuels her disgust.

10. The Dougga mosaic in situ. Photo from Fantar 1987.

The Marsyas myth – particularly the satyr's later music contest with Apollo, for which the presumptuous satyr was flayed alive – was a popular theme in Greco-Roman art from the Classical period onward.[43] In Roman art the episode is represented in various ways. A fourth-century triclinium mosaic from Dougga, now in several fragments, captures the moment after the helmeted goddess's encounter with her reflection as she draws the pipes from her mouth (Fig. 9).[44] She looks away, perhaps in disgust; her reflection in a small pool also turns sharply askance. Both referent and reflection depict the gorgon-headed aegis on her breast, a reminder, perhaps, of the pipes' own function as a mnemonic of the gorgon's shriek, as Pindar explains it.[45] On a now detached fragment situated in the background, Marsyas is shown watching intently from behind a rock, as if the goddess's convulsion of self-doubt were as private and potentially shameful as nakedness (Fig. 10). This is not the only Roman representation of the scene to present Marsyas skulking like a voyeur in the background.[46] A fourth-century mosaic from Kélibia (Clupea), Tunisia also shows the young satyr looking on from behind a stylized rock

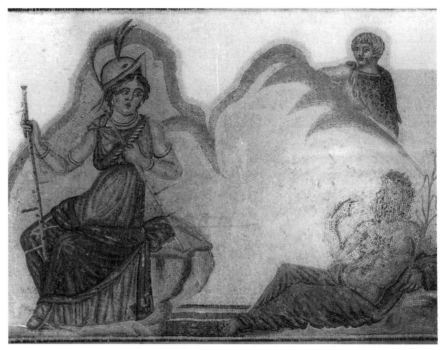

11. Mosaic from Kélibia (Clupea), Tunisia. Fourth century c.e. Museum of Nabeul 13.03.19.1. Courtesy of l'Institut National du Patrimoine, Tunisia.

(Fig. 11).[47] But here Minerva does something very interesting: drawing back from her pipes, she exchanges an intense gaze with the attendant river god, as if he were the incriminating reflection itself.[48] This threesome also appears on sarcophagi, again with the exchange of gazes between the goddess and river god; for example, on an early Severan sarcophagus in Copenhagen, the triangle is laterally reversed but retains the same basic composition (Fig. 12).[49]

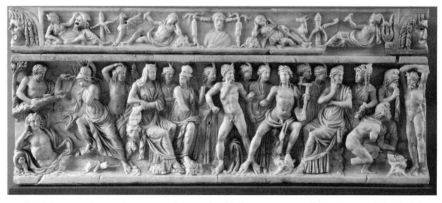

12. Marble sarcophagus. Late second or early third century c.e. Copenhagen, Ny Carlsberg Glyptotek IN 0844.

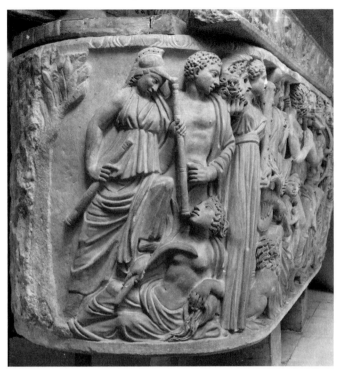

13. Side relief of a marble sarcophagus. Early to mid-third century C.E. Rome, Galleria Doria Pamfili. Photo: DAI Inst. Neg. 71.1495.

The reciprocal glare is even more piercing on a slightly later sarcophagus at the Galleria Doria Pamfili in Rome, but Marsyas is missing from the vignette; in this case the water deity is female (Fig. 13).[50] This reciprocity of gazes is a radical, and to my knowledge unparalleled construction in the grammar of Roman visuality: the reflected gaze is denatured and allegorized into the mythological embodiment of the mirroring medium itself, the river god. Such is the didactic mirror in perhaps its most concentrated form, where any semblance of the hyperreflexive self has given way to a purposefully reproachful Other.

Perhaps the most interesting Roman rendition of the episode is a fresco panel from the House of Queen Margherita in Pompeii, accurately reproduced in an engraving made directly after its discovery in the late nineteenth century (Fig. 14).[51] Minerva's helmeted figure, partially obliterated, sits on a rock near a sacral-idyllic shrine, piping; her shield rests beside her. But instead of gazing directly into the pond at her feet, she looks toward an attendant nymph who emerges from the water holding out a large circular or elliptical mirror, angled slightly upward. An allegorical figure with a cornucopia sits nearby, watching.[52] Atop a rocky outcropping above Minerva's head, the nude figure of Marsyas, rustic *pedum* in hand, leans forward; he appears to be listening or

gazing intently.[53] He could, in fact, even be spying on the goddess by way of the mirror, creating a voyeuristic triangle. (The other figures belong to subsequent episodes in the story, when Marsyas discovers the pipes and challenges Apollo to a music contest.[54]) Without extrapolating too freely from this ambiguous scene, one may suppose that Marsyas sees Minerva's figure piping in the angled mirror, just as the goddess does, but from a different angle. One mirror image, two points of view: Marsyas' persona could, in effect, represent the male half of Minerva's split subjectivity. Her distaff side will blush, demur, retreat; her masculine persona, momentarily feral and satyric, declaring impossible independence, will revel in invention and virtuosity, will adjust outer appearance (thanks to the cheek-bands, an authentic part of the ancient piper's equipment) to fit his dignity without discarding his art. He will madly challenge Apollo to a duel of musical performance, be cheated of the crown, and be brutally killed.

Minerva's subjectivity is divided and thereby conquered. The masculine response is to use the mirror as a channel to accomplishment, not a barrier to it; to practice before the mirror, to temper the comical aspects, and bring the surface persona into line with the inner virtues. But no female, not even the great and fearless Athena, can be *doing* in front of a mirror – unless that doing pertains to perfecting her own cosmetic femininity, to which no higher virtues correspond. If we see Marsyas as a projection of Athena's ambitious and creative self, it is a fittingly androcentric conclusion to the tale, perhaps, that he is stripped not only of his life, but of his *surface* – his very skin, ripped from his body as he hangs conscious from a tree – in one of the most savage episodes ever recorded in Greek myth.[55]

ACTIVE PASSIVITY: THE PERFORMATIVE MIRROR OF WOMAN

First and foremost, the Greco-Roman mirror was a mediator of surfaces – and according to the social norms of the time, woman was a creature of surface value. This is not to say that she was granted no interiority, agency, or personality; the ideal woman of Latin elegy, for example, was expected to be well read and witty as well as beautiful – but even this *cultus* was an adjunct of her desirability.[56] In general, woman's nature was deemed to be defined and limited by her body, which in itself was a pliant and inconstant thing. In popular and intellectual discourse alike, the archetypal female – like a child, a slave, or an animal – was concerned principally with appetites.[57] The mirror is the perfect agent for this innate degeneracy, making the possibility of excessive self-love all too real. The pathic side of the mirror – the side that returns nothing masculine to its viewer – is embodied in a series of Helleno-Persian gemstones of the fourth century B.C.E. These represent a naked woman in regional headdress

14. Engraving of a third-style wall painting from the House of Queen Margherita (5.2.10) at
Pompeii. Original: Naples, Museo Nazionale 120626. From Mau 1890.

being penetrated dorsally by a man, also in Persian costume (Fig. 15).[58] In one hand she holds upright a handled mirror, though she gazes sharply back over her shoulder. The mirror is in no sense a direct accessory to the action; but *indirectly*, as a signifier of the woman's very nature, and the endgame for which it – and she herself – were invented, it speaks all too clearly. Is female pleasure to be found in this unusual threesome? Does it come from both directions? From what we know of Greek attitudes toward the "decadent" Persians, the answer to both questions must be a definitive yes; but that hardly translates to an endorsement.

The notion that femininity was more fully defined by the body than masculinity aligns closely with Seneca's Stoic hierarchy of heavenly and earthly being, a continuum that places the disembodied soul of godhead at the very top, and bestial nature – that is, the impulse to service one's body with no care for the soul – at the bottom.[59] The righteous man, who used the mirror wisely as a *consilium* to trace the corporeal manifestations of his spiritual component, was firmly in the middle; women occupied a lower place, nearer to bestiality. Hostius Quadra, who enjoyed being penetrated by men in every imaginable way, and witnessed his perversions in magnifying mirrors, was the quintessential bottom-feeder: "Well then, I'll feast on a lie" is his pathetic peroration (*mendacio pascar, Nat.Q.* 1.16.9). In Seneca's estimation Hostius is far more noxious than any woman, for he willfully debases his masculinity; whereas for most women, Seneca might have argued, obsession with the corporeal is only to be expected: it is their birthright, their natural state.[60]

Eros, according to majority intellectual opinion in antiquity, was driven by the appetite of the eye – and this appetite was whetted on the surfaces of bodies. The primacy of vision in bodily desire, and the profound human reliance on appearances to shape desire, was a phenomenon that occupied philosophers and writers from Plato and Epicurus to Achilles Tatius and beyond.[61] Maria Wyke notes the persistence with which Roman culture dwells on surfaces; indeed for the archetypal Roman woman, she suggests, *cultus* (which can mean a range of things, from adornment to education to culture itself) is nothing more than a defining of the surface of an otherwise empty being.[62] Accordingly, the *praeceptor*, the omniscient dispenser of erotic advice in Ovid's *Ars amatoria*, can be happy only when a woman's surface has been thoroughly encased in an illusory film of seductive beauty; "for nothing disgusts the *praeceptor* more than the un-encased woman."[63] The woman, too, learns from the mirror, but what she learns is the precepts of visual beauty.[64] The iconic symbols of femininity, which appear on funerary reliefs around the Roman world, pertain characteristically to the visual manipulation of body surface: the cosmetic box, comb, and mirror for direct enhancement of desirability; the wool basket, distaff, and spindle for the secondary surface effects provided by clothing.[65]

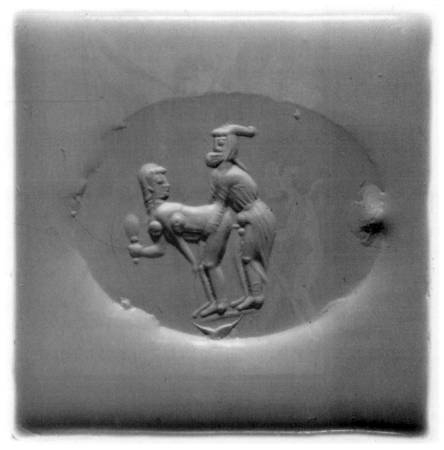

15. Impression from a Helleno-Persian scaraboid. Fourth century B.C.E. Malibu, J. Paul Getty Museum 85.AN.370.26.

Carlin Barton has suggested that female cosmetics served, paradoxically, as armor against inner shame: "Hiding behind painted-on blush proclaimed not one's blushing modesty but one's brazen shamelessness. And so, ironically, it was a challenge and an invitation to violation."[66] Perhaps; but if this is so – and if, as Barton suggests, the unpainted woman was upheld as the ideal in Roman elite culture – it must also be said that such asperity was appreciated in direct proportion to its rarity. Bourgeois respectability, it seems, went in for common taste; many were the Roman women who preferred to be immortalized with some material reminiscence of their daily toilette.[67] Even the mirror could be presented as an adjunct to matronly chastity. A third-century-C.E. funerary relief from Neumagen, though it depicts a boudoir scene, could hardly be more stately and reserved: the deceased honorand, an aristocratic woman of Gallia Belgica, sits fully wrapped in the voluminous *stola* of the matron, assuming

the traditional *pudicitia* pose of the honorable wife with one wrapped hand held to the chin (Fig. 16).[68] Even her wicker chair, a type often seen on reliefs in this region, is a common attribute of the stolid late-antique materfamilias. Two maidservants, one with an oil or perfume flask tucked in the crook of her elbow, arrange her hair; a third holds a *miroir à poignée* before her mistress; a fragmentary fourth attendant (restored in the cast illustrated here) stands by with a small pitcher.

This is a very orderly manifestation of Eros, but it is Eros nonetheless, invoked all the more ardently in a woman's maturity. Her goal is no longer sex, but rather the memory of sex. A woman who has probably outlived her usefulness as defined strictly by society (I make no judgments about her personal value to friends and family) has fashioned a reminder to her society that she abided by its rules and was rewarded with honor and wealth. Where an equally conventional man would have been commemorated on his magistrate's chair, or presiding over games he had sponsored, or clutching the scrolls denoting his rhetorical education, this woman chose for her lifetime achievement a state of being – that is, being beautiful – cultivated and iterated daily for her entire adult life. Without the male subject, the ritual was meaningless; but ratified by the approval of society, it defined her existence. More important than any image that the mirror might have returned was the persistence of the mirror itself – to remind every visitor to the memorial that this lady had done her duty and *perceived it to be done*. In short, her memorial recorded a carefully calibrated performance that she had perfected over a lifetime.

More than jewelry or perfume, more than the ivory comb in the lamplit boudoir, more than the distaff or the loom, the mirror was femininity embodied. Within its circle was spun the shape of fantasy; upon its frame were woven (in Françoise Frontisi-Ducroux's lovely phrase) *les tissus du désir*. On the one hand, the mirror is essentially form without native substance, admitting anything reflected upon it; thus it resembles the Greco-Roman cultural paradigm of the female as a passive, amorphous receptacle of masculine agency.[69] On the other hand, it was by the mirror, alone among the implements of domesticity, that a woman would – like the male actor, but to a different end – perfect her performance. It was her own portable *praeceptor* of the art of love. Free of the prophylactic mask of dramatic characterization, the woman saw both performer and audience in herself. But in keeping with our general rule, her role in the mirror was to approach a behavioral ideal of studied passivity – to provide the object noun upon which the masculine subject would be incited to act. A woman could *induce* action in another; or she could act *in turn*; that is, she could – and was expected to – excite or reciprocate erotic love. But she could not properly initiate it,[70] at least not without incurring dire or freakish

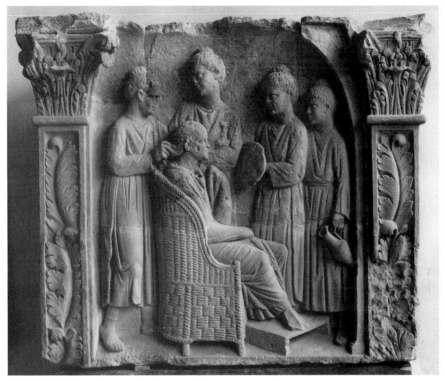

16. Funerary relief from Neumagen. Third century C.E. Trier, Rheinisches Landesmuseum RD.60.46. Photo: Th. Zühmer.

consequences of the sort that befell Hermaphroditus, who will be discussed in the next chapter. The actor's role, with or without a mask, was to create a person; the woman's role, to create the mask itself. Her body was both actor and performance.

The feminine ideal was static, timeless, and removed from narrative. It is no accident that whereas the occasional masculine encounter with a reflection in Roman art and literature is packed with narrative tension and movement, the female-with-mirror is almost exclusively confined to the "genre scene" that tells no story in itself, though it may be sauced with mythological references. The famous late-Republican Dionysiac frieze in the Villa of the Mysteries, for example, isolates its feminine hairdressing scene, *cum* mirror, from the rest of the narrative; yet an attendant Eros who holds the mirror (a sliding or folding box model, with a reductive convex surface) introduces an allegorical touch to remind the viewer of the ultimate goal of the toilette, erotic love (Fig. 3).[71] "Pure" genre scenes of the kind that appear on Attic vases and stelae are less common in Roman art, at least outside of funerary contexts. A small vignette from Stabiae shows a touchingly tender scene of an adolescent girl

contemplating herself in a silver grip mirror (Fig. 17).[72] Not overtly engaged in her toilette, she seems to be involved in the timeless ritual of adolescent self-contemplation with all its attendant anxieties. Her gaze is unusually intense, her hair-twirling gesture meditative. This is an early forerunner of Brock-hurst's *Adolescence*, Rockwell's *Girl at the Mirror*, and countless other studies of dawning female sexuality and self-awareness.[73] Her seminudity is not entirely banal in this context, for a girl of her age might be expected to observe the developments of her body, and not just the features of her face, with urgent interest.

The woman featured on the Mysteries Frieze is more mature; she is generally presumed to be a bride or a matron. As frequently happens in Roman art, the mirror is angled to present its image to the viewer in such a way that the woman, were she in real space, would be unable to see her image at all. In this way the image implicates the viewer in her subjectivity and objectivity; for in this case not only does the face appear in the mirror but both image and referent gaze directly at us. In effect the presumptive line of the gaze has been warped into a long U. Perforce the innocent viewer partakes of both the woman's subjective appraisal and the objectivity of the mirror itself. As if to emphasize the exclusivity of this circuit, the maidservant, who stands behind the referent and gazes directly down at the mirror, appears to be completely elided from her expected place in the mirror image (which, unusually, is not reversed; the proper left arm is clearly visible rising over the head, just as in the referent). This mirror has little use for naturalism: it filters out extraneous background noise, eliminates unbecoming oblique angles of sight. Its sole purpose is to draw the viewer into its cycle of meaning.

I will call this pictorial device – confronting the viewer equally with the face of the referent and its reflection – the flexed gaze. Like prying open the coupled pages of an incipient Rorschach inkblot test, or disengaging a freshly impressed sheet from its bed of inked type, the flexed gaze is an act of opening, and thus of signification. It breaks the imagined tautology of pure reflexivity, swinging the reciprocal gaze out into the interpretive field of others. Transfixed midway along its arc, the viewer is both the protago-nist's ordinary audience and her critical self. The flexed gaze is not always absolute; that is, it is not necessarily bent double, as it is in the Mysteries Frieze vignette. Like a book only half open, it need not engage the viewer directly; as often as not, it is angled obliquely, so that the lines of vision projected from referent and reflection meet somewhere in front of the viewer. The effect is virtually the same, for it still involves the conscious breach of the "fourth wall" (the imaginary divide between stage and audience).[74] Every theater actor is familiar with the principle: while pretending to engage another character directly, the actor stands, enunciates, and often even looks obliquely into the audience.

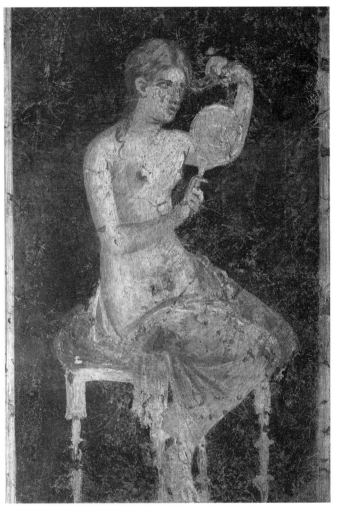

17. Fourth-style wall painting from Villa Arianna, Stabiae. Naples: Museo Nazionale 9088.
Photo: DAI Inst. Neg. 71.1655.

THE MIRROR OF VENUS

Because Roman women at the mirror were in the business of self-idealization,
it is no surprise that most female mirror scenes in Roman art occur in the
already idealized domain of myth. These too tend to represent static intervals
with little, if any, narrative content; for example, the generic "floating" maenad
from House 4.4.49 in Pompeii (Fig. 5). Even where the narrative context is
obvious, the mirror locks the action into a freeze-frame of seductive stasis. On
the rightmost of three exedrae built into the proscenium of the Roman theater
at Sabratha – a locus of the collective male gaze if ever one existed – a relief
of the popular sculptural type of the Three Graces was slightly modified by
the addition of a mirror in the hand of one of the trio (Fig. 18).[75] It seems

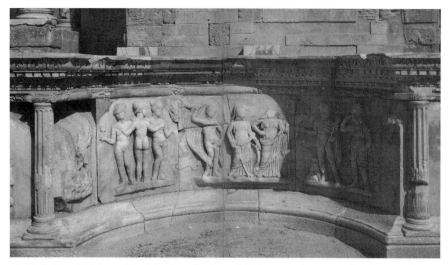

18. Relief on the left exedra of the hyposkenion of the Roman theater at Sabratha. Late second century C.E. Photo courtesy of R. Polidori.

an entirely appropriate adjunct, for the famous triad of fetching contrapposto poses is all about the self-conscious and hard-won perfection of feminine stasis, the aestheticization of bodily form for the leisurely consumption of the male viewer. Here the Graces evoke the three goddesses to their right – Venus, Minerva, and Juno. In turn, the goddesses are inviting the visual appraisal of the Trojan Paris, who sits at the far right of the exedra, attended by Mercury. Significantly the leftmost of the goddesses, Venus, corresponds to the mirror-bearer among the Graces, also on the left. The love goddess handily won the Judgment of Paris. The enabler and *praeceptor* of her superior beauty, this grouping suggests, was the mirror itself.[76]

Venus and the mirror established an iconic compatibility in Hellenistic and especially Roman art. When Venus – or her surrogate, Eros – is shown holding a mirror, any narrative context is usually suppressed; in presenting this theme, artists and their patrons favored simple painted vignettes in domestic contexts or relatively inexpensive statuettes that could be displayed in an intimate context. There is little of high seriousness in these works; quaintness, even sentimentality, predominates. A characteristic example is a first-century-B.C.E. terracotta figurine of Eros from Myrina hoisting an out-of-scale box mirror on his shoulder (Fig. 2).[77] When the goddess was in her erotic mode (as she usually was), Roman usage across the empire preferred to represent her in bathing or "cowering" poses that had been adopted from late-Classical and Hellenistic prototypes.[78] But there was no shortage of alternate scenes showing Venus simultaneously enthroned in glory and enjoying the ministrations of the mirror; the theme appears several times in Pompeii, for example

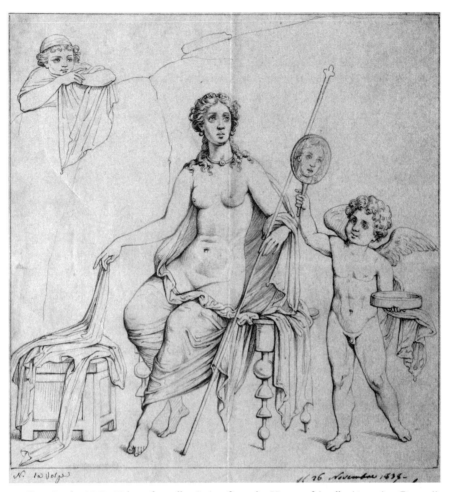

19. Drawing by N. La Volpe of a wall painting from the House of Apollo (6.7.23) at Pompeii. Photo: Naples, Museo Nazionale.

(Figs. 19, 20). In the late second century, the Venus-at-toilette scenario was merged with the marine *thiasos*, a cortege of watery creatures that had long been used to denote triumph at sea; the hybrid type is sometimes called Venus Triumphans.[79]

Venus Triumphans emerged in Roman Africa in the second century and continued into late antiquity, when the type spread to Italy, Syria, Gaul, and beyond.[80] Perhaps its earliest known instance is not an extant artwork but a descriptive passage in Apuleius' *Metamorphoses*, an inset into the famous tale of Cupid and Psyche:

> [Venus] stepped out with rosy feet over the topmost foam of the quivering waves and – lo! – she sat down upon the clear surface of the deep sea. What she began to desire happened at once, as if she had given orders in advance:

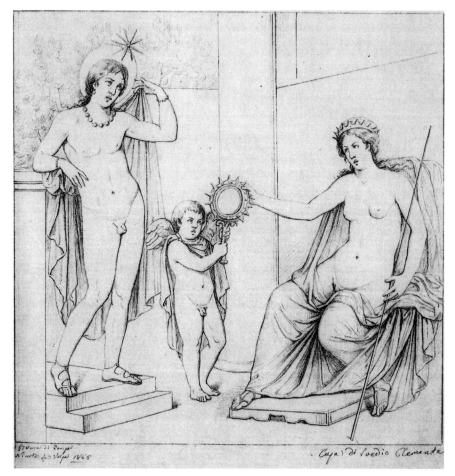

20. Drawing by N. La Volpe of a wall painting from the House of M. Epidius Rufus (9.1.20) at Pompeii. Photo: Naples, Museo Nazionale.

the instant obeisance of the seas. Nereus' daughters came singing a choral song, and shaggy Portunus with his sea-green beard, and Salacia with her womb teeming with fish, and Palaemon the little dolphin-charioteer. Now troops of Tritons bounded helter-skelter through the sea-water: one blew gently on a tuneful conch shell; another shielded her from the hostile sun's blaze with a silken awning; another carried a mirror before his mistress's eyes; others swam along yoked in pairs to the chariot.[81]

Apuleius presents an image that is palpably similar to grand mosaics of his native north Africa. Strictly speaking, his imagery is not triumphal: Venus is simply holding court on the waves, surrounded by her fishy and finny vassals. Such hybrid exuberance is characteristic of Venus Triumphans scenes, which tend to be more or less chaotic combinations of a number of distinct pictorial traditions: Hellenistic court or coronation scenes, toilette scenes, public triumphal imagery, and fish scatters (naturalistic pictorial catalogues of sea

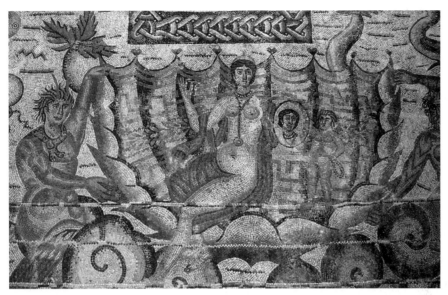

21. Mosaic from the House of the Donkey at Djemila. Late fourth to early fifth century C.E. Djemila Museum, Inv. Alg. 293.

creatures). Their popularity in Roman art peaked in the fourth and fifth centuries. The nature of Venus' conquest remains vague; despite attempts to identify religious origins behind various components of the scenes, the sentiment "love conquers all" seems to characterize the situation well enough. To provide a proper setting for this paragon of feminine self-satisfaction, the enthroned or reclining Venus is attended by some combination of erotes, nereids, tritons, or other sea creatures. She conventionally is enthroned on a seashell or is borne comfortably on the back of a hybrid marine animal. Sometimes an attendant proffers a cosmetic box or a mirror to the goddess, or she may hold the mirror herself. One of the grandest examples is a large mosaic from the House of the Donkey at Djemila (Algeria), dating from the late fourth or early fifth century (Fig. 21).[82] A magnificent mid-third-century mosaic from Shahba (Philippopolis) in Syria, now in Soueida, shows Venus enthroned in a cockle shell supported by two sea centaurs; two erotes hover above like victories to provide a canopy over her head (Fig. 22).[83] In her left hand she holds a small mirror to produce an oblique flexed gaze on a reduced scale. Unusually, she has a nimbus – a general trope of radiance, but here providing a pleasing symmetry to the encircling mirror in her hand. In condensed form the motif appears in relief on treasured private objects in late antiquity, such as the Projecta Casket from Rome (Fig. 23).[84] In all of these scenes Venus is characteristically bejeweled, coiffed, crowned – and nude, but for some extraneous drapery.

By the third century the sea *thiasos* and the mirror had become so firmly associated with Venus that they could, on occasion, denote her presence and

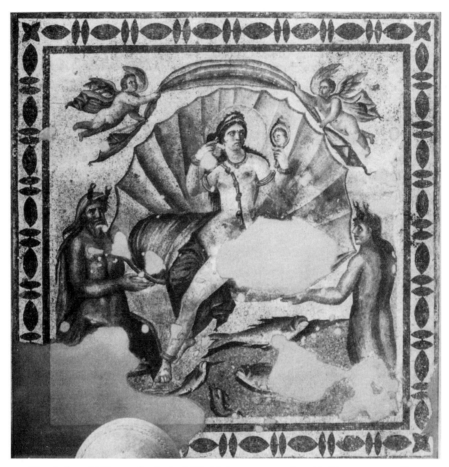

22. Mosaic from Philippopolis, Syria. Mid-third century C.E. Soueida Museum 1129. Courtesy of Soueida Department of Antiquities and Museums.

function without depicting her at all. In the Cortile Ottagono At the Vatican Museums there stands a pentagonal marble tripod base of the mid-third century C.E.[85] It depicts, in crude relief, conventional hybrid sea creatures on four of its five sides. But on the front, in the privileged position, stands only a small Eros (?) holding a round grip mirror in his right hand. The strangely semaphoric vignette not only signifies the mirror's missing referent, Venus herself, but by its aggressive frontality invites the viewer to contemplate the mirror with its universal message of female aspiration and limitation: "I am Venus, and I am present; if you wish to see me, look in the mirror."[86]

It is an interesting and often overlooked irony that the most public and masculine of all subjects of Roman art – the triumphal procession – should have been merged over time with the private, nonnarrative, antihistoric genre of the woman at her toilette. We are confronted with a remarkable paradox: the importation of the *being* woman into the framework of the *doing* man – or

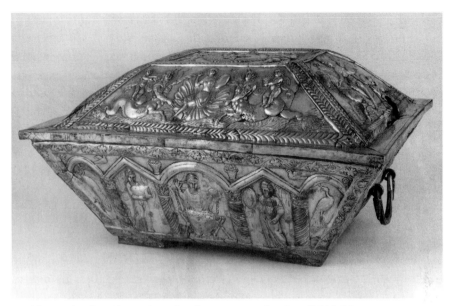

23. Silver casket from Rome. Late fourth century C.E. London, British Museum 1866.1229.1. © the Trustees of the British Museum.

perhaps the reverse, for certainly the feminine aspect predominates. The triumphal toga gives way to pink, plucked female flesh; the traditional chariot of the *triumphator*, adorned with an amuletic phallus,[87] accedes to the organic and distinctly womblike cockle shell; the general's apotropaic *bulla* yields to inviting jewelry of the goddess; and the public slaves who accompany him are replaced by little putti holding forth crowns, cosmetic boxes, and mirrors for their mistress. The military triumphs enacted in Rome were a panopticon of spectatorship par excellence: not only did the participating soldiers and their captive prisoners absorb the public gaze, to their collective honor or shame, but the triumphant general was specifically enjoined by a public slave shadowing him in his chariot to "look behind you; remember you are human."[88] A specific apotropaic act meant to combat the evil eye, the ritual glance backward was a sharp reminder that even for the general processing through Rome in his glory, not all gazes were beneficent. Venus, it seems, receives a rather different injunction from her retinue of erotes, one that is similarly hortatory and optical, but more confident: "look into the mirror; remember you are a goddess." It is a directive that any conventional Roman woman would appreciate. In a sense, a part of Venus resided in every woman's mirror. Her task was to liberate the goddess – to make Venus part of herself – by making good use of her domestic tool of self-improvement.

But what is most remarkable about Venus Triumphans is precisely the phenomenon that drives the flexed gaze: the opening of a private and cloistered

ritual, that of female self-appraisal, to the world at large – and in as dramatic a fashion as possible, by merging it with the convention of a public spectacle. The downcast gaze of proper modesty is nowhere to be found here. Nor is there any trace of the "cowering" Venus surprised in her bath: a more titillating prospect for the male viewer, perhaps, than the forthright sex goddess enthroned in pomp. The public Venus, validated by her mirror, is as frank and confident as Manet's Olympia, fresh from the battlefield of seduction and ready for more: there is no clearer code of female sexual readiness than jewelry artfully applied to a nude body. At the most general level, Venus Triumphans provides an almost Ovidian brand of female empowerment within a patriarchal and patronizing society – but an illusory empowerment nonetheless. Though displayed seductively before the eyes of the viewer, Venus simultaneously promenades on the stage englobed within the mirror, in thrall to her own inner audience. Her performative venue, like her reflexive self, is radically divided. What are we to make of this strange penchant for merging private rehearsal into public performance? Why is a *preparatory* act – using the mirror – thrust into the frame of celebratory affirmation? Why didn't this divine actress, like her human counterparts, set the mirror aside when she mounted the stage?

The fact that Venus retains the mirror, and performs the toilette before a real and imagined audience, expresses the constricted, solipsistic ideal of femininity that prevailed throughout the Roman world. As I suggested earlier, the Roman woman's body was both performer and performance. If the body was rendered desirable, its existence alone was enough. There was little that it had to *do*; certainly there was no need to situate it in history. Though she might have been capable of great accomplishments, and (within limits) even free to pursue a life worthy of a narrative, from the standpoint of social value she could aspire to no projection of herself beyond the confines of her own corporeal cage. It might have been said of any great Roman man that he would deserve to conquer the world only if he conquered himself first. The same could perhaps have been said of a Roman woman of leisure, but with this crucial difference: the world that she was permitted to conquer was a construction of desire. If she could not command desire, she was effectively worthless, except as a source of labor and an incubator of offspring.

The late-antique poet Claudian imagines Venus inhabiting a palace of exotic marbles so highly polished that they emulate a vast hall of mirrors. In this place the love goddess delights in her leisurely toilette, allowing herself to be "ravished wherever she looks."[89] The erotic power of scenes of idealized females primping at the mirror lies in the prospect of a seductive woman who is seduced by her own beauty – the knowing *connoisseuse* of the self. (After all, isn't her power to arouse desire only strengthened if she desires

herself?) Projecting this reflexivity into a public context heightens the fantasy – not, perhaps, of classic scopophilia (which is better exemplified in scenes of nakedness shaded by feigned modesty), but of social control. Putting a goddess's self-assessment on public view presents to the viewer a model of female servitude to male desire cloaked in the guise of female self-empowerment (if that isn't too modern a term). Eros staggers under the weight of his mirror.

THE DOVE AND THE PARTRIDGE

Aphrodite/Venus, as everyone knows, was born of the sea; and it is this simple mythological truism, more than any demonstrable affinities to water in the record of her deeds, that lent such a powerful marine character to this goddess. In art she is generally watery only when she is static and self-referential; when Venus acts in story, the mirror and the water recede from view. But it is the passive, bathing, preening, teasing Venus that interests us here. As the most sexual of the gods, she represented the quintessence of femininity; and so from the standpoint of ancient thought her disposition lent itself naturally to the element of water. Anne Carson has commented upon the overwhelming ancient scientific and philosophical consensus that woman's predisposition to sexual excess, her irresolute and pathic nature, was due to her cold and wet temperament, which was more capable of absorbing the searing heat of sexual passion than the relatively dry and warm male temperament:

> [The male] condition of dry stability is never attained by the female physique, which presumably remains cold and wet all its life and so more subject than the male to liquefying assaults upon body and mind, especially those of emotion. That the female is softer than the male and much more easily moved to tears, pity, jealousy, despondency, fear, rash impulses, and sexual desire is a *communis opinio* of ancient literature, voiced by such widely differing temperaments as Aristotle (*HA* 9.1.608b), Empedocles (B62.1 *VS*), and Semonides of Amorgos (7 W). Throughout these sources greatest attention is given to the emotions of love. Women are assumed to be markedly more open to erotic desire than men and sexually insatiable once aroused.[90]

The origins of reflection, like those of Aphrodite/Venus herself (born of *aphros*, the sea-foam), are traced to the surface of water. Not only is the conventional mirror reflective in the Venusian environment; the very humors with which she replenishes her archetypal femininity are equally mirrorlike. It is worth observing how water is used symbolically in some female toilette scenes, and particularly in a certain type of secondary vignette that could easily be overlooked as a trite and meaningless adjunct of an equally hackneyed

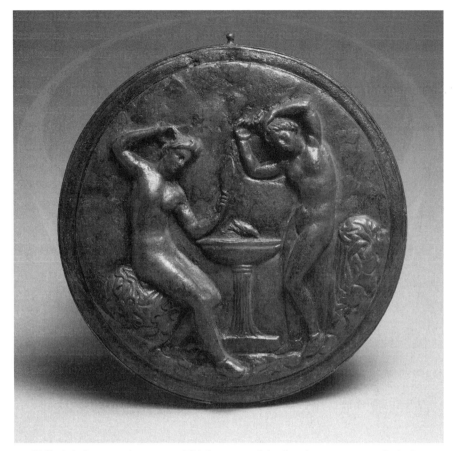

24. Hellenistic bronze mirror cover. Third quarter of the fourth century B.C.E. Paris, Louvre Br. 1713. Photo: Réunion des Musées Nationaux/Art Resource, NY.

principal theme. I am referring to birds at the woman's washbasin, as on a Hellenistic box-mirror cover in the Louvre (Fig. 24), or on a Roman gem from Lorraine, now in the Cabinet des Médailles (Fig. 25).[91]

Aphrodite/Venus, like her kin Astarte and the Potnia Theron, is a goddess with a marked affinity for birds both terrestrial and marine – doves, coots, geese, and swans in particular, but others as well.[92] A woman's funerary relief of the third century C.E. in the Louvre, probably from Italy, has reduced the goddess's symbolism to its barest essentials: a dove perched on a mirror, which in turn rests upon an altar (Fig. 26).[93] On this notional altar, perhaps, the woman had vowed a mirror to the goddess, who is represented by her most sacred and emblematic bird. A funerary altar at Aquileia depicts the young deceased woman, named Maia Severa, seated in a chair. One hand holds a mirror, the other strokes the fowl (Fig. 27).[94] Whether this is a dove, as has been claimed,[95] or a hen, as I suppose, is probably unimportant. It may have been simply a favorite pet, like the birds in hand that appear on Attic funerary reliefs; but also like those birds,

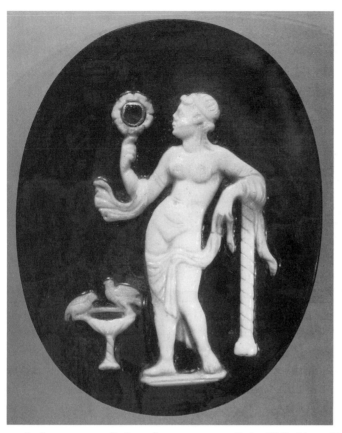

25. Sardonyx cameo. Perhaps first century C.E. Paris, Bibliothèque Nationale, Cabinet des Médailles, Camée 42.

its potential for symbolism remains undiminished. The avian metaphor for erotic love extends far back into Greek culture, particularly in the form of the winged phallus; in Roman culture any distinctive "maleness" in this construct gave way to the image of flocks of cupids and psyches, which have their own wayward, irrational spirits. The famous "peddler of erotes" scenes from the Villa San Marco at Stabiae and the House of the Colored Capitals (8.4.31) at Pompeii present (so it is believed) the little winged creatures as caged birds to be tendered in the commerce of a lonely woman's heart, or as wayward passions that induce their very mother, Venus/Aphrodite, to sell them off (Fig. 28).[96] A third-century mosaic in Baltimore, from the eponymous House of the Peddler of Erotes at Antioch, offers a richer and even more suggestive iconography (Fig. 29).[97] Here the erotes, like fowls of the forest, are snared by an old man who is evidently using flowers for bait. In the outer corners of the upper register the winged boys engage in pursuits that traditionally denote erotic love, fishing and hunting. The central vignette of the register is a bit unusual, though: an eros lies asleep on a rock, or perhaps he gazes down, rather like a reclining Narcissus,

26. Marble funerary relief, perhaps from Italy. Third century C.E. Paris, Louvre MA 110. Photo: Dist RMN / © P. Lebaube.

at the action below. In the crook of his left elbow he cradles an ignited torch, symbol of flaming passion. In his right hand, between the torch and his head, he grips what appears to be a mirror. The mirror is not in use, nor does any image appear on it; here it is strictly symbolic of the kind of feminine narcissism that goes hand in hand with eroticism. Mistress Venus is almost palpably present in this languid, nocturnal vignette, waiting in the wings of the mirror's little virtual theater.

The birds present at scenes of female toilette, then, are not necessarily just background noise; they are proxies of the goddess of love, or more generally of the reflexive, self-conscious brand of female sexuality. With the bathing scenes, the viewer can hardly escape the obvious implication that birds perched on the basin are aping the behavior of the women themselves: washing, preening, *reflecting* – drinking in their own visual radiance, replenishing their self-absorption. The same subtext prevails even when the women are absent. Sosus of Pergamon is said to have rendered in mosaic a "wondrous dove" (*mirabilis*

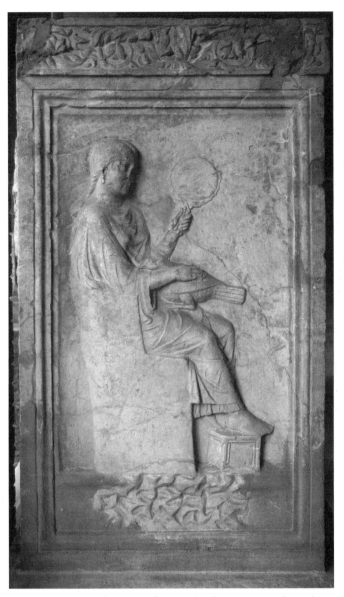

27. Relief on one side of the altar-tomb of Maia Severa, from the region of S. Egidio near Aquileia. Mid-first century C.E. Aquileia, Museo 1184. Further reproduction prohibited except by permission of the Ministero per i Beni e le Attività Culturali, Soprintendenza per i Beni Archeologici del Friuli-Venezia Giulia.

columba) drinking from a vessel, its reflection (*umbra*) clearly visible in the water (Pliny *HN* 36.184). Roman filiations drawn loosely from this Hellenistic masterpiece are numerous; and although none of them distinctly renders a reflection, all feature at least one dove craning its head intently down toward the water while others perch in various positions on the rim or on the table

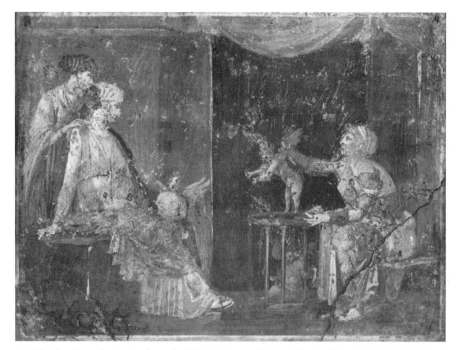

28. Third-style wall painting from the Villa Arianna at Stabiae. Naples: Museo Nazionale. Photo: DAI Inst. Neg. 75.1481.

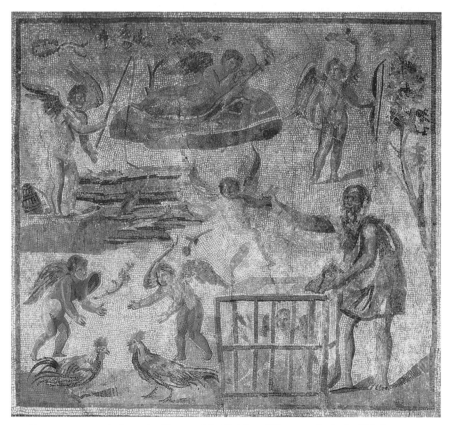

29. Eponymous mosaic from the House of the Peddler of Erotes at Antioch. Third century C.E. Baltimore Museum of Art, Antioch Subscription Fund, BMA 1937.128.

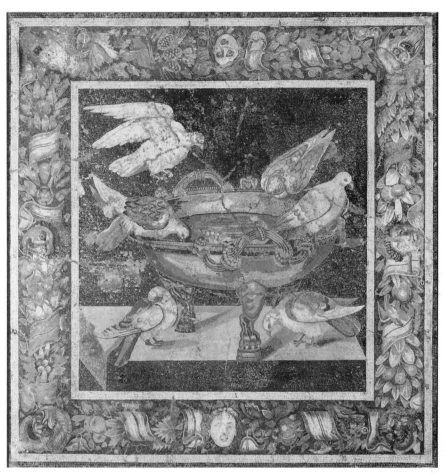

30. Mosaic *emblema* from House 8.2.34, Pompeii. Early to mid-first century B.C.E. Naples: Museo
Nazionale 114281. Photo: Scala/Art Resource, NY.

below (Fig. 30).[98] The spirit of Venus may also be present in a mosaic *emblema*
from Pompeii depicting a rock partridge, easily identified by its distinctive
coloration and striations, plucking a mirror from a toilette basket (Fig. 31).
An almost identical *emblema* has been found in the peristyle of House 1 at
Ampurias, Spain.[99] The partridge was notorious in antiquity for its salacious
and inconstant nature.[100] Females displayed such prodigious sexuality, it was
believed, that they became instantly pregnant, and even laid eggs spontaneously,
the moment they caught wind of the males. The early Hellenistic philosopher
Clearchus of Soloi is equally specific about the males:

> Sparrows, partridges, cocks also, and quails emit semen not merely if they
> see the females, but even if they hear their call. The cause of this is the
> imaginative thought of union arising in their consciousness. This becomes
> most obvious at the season of mating, when you place a mirror directly

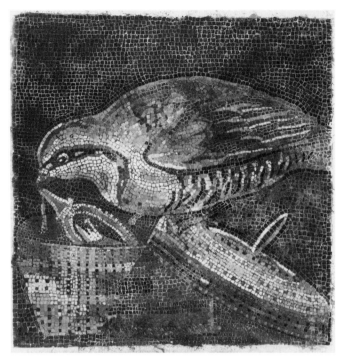

31. Mosaic *emblema* from the House of the Labyrinth (6.11.8−10), Pompeii. Early first century B.C.E. Naples, Museo Nazionale 9980. Photo: Alinari/Art Resource, NY.

> in their path; for, deceived by the reflection, they run up to it and so are caught; they then emit semen − all, that is, excepting the barn-yard fowls [i.e., the cocks]. The latter are simply provoked to fight by the sight of the reflection.[101]

Even a harmless and charming genre scene, it seems, is tinged with a moral message about feminine nature. To be sure, the partridge depicted in the mosaic is male; but the reputedly licentious and self-destructively mindless behavior of certain birds − particularly their tendency to mistake their own mirror images for an eager suitor − was classically representative of the human female construct in antiquity. The Greek word *akkô* or *makkô*, meaning a foolish or silly woman, was defined more explicitly in the *Suda* as "a woman who is deceived on account of foolishness − who, it is said, when she saw her own image in a mirror, mistook it for someone else's."[102] Just such a frivolous female crops up in Ausonius' *Mosella* as a late-antique paradigm of the unexamined life.[103]

The bird at the reflection, then, conforms to one of two types, both of which were applied to women in antiquity. One is exemplified by the partridge, the other by the dove. Either she is so naïve that the mirror peoples her feverish mind with a phantom companion; or she is aware that the reflection is her own, and like the famously preening dove takes undue, even autoerotic delight in

her beauty. The partridge, in short, is the silly, naïve girl who is besotted by her own mirror image; the dove is the knowing woman in love with herself: the woman who aspires to emulate Venus. Interestingly enough, they conform to the two sequential manifestations of Narcissus, the youth of ambiguous gender to whom we will turn next.

MIRRORS MORTAL AND MORBID:
NARCISSUS AND HERMAPHRODITUS

NARCISSUS IN ROMAN LITERATURE

T HE NARCISSUS OF MODERN WESTERN IMAGINATION IS A PHENOMENON
born of Roman literature, not art.[1] From Dante to Borges, from Christine
de Pisan to Bill Viola, the inspiration for hundreds of retellings and reimaginings
of the deceptively simple story of a youth who loses himself in a reflection
is drawn from a single dominant source, about 170 lines of hexameter from
Book 3 of Ovid's *Metamorphoses*. Strictly within the purview of classical studies,
most investigations have slighted the more than fifty surviving Roman visual
representations of Narcissus at the spring, instead relying on the literary account
of Ovid as well as alternate versions preserved by Conon and Pausanias.[2] Even
such a seasoned interpreter of ancient art as Françoise Frontisi-Ducroux, in
her treatment of the Narcissus story, bypasses the visual evidence in favor of
literary texts.[3] Until recently, surprisingly few gave the same kind of thoughtful
analysis to images.[4]

Before turning to the images ourselves, we must be cognizant of the versions
of the Narcissus myth that circulated around the Roman world. According to
Ovid's dominant version (*Met.* 3.339–512), the story goes as follows. Born of
the river Cephisus and the nymph Liriope, the baby Narcissus is brought before
Tiresias, whose gnomic commination forecasts a long life for the boy only "if
he should never know/recognize (*noverit*) himself" (*Met.* 3.348). As a beautiful
youth of sixteen he proves a cold-hearted quarry, scorning the advances of

enamored youths and maidens. Among his many admirers is Echo, a nymph who has been condemned by Juno to mimic the closing words of anyone who addresses her. Narcissus rejects her too, leaving her to waste away with sadness until her bones have become nothing but rocks; all that remains is her voice. At last, one spurned youth demands redress from the goddess Nemesis: he prays that Narcissus, like his victims, may feel love but be unable to win the thing he loves. One day, after a long hunt in the wilderness, Narcissus comes upon a still and silent spring, untouched by human, animal, or even the sun. As he bends down to quench his thirst he spies his own reflection in the water and is immediately smitten by its beauty: "all things, in short, he admires for which he is himself admired."[5] His fascination soon turns to frustration as he seeks to kiss and embrace the comely boy he sees in the spring. The image seems to return his affections, mimicking his every action; yet his tears and embraces only roil the water, dissipating the object of his obsession. Finally he comes to realize that he pines for his own reflection:

> Oh, I am he! I have felt it. I know now my own image. I burn with love of my own self; I both kindle the flames and suffer them. What shall I do? Shall I be wooed or woo? Why woo at all? What I desire, I have; the very abundance of my riches beggars me. Oh, that I might be parted from my own body! and, strange prayer for a lover, I would that what I love were absent from me! (3.463–67)

Recognizing both himself and his terrible dilemma, Narcissus is doomed, just as Tiresias predicted. Unable to dispel his obsession, he remains as he was, fixated on this reflection until he is driven to madness. As he beats his chest in dismay, he melts away into the form of a flower, the red and white narcissus. Even in death his delirium persists: he lies perpetually on the banks of the Styx gazing down into its waters.

Two other shorter versions of the story of Narcissus have survived, one transmitted by Conon and the other by Pausanias; a third, from an Oxyrhynchus papyrus, was virtually unknown until its publication at the time of writing.[6] Each has its own unique features. According to Conon, Narcissus was a native of Thespiae in Boeotia. He is again characterized as a despiser of love, but in this case the principal lover is a youth named Ameinias. Narcissus refuses his advances, giving him instead a sword with which to kill himself; Ameinias obliges. Then Narcissus encounters his reflection in a spring, and he falls in love. Whether he is aware that the image is his own, Conon does not say: he is simply a "strange [literally, "dislocated"] lover" (*atopos erastês*). Seized by remorse for his treatment of Ameinias, Narcissus acknowledges that his punishment is just and he commits suicide – by what means, we do not know, but it is a sanguinary death: from his blood the narcissus flower emerges. Shaken by these events, the Thespians decide to give greater honor to the love god, Eros.[7]

Pausanias too places the action in the territory of Thespiae, specifically at a spring called Donakon ("reedbed"). He impatiently dispenses with the traditional story, about which he offers only one other corroborative detail: Narcissus did not know the reflection he loved was his own. The presumption of such naiveté on Narcissus' part, he says, is "sheer stupidity." Instead, he proposes an alternate story that was also circulating. Narcissus had a twin sister, exactly like him in appearance, with whom he fell in love. When the sister died, he found some relief for his grief in his own reflection, which reminded him of his lost love.[8]

The Oxyrhynchus version, which has been attributed tentatively to Parthenius of Nicaea (who flourished in the mid-first century B.C.E.),[9] may be the oldest of them all. It mentions no metamorphosis, though it may hint at a "fertile" death. The youth simply commits suicide: "the boy shed his blood and gave it to the earth to bear."

Although the Narcissus story may have originated in Boeotia, it never acquired the status of a canonical Greek myth; it seems to have waited for Ovid – anticipated, no doubt, by simpler versions from such authors as Parthenius, Hyginus, and Conon – to achieve full exposition.[10] It was Ovid, evidently, who wove together the stories of Echo and Narcissus.[11] In the visual arts various attempts have been made to interpret certain statue types, extending back to the schools of Lysippus and even Polyclitus, as representations of Narcissus. These feature a standing youth, often in a languid contrapposto, looking vaguely downward and to one side. But these hypotheses are founded entirely on conjecture and have little to recommend them.[12] The single "pre-Roman" representation of Narcissus that once enjoyed some credibility, a terracotta statuette reputedly from Tanagra, is now acknowledged to be a fake.[13]

In the dense garden of Greco-Roman myth, Narcissus was a late bloomer. From Augustan times onward, however, his myth so completely dominated the folk consciousness that it became a permanent fixture of literate discourse. Many minor or fragmentary references to the story survive in scattered sources, both ancient and medieval, from Statius to the *Suda*.[14] In the Flavian period the myth certainly inspired Columella's outlandish assertion that mares become infatuated with their reflections in water, wasting away to the point of death until they are made ugly by the shearing of their manes.[15] In the early third century C.E., the sophist Philostratus Lemnius the Elder, and a century later Callistratus, devised *ekphraseis* of a painting and a statue, respectively, depicting Narcissus absorbed in his reflection.[16] Writing in the interval between these two authors, Plotinus found a place in his Neoplatonist cosmology for the doomed youth and his mirror – as an allegory of the soul's search for truth that founders in the flood of materiality.[17] Lyric poets of various periods, ever fond of the conceit of reflectivity, took up the Narcissus theme; some of their efforts are preserved in the Latin Anthology.[18] Even Nonnus of Panopolis, in his epic

Dionysiaca of the sixth century C.E., invoked the myth, but with a twist: now Narcissus was made to be the son of Selene and Endymion, a sleepy, languid, and effeminate youth to whom Narcissus is often compared.[19]

Quite apart from the discipline of psychoanalysis, which has brought the hermeneutics of Narcissus and narcissism to the level of a cottage industry,[20] the Narcissus story – particularly the version of Ovid and the descriptions of Philostratus and Callistratus – has fostered a whirlwind of interpretations. So static in terms of action but so rich in psychological and symbolic meaning, it has engaged a number of recent scholars who have sought to understand reflectivity in Greco-Roman art and story. A distinctly postmodern perspective, influenced by psychoanalysis, is above all conscious of self, alterity, and intersubjectivity in Ovid's virtuosic play of echoes and reflections.[21] An anthropological approach seeks in Ovid the vestiges of a primitive gorgon story, detecting traces of petrifying fascination in both Echo and Narcissus – Echo, because her bones were turned to stone by Narcissus' "evil eye"; Narcissus, because he destroyed himself with his own gaze.[22] Another sees a mantic ritual – specifically hydromancy, or divination by water – at the core of the story.[23] Many have seen the influence of various philosophical and scientific theories at work. The intimations of philosophy begin immediately with Tiresias' prophecy, which slyly interrogates the Delphic dictum, "know thyself."[24] And recent scholarship has brought to light the striking influence upon Ovid of Lucretius' ideas about sensory illusion.[25] Plato, and particularly his theory of *eros* and *anteros* – love that rebounds between lover and beloved like a reflection on the pupil of the lover's eye – has been attached to the Narcissus story at least since Oscar Wilde's *The Picture of Dorian Gray*.[26] Shadi Bartsch has paid especially close attention to the "dialectics of erotic reflection" as it appears in the story and the path that it takes between the competing optical theories of intromission and extramission.[27] My own investigation does not insist on a straight and narrow path to the "truth" about Narcissus' mirror, which is surely one of the slipperiest semantic surfaces ever devised in antiquity. I will be satisfied to investigate some of the more interesting possibilities for meaning in the surviving visual media from antiquity.

Languor, stupor, torpor – and their most extreme expression, death – seem to pervade the Narcissus phenomenon at every level. From Tiresias' prophecy onward,[28] Ovid's account abounds with echoes of morbidity; his protagonist is like an animal immobilized by a predator's venom as it helplessly waits to be consumed. The darkling pool, so unnatural in its perennial shade and its sequestration from the human and animal world, is both a dreamscape reflecting the young man's own tortured interiority, and in Philip Hardie's characterization, "a deathlike place," reminiscent of Vergil's Lake Avernus. It even has a touch of Tartarus about it: the youth's appetite for his own image becomes insatiable, like the hunger of Tantalus.[29] This still, silent spring with its crystalline

and silvery waters (*fons . . . inlimis, nitidis argenteus undis*, 3.407) is the magnetic mirror at its most lethal, a place of ruthless entanglement in self-desire and self-loathing. Like Narcissus' hunting nets, which closed upon his trembling quarry (3.356), it offers no escape.[30] Yet nobody else populates its shores or falls into its snare. It is, as Marilyn DiSalvo has suggested, the dark interior kingdom of the protagonist's own mind.[31]

Narcissus himself, the victim of a kind of self-induced nympholepsy,[32] is hardly capable of resisting. In Roman art he is usually portrayed as a soft and sensuous ephebe with long, flowing hair and an effeminate pallor; sometimes he is alone, but often he is attended by subordinate figures such as erotes and nymphs.[33] The attitudes he strikes are akin to those of other pretty boys in myth, such as Adonis, Endymion, and Ganymede.[34] Particularly in sculpture, he may crook one or both arms limply over his head, a gesture signifying vulnerability, torpor, slumber, or a general lack of awareness.[35] A late-Antonine sarcophagus in the Vatican, for example, represents the youth in a languid contrapposto, both arms over his head, as a little Eros bestrides the facial reflection that appears in relief at his feet (Fig. 32).[36] The narcissus flower – born of human death, like the crocus and the hyacinth of myth – had powerful associations with the underworld long before the story of the eponymous youth was concocted. Crowns of narcissus were ill-omened because they were dedicated to chthonic divinities, especially Persephone. Already in the seventh century B.C.E., the *Homeric Hymn to Demeter* relates how the young Persephone was reaching out to touch the alluring narcissus at the very moment when Hades emerged from the underworld to drag her down. The flower, perhaps because of its overpowering perfume, was thought to have dangerous narcotic properties, and so its etymology was traced to *narke*, "numbness."[37] From the folk tradition of the flower, then, it is possible to glimpse the rudiments of an etiological myth about its personification, even if its relationship to the central themes of the myth – reflection, duplication, reflexivity – remain obscure.

Reflection is most elementally a property of water. Ovid's Narcissus, it has been suggested, is drawn to water because of his own watery nature.[38] Born of liquid (the river Cephisus and the naiad Liriope), to liquid he returns, first weeping, then melting away in death like wax or frost (*Met.* 3.464, 487–93). Just as, at his forced conception, his mother was imprisoned in the winding stream (3.341–4), so Narcissus is held in bondage to water at his death, incapable of leaving the pool even to eat. The famous cry, "I am he," does not convey the contempt inherent in the Latin pronoun. It could be translated "I am *that* one" (*iste ego sum*) – not a complete person, but the Other. Any personhood that had developed in him seeps away into the grotesquely incomplete, inanimate thing that peoples the pond. It is not surprising, then, that the later tradition espoused by Plotinus and others has Narcissus falling into the water and drowning.[39] I will consider the implications of a submerged, corpselike Narcissus below.

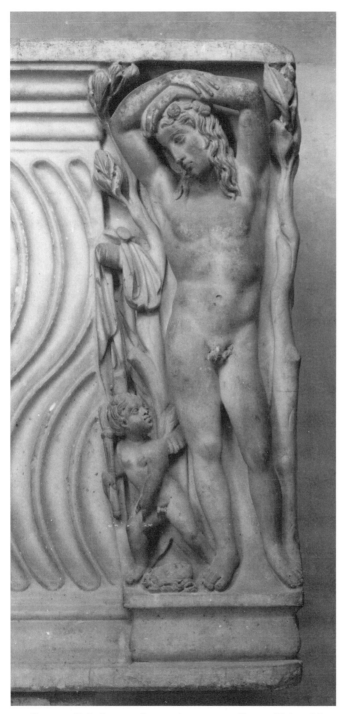

32. Corner relief of a sarcophagus. 180–190 C.E. Rome, Vatican Museums, Galleria Lapidaria 169. Photo: DAI Inst. Neg. 71.1710.

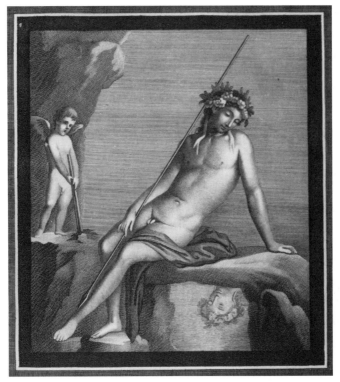

33. Engraving of a fourth-style wall painting from the Villa of Diomedes, Pompeii. Original: Naples, Museo Nazionale 9383. Photo: DAI Inst. Neg. 85.3855.

Once Narcissus' fate – whether it was suicide, accidental drowning, or wasting away into a flower – was sealed in the mythological record, and the *cause* of his fate attributed to his disdainful treatment of lovers and a fated obsession with his own reflection, foreshadowings of his death naturally made their way into artistic representations. With the often-seen spears and dogs in the youth's presence, the theme of the hunt is present in most Roman visual representations of the myth, and in some it is emphasized – principally, no doubt, because the hunt may serve as a sexual metaphor, and because in Narcissus' case the hunter has become his own quarry.[40] It is also common to see Narcissus crowned with a wreath of greenery and flowers, as in a rendering from the Villa of Diomedes at Pompeii (Fig. 33).[41] Although it is hardly possible to identify these plants for certain (the artists may not themselves have intended any specificity), it is only natural to conclude that they are the narcissus itself – the very thing that sprang from his dying body, according to all the major traditions of the story.[42] In his *ekphrasis* of a painting on the theme, Philostratus populates the scene around Narcissus with flowers; although unnamed, these again encourage the same conclusion.[43] But if flowers offer a whiff of oblivion, it is water that seals the youth's fate. In an artful bit of description, the ekphrast expresses both the

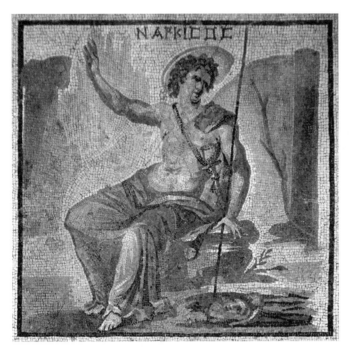

34. Inscribed mosaic from the House of Narcissus at Antioch. Early to mid-second century C.E.
Baltimore, Baltimore Museum of Art, Antioch Subscription Fund, BMA 1938.710.

appearance of the young man's inverted image and his drastic infatuation in a
single turn of phrase: "he has fallen into the water up to his eyes and ears."[44]
Even his hair is described in terms reminiscent of an aquatic plant.[45] Philo-
stratus' Narcissus, though he has not literally drowned as in Plotinus' narrative,
is a victim of a figurative drowning, his reflection serving for a waterlogged
denizen of the subaqueous nether world. Callistratus too offers a decidedly
star-crossed image of the young lover.

Or let us take another motif, this time strictly in the visual media: the "sur-
prise gesture" that emerges in a few Narcissus scenes of the mature Roman
Imperial period, such as the mosaic from the eponymous House of Narcissus
at Antioch, dating to a few decades after the eruption of Vesuvius (Fig. 34).[46]
This Narcissus (who either wears a broad-brimmed *petasos* or is unaccountably
equipped with a nimbus) reacts with a raised right arm to the image seen in
the water. It is certainly possible, even desirable, to interpret this attitude as one
of the initial astonishment that the youth experiences when he first catches a
glimpse of his reflection in the spring.[47] An epigram of the Latin Anthology by
Pentadius enumerates Narcissus' physical and emotional reactions: "he stands,
gapes, lingers, loves, solicits, nods, stares, burns, flatters, protests."[48] But as we
will see in the next chapter, a very similar gesture also has a longstanding con-
nection to hallucination, divination, and prophetic inspiration.[49] A tradition in

Dionysiac art presents a protagonist reacting with upraised arm to a terrifying vision or portent appearing in a bowl of liquid or some other medium. The dramatic potential of this gesture may have influenced artists of the high Imperial age to introduce it into the usually placid Narcissus tableau as yet another proleptic marker of death: Narcissus encounters not just a face in the water, but a vision of his own demise.

By the time of Callistratus, writing in the early fourth century C.E., this idea seems to have caught on, now translated from a gesture into an expression: "in the nature of the eyes art had put an indication of grief, that the image might represent not only Narcissus but also his fate" (5.1.23–6). Eventually the topos inspired a variant of the myth: rather than involve the boy's parents in Tiresias' prophecy, the nymphs addressed the old man's warning to Narcissus *himself* while he pined by the water, thereby giving him direct knowledge of his fate.[50] A similar instance of anticipatory dismay in Roman art, in which Thetis learns of the future fate of her son Achilles by examining his freshly forged shield, will be discussed in Chapter 4. These episodes are not canonical in any literary sense; if anything, they subvert the conventions of narrative, thrusting the effects of action into the temporal realm of their own causes. The resulting pictures are enriched and problematized by their elegant dismissal of temporality.

NARCISSUS IN ROMAN ART

To the extent that they follow any literary version of the story at all, surviving visual representations of the Narcissus episode seem to depend most heavily on Ovid.[51] Well over half of the 65-odd known artworks featuring Narcissus come from the Vesuvian region, and these in particular show the poet's imprint, if only loosely.[52] No standard pose or gesture asserts its dominance among this group. In a few cases, the youth is shown in the hunt, but these images will not detain us here; I concern myself only with the majority of images that have for their setting Narcissus at the spring. He is shown in varying attitudes, either alone or in the presence of various ancillary figures, mostly nymphs and erotes. Certain principles obtain generally, at least among the paintings and mosaics. There is always a water source, whether a spring, a fountain, or simply a basin into which water is being poured by an attendant. Narcissus is pallid and ephebic, and his pose is static and contemplative, though he does not always gaze directly at the water. More often than not, his face appears in the water, and only very rarely his body.

Some of the Pompeian Narcissus scenes, such as a panel painting from the House of M. Lucretius (9.3.5–6, 24), include a figure of little Eros by the side of the pool extending an overturned torch toward the reflected image of the

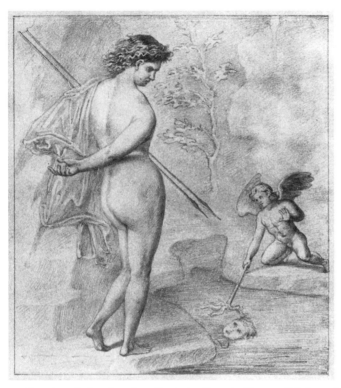

35. Drawing of a fourth-style wall painting from the House of M. Lucretius (9.3.5−6), Pompeii. Original: Naples, Museo Nazionale 9381. Photo: DAI Inst. Neg. 89.297.

youth's face (Fig. 35).[53] The torch, and its inversion down toward the water, can be interpreted in a number of ways. The fire of passion, of course, comes immediately to mind; but let us first discuss other possibilities. In Roman art the torch often carries a charge of religious suggestion, either direct or residual. It is a ubiquitous implement in numerous cultic contexts. Whether or not it is defined by a specific framework of cult (such as those of Luna, Dionysus, Demeter/Ceres, and Cybele), it is likely to take on strongly nocturnal or chthonic associations, evoking the darksome domain of death − and more specifically its divine mistresses, such as Hecate[54] and Persephone/Proserpina. Held purposefully at a downward angle, the torch evokes a scene of sacrifice, as in the S. Ildefonso statue group in the Prado, which represents, in part, a youth kindling an offering on an altar. Seen in such a light, Narcissus (or his image) becomes a victim on the altar of Eros. Specifically, the *overturned* torch is a harbinger of death and ruin, evoked in Narcissus' words "I am extinguished in the prime of youth."[55] In some images its inversion is extreme, to the point where the little Eros is extinguishing it either on the ground or in the water: a symbol, it would seem, of the young man's impending death (Figs. 35,

36).[56] A modern viewer might also be inclined to read into the phenomenon of the lowered torch a phallic corollary to Narcissus' palpable loss of virility as he languishes at the pond: the closer it comes to its target, the more impotent it becomes, until it is snuffed out altogether upon contact with the reflection. Such is the erotic conundrum entailed in the false reciprocity of narcissism.[57]

The torch is also, of course, a metaphor for the inflamed passion of Narcissus. It is only proper that it should be wielded by Eros, near whose sanctuary at Thespiae, according to Conon, the event took place.[58] The fire of love, in Ovid's account, is not a spontaneous thing; it is lit by the object of desire. In this way, he says, the desire for Narcissus was kindled in the heart of Echo:

> Now when she saw Narcissus wandering through the fields, she was inflamed with love and followed him by stealth; and the more she followed, the more she burned by a nearer flame; as when quick-burning sulphur, smeared round the tops of torches, catches fire from another fire brought near.[59]

Ovid's simile of heat transfer from fire to torch found a clever expression in this Roman pictorial tradition. Eros, who never appears directly in any version of the written narrative, is shown in pictures of Narcissus as an embodiment of the youth's desire; he sometimes seems to kindle the torch of passion from its very source, the reflected face in the water (see Fig. 35). Strictly confined to the Roman visual tradition, Eros-cum-torch seems to have made its own way into the cultural *koine* of the Narcissus story, eventually inspiring an anonymous epigrammatist of the Latin Anthology to suggest that the water itself, or the image within it, lit the flame: Narcissus "found his own fire in the water's midst, and his image burns the deluded man."[60] Ovid's image of Narcissus melting like wax or frost in the heat of his own passion (*Met.* 3.464, 487–93) evolves into one in which the inflammatory agent is nothing so abstract as an emotion, but is the duplicate image itself – even the very water in which his double is suspended.

The strictly visual topos of the torch touching the water near the reflected image is, I believe, a distillation of an idea that was introduced to Roman readers in book 4 of Lucretius' *De rerum natura* – a work that profoundly influenced Ovid's construction of the Narcissus narrative.[61] Among the many human delusions that the poet enumerates in the course of his atomistic theory of sense perception is that of lovesickness. Paradoxically, Lucretius says, a lover's hopeless desire for a visual simulacrum of the beloved – the insubstantial film projected by the body that constitutes an image – only increases as it is consummated, like a man whose thirst grows worse when he imagines himself drinking:

> As when in dreams a thirsty man seeks to drink, and no water is forthcoming to quench the burning in his frame, but he seeks the image of

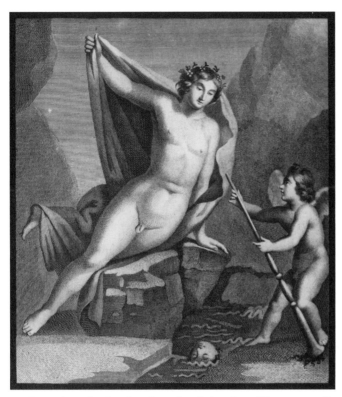

36. Engraving of a fourth-style wall painting from House 6.1.6, Pompeii. Naples: Museo Nazionale 9701. Photo: DAI Inst. Neg. 85.3856.

> water, striving in vain, and in the midst of a rushing river thirsts while
> he drinks: so in love, Venus mocks lovers with images [*simulacra*], nor can
> bodies even in real presence satisfy lovers with looking. . . .[62]

Lovesickness, according to Lucretius' formulation, is doomed to this para-dox. Although the lover's hope is that "the fire may be extinguished from the same body that was the origin of the burning" (i.e., that of the beloved), nature denies that possibility (*DRN* 4.1086–88). In these pictures, then, is Eros *kindling* the torch in the reflection of Narcissus, or *extinguishing* it? In light of Lucretius' theory, the answer must be that he is doing both simultaneously, for scratch-ing merely aggravates the itch. Narcissus' desire is no different from the kind described here, except that in his case the beloved is the lover himself; he is, in effect, hyperreflexive, simultaneous subject and predicate, like the *ouroboros*, the serpent that consumes itself.[63] Whether or not Narcissus recognizes himself in the water is immaterial to the power of his desire. As he seeks to slake his thirst at the spring, "another thirst springs up" (*Met.* 3.415), one that cannot be assuaged *even by self-knowledge*. If anything, the appalling realization, "*iste ego sum*," is an escalation of his dementia, the point of no return. His prison is a pool of fire-water that only inflames what it tries to extinguish. Whereas Echo

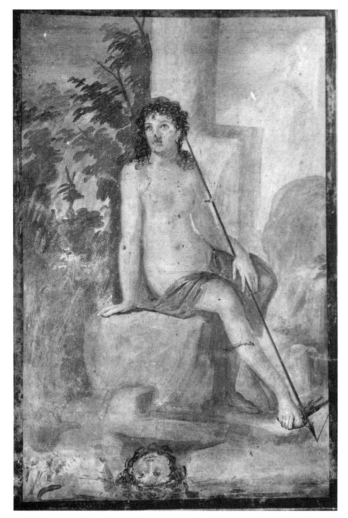

37. Fourth-style wall painting in the garden portico of the House of Octavius Quartio (2.2.2), Pompeii. Photo: DAI Inst. Neg. 57.872.

simply dried up (*in aëra sucus corporis omnis abit*, 3.397–98), Narcissus' own fate is to burn ever hotter in the fount of his own inexhaustibly volatile humors.

Let us consider yet another point of view. Few have paused to consider how strange it is that Narcissus should pine for an image of himself that lies recumbent (*resupinus*), gazing up at him and mouthing his words from the depths. This is self-deception on an altogether different order from an *upright* encounter with one's own reflection, a meeting that might credibly provoke an honest misunderstanding, at least for a person uninitiated in the ways of mirrors. Instead, Narcissus replicates himself in the position of sex, or of death: his body casts its double *en abîme*, wheeling it around to face the sky, like a bedded woman awaiting her partner – or a corpse lying in state.[64] The volatile simulacrum shimmers, sporadically shatters under the invasion of

38. Drawing by A. Aureli of a lost wall painting from the House of M. Holconius Rufus (8.4.4), Pompeii. Photo: DAI Inst. Neg. 53.599.

tears and hands, but is always reconstituted to inflame the "real" Narcissus with mad desire. What is the fuel for this virtual fire, if not the outstretched *imago* itself? In this scenario, Eros can be understood not as the receiver of the flame, but as the one who imparts it. In effect – if one follows the more morbid interpretation – he is a funerary torchbearer who touches off the notional pyre bearing the notional corpse of Narcissus. As the lovesick youth says after the realization that he sees only himself, "I both kindle the flames and suffer from them" (3.464). Almost universally in the artistic renderings of the scene, Narcissus' inverted head is the only part of his body to appear in the water. Sometimes it floats disembodied, almost like a gorgon head – as on the fresco panel at the end of the "euripus" in the House of Octavius Quartio in Pompeii (Fig. 37) – a clean synecdoche for the totality of Narcissus' object of desire.[65] But one case is very different. A drawing of a badly damaged fresco from the House of M. Holconius Rufus in Pompeii (now completely obliterated) preserves little of the half-reclining Narcissus himself, but much of his supine mirror image, a complete body strangely reduced in size and only loosely reconcilable to what remains of the referent above (Fig. 38).[66] The image, though most of its head is

unintelligible, looks surprisingly corpselike, almost as if it were floating lifeless in the water, Ophelia-like. A kneeling Eros in the foreground plants the torch more or less where the knees ought to be, as if he were setting fire to the garment still gathered around the simulacrum's legs.

Little of the "real" Narcissus is visible in this drawing, but enough of his legs survive to suggest that his attitude more or less parallels the type in Fig. 36.[67] Although the Roman image of Narcissus became more virile over time, this pallid, almost androgynous manifestation was the one favored in the first century C.E.[68] Ovid, however, says almost nothing about his protagonist's body below the shoulders, focusing on the starry eyes, the locks worthy of Bacchus or Apollo, smooth cheeks, ivory neck, and "the blush mingled with snowy white," all decidedly effeminate features (3.420–24). But what of his *body*? We learn only that it is like Parian marble in its luscious pallor (419), and only by inference that (unlike his representations in art) it is clothed up to the neck.[69] Ovid's Narcissus had reached his sixteenth year, and "could be seen as either a boy (*puer*) or a young man (*iuvenis*)" (3.352). An idealized sixteen-year-old Mediterranean male, it seems, would have been regarded as barely over the verge of pubescence.[70] Belonging to an adolescent of "slender form" or "delicate beauty" (*tenera forma*, 3.354), Narcissus' ephebic attractions evidently needed no further elaboration from Ovid: he was ripe for sexual harvest, but also capable of his own sexuality. Discerning a youth of his very same age in the water, he cries, "Surely my form[71] and age are not such that you should shun them, and me too the nymphs have loved" (3.456).

It is significant, then, that Narcissus in this picture is such a forthright exhibitionist, unveiling his naked body – and a bodily desire for his reflected nakedness – in a way that Ovid, constrained by the decorous conventions of hexameter, and perhaps by Augustan censoriousness, could not. Paul Zanker has suggested that such an obviously autoerotic scene must represent the "knowing" Narcissus, that is, the youth after he has recognized that the reflection is his own.[72] As such, he has passed the point of no return, having fulfilled the dark side of Tiresias' prophecy that he will live long only "if he should never know/recognize himself." But in purely pictorial terms, though not in an ordinary narrative sense, the mad Narcissus is not only autoerotic, but also something of a necrophile. For in the reflective surface of the water, a multivalent Narcissus is unveiling and admiring a luscious body that is simultaneously a corpse: a premonition of his undoing, like the upended torch in the hands of the attendant Eros. Of all the Pompeian representations of Narcissus, this single lost fresco seems an ironic fulfillment of his cry of frustration shortly before his death: "Oh, that I might be parted from my own body!" (3.467). It takes two to tango, he has reasoned – and yet, infuriatingly, he is only one. In a sense his wish comes true, but not in the way that he had hoped. His

body dies away into the form of a flower, while his incorporeal shade peels off to the underworld where it perpetuates its torment by gazing into the Styx.

PATHOLOGICAL REFLEXIVITY 1: THE ALLURE OF THE FEMININE REFLECTION

When understood in conjunction with the various versions of the myth that were circulating from the Augustan period onward, the painted or sculpted reflection of Narcissus is telling both in its iconic simplicity and in its semantic complexity. What can be said about its nature and function? It must be emphasized that Narcissus' encounter with his reflection is not pure reciprocity. The youth and his image must be triangulated to the viewer, just as they are to the reader in any written account.[73] To begin with a purely mechanical observation: when seen from directly above, reflections on water generally are not as intense in color or opacity as they appear from an oblique angle; in fact, under many lighting conditions outdoors, one's own reflection seen from above simply provides a dark, clarifying window into the water's depths, which otherwise are concealed by the reflection of the sky. Partly for this reason, perhaps, the standard terms for a reflection, the Greek *skia* and the Latin *umbra*, mean "shadow."[74] When Philostratus says that "the pool paints Narcissus" (1.23.12) – that it remakes his image in brilliant color and naturalism – he is speaking from a distant spectator's point of view, a locus where the painted Narcissus and his painted reflection are both equally compelling falsehoods. The image of Narcissus that the viewer sees in the water is not the one that Narcissus himself sees; it is a more complete counterfeit in many ways. From across the pond (and most Roman painted versions take this vantage point), the viewer could conceivably see the youth's full body reflected, whereas he probably could not. The viewer could see it with optimal vibrancy and opacity, whereas Narcissus would see a thin, transparent shadow interpenetrated by anything that might appear in the depths below. (Let us remember that his pool is a sunless place.) As Ovid describes the spring, it is extreme both in clarity and in reflectivity: *fons erat inlimis, nitidis argenteus undis* (3.407) – a telling juxtaposition of properties. But Narcissus' fixation is all silver, no glass; all surface, no depth. He has no faculty with which to see what might be obvious to others, the crystalline depths that lie through the window of self-desire. Hovering on the windowpane, unable to hurdle its lucent barrier, he is visually impotent. In this important respect – Narcissus' indisposition to look beyond surfaces – he resembles the pathologized female characterized in the previous chapter.

The acknowledgment of participatory triangulation is evident in the various directions of Narcissus' gaze and position in Roman art. In antiquity he

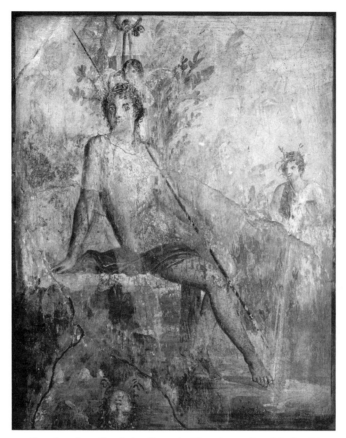

39. Fourth-style wall painting from the Vesuvian region. Naples, Museo Nazionale 9388.

is never shown in "full Caravaggio" – that is, with his head craned forward to position his face parallel to the water, as most modern images have represented him.[75] Instead he sits, stands, or even reclines with a preening uprightness that is best viewed horizontally, almost as if the plane of the water had been upturned to form a window between himself and the viewer – almost as if the viewer were taking the part of the reflection. In some cases his eyes are downcast in the general direction of the water, but in others he seems to look directly at the viewer, as in Fig. 37 or a similar panel in Naples (Fig. 39).[76] Winfried Prehn has interpreted the collectivity of Narcissus' "beautiful" attributes – including his exhibitionism – as the product of a culture of pederasty in which certain elements so important to the myth – the youth's interiority, the importance of reflexivity in his self-understanding, indeed the reflection itself – have yielded to the aesthetic desires of the Roman viewer, whose primary interest is in Narcissus as a sex object.[77] Jaś Elsner draws particular attention to the painted Narcissus' engagement with the viewer, suggesting that it disrupts the voyeuristic autonomy of the gaze; in effect it makes of the

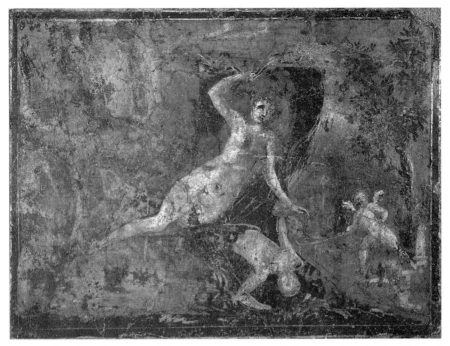

40. Fourth-style wall painting from House 1.14.5, Pompeii. Soprintendenza Archeologica di Pompei inv. 20547. Reproduced by authorization of the Ministero per i Beni e le Attività Culturali.

viewer a new Narcissus.[78] I may be tempted to look with desire upon a seemingly responsive simulacrum, to lust after a lusty unreality – and to wonder if *any* image can be seen uncolored by one's narcissistic self-absorption.

Armed with these insights, one might still approach another apparent Narcissus scene, this one in a wall fresco from house 1.14.5 at Pompeii, with puzzlement (Fig. 40).[79] Here we encounter some of the things we have come to expect in a Narcissus scene: a soft and pallid figure posing dramatically above a striking reflection, with an attendant Eros thrusting a blazing torch at the image. The difference is that this figure is much more strikingly female than other renderings of Narcissus, even those in Figs. 6 and 8, which have distinctly effeminate features.[80] To be sure, its painter was not the most skillful at his craft, but he unambiguously presented all the conventional Roman markers that distinguish a woman from an ephebic male: exceedingly pallid skin; a large, ovoid pelvis; a narrower torso tapering away from the hips rather than toward them; and pronounced, conical breasts. (The dark line defining the left breast, and the dark right nipple, however, are defacements.) The hairstyle too is characteristically feminine in a recognizable Flavian way, with multiple corkscrew ringlets framing the face. On the other hand, strands of the dark hair spill down onto the shoulders – an attribute more characteristic of ephebic

males than of females, whose hair is usually done up in a chignon off the shoulders. Unfortunately the genital area is too damaged to sex this figure securely, but the combined markers suggest only two unequal possibilities: the figure is either entirely female or hermaphroditic, and probably the latter.

Now there is nothing in any version of the Narcissus story to suggest that the youth ever had, or acquired, the physique of a woman. What would explain the rather extreme gender-bending tone of this *pictorial* Narcissus? The artist, I think, was experimenting with two existing models that were naturally congenial to the canonical story, but in a pictorial language all its own. The first is a Roman psycho-physiological scale of gender, and the second is another Ovidian exploration of specularity and metamorphosis, the story of Hermaphroditus.

First let us consider gender. Narcissus' madness is erotic and his appetite insatiable. His desire for himself, like that his admirers feel for him, is all about sexual consummation; it has none of the Ouranian components that temper most Greek philosophies of eros.[81] As I suggested in the preceding chapter, he embodies the foolish obsession of the partridge and, sequentially, the willful autoeroticism of the dove. In either case, his persona is quintessentially effeminate.

Roman social norms pathologized sexual excess in both physical and mental terms. They did so not in reference to sexual orientation, which – even if it played an important role in real behavior – had little to do with the *construction* of sexuality in antiquity.[82] That Narcissus' desire is evidently homoerotic, and Echo's not, has no special significance, either in art or in literature.[83] The important thing is gender role, the extent to which Narcissus' sexuality is deemed pathic – that is, of the kind that takes the passive role in penetration – or active, and thus safely within the realm of the controlling male. But even more to the point, the femininity index was linked to the degree of pleasure sought and gained, *whether or not that pleasure was pathic in nature*.[84] Too much sex of any kind – active or passive, consummated or only imagined – signaled a pathological weakness ascribed to femininity.

In myth this disposition was embodied in such baneful females as Helen, Clytemnestra, and even the Trojan women, who on the eve of calamity had nothing better to do than gaze solipsistically "into the endless light of golden mirrors."[85] And few Roman authors were more eloquent about the gendering of sexual pathology than Ovid, despite his taste for an inclusive eroticism that subverted the straightforward masculinity promoted by the Augustan regime.[86] In the *Ars amatoria*, he consigns the task of elaborate personal adornment to seductive girls and "doubtful" (i.e., pathic) men (1.505–24); and at the peroration of a long list of sexual outrages committed by lubricious females, he laments, "All those crimes were prompted by women's lust (*feminea libido*); keener is it than ours, and has more of madness" (*Ars* 1.341–3, transl.

J. H. Mozley). Many others echoed these sentiments. Plutarch, himself no crass misogynist, would nevertheless take the party line concerning the base nature of both women and effeminate men in his *Advice to Bride and Groom*: "Women will not believe that Pasiphaë, the consort of a king, fell in love with a bull, in spite of the fact that they see some of their sex who feel bored by uncompromising and virtuous men, and take more pleasure in consorting with those who, like dogs and he-goats, are a combination of licentiousness and sensuality" (*Mor.* 139b; transl. F. C. Babbitt). Women, he believed, did not have to submit to their base, animal instincts. They could be taught by the moral mirror of their husbands:

> When their husbands try forcibly to remove their luxury and extravagance they keep up a continual fight and are very cross; but if they are convinced with the help of reason, they peaceably put aside these things and practise moderation. . . . Just as a mirror, although embellished with gold and precious stones, is good for nothing unless it shows a true likeness, so there is no advantage in a rich wife unless she makes her life true to her husband's and her character according to his (139e–f).

According to Plutarch, then, even a woman could triangulate to a superior model. But the task was laborious, and the model had to exert a moral force on her life, generating an exemplum to inhabit her mirror in lieu of her own. Narcissus, we will note, has no aspirations, no models; he is a creature who retreats from history. His reflection completely lacks an improving presence, a third party with whom he could amalgamate or animate his own redundant reflection. He does not see beneath his own features into the depths, freely choosing instead to regress into a feminine fascination with surfaces.

The female has been regarded in many societies, including ancient Rome, as the "default" gender. "Masculinity in the ancient world was an achieved state radically underdetermined by anatomical sex," writes Maud Gleason.[87] According to this construction, men – and even virtuous women seeking to be worthy of their men – must fight the animal presence of the female within themselves and dominate its enervating tendencies. *Rites de passage* in these societies are often interpreted as prescribed male repudiations of the innate femininity present in one's youth.[88] One by-product of this cultural asymmetry is that women are conceded the right to experience intense and prolonged sexual pleasure, if only because it is in their character to want it; but in men, such wantonness is regarded with fear and loathing. None other than Tiresias himself, who had been both a man and a woman, codified the principle in Greek myth when he settled a wager between Jupiter and Juno by testifying that women experienced nine times more pleasure from sex than men.[89] It might surprise us that Juno was deeply displeased with the verdict, blinding the prophet for his troubles. But her reaction is best understood within an ancient

Greek ethos, and Roman too, that regarded excessive lust as shameful and dangerous. The feverish desire for orgasmic pleasure was deemed a character flaw and an adjunct of bodily degeneracy; and Juno, it must be emphasized, was very much in the business of promoting *pudicitia*, chaste self-control. Though a womanly norm, hypersexuality was no womanly virtue; and according to specifically Roman social attitudes, any woman who sought true distinction should herself combat it.[90] Any male who lingered too long over the pleasures of the flesh was a *mollis vir* or a *cinaedus*, a soft and womanly man. Such, for example, was the emperor Otho in Juvenal's eyes, who brought a mirror on his military campaigns (2.99–101). Narcissus' fixation was nothing if not an extreme case of precisely such *mollitia* or hypersexuality; and as such, it was a case of mental degeneracy that translates very plausibly into a physical ungendering.

Let us consider another passage from Ovid. Deianira's letter to her husband Hercules in the *Heroïdes* bitterly condemns him for ceding his masculinity and its symbols – the lion skin, the spear, the club – to a mere woman, Omphale. She concludes a stinging catalog of his self-abasement with the image of his weapons reflected in a mirror:

> You are mistaken, and know it not – that spoil is not from the lion, but from you; you are victor over the beast [the Nemean lion], but she over you. A woman has borne the darts blackened with the venom of Lerna [i.e., from the Hydra], a woman scarce strong enough to carry the spindle heavy with wool; a woman has taken in her hand the club that overcame wild beasts, and in the mirror gazed upon the armor of my husband![91]

Omphale is now in possession not only of Hercules' material weapons, but of his cultural prerogative, the gaze. But that gaze, in the characteristic fashion of the feminine, is directed back at itself, and not out to the world. Omphale, when looking in the mirror, is admiring *herself* decked out in the martial habiliments of Hercules – not simply the objects in themselves. Her magnetic mirror – which, Ovid implies, was the only weapon she needed to defeat the hapless hero – has sucked into its maelstrom of debilitating allure the very symbols of his masculinity, the artefacts of his history, and converted them (at least temporarily) into baubles, the booty won by her womanly wiles. But the mirror, the medium of surfaces par excellence, has transformed her into the man she has vanquished; she has metaphorically skinned him, just as he skinned the lion, and mantled herself in his persona of all-conquering hero. Mirrors reverse things; and here, the unidirectional intent of weaponry is turned upon its master, not only reversing his fortunes but stealing his very persona. A delightful distillation of the role inversion in this famous story is preserved in a group of Campanian mirrors, the most noted of which comes

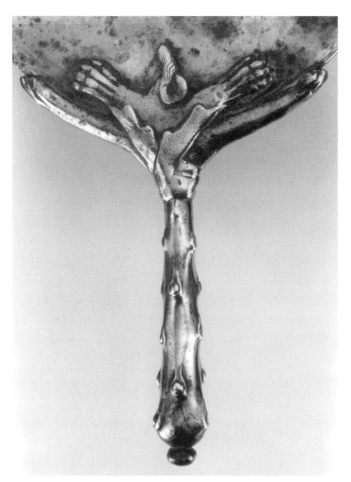

41. Silver mirror from the treasure of the Villa della Pisanella at Boscoreale. First century C.E. Paris, Louvre BJ 2160. Photo: Dist RMN / © Les frères Chuzeville.

from the Boscoreale silver hoard now in the Louvre. The handle consists of the club of Hercules wrapped about by the skin of the Nemean lion (Fig. 41).[92] The mirror, the weapon, and the spoils of conquest have all been rolled into a multiple signifier that would not have escaped the understanding of its cultured owner.

PATHOLOGICAL REFLEXIVITY 2: HERMAPHRODITUS

The principle that all hypersexuality is inherently feminine – and the confirmation of this femininity in reflections – is abundantly evident in Roman representations of Hermaphroditus, a mythological character who, according to Ovid's dominant account in book 4 of the *Metamorphoses*, began life as a

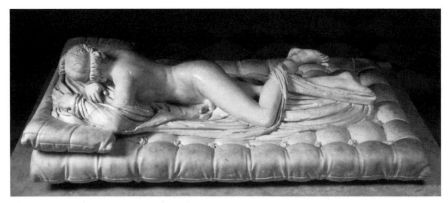

42. Marble sculpture of sleeping Hermaphroditus. Second century C.E. Paris, Louvre MR 220. Photo: Réunion des Musées Nationaux/Art Resource, NY.

male, and who retained a masculine identity that mingled with the feminine essence of the nymph Salmacis. One might presume that the two essences met halfway to create a genuinely androgynous hybrid. Yet many ancient images of Hermaphroditus – probably a majority in the case of narrative scenes – present a body that is emphatically female, its male genitals applied to it almost as provocative afterthoughts. The "sleeping Hermaphroditus" type, exemplified by the famous recumbent statue in the Louvre, is only the most prominent among them (Fig. 42).[93] In fact, mistaken gender identity is a favorite theme attached to this hybrid creature: taken for a woman, he impishly lifts his tunic to expose his vestigial masculinity.[94] Or, in a type favored in Imperial Roman Italy, he is assaulted by a satyr or pan;[95] sometimes the assailant recoils in disgust when he realizes his error (Fig. 43).[96]

This gender imbalance is no accident of taste, but the result of an evolution or consolidation of attitudes about sexual pathology in the Hellenistic and Roman periods.[97] Characteristic of his time, Suetonius characterizes the *androgynos* as "having something of the shape of a man, but in all other things effeminate"[98] – an opinion shared by many other writers of the Roman period. It was inevitable, perhaps, that myth and its representations too should evolve with the popular paradigm. From the Hellenistic period, Hermaphroditus' identity as a being of roughly equal gender balance had been overrun by that of the aggressively licentious, languorous female.[99] Returning then to the fresco in House 1.14.5 (Fig. 40), it is hard to escape the impression that this is a conscious conflation of the Narcissus and Hermaphroditus episodes from Ovid. Merging these two stories was eminently logical, for the poet himself was aware of the rich possibilities of comparison;[100] indeed, in the Hermaphroditus story (*Met.* 4.285–388), he draws attention to reflections in water no fewer than three times.

Hermaphroditus, it appears, was worshiped as a minor deity from at least the fourth century B.C.E.[101] But like Narcissus, he seems to have possessed

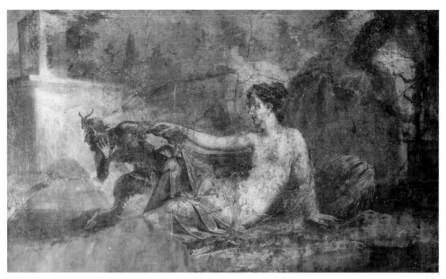

43. Fourth-style wall painting from the atrium of the House of the Dioscuri (6.9.6−7), Pompeii. Naples, Museo Nazionale 27700. Photo: DAI Inst. Neg. 63.2171.

no cogent history before Ovid; in fact, the poet takes pains to assure the reader that his etiological tale is "pleasing because new" (*Met.* 4.284). His story within a story, narrated by Alcithoë as she weaves at her loom, purports to explain why the spring of Salmacis at Halicarnassus in Caria has a weakening and softening effect (in terms of both sexual potency and bodily strength) on all men who bathed in it.[102] Born of Mercury and Venus – Hermes and Aphrodite, hence his name – and possessing the beauty of both, Hermaphroditus at age fifteen undertakes to "wander in unknown lands and see strange rivers."[103] One day he happens upon this crystal-clear spring. In the pool dwells the naiad Salmacis, a pleasure-loving nymph who is wont to linger in luxury, preening over her reflection in the water. Unlike the other nymphs, who temper their soft femininity with the rigors of hunting, "she only of the naiads follows not in swift Diana's train" (4.304); that is, she disdains not only the hunt, but (implicitly) virginity itself. Ironically, she proves the most enthusiastic huntress of all, but strictly in a carnal sense.[104] Seized by desire when she sees the comely youth, she praises his beauty, begging him to join her either in "stolen joy" (*furtiva voluptas*, 4.327) or marriage. Blushing, Hermaphroditus fends off her advances; when she retreats, he casts off his clothes for a swim. Watching unseen from a thicket, Salmacis' burning lust is redoubled. But only when he penetrates her domicile – the water itself – does she make her move. Throwing off her robes, she dives in after him and clasps him in a firm embrace; try as he might, the boy cannot escape her entwining limbs. Salmacis entreats the gods to keep the pair fast together for eternity. The gods hear her prayer and merge their bodies into one, a single face and form

serving for both. Ovid's masculine pronoun confirms that Hermaphroditus retains his essential identity after the metamorphosis; but rather than gaining from this convergence, the youth, abruptly rendered "half male" (*semimas, semivir*), suffers a net loss: his body is softened, his strength sapped, his voice drained of manly vigor.[105] Salmacis' absolute domination comes through in the very language of the passage: "I win, and he is mine!" she exults as she entwines his body like a powerful serpent or the sea-polyp ensnaring its victim.[106] Overrun by the flaws of femininity, he acquires no distinctly feminine *virtues* in compensation, for the wanton and aggressive Salmacis has no (Roman) virtues to give. In the words of Brooks Otis, "Salmacis is, in fact, the prototype of the *furiosa libido* that, as the *Ars Amatoria* . . . had declared, is peculiarly female."[107] Hermaphroditus "saw that the waters into which he had plunged had made him but half-man" (380–81): the spring, not the nymph or gods, is blamed for his misfortune. Invoking his divine parents, he asks that any man who should enter the pool thenceforth should emerge a half-man; immediately the waters become poisoned "with an unchaste tincture" (*incesto medicamine*, 388, my transl.).

The artist of our ambivalent Pompeian scene (Fig. 40) chose to preserve the conventions of the Narcissus theme, but also to transmit the youth's fatal weakness by way of a somatotype known to every Roman viewer as that of Hermaphroditus. The reflection, however, belongs to both traditions and so fulfills a dual function. On the one hand, it embodies Narcissus in his madness. On the other, it establishes a unique bond to the Hermaphroditus story that is nowhere else exploited in surviving Roman art: it evokes the direct aftermath of the boy's union with Salmacis, when the new creature awakens to its duality. Hermaphroditus has arrived at his moment of self-awareness by doing what Salmacis was so fond of doing before: gazing at his own reflection. That, at least, is the most plausible interpretation of Ovid's rather imprecise description: the youth "saw that the waters into which he had plunged had made him but half-man" (4.380–81, transl. F. J. Miller). If we could, for a moment, spirit away the obvious influence of Narcissus scenes on the painting under discussion, we might ask: Why is the diminished Hermaphroditus preening with evident self-satisfaction before his mirror image? Surely he should be horrified by his fate, and not – as the "knowing" Narcissus must be – absorbed in admiration of himself.[108] But in fact, nothing in Ovid's account suggests that he regrets this new hybrid condition. In this image, and perhaps implicitly at the conclusion of Ovid's tale too, Hermaphroditus' soul has been consumed by femininity along with his body, and he has acquired the reflexive subjectivity of a self-absorbed woman. Certainly it would be hard to argue otherwise with respect to a fresco panel from House 6.7.18 in Pompeii, which represents a languid, half-reclining Hermaphroditus surrounded by attendants of

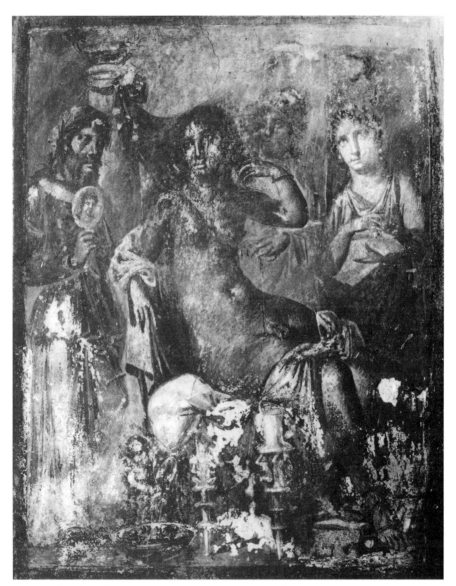

44. Fourth-style wall painting in House 6.7.18, Pompeii. Photo: DAI Inst. Neg. 54.1072.

both sexes, directing the flexed gaze toward a mirror in the hand of the attendant to his proper right, in which his image appears, reduced but starkly visible (Fig. 44).[109]

A similar scene from the House of Siricus (7.1.25), though more ambiguous iconographically, may also represent the catoptric Hermaphroditus. The original has completely deteriorated, and so we are left with Nicola La Volpe's drawing of 1871, which may not be interpretively correct in every respect

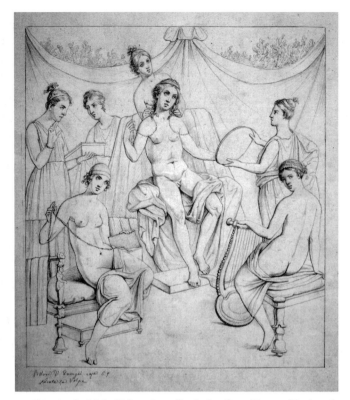

45. Drawing by N. La Volpe of a wall painting from House of Syricus (8.1.25), Pompeii. Photo: Naples, Museo Nazionale.

(Fig. 45).[110] At the center of this picture is a seated youth with the characteristic ephebic hairstyle but few primary or secondary female characteristics. Surrounded by attentive women, he is enjoying the full complement of feminine toilette rituals before a large disk mirror proffered by an attendant. A necklace is arranged about his shoulders, as yet unfastened; he dangles one loose end in his right hand. A female attendant (who, like the male mirror-bearer in Fig. 44, wears an unusual, and perhaps "Asiatic" cap) draws another necklace from a jewelry box in the foreground. These necklaces are of the extra-long kind that appears only on the female nude, especially Venus, crossed like a bandolier across the torso and fastened in back. As an adornment for nudity, it is exclusively and unambiguously erotic. The two women behind the youth's right shoulder are assessing the contents of a cosmetic box, while another arranges his hair. Quite possibly La Volpe suppressed the principal's feminine bodily characteristics, for such a scene involving a male, even one with ephebic characteristics, would – to my knowledge – be unprecedented in surviving Roman art.[111] Despite the presence of a harp, which has no evident connection to Hermaphroditus, it is hard to imagine who else the

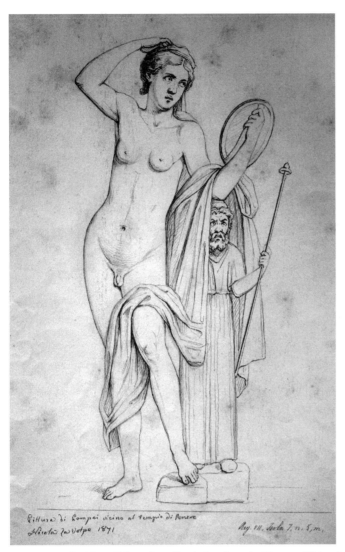

46. Drawing by N. La Volpe of a wall painting from the House of Triptolemus (7.7.5), Pompeii. Photo: Naples, Museo Nazionale.

youth could be: certainly not Adonis, Paris, or Apollo, none of whom is ever effeminized in such a literal manner, whatever the gender ambiguities of their bodies.

Another of La Volpe's drawings serves the catoptric Hermaphroditus straight up, as a standing figure with small but pronounced breasts (Fig. 46). Again the original (from the House of Triptolemus, 7.7.5) is lost, but interestingly, an alternate reproduction by Geremia Discanno, also from 1871, confirms not only La Volpe's essential correctness in composition, but also his tendency to

downplay female characteristics in his hermaphrodites (Fig. 47).[112] Discanno's protagonist is a far more voluptuous creature, its male genitals vestigial to the point of no return. A statuette of Silvanus – god of travel, master of the uncultivated wilds and all things foreign – appears as a reminder of the glade of Salmacis that the youth encountered unexpectedly on his restless travels. Like the seated figure just discussed, this Hermaphroditus wears a tiara-like circlet. Here it seems to command his admiration in the mirror, for he fingers it self-consciously.

Salmacis, the self-obsessed nymph, has possessed Hermaphroditus, comman-deered his being, and infused him with the most base, Epicurean formula for eros, which admits of no higher purpose than the empty pursuit of surface beauty to satisfy lust.[113] We can even surmise that his final prayer supplicating his divine parents to charm the spring – in effect, to perpetually spike the punch bowl on which he himself has become drunk – is a gesture not of vin-dictive bitterness, but of morbid delight. Ovid withholds an easy indictment in his tale, but by the ethical standards of his day, Hermaphroditus would have seemed every bit as much a lost soul as Narcissus.[114] The moral cushion of myth, of course, rendered such scenes delightfully piquant, and nothing more; it was deemed perfectly appropriate to surround the standing Hermaphroditus at the House of Triptolemus with charming friezes of erotes at play.[115]

Even the well-established Narcissan trope of Eros with a torch might be borrowed for a new "Hermaphroditic" purpose. Ovid's latter tale dwells often on the play of light, both direct and reflected. When Hermaphroditus blushes at Salmacis' initial advances, he is compared to a moon tinted red (4.332–3).[116] And when Salmacis' passion reaches its zenith, her blazing gaze is compared, interestingly, to a reflection: "the nymph's eyes gleamed too, just as when the shining perfect circle of the sun is reflected in the reversed image of a mirror."[117] A strikingly similar conceit appears in Apollonius' *Argonautica*, in which the young Medea first experiences the stirrings of passion for Jason. But here the maiden's pounding heart, not her eyes, draws the comparison:

> And fast did her heart throb within her breast, as a sunbeam quivers upon the walls of a house when flung up from the water, which is just poured forth in a caldron or pail maybe; and hither and thither on the swift eddy does it dart and dance along; even so the maiden's heart quivered in her breast.[118]

This passage, in turn, echoes the painted Narcissus described by Philostratus, whose brilliant body "flashes lightning" directly into the water (*astraptei . . . es to hydôr*, *Imag.* 1.23.16–17, my transl.), and thus implicitly reflects off the water's surface and into the eyes of the imagined viewer.[119] Modified somewhat by Stoicism and Epicureanism, these similes evoke Plato's famous catoptric model of *eros* and *anteros*, the love-image that rebounds off the pupil of the lover's

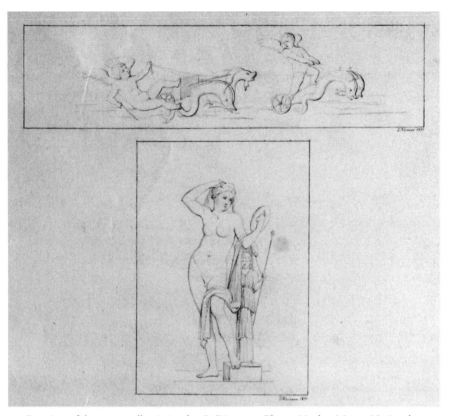

47. Drawing of the same wall painting by G. Discanno. Photo: Naples, Museo Nazionale.

eye and enters the eye of the beloved, who comes to reciprocate his companion's love through love of himself.[120] But in the Hermaphroditus tale no closed economy of reciprocity prevails; the image is ultimately deflected to the disinterested viewer. In Ovid's account the source of light, the sun, would appear to emanate from the beloved, whose dazzling whiteness (foiled once by a blush) draws repeated emphasis. Apollonius' Jason, the object of Medea's desire, is a straightforwardly masculine hero, well suited to take the sun's role. Here, as in Plutarch's formulation, woman becomes the mirror of man, who is privileged to be the source of her light and her form.[121] On the other hand, Hermaphroditus before his violation is both the moon and the sun at once: blushing, nocturnal female and radiant, diurnal male. But that radiance, implicitly, will dim permanently into the lunar variety once Salmacis has joined with her beloved. Significantly, Ovid's Narcissus met his fate in a pristine but sunless place; and both Philostratus and Callistratus compare his effulgence to the flicker of lightning rather than the constancy of the sun. It is only appropriate, then, that a torch – the wavering and inconstant illuminator of darkness, and a common symbol of the moon – should be the light by which the newly

minted hermaphrodite sees himself. Subject and object have merged, and in the process something of the object's brilliance has been lost.

The mirror of Salmacis' passion creates an open triangle: the ray is generated by the sun (the still male Hermaphroditus) and caroms off a mirror (Salmacis' eyes?) to an unspoken terminus. In Apollonius' beautifully wrought conceit, the terminus is a blank wall on which the reflected and projected effulgence pitches about like a riotously pounding heart; but in the Hermaphroditus story, as with the Narcissus story, the terminus is implicitly none other than *the reader or viewer, the voyeur gazing in through the story's transparent "fourth wall."* We participate in a kind of scopic triangulation that resembles our relationship to Narcissus and his reflection. But there are differences: Narcissus' beloved has no autonomy, being a mere reflection, and the youth is the source of the lightning's emanation. In the Hermaphroditus tale, by contrast, lover (Salmacis) and beloved (Hermaphroditus) are autonomous entities, and have exchanged places; now the beloved is the point of emanation, the lover the point of reflection. In both cases, we the audience are the terminus of the ray of desire.

INVOLVING THE VIEWER: REFLECTIONS ON ACTAEON

The fact that we, the readers or viewers, are privy to this emanation – an artefact of Platonic *anteros* – without in any way assuming the burden of reciprocity is a matter of some moment. Every time we are granted a glimpse of the object of desire in another's mirror, a privilege we would not usually have in real life, we are given a share in the outcome of that object's meaning. Recently Niall Slater has addressed this very matter.[122] In book 2 of Apuleius' *Metamorphoses* the reader is treated to an elaborate ekphrasis of a thematic sculpture garden as seen through the eyes of Lucius the ass (2.4–5). The domestic garden scene reworks the well-known story of Actaeon and Diana into a strange ensemble that fractures the tale's conventions of time and space. Whereas in Ovid's dominant version, confirmed in several examples of Roman art,[123] the young hunter Actaeon had happened upon Diana bathing naked with her nymphs at a grotto in the woods, here Diana is represented clothed and active, striding (in anger?) toward the viewer. The grotto with its artificial spring, adorned with sculpted fruit trees and grapes, appears behind her. Here "in the middle of the marble foliage the image of Actaeon could be seen, both in stone and in the spring's reflection, leaning towards the goddess with an inquisitive stare, in the very act of changing into a stag and waiting for Diana to step into her bath."[124] All very strange: for Ovid's Actaeon was transformed only *after* he saw Diana in her bath; his metamorphosis took place gradually, as he ran from the grotto; and it reached its conclusion only when he paused in flight and glimpsed his reflection in another pool, and then was torn to shreds by his own hounds when no voice issued from his mouth to call them off. Here, only Diana's

hounds are present, at her side, and Actaeon waits patiently for the goddess to appear – though she is eminently apparent already!

This radical dissolution of temporal sequence and spatial logic, Slater suggests, is largely due to the viewer's forced participation in the new narrative. Diana's rage, it is implied, will be deflected upon the viewer, who will provide the missing climax: "we, insofar as we identify with the first-person narrator Lucius, are on the menu. We look out of Actaeon's eyes as the dogs spring at us."[125] Slater loosely compares this paradox of displacement to that of Velázquez' *Las Meninas*, in which the artist substitutes himself for the subject matter of his painting; in which the viewer assumes the perspective of the sitters (the Spanish royal couple), who are implicitly posing just on this side of the picture frame, looking in from our perspective, and seeing themselves only in a mirror in the distant background behind the artist.[126] The reflected image in Apuleius' ekphrasis doesn't play quite the same role, for its referent – the marble Actaeon – is also visible. Why, then, include the mirroring spring in the ekphrasis, and why introduce Actaeon by way of a reflection that does not play its traditional part in the story? Perhaps, as John Winkler suggests, Lucius is inviting us into the tableau to behold our own reflection in the water, thereby sharing the pathos of Actaeon's fate.[127] But there may be more at work:

> While the most common scenes containing reflections, both in ancient art and later, show us a figure gazing at its own reflection, from at least the Alexander mosaic on there are fascinating variations. Reflection does not necessarily double vision; it can also fracture it. Two views of a single person need not more tightly circumscribe, making doubly sure it is what it is, but rather can enact the possibility of heterogeneous meaning. Reflection opens up another standpoint and viewpoint: give me a place to stand and I will reenvision the world. . . . The third viewpoint disrupts [a] strict economy, postulating an angle of observation outside the either/or of domination and subjection. The reflection allows us as readers to see something we would otherwise not see.[128]

The reflection as Slater formulates it instantiates a kind of hyperrealism reminiscent of cubism: an unfolding of the object's manifold dimensions before the eyes of the viewer. Apuleius, who elsewhere extols the power of mirrors to reproduce nature more faithfully than art because of their capacity to capture movement (*Apol.* 14), reprises this theme in his ekphrasis. After praising the extreme naturalism of the fake fruits, he boosts their verisimilitude further by appealing to their mirror images: "if you bent down and looked in the pool that runs along by the goddess's feet shimmering in a gentle wave, you would think that the bunches of grapes hanging there, as if in the country, possessed the quality of movement, among all other aspects of reality." We should hardly take Apuleius precisely at his word here: shimmering reflections never seem more truthful than their referents. Metaphorically, however, he is

onto something; for the quavering reflection allows the viewer to appreciate the *elasticity of the real*, its continuously shifting meanings, its constant demand that our attention oscillate between immediate experience and memory – in short, Slater's "fractured vision."[129] It is in this spirit that we might also take Medea's pulsating passion entrained on a beam of light that emanates, as it were, from her beloved. Hers proved to be a most complicated and heterogeneous love.

CONCLUSION

In Roman art and culture, masculine and feminine impulses battle for predominance in the mirror. Femininity has the native advantage, and often gains the field unchallenged. In certain circumstances masculinity prevails: the mirrors of Socrates and Seneca, properly used, can chase the tenacious remnants of moral lassitude from a righteous man. Even the obedient wife may overcome her animal nature if she consorts with the mirror like a philosopher, superimposing upon her image that of her husband. The most interesting cases, though, are the moral mirror's catastrophic casualties: Hostius Quadra, Narcissus, Hermaphroditus. They would not be catastrophic, or even interesting, of course, unless we were watching and judging. What we are watching is a variant of the flexed gaze: referent interacting with reflection. How is Slater's heterogeneity evident in these episodes – that is, in what ways can we, the viewers, discern a cultural distinction between referent and reflection?

Narcissus is quite susceptible to a reflection with contrary or complicating meanings. In Roman art his reflection is never especially ominous, revealing, or strange, except to the extent that it is sometimes distorted or misplaced by an artist who had little experience painting inverted faces or bodies. But to the informed viewer, *circumstances* – the attendant erotes, the torches, the authority of the literary tradition, the inconstancy of his gaze – estrange, or at least distinguish, the reflection from the pining youth. It has been the intent of this chapter to demonstrate some of the ways in which a difference is realized.

First, and most important, the very *presence* of the reflection confirms to us that the youth it reflects is Narcissus, and not some generic or unidentifiable ephebe – and that fact in itself differentiates the pair. Second, we are drawn to the reflection's inversion; from our perspective, an ominous specter of death hovers in the shallows. Third, there is an asymmetry of reaction. The mirroring pool is oddly magnetic: it attracts the attention of all present. The reflection itself, and not the youth's sick attachment to it, seems to draw most gestures of surprise or dismay. And it attracts the erotes' smoldering torches. By the standards of the phenomenal world, reactions to a simple reflection would be misplaced unless it were in some way uncanny. The uncanniness in these paintings, we must presume, resides somewhere beneath their relatively banal surface. Fourth, we are privy to the confining boundaries of the pool

(sometimes the "pool" is nothing more than a small basin), relative to the roomier stage for the full-body Narcissus. We are presented, more often than not, with an awkward synecdoche of the referent, a strangely disembodied head. The head must be present, because it contains the organs of sight that reciprocate Narcissus' greedy stare.

Finally, there is the rippling inconstancy of the pool. Ovid's Narcissus disturbs the perfection of his beloved with every tear he sheds, with every attempt to embrace the fragile simulacrum. Various artists convey the effect of shimmer in various ways – by smearing, displacing, discoloring, or fragmenting the inverted image. Decidedly, the mirror of Narcissus is not a vehicle of perfect naturalism. We have returned to the problematic we observed in Apuleius: a claim to hyperrealism in the movement of a wavering reflection where, if anything, the phenomenal world would deliver an effect that could only break the illusion of perfect replication.

In every way, the difference between illustrated reality and illustrated illusion punctuates the absurdity of mistaking one for the other. Yet that is precisely what Narcissus did. And his error is nothing more than an exaggeration of errors that we all commit, if we are inattentive to triangulating influences in our lives. Experience itself is a mirror, as Plato repeatedly observed. Unavoidably, our perception of reality is a fragile, trembling, shadowy, nocturnal thing. Like the addled youth, we cannot get a definitive grip on our experience, least of all upon the experience of ourselves. Of course there is the option of self-improvement, the road not taken by the haughty Boeotian boy. The mirror offers some clarity, but one can only hope to benefit from it if there is a third face in the room, an attentive audience, a *praeceptor* to interpret what is seen, to distinguish right from left, up from down, male from female. Every reflection demands an act of judgment.

THREE

THE MIRROR OF DIONYSUS

FOR ALL THEIR INTERPRETIVE ELASTICITY, THE MIRROR ENCOUNTERS WE have investigated so far have been essentially realistic. That is, the reflections mimic reality by transmitting the images of their referents. However the viewer or protagonist chose to interpret the image, there was no question as to the strict catoptric relationship between the image and its source. In this chapter we will step through the looking glass, as it were, into the magico-religious sphere, where the mirror becomes an initiatory threshold into an alternate state of being. Mirrors are known to have served ritual purposes in a few ancient cults; for instance, we hear more than once of the female adherents of the Isis cult carrying mirrors in rituals.[1] But the preponderance of evidence for mirrors in cult practice belongs to the realm of Dionysus.

A god whose imagery dominated the private sphere of Roman life like no other, Dionysus represented not just a cult but an entire culture. On the one hand, the organized social structure surrounding his worship – which, for lack of a more precise term, is called a cult – was vast in scope, eventually spreading to almost every outpost of Roman occupation. It spanned well over a millennium in duration and embraced a great diversity of practices and beliefs. On the other hand, the popularity of the god's society of initiates, or *thiasos*, spilled over into society at large: it was a cultural phenomenon of massive proportions. Dionysus' patronage of such popular themes as the theater, sexual potency, and drunkenness – as well as the less delightful but universally necessary theme of

death – seems to have ensured him a robust following even if the great majority of his followers were not *mystai*, initiates into the mysteries, but worshiped him only casually. Most Dionysiac art was designed for the uninitiated and carried symbols that elicited immediate recognition but no deep understanding. An enormous sampling of it has come down to us, ranging from the banal (by far the majority share) to the exquisitely esoteric.

Transformative experience – the ecstasy of intoxication, direct communion with the god, initiation into a secret society, assurance of life after death – was the principal purpose of the Dionysiac cult and the cause of its massive popularity. Detailed knowledge of the experience unfortunately will elude us forever. But although we lack texts that describe and explain the cult from within, we can at least resort to its rich symbolic legacy. Like other mystery cults, this one was dominated by symbols at varying levels of abstraction that, when combined in different ways and varying contexts, conveyed meanings on many levels. Perhaps the most intriguing and elusive of these symbols is the mirror – elusive partly because of the difficulty of determining its function in the structures of belief and ritual, but also because mirrors, being defined more by function than by form, are sometimes hard to identify in iconographic contexts.

This chapter will explore an idea whose century-long history has not yet produced a careful study of all the evidence bearing upon it. That idea asserts that reflectivity served as both a tool and a symbol of personal transformation for members of the cult of Dionysus. There were several ways in which the mirror could have made itself useful. First, it was the most persistent signpost of a strand of Dionysiac belief that is otherwise nearly invisible in art, but fairly robust in literary and epigraphic sources. That strand is Orphism, a quasi-theological creed that advanced the story of the mythical child Zagreus. Mesmerized by a mirror, the boy was murdered and reborn as the god Dionysus. Second, as a tool of achieving ecstasy or divine epiphany, the mirror was a companion to other "ritual hallucinogens" of revelatory mystery cults such as wine, incantations, dance, staged miracles, and evocative music. By an etiological process, it is supposed, these two functions achieved a kind of kinship: the person who used a mirror to achieve an ecstatic state "became" Zagreus, and thereafter Dionysus. Third, the mirror, by virtue of its functions, was a metaphor for the passing of Zagreus, and more generally a symbol of personal metamorphosis, either temporary or permanent – denoting the transformation either of a state of mind or of an eternal soul. None of these assertions is easily proven, and I make no claims that my arguments in this chapter will constitute proof of historical verities *in particular*. But taken in aggregate, the evidence for a Dionysiac mirror of metamorphosis, whatever the exact meaning of metamorphosis in a given case, is both abundant and persuasive. By necessity this chapter will

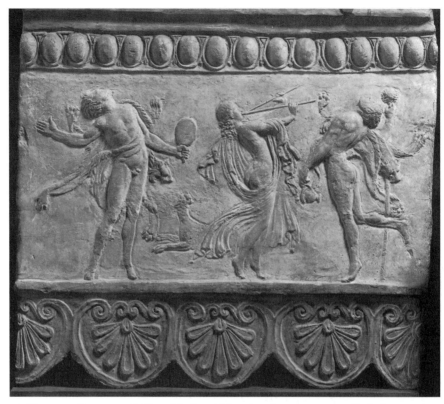

48. Terracotta Campana relief from Myrina. Mid- to late first century B.C.E. Paris, Louvre 3894. Photo: Alinari/Art Resource, NY.

periodically expand its inquiry backward in time to pre-Roman practices in central and southern Italy, with an occasional glance eastward to Greece.

Most visual evidence of mirrors in the Dionysiac cult comes from Italy, whose Greek communities, and the peoples they influenced, embraced Orphism with creative zeal. The popularity of Dionysus' cult never waned, even after a bloody suppression in 186 B.C.E. in which the Roman Senate set out to purge the cult of excessively decadent and immoral activity (Livy 39.8–19). But the cult seems to have emerged from that hysteria with many of its distinctive traditions, if not its penchant for Corybantic revelry, intact.[2] Let us begin, then, with two characteristic examples of Bacchic imagery from the Roman period. A striking image of mirrors in a Dionysiac context appears on a terracotta Campana plaque type from early-Imperial Myrina (Fig. 48).[3] It conveys a conventional scene of the god's entourage with satyrs and maenads in ecstatic dance.[4] The satyr on the left is nude but for the panther skin (*pardalos*) flailing around him. His body is flexed backward, his head wrenched back in a typical gesture of ecstatic agitation. Normally such a character would be carrying one of the standard attributes of the Dionysiac retinue: a *thyrsus*, a drinking

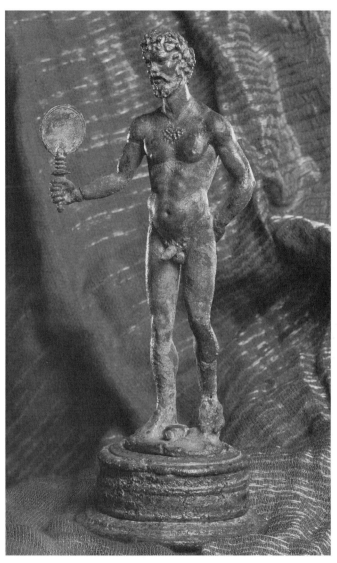

49. Bronze statuette. Undated; perhaps early Imperial. Chieti, Museo Archeologico Nazionale di Abruzzo, Collezione Pansa 189664.

cup, a torch, or a tympanum. Instead, in his left hand he carries an ordinary hand mirror, held upright as if for use. Less dramatic, but equally arresting, is a bronze statuette at Chieti depicting a standing or pacing ithyphallic satyr holding an ornately handled mirror in his right hand (Fig. 49).[5] Like his companions on the relief, he is not directly engaged with the mirror; here he holds it at chest height, oblique to his gaze. The most startling thing about these images, besides the incongruity of a mirror that is not being directly observed, is the direct association of males (even satyrs!) with this most feminine of possessions. Despite good evidence that men used mirrors in actual practice,[6] such

juxtapositions simply do not exist in Roman representations of ordinary life. There must be reasons for Dionysus' unique cultic associations with mirrors and reflections.

AMPHIBIOUS DIONYSUS

The mirror in antiquity, when regarded as a magico-religious artefact, is a decidedly liminal thing: a portal for transgression, transfiguration, transition, transmission. Dionysus is the liminal deity par excellence: a god resurrected from mortal flesh; a god of death who is abundantly present among the living; a god of intoxication, hallucination, and ecstasy, states of mind that entail, in the traditional understanding, the crossing of a threshold of self-possession. And he is the patron of the theater, which implies in role-playing the metamorphosis of personal identity.[7] His association with reflections may extend back to a pretechnological era when reflections were encountered almost exclusively on the surface of water. It is interesting, then, that Dionysus bears vestiges of an amphibious being himself, though he shows few traces of it in his Roman manifestation. This most changeable of the Olympians was once a denizen of two worlds, those above and below water.[8] The upper world is one of human suffering and impermanence; the lower, of death, release, eternity, divinity. In the Homeric version of the myth of Dionysus' youth, Lycurgus chases down the god's nurses and forces him to seek refuge with Thetis under the sea (*Il.* 6.130–37). In another, he is pursued by Perseus and cast into the lake of Lerna;[9] indeed, there was even a class of priestesses in Athens dedicated to the cult of Dionysus "in the ponds."[10] In Elis, Plutarch observes, "Dionysus also they call Hyes since he is lord of the nature of moisture. . . . They call him up out of the water by the sound of trumpets, at the same time casting into the depths (*abysson*) a lamb as an offering to the Keeper of the Gate."[11]

For the most part, Dionysus' primordial associations with water dissipated over time; but the amphibiousness of his nature may have persisted and even gained strength by a shift of his principal element from water to wine. The metaphoric potential of liquidity was maintained while an additional layer of meaning, perfectly consistent with the god's liminality, was added: wine's capacity to induce abrupt change in subjectivity and experience. The phenomenon of reflection, quite apart from its cultural modes of representation, is itself a complex floating signifier in many societies; and indeed we may be witnessing a semantic slippage from water as a literal element of outer reflection to wine as a metaphoric element of inner reflection. "Wine is a mirror of mankind," wrote Alcaeus; and Aeschylus declared, "a mirror is the bronze of beauty; wine, of the soul."[12] Gnomic lines of this sort might suggest just such an evolution. The mirror of wine is surely not reflexive: drunkenness is hardly a path to finding oneself. Instead it is decidedly triangulative, for it reveals one's soul to

others. And as such, it is like the most powerful reflections on expansive tracts of water, the oblique ones.

THE ORPHIC ZAGREUS

The mirror appears prominently in the Orphic myth recounting the murder of the mortal child Zagreus and his palingenesis into the immortal Dionysus.[13] The best-known accounts of this episode appear in Neoplatonic contexts, but the core myth is attested from the beginnings of the Hellenistic period, and evidence for associations of Dionysus with Orphism extends back at least as far as the sixth century B.C.E.[14] The story has many variants, but at the core it is relatively coherent. The mortal boy Zagreus was born of a dalliance between Zeus and Persephone. Zeus entrusted the child to Hermes, who in turn committed him to Ino and her husband Athamas. Willing participants in the deception, the couple raised him as a girl. But the jealous Hera, furious at her husband's tryst, enlisted the help of two Titans, called the Curetes (Greek Kouretes), to murder the child. They found him sitting on the throne of Zeus, and distracted him with various toys, the most prominent of which was a mirror.[15] It did not simply charm the child like the other toys, but transfixed him so that he followed it to the site of the murder.[16] Nonnus describes what ensues:

> Smearing the cunning circles of their faces with deceptive chalk, by the rage of wrathful Hera – heartless spirit! – the Titans destroyed him with an infernal knife as he gazed at his bastard image in a rebounding mirror. His limbs were cut asunder by Titan steel; but Dionysus held both the end of life and its revocable beginning, and he took a new form.[17]

The Titans cooked the slaughtered remains in a cauldron and ate them; but according to a Cretan version of the myth, Athena saved the heart from destruction and brought it to Zeus, who embedded it in a plaster effigy of the boy. Zeus blasted the Titans with a thunderbolt, and from their ashes arose the human race.[18]

The myth of the baby Zagreus correlates the action of the mirror metaphorically with the core tenet of many mystery religions, ritual death and rebirth. The mirror of Zagreus becomes a symbol of the god's emergence from death, the model of his initiation ritual,[19] and perhaps even a "messenger of his mission in the world," in Vittorio Macchioro's estimation.[20] It is a story that invites ritual reenactment. M. L. West reconstructs a Dionysiac initiation rite in which the (surely terrified) novice was given the role of Zagreus. Made to follow a flashing mirror as if mesmerized, he smelled roasting flesh, saw the ghostly, chalky faces of the dancing Curetes and their flashing knives, and heard the chilling sounds of slaughter before he emerged from the ordeal happily, a new Dionysus.[21]

The myth of Zagreus proved irresistible to exegetes from Diodorus Siculus to the Neoplatonists.[22] Philosophers of the late Roman era made much of the mirror of Zagreus, perhaps because the optical properties of mirrors, which include a seemingly endless depth, promoted their creed of divine light, or intellect, from which the souls of humans originated.[23] Such esoterica never made much of an impact on the thinking of ordinary Romans, but it appears that the Zagreus story – with or without a hermeneutic tradition – retained its importance in the cult from at least the fifth century B.C.E. into late antiquity. In some areas there is evidence that the whole range of objects that captivated the baby Zagreus at the moment of his death was replicated in real rituals of initiation, and even distributed to initiates as keepsakes.[24] Firmicus Maternus, who recites the fullest version of the story of Zagreus slain, notes that "the Cretans, wishing to allay the fierceness of their mad tyrant, put on festivals of the day of his death and organize an annual ceremony, with a consecration every other year, enacting sequentially everything that the dying boy did or suffered."[25] This tradition could hardly have been without the mirror, which in Firmicus' version was paired with a rattle.[26] Together these objects "so entangled his spirit" that the child was led entranced into an ambush.

As a narrative the story of Zagreus never took hold in the visual arts, though the baby Dionysus appears frequently.[27] However, a fifth-century-C.E. ivory pyxis from Milan, now in Bologna, demonstrates that it was known to artists in late antiquity, when Neoplatonism was at its height.[28] The pyxis depicts several scenes of Dionysus' beginnings, progressing from left to right. After the first scene, which shows the birth of the boy Zagreus, there appears the episode of the boy enthroned and enticed by the Curetes (Fig. 50). These are followed by two more episodes of the boy, and then the adolescent, among satyrs and maenads, which would indicate that he has been transformed into the god. The second scene, then, is the critical one: the child sits frontally, but in the manner of a recumbent infant seen from above.[29] His arms are outstretched as if he were in the throes of ecstatic vision. His head is angled to his proper right and slightly downward, in the direction of a kneeling nurse who extends a mirror toward the child with her right hand, which is somewhat damaged. To either side of this pair are the armored figures of the Curetes. The one on the right dances wildly with a knife in one hand. The pose he strikes, a well-known type on neo-Attic reliefs, is always associated with ecstatic dance.[30] The figure on the left – closer to the boy's gaze, and thus more subversive – appears to be feinting away and then whirling back, drawing his knife for the strike; but he too is engaged in a kind of dance.[31] There can be little doubt that we are witnessing the murder scene, which has privileged the mirror above all the other toys that enticed the young Zagreus.

Knowing the story in outline, we can identify three iconographic markers of the child's impending metamorphosis. The first is the mirror, which captivated

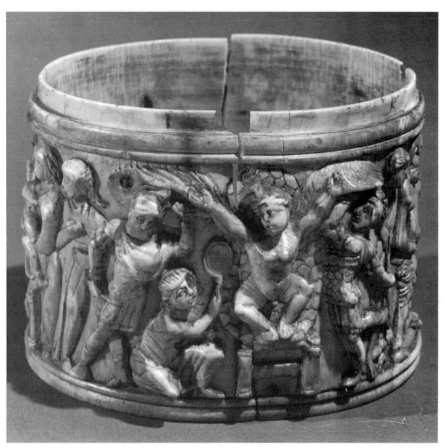

50. Ivory pyxis. Fifth century C.E. Bologna, Museo Civico Archeologico Pal. 693. Photo: Alinari/Art Resource, NY.

his soul and led him to the place of ambush. The second, his outstretched arms: enraptured, he is defenseless to his attackers and reaches out, as it were, to welcome his next life. The third is the dance of the Curetes. Whether these insidious titans are themselves in a trance, or simply feigning one, their gestures are just the sort that were used by initiates to induce a trance – in themselves and in others. The outer circumstances of the murder of Zagreus are all meant as signs to encourage inner transformation of the initiate. That is why the initiation ritual – probably the most important ritual in the cult – is likely to have been a reenactment of this very episode in the god's myth.

As allegory the story was rich fodder for Neoplatonism; but as religion – and quite probably the kernel of some very old beliefs – it represents something more elemental and less rational, a transition between the two states of being.[32] Zagreus follows his image to the other side and is destroyed. The follower of Dionysus is called to do the same: to look in the mirror and suffer dissolution.[33] Nourished on the influential work of such scholars as E. R. Dodds and Gilbert

Rouget, we might be inclined to regard "telestic madness," to use Plato's term for Dionysiac ecstasy, strictly as cathartic release, a cure for a malady of spirit.[34] But this kind of therapeutic purification rarely proceeded without a sterilizing dose of pain or terror or a destabilizing (if temporary) loss of moral direction – what anthropologists would call crisis.[35] Possession terrified and fascinated the Greek and Roman psyche and was tinged with intimations of death, dissolution, and dismemberment. Telestic trance states, it would seem, usually had a dark side against which euphoria necessarily oscillated. The locus classicus of terrifying Bacchic delirium is Euripides' *Herakles*, in which the entranced principal descends into his own personal hell, peopled by serpent-seething Gorgo, petrifying Lyssa, and his own moral demons: "horrible, horrible the music from those pipes."[36] What was initiation, after all, if not a simulated journey through hell? So the Bacchic mysteries of the Roman period, like others too, called for initiands to endure "apparitions and terrifying sights," perhaps in advance of complete possession by the god.[37] It is no accident that the word *panic* is derived from the attributive adjective of Pan, the satyr-daemon and associate of Dionysus who played entrancing musical pipes.

In such circumstances the mirror is an apt tool and a fitting metaphor, for it too has a sinister side. Societies around the world have regarded mirrors as portals to the spirit world and as traps for the souls of the dead; thus reflective surfaces are dangerously charged with transformative power.[38] In the literary sources mirrors are often agents of fascination, entrapment, and fragmentation.[39] The belief that they can induce self-fascination – and specifically a reflex action of the evil eye – comes up several times in Greek and Roman sources. According to this belief, which I will discuss more fully in the Appendix, intense self-regard is apt to bring misfortune. Plutarch asserts that the evil eye attacks itself when confronted with a mirror (*Mor.* 682e–f). Artemidorus, in *The Interpretation of Dreams*, claims that if a person dreams of seeing his own reflection in water, he is approaching death (2.7). Even a pair of Pythagorean apophthegms enjoining adherents to avoid using a mirror near a light source, or contemplating themselves in the water of a river, are charged with dread of the loss of selfhood.[40] And of course the shadow of Narcissus himself lurks around Zagreus in his intense fascination with the mirror.

Yet the purpose of Dionysiac belief was to channel dread into something positively transformative. The baby boy may have suffered an even worse fate than the Boeotian youth, but (magical mirror!) he blossomed into something far greater than a mere flower. For the votary of Dionysus, his own resurrection represented a union or communion with the god – and even, in a sense, with his murderers. When he danced into an ecstatic state he became both the dancing agents of his transformation, the Curetes – and Zagreus himself. Change was what the initiate sought, and it could not be effected without (at least) a temporary destruction of his old self.[41]

Initates in the cult served as agents in a reenactment of the same basic metamorphosis in either of two ways: temporarily, in rituals of intoxication or hallucination; or permanently, in rituals of initiation, weddings, and funerals. Dionysus' adherents were calculating murderers – not so much of the god himself as of their old selves. And they may have achieved their own ecstasy, or that of initiates, by reenacting the death of the vulnerable man-child, and the birth of the god-child, with mirrors. As such, Dionysus lies at the core of a soteriology of self-resurrection that applies equally to temporary ecstatic states and to the afterlife.[42]

MECHANISMS OF TRANSFORMATION 1: AN APULIAN TREND

We turn first to the afterlife, and to a fascinating artistic corpus from pre-Roman Italy: Apulian vases, which iconographically associate mirrors with the dead as a matter of course. Hélène Cassimatis has analyzed representations of mirrors on these vessels, most dating to the fourth century.[43] Obsessively, almost fetishistically, the Apulian corpus features human figures interacting with a circumscribed set of objects, some of which are easily identified, others not. Among the most common of these are two categories of implements that are often held upright by human and divine figures: the oval or circular hand mirror, and a larger, concave circular handled object similar to a *phiale*, or libation bowl. Both, for example, are featured on a volute crater in Munich (Fig. 51). A nude young man on the left holds a handled *phiale* (I will explain this identification momentarily) upright with his right hand, and an ordinary one horizontally in his left. Below him a seated woman bears a mirror in her right hand. The proliferation of both objects in Apulian art is prodigious, as even a cursory glance through the corpus will attest.[44] They tend to be heavily ornamented with finials, openwork on the handles, and decorative patterns on the back surface. No reflections are represented on them, but the figures holding them often, but not always, engage them with their gazes. Three things about them immediately demand explanation. First, why is a *phiale* shown as if it were a hand mirror? To my knowledge, no other documentation of the use of a libation bowl in this way exists elsewhere in the Greco-Roman world; yet it is common on Apulian vases. Second, why do both male and female figures seem to engage these objects interchangeably? Clearly the strict association of mirrors with femininity, so thoroughly evident in the corpus of Attic vase painting,[45] is of little importance here. Third, why do these objects, when held in the hand, often seem to mediate compositionally between two individuals, or between an individual and a symbolic object?

Despite H. R. W. Smith's epic attempt to identify the handled *phiale* (or as he called it, a "pan symbol") as a special vessel for nuptial ablutions, none of these three curiosities has ever been satisfactorily explained.[46] Cassimatis,

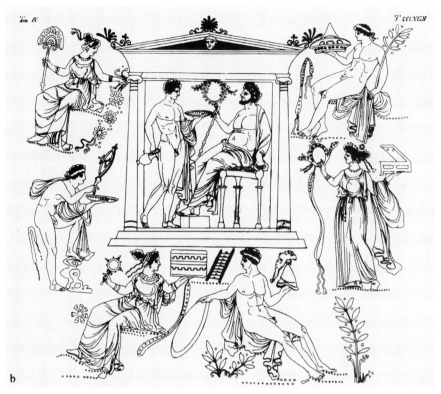

51. Drawing by F. Inghirami of a funerary scene represented on an Apulian volute crater. Fourth century B.C.E. From Smith 1976: pl. 1. Original vase: Munich, Staatliche Antikensammlung 3297.

however, goes some distance in accounting for the second and third. She recognizes two principal categories of scenes involving the use of mirrors and upright *phialai*. One type is focused on a *naïskos* or small trabeated shrine, which shelters the deceased (Fig. 51). The other type is centered on a funerary stele, near which or upon which may appear figures of the dead to whom the monument, presumably, is dedicated. On an "underworld" amphora in Geneva, for example, in a register below a scene of Pluto and Persephone in their chariot, the presumed deceased dedicatee sits to the right of his stele (complete with cinerary urn on top), while a winged male figure stands on the opposite side bearing an elaborate crown in his left hand and an upright *phiale* in his right, into which he appears to gaze intently (Fig. 52). A woman on the right holds an ordinary *phiale* horizontally and a parlor mirror upright, with which she does not engage. On an amphora in London, the deceased is absent; on either side of the stele a woman holds out a mirror toward it (Fig. 53).

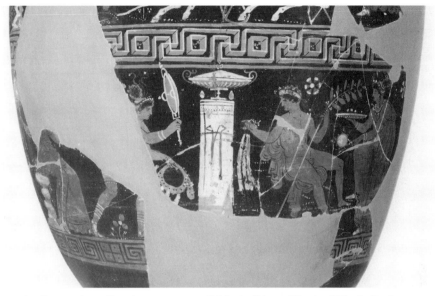

52. Apulian amphora. Fourth century B.C.E. © Musée d'Art et Histoire, Ville de Genève 15043. Photo: Bonnard Yersin.

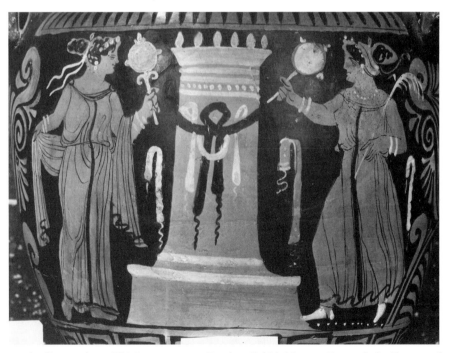

53. Apulian amphora. Third century B.C.E. London, British Museum F 280. © the Trustees of the British Museum.

It is the Apulian practice to represent the enshrined dead as if they were alive. Sometimes a figure inside the *naïskos* holds a mirror or *phiale*; often a figure outside holds the mirror in the direction of the deceased. Observing that most of the vases on which these scenes appear are from funerary contexts, and that mirrors too have been found in both male and female burials in the region, Cassimatis concludes that the upright *phiale*–mirror phenomenon depicted here is akin to the traditional practices of catoptromancy (divination by mirrors), lecanomancy (divination by bowls of liquid), and other forms of scopic divination in which reflections may have played a part.[47] As such they are virtually ungendered, being nothing more nor less than magical tools of communication between the living and the dead:

> The numerous examples that we have cited to illustrate the variety of cases indicate that the mirror participated as an instrument of magic, not simply of ritual. . . . Its action bypasses the ritual and enters into a complex system of relationships to death, to the soul, to the unknown powers that govern mortals. Its role would seem to be that of a revealer: to attract the dead revealed within it. . . . Its ties to the cult of Dionysus seem clear, at least for certain images.[48]

The mirror and handled *phiale*, then, had a privileged place in the panoply of objects traditionally depicted in this corpus: they served as portals through which the dead could be summoned by the living. Indeed, it is known that Dionysiac rites were sometimes performed directly at the tombs of dead members of the *thiasos*, probably as acts of appeasement, blessing, or purification.[49] Such events would have offered an appropriate opportunity to channel the dead by whatever means were socially sanctioned.

It cannot be said that such an interpretation emerges of its own accord from the visual evidence. Apart from mirrors and mirrorlike objects, a number of other object types – including horizontally held *phialai* without handles, wreaths, *kalathoi*, and lidded boxes – are given similar prominence, in similar numbers, on Apulian vases. Those who hold them seem to gaze just as intently at them (or not, intermittently) as they do at their mirrors and upright *phialai*. What makes these latter objects different, and uniquely compelling, is that they *exist* for the gaze. They send a tacit message to the external viewer: "I am not meant just to be looked at; I am meant to be looked *through*. I am not an object of vision; I am an instrument of seeing." Pausanias describes a strange cult practice at the sanctuary of Demeter at Patras that may have presumed similar powers in a reflective object. During consultations of the oracle by the seriously ill, a mirror (its shape is not known) was lowered on a cord until its edge touched the surface of the sacred spring. From this the oracle was able to summon a vision of the pilgrim, either alive (and presumably cured) or dead.[50]

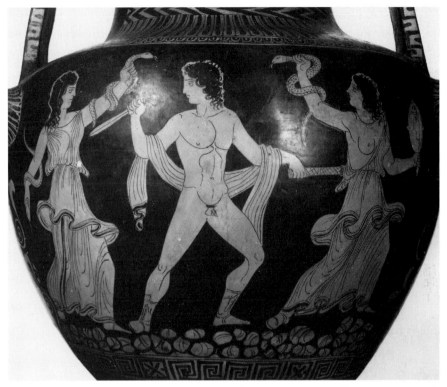

54. Oresteia scene on a Lucanian nestoris. Fourth century B.C.E. Naples, Museo Nazionale 82124. Photo: DAI Inst. Neg. 73.1706.

Magical properties of the kind suggested by Cassimatis are ascribed to mirrors in many cultures, perhaps most commonly in the west. Nineteenth- and twentieth-century folklorists amassed considerable evidence for the use of mirrors at gravesites to invoke the dead or their messengers.[51] An interesting mythological application of the principle of such catoptric channeling in south Italian antiquity survives on an early-fourth-century Lucanian *nestoris* from Basilicata, now in Naples, featuring Orestes pursued by the Furies for murdering his mother Clytemnestra (Fig. 54). One of the two serpent-entwined demons brandishes a mirror in which appears a face without visible referent – undoubtedly that of Clytemnestra herself, as many have suggested.[52] She peers out through its surface from beyond the grave, an avenging spirit acting through her terrible surrogates.

One might surmise further that mirrors were buried with the dead in late-Classical and Hellenistic Apulia not for their traditional purpose in the afterlife, but because this mode of invocation, like a telephone line, requires a terminal device at either end to establish a channel of communication. It has been argued that in Greek society, as in other cultures, the mirror allows one to "capture" the soul of a dying person, or recall it after death, to simulate discourse among

the living.[53] However, the terms "communication" or "discourse" may not be adequate to describe the personal exchange suggested by these images; the transaction is probably more akin to the classic Dionysiac *orgia*, in which a mourner might, in a sense, be possessed by the deceased much as he would by the god. Such a process, which Vernant in particular has articulated, would more authentically express the core mechanism of ecstasy in antiquity.[54]

Although the procedure seems effortless as shown, the real-world practice it evokes must have been highly ritualized and carried out with careful supervision, controlled suggestion, and prescribed formulas of behavior. Cassimatis seems to deny that vision played a part in the ritual, evidently on the ground that the person holding the object does not always engage directly with it. But it cannot have been enough merely to "offer" the mirror or *phiale* in the direction of the desired object, as she implies. The precedents of hallucinogenic ritual, so carefully analyzed by Delatte, Macchioro, and others, demand the agency of the senses – here, vision specifically – even if the apparition is more of an interior, autosuggestive projection upon the object than a strictly optical phenomenon.

Behavior of this sort is exceedingly deliberate. It must be carefully engineered, supervised, and staged.[55] Cassimatis is probably right to conclude that the living who engage with the dead in these scenes are meant to represent initiates in a cult, most probably that of Dionysus. Dionysiac imagery is ubiquitous in south Italian funerary art, reflecting the god's powerful associations with both the living and the underworld in this region.[56] But the highly abbreviated and conventionalized mode of representing such an intense and esoteric ritual – a ritual, moreover, whose secrets were probably jealously guarded by initiates – can only be expected to convey the process in a vaguely evocative manner.

But the upright handled *phiale*, replicating the mirror, remains a puzzle. Why was it amenable to such an apparent redundancy, and what, if anything, does it signify? Customarily, of course, the *phiale* (equivalent to the Latin *patera*) is strictly an implement of sacrifice. Always held horizontally, it receives the sacrificial wine, milk, or other liquid from a crater or a pitcher. The sacrificant then pours the liquid onto the altar or into a sacrificial flame, or in some similar way commits the liquid to the dedicatee of the sacrifice, be it a god or a spirit of the deceased.[57] It is no surprise that such a ubiquitous and essential instrument of Greek sacrifice acquired other functions – both practical and symbolic – over time. A famous fifth-century-B.C.E. Attic cup in Berlin depicts the Delphic oracle Themis seated on a tripod, gazing down into an ordinary *phiale* in her left hand while King Aigeus stands awaiting a pronouncement. This scene has often been taken as evidence of catoptromancy or lecanomancy in the oracular process.[58] It is a distinct possibility, in fact, that the Delphic tripod cauldron itself once had this function, and that Dionysus himself was believed to have delivered oracles from it.[59]

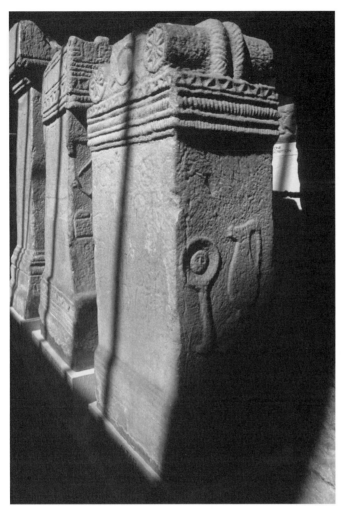

55. Stone altar from Vindolanda with sacrificial reliefs on either side. Third century C.E. Chesters Museum 242. Photo: R. Taylor.

A number of other images from the fifth and fourth centuries showing humans or gods giving attention to horizontally held *phialai* have been collected.[60] The *phiale* was a locus for the gaze even under ordinary circumstances; numerous surviving examples, and many more in representations, bear the image of a gorgon or Silenus head engraved on the *omphalos* as a standard apotropaic device to protect the viewer, or perhaps as a "talking head" associated with divination.[61] A Romano-British altar from Vindolanda is fairly typical: it bears in relief the image of a handled *phiale* with a crudely carved face at its center (Fig. 55).[62] The face is oriented not at right angles to the handle, as one might expect of an implement held horizontally, but on axis with it, as if the *phiale* were to be held upright directly in front of the face, like a mirror.[63]

I have presumed momentarily that visual inspection was a process separate from and secondary to the libation itself, but that is not necessarily the case. From the purely practical standpoint of the sacrificant, there is no need for a *phiale* at all; the liquid could more easily be poured straight from the pitcher onto the altar or into the flame. The *phiale* arrests the procedure at the midpoint between the offering of the liquid and its delivery to the god. It only stands to reason that the original purpose of this broad, shallow bowl, then, was for the *inspection* and subsequent blessing of the liquid before it was committed to the sacrifice. The nature of that inspection could have taken many forms, including lecanomancy; and it may eventually have developed into the Apulian practice of reading the vessel itself, rather than the liquid it was meant to contain.

The magical potential of liquidity was doubtless exploited far back in time. Odysseus' "journey" to the underworld, constituting one of the central episodes in the Greek literary heritage, covers no physical terrain, but takes place entirely within the confines of a pool of sacrificial blood as the hero and his men look on from the edge (Hom. *Od.* 11). Lecanomancy, as well as the closely related disciplines of catoptromancy and hydromancy (divination in water), are well attested in Greco-Roman antiquity and through the Middle Ages in Europe, the Levant, and the Arab world.[64] Lecanomancy appears prescriptively several times in the magical papyri, which specifically recommend a *phiale* as a worthy vessel for the ritual:

> 4.162–7: You will observe through bowl divination on whatever day or night you want, in whatever place you want, beholding the god in the water and hearing a voice from the god which speaks in verses in answer to whatever you want. You will attain both the ruler of the universe and whatever you command, and he will speak on other matters which you ask about.

> 4.220–32: You may achieve a nature equal to the gods thanks to this union, which can bring about a face-to-face vision – a lecanomancy equal to the summoning of the dead. Whenever you want to inquire about matters, take a bronze vessel, either a bowl or a saucer [*phiale*], whatever kind you wish. Pour water: rainwater if you are calling upon heavenly gods, seawater if gods of the earth, river water if Osiris or Sarapis, springwater if the dead. Holding the vessel on your knees, pour out green olive oil, bend over the vessel and speak the prescribed spell. And address whatever god you want and ask about whatever you wish, and he will reply to you and tell you about anything. And if he has spoken dismiss him with the spell of dismissal, and you who have used this spell will be amazed.

> 5.1: "Oracle of Sarapis, [by means of] a boy, by means of a lamp, saucer [*phiale*], and bench."[65]

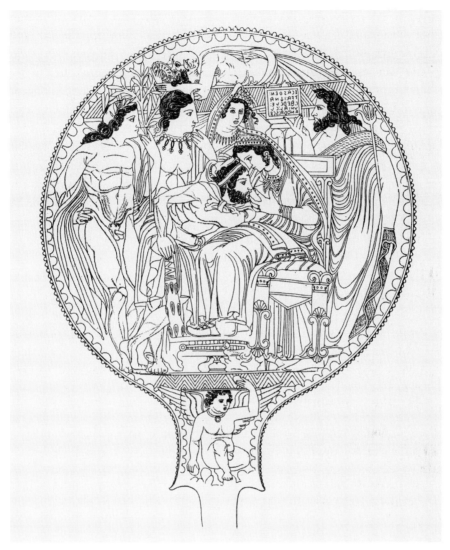

56. Etruscan bronze mirror from Volterra. Late fourth century B.C.E. Florence, Museo Archeologico. Drawing after *ES* 5.60, courtesy of N. de Grummond.

These texts from Hellenized Egypt offer sufficient evidence to suggest that the ordinary *phiale*, when filled with liquid, could be used as a tool for scopic divination. A pair of engraved mirrors, one Etruscan and the other Praenestine, provide iconographic evidence that the *phiale/patera* was used for lecanomancy. In the better-known example of the late fourth century B.C.E., from Volterra, the central zone depicts the goddess Uni enthroned in front of a tablet enumerating the future achievements of Hercle (=Hercules) as she nurses the newly adopted hero (who by convention is shown fully grown). This vatic scene is accompanied in the upper zone by an image of Silenus gazing intently into (and possibly drinking from) a *phiale* (Fig. 56).[66] A simpler tableau is found

on a fourth-century-B.C.E. Faliscan-style kylix in the Villa Giulia, on which an obviously inebriated satyr looks intently down into a horizontal *phiale* held out by a maenad.[67]

The Apulian imagery, on the other hand, would suggest another step in the evolution of cult practice. Now the *empty* vessel – brightly polished and in its concavity receptive to the hallucinatory visions of an entranced initiate – was employed in the evocation of the dead. This step was aided, no doubt, by the formal similarity between the handled *phiale* and the ordinary mirror, which carried its own tradition of ecstatic channeling. But there must also have been a metaphorical component to the union: perhaps the recognition that the *phiale*, as an implement associated with burnt offerings, connoted the immolation of Zagreus.[68] The union of *phiale* and mirror was the result of a process that I will call *lamination*: the purposeful conflation into a single, multivalent signifier of two or more distinct things that accidentally share a formal similarity.

MECHANISMS OF TRANSFORMATION 2: OTHER ITALIAN EVIDENCE

> In *ekstasis* the soul is liberated from the cramping prison of the body; it communes with the god and develops powers of which, in the ordinary life of everyday, thwarted by the body, it knew nothing. Being now a spirit holding communion with spirits it is able to free itself from Time and see what only the spiritual eye beholds – things separated from it in time and space. The enthusiastic worship of the Thracian servants of Dionysos gave birth to *inspiratio mantikê*, a form of prophecy which did not (like prophecy, as it invariably appears in Homer) have to wait for accidental, ambiguous and external signs of the god's will, but on the contrary entered immediately into communion with the world of gods and spirits and in this heightened spiritual condition beheld and proclaimed the future.[69]

> *Bakcheuein* means the special form of cultic ecstasy (which may sometimes coincide with drunkenness) characteristic of the 'frenzied Dionysus' and his retinue; the follower as well as the god himself may thus be *bakchos*. The new horizons of consciousness attained by *bakcheuein* might well appear to overcome the factual banality of death.[70]

Dionysiac initiation was more than just a change of status. It was a change of mind, a new vision of the world. Through various secret techniques initiates achieved the dual goals of *ecstasy*, an altered state of mind, and *epiphany* – the sudden, often terrifying appearance of the god, of a ghost of the dead, of the refashioned self, or the self *as* the god, *bakchos*. In the throes of divine frenzy the mind moves from one side of the mystic barrier to the other, and in each case one experiences simultaneous death and birth. But across the threshold there must also be some kind of encounter, a revelation that gives meaning

to the journey. Mystery and oracular cults developed various ways to induce these conjoined psychological phenomena. Careful staging, prompting from intermediaries, incantations, drugs or alcohol, dance, and evocative music all had their place; but the nature of the encounter – what gave it coherence and structure – was conditioned largely by the power of suggestion.[71]

Suggestion, of course, can be imprinted on the mind in many ways, most simply by prolonged exposure to a way of thinking. It was always the foundation for more concentrated methods of generating a mind-altering experience, such as theater, intoxication, and hypnotism. Mirrors in particular seem to have been especially good at the last of these methods; yet it is far from obvious to our modern minds how a reflective surface, which seems to offer so little opportunity to deviate from the reality it reflects (except in fairly predictable ways), could be used in summoning visions. Nevertheless, the evidence is overwhelming that divination from reflections has been practiced at least since Etruscan times[72] and persisted in the West until quite recently. Writing in an age when hypnotism was a topic of urgent interest (it was the science that launched Freud's career), and when such movements as spiritualism and parapsychology still saturated the popular consciousness, Macchioro provides fascinating insights into the catoptric techniques of his own day used by a variety of operators, from psychoanalysts to professional *magnetizzatori* (mesmeric mind readers).[73] With little more than a mirror or a crystal ball and the power of suggestion a subject could be led, after a prolonged fixation, to arouse an image from the subconscious and perceive it vividly in the receptacle. One's own reflection could be transmuted into the image of another, or entirely new scenes could be envisioned. This process of monoïdeism, as Macchioro calls it, while induced, is not voluntary; thus, like a dream, it can seem terrifyingly real.[74]

About a decade after Macchioro, Delatte undertook a thorough review of the ancient and medieval evidence for catoptromancy.[75] The nature of the rituals he examined varied significantly among themselves, but they all adhered strictly to a cardinal rule. Without exception their method was hallucinatory, not ominal; that is, it required not the interpretation of signs, but a kind of ecstasy dominated by autosuggestive sensation.[76] Plato characterizes the distinction as that between the *manic* and the *mantic*, a single letter designating the qualitative divide between two religious natures.[77] As such, catoptromancy differed from divination with liquids, which could also be hallucinatory but often was characterized by the choosing of lots cast into the liquid, or the reading of patterns made on the surface or in the depths, rather like the proverbial tea leaves.[78]

From a purely objective point of view a mirror would seem no better a receptacle for exteriorized ideation than a blank wall or an empty frame.[79] It is the power of suggestion, fueled by accumulated metaphor and tradition,

that gives it special authority. But its greatest appeal must have resided in its documented capacity to transmute, by way of hypnotism, a person's *proper* face reflected in its surface (and implicitly his very identity) into that of the desired person or god. In this respect a mirror is like no other apparatus of ecstasy: it begins by enabling the simple reflexive act of seeing one's own image, but *without breaking the continuity of the initiand's subjectivity*, displaces that image with someone else's. Reversing the cognitive process experienced by Ovid's Narcissus, the subject moves from perceiving the self to seeing the not-self: it witnesses the self becoming the Other. This phenomenon, I believe, finds an analogy, or perhaps even a metaphor, in the pictorial convention that conveys *mania* by a sharp sidelong turn, or upturn, of the head: it is the pictorialization of Pindar's "head-tossing agitation"[80] – a way of conveying the inner state that no longer "sees straight," that experiences an inversion of identity.

Certainly there were other ways in which the unique qualities of reflection suggested its adoption into ritual. The ancient phenomenon of catoptromancy may have been driven in part by the Greek perception that the unknown lies at one's back. This trope takes two principal forms. One form is purely metaphorical; it was a commonplace in Greek thought that we walk backward into the future, for the future is wholly unseen while the past remains (variably) visible.[81] The other notion, less rarefied and more demotic, reflected deep-seated beliefs about the interactive worlds of unseen spirits and of ordinary humans. Harmful spirits dwelt behind the back, threatening to thwart good fortune or hubris; hence the injunction to the triumphant general traversing Rome in his chariot, "Look behind you; remember you are human." It served partly as a prophylactic incantation against the evil eye, and partly as an acknowledgment of the vigilant gods and their privileged place outside the phenomenal world.[82] Similar beliefs inspired the Renaissance conceit of Vanitas and the memento mori, in the form of a decaying corpse or a grotesque demon (or both) hovering behind the back of the vain young woman admiring herself in the mirror.[83] Just as the gorgon head painted on the inside of a drinking cup was directed not at the viewer, but at invisible demons in the background that meant the viewer secret harm, the mirror gave its user the capacity to see into, and even enter, the dorsal spirit world. A mirror could help the individual look around the bend to personal transformation. More than a window, it was a magical doorway, imparting not only knowledge but experience.

Indeed, experience was the primary objective of Dionysiac revelation.[84] To be sure, the cult had an oracular dimension, as P. B. Mudie Cooke demonstrated in one of the first major publications on the Mysteries Frieze.[85] But the business of Dionysus was not principally divination, as it was for his cohabitant at Delphi, Apollo.[86] Dionysiac delirium was about gaining access to the spirit world directly. To the extent that mirrors or reflections ever helped to achieve

the desired instability of the subject, it would seem that they did so not to foretell the future or to make known the unknown for purely pragmatic ends, but to invite the user across their transforming threshold.

As far as we know, there is no such thing as a literal depiction of Dionysiac ritual in any genre of Greco-Roman art. Varying degrees of realism apply to various types of cult practice. Sacrifice in public cult, for example, tends to be played relatively straight: sacrificants, attendants, and victims are rendered more or less as they would have appeared in real life. Sometimes figures of gods appear among the humans, but their identities and roles remain distinct. The imagery of official state cult is, after all, a visual record of a public transaction – and all such transactions should properly be acknowledged with clarity and precision. But in representations of mystery cult, and particularly the cult of Dionysus, public transaction is subordinate to private transcendence. Elaborate scenes of sacrifice are rare; instead, the viewer is transported into a half-wild, half-bucolic landscape where ecstatic dance and triumphal revelry blend with the symbolism of esoteric ritual. The phenomenal world is fused with the spirit world in an intentionally disorienting way, blurring roles and identities, particularly between humans and demigods such as pans and satyrs. Time – or the syntactic conventions that distinguish before from after, and cause from effect – can seem to rupture. Even the setting may be ambiguous, oscillating between indoor and outdoor, urban and Arcadian, civilized and savage. The viewer might swing between the role of witness and participant, or between feelings of distance and involvement.

No work of art characterizes the ambiguity of ecstasy more successfully than the Mysteries Frieze at Pompeii, where "structured" episodes of human ritual are interleaved with the world of the Other, with its clusters of gods, satyrs, and demons. The ligature of continuity, as steady as the rhythmic background pattern that paradoxically insists on a flatness that the figures renounce, is the viewer's inner experience. One travels through each vignette in turn – in essence, taking the part of the initiand who must negotiate both worlds.[87] If we view these scenes from the proper perspective, we can never be entirely sure when the Other remains the Other, or when the initiand has stepped into the storybook – when a female subject has become a winged demon, a panisca, or a maenad, a male subject has become a satyr or a silen, or either has become *bakche* or *bakchos*, one with Dionysus. Complicating matters further is the fact that satyrs and maenads, who dwell in a world apart from our own, are themselves often represented in ecstatic states, dancing to the pipes and pounding the tympanum – not because there is a second order of otherness to which even the Other aspires, but because we, the real or potential initiates, should imagine *ourselves* to be satyrs and maenads as we dance into the trance that is necessary to enter their world, and thereby to gain access to the divine; for telestic trance is at heart a process of identifying with the god and his

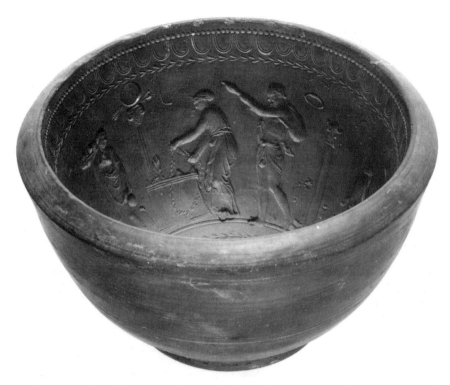

57. Arretine bowl mold from the workshop of M. Perennius. 25 – 15 B.C.E. New York, Metropolitan Museum 23.108. Image © The Metropolitan Museum of Art.

followers.[88] In essence, effect is blurred into cause; time collapses into the eternal moment when both worlds are equally real. Surrogacy of many kinds – symbols, masks, actors playing specific roles – probably assisted in the successful prosecution of cult rituals. So we may surmise from Plato, who informs us that the Bacchic dance is an exercise in role playing, the roles comprising the Dionysiac retinue of nymphs, pans, silens, and satyrs.[89] Initiates, perhaps wearing masks and appropriate costumes, may have assumed the identity of the characters to whom they aspired, or to whom the initiand entrusted himself in the other world. In art, the costume dissolved into an authentic character type: the maenad, the satyr, the little amorino, the bulbous old Silenus, Dionysus himself and his consort Ariadne.[90]

It is in this spirit of instability between signifier and signified, cause and effect, that we must approach all but the simplest works of Dionysiac art. I will not concern myself here with modes of representing ecstasy alone, such as Bacchic dance. I wish to address a much smaller group of artworks that also carry intimations of epiphany – and, at least potentially, of epiphany by mirrors. Mystery cults always seem to revolve around hierophancy, or optical revelation – often by the act of unveiling (of the initiand, of a child, of an object of veneration, of the ritual phallus, of the *cista mystica*, the basket containing the

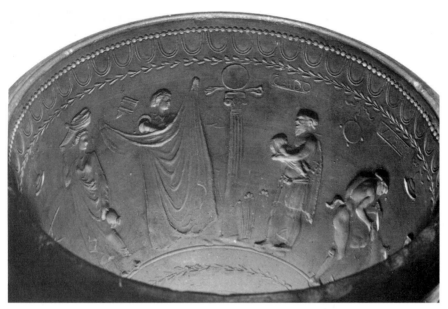

58. Another view of the same mold. Image © The Metropolitan Museum of Art.

mysteries). Veiled mystic objects are fairly common in Roman sacral art, as is the representation of a veiling or unveiling within the narrative context of ritual.[91]

One of the most interesting initiation scenes is rendered on the interior of a late-Republican or early-Imperial Arretine bowl mold from the workshop of Perennius in the Metropolitan Museum in New York (Figs. 57, 58).[92] Typically, it blends episodes from human ritual with the activities of satyrs and maenads. The two focal points, separated diametrically, are anchored by the motif of an Ionic column supporting a disk. In one instance a female figure presents offerings of a garland and incense on an altar before the column, while another stands by with a plate of food offerings and a pitcher of sacrificial milk or wine. On the right a satyr points meaningfully to the enshrined disk. On the other side, the column and disk serve almost as a divider between domains. On the left stands a female *liknophoros* and, nearest the column, a figure standing behind a curtain. Evidently she (if it is a woman) is experiencing the moment of revelation; as the top of the curtain is lowered she peers intently over its descending edge into the alternative world on the right. Here a satyr and maenad are busy butchering an animal, presumably a victim sacrificed on the altar. Nearest the column, returning the initiand's gaze, the unmistakable figure of Silenus stands with a veiled child in his arms. Silenus was the young god's tutor, and so there can be little doubt that the child should be understood as Dionysus himself. The initiand, out of mind and body, thereby *becomes* the child, reborn into immortality, whose head is perhaps unveiled at the moment

after the curtain drops. One may envision initiates in this drama assuming the satyric roles with the cooperation (or not!) of an infant.

For our purposes, the principal points of interest are the disks at the frieze's two focal centers. Absolutely plain but for the simple ribbons arranged beneath them, these are surely not tympana, the tambourine-like drums (adopted into the cult at an early date from the cult of Meter/Cybele) that appear in thousands of Dionysiac scenes. In fact two tympana, identified by the jingles around their edges, hang in the voids between some of the figures, along with finger cymbals, pan pipes, a *pedum* (the curved staff of the rustic herdsman) and a *cista mystica* – all standard equipment in the Bacchic entourage. But the columnar supports, along with their compositional centrality, impart a solemnity and significance to the disks. These are objects of special regard or veneration.

Often consigned to the status of generic "cult object," the disk on a pedestal occurs in a wide variety of contexts. Its formal origins may reside in Egypt, where the sun-disk appears in many contexts as a plain circle; but in Greco-Roman usage, a single identity or function for this object has never been established. Very rarely a sunburst is represented on the otherwise plain surface, as if to emphasize its brilliance.[93] Shields, along with other implements of war, occasionally appear on pedestals or columns as memorials to dead heroes or warriors.[94] But there is no good reason to suppose that a shield would be a center of interest in a cultic ritual of this kind. Disklike objects on columns or pedestals sometimes appear in Isiac contexts.[95] Now faded beyond recognition, painted renditions of them once appeared on the pillars along one side of the "Euripus" of the House of Octavius Quartio in Pompeii, whose decoration in this area seems to have projected a vaguely Isiac theme.[96] Other examples, in various cultic contexts, are easy to find.[97] But they rarely achieve the kind of centrality of importance ascribed to the objects depicted here. The disk could act almost as a mediator of this mutual epiphany: the unveiling of the initiand and, perhaps simultaneously, of the child-god.

Could the Dionysiac disk – as well as many of its cognates in other mystic contexts – have been a mirror?[98] As a machine and portal of metamorphosis it would have served as the very locus through which the mutual gaze, and the chiastic change of identity, were achieved. Would the woman and a *real* child, a suggestive surrogate for Dionysus redivivus, have exchanged gazes at one another in this orb (inclined slightly downward from its superior height) until the woman, overcome by the inducements of suggestion, or by the masks worn by her opposites, fell into a hypnotic state?

In size and simplicity this disk resembles the *miroir à poignée* type, which is held by a grip on the rear. But as a revered cult object, such a disk may have been given a "pure" form without handles or decoration to isolate it functionally and symbolically from the merely quotidian. The Dionysiac domain in art is full of plain disks – held, propped, or suspended – usually identified simply as

59. Detail of the fourth-style stucco decoration of the western enclosure in the palaestra of the Stabian Baths, Pompeii. Now lost. From Rostovtzeff 1927: pl. XIII.2.

tympana or *oscilla*, generic plaques of a few prescribed shapes (including circles) that were hung from Roman intercolumniations. Having dealt with such disks at some length elsewhere,[99] I will return to a few only briefly.

On a now lost stucco relief panel from the courtyard of the Stabian Baths at Pompeii, dating to the final phase of decoration a few years before the eruption in 79 C.E., the old satyr Silenus is shown scrutinizing a similarly featureless disk, this time suspended from a tree (Fig. 59). Such *"oscilla"* appear elsewhere in Dionysiac art of the Roman period, usually hanging from trees.[100] Suspended votive objects are a commonplace in sacral art of the Roman period, but they are not typically thrust into the narrative foreground. Why such close scrutiny here? The aforementioned mirror at the sanctuary of Demeter at Patras, lowered on a cord down to the level of the sacred spring and used by the priestess as a channel for visions of pilgrims' futures, could hint at a

60. Second-style dining scene in the Hall of the Mysteries, House of the Cryptoporticus (1.6.2–4), Pompeii. 40–20 B.C.E. Photo: DAI Inst. Neg. 87.43.

similarly divinatory role for this disk. We are not told how the vision at Patras was achieved; but the prospect of the mirror's oscillation as it was lowered to the water, and the sheer folkloric power of reflections in many magical rituals, suggest a process akin to hypnotism.

A more widely discussed fresco tableau from the Hall of the Mysteries in the House of the Cryptoporticus in Pompeii (1.6.2–4) depicts a dinner party at which an obviously startled Silenus on the left appears to react to a small, evidently metallic, round object proffered by the diner on the right (Fig. 60).[101] This figure makes a referential flourish with the left hand, as if to say, "voilà." Silenus' reaction, as Nancy de Grummond has recently demonstrated, conforms to a longstanding Etrusco-Italic convention for representing prophetic afflatus. Much discussion of this scene has revolved around the identity of the object held in the diner's hand. Some have taken it to be a small reflective *phiale*, others a mirror. Having no handle, it may in fact be a reflective, purpose-designed "ritual disk."[102]

Similar disks appear on the decorated rim of a third-century-C.E. silver *patera* from Thil (Haute-Garonne) in the British Museum that features a frieze bearing conventional Dionysiac imagery.[103] The only human forms appearing on it, besides the traditional theater masks, are two separate pairs of putti standing on either side of a small altar. In one of the two pairings, the boy on the left dangles a small disk suspended from a cord over the altar, on which sits the head of a sacrificial goat (Fig. 61). The winged tot on the right holds a larger disk by

61. Dionysiac scenes decorating the rim of a silver *patera* from Thil (Haute-Garonne). Third century C.E. London, British Museum GR 1824.4–89.70. © the Trustees of the British Museum.

its rim, extending it purposefully out at eye level toward his counterpart, who wrenches his head away. This latter gesture, I have already suggested, should be understood not as aversion or inattention, but as absorption to the point of ecstasy, the pinnacle of religious *mania*. The boy is already mesmerized by these swinging and fixed disks and manifests his mental state in classic Bacchic fashion, with a sharp turn of the head.

The meaning of such scenes probably challenged the average ancient viewer. None of these images, even the dining tableau, is likely to have presented a narrative framework to orient the viewer; they are simply meant to evoke the generic setting of wine and revelry to which satyrs and maenads, cupids and psyches are often attached. Clearly something is going on in each case, but the meaning of the action does not come into perfect focus. The viewer's confusion was not entirely accidental; images of this sort were "teasers" to advertise a cult that was defined by its jealously held secrets.

A fourth-style room in the House of the Ship in Pompeii (6.10.11) depicts a "floating" maenad carrying a *thyrsus* with one hand and with the other a very thin disk on a thong (Fig. 62).[104] This small disk type, which is quite common in the Dionysiac art of Roman Italy in the first centuries B.C.E. and C.E., surely denotes "tympanum," yet it is not at all like the conventional percussive instrument that appears more commonly in Greek and Roman art; it is small and flat and has no jingles or tassels, whereas a "genuine" tympanum is at least the size of a large platter and two or three inches thick. The only thing that would distinguish the smaller type from a disk of pure polished bronze is a grayish circle centered on the otherwise tawny surface – a "bull's eye"

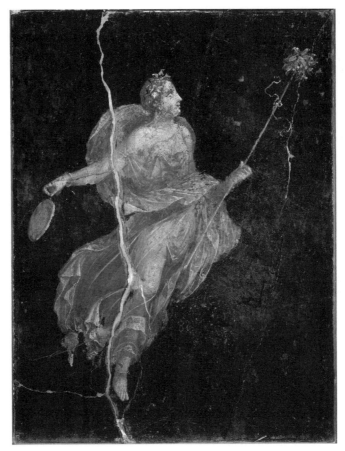

62. Fourth-style wall painting from the House of the Ship (6.10.11) in Pompeii. Naples: Museo Nazionale 9298. Photo: Scala/Art Resource, NY.

that occasionally characterizes the disk-on-pedestal as well.[105] A tympanum is always struck with the bare right hand, yet the maenad has no hand free with which to put it to its intended purpose. Is she just carrying her timbrel, then, to announce her Dionysiac credentials, rather like the ever-present *thyrsus?* Or is she wielding something *more than just a drum* – a hybrid signifier derived from two ubiquitous forms of distinct provenance?

Skeptics would doubtless dismiss this notion, were it not for the presence of a work of Roman art that patently and indisputably laminates precisely the two instruments under discussion – tympanum and mirror – into one. The work in question is one of a pair of ornate silver *skyphoi* of the first century C.E. from the Berthouville treasure (Fig. 63).[106] The flanks of these cups are overflowing with iconographic detail forming loosely organized vignettes that emphasize Dionysiac symbolism over narrative. A number of the objects rendered on these two cups display, on their surfaces, miniature scenes in relief representing episodes from myth. Some, such as the Rape of the Leucippidae on an amphora,

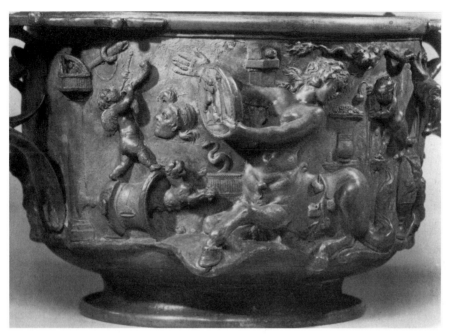

63. One of a pair of silver *skyphoi* from the Berthouville treasure featuring centaurs and Dionysiac imagery. Mid-first century C.E. Paris, Bibliothèque Nationale, Cabinet des Médailles, Babelon 60.

convey symbolism specifically appropriate to the Bacchic experience (in this case, apotheosis).[107] The most interesting panel, however, is self-referential in a way that these more conventional vignettes are not. The panel is dominated at the center by a centauress; Babelon has suggested she is Hippa, the young Dionysus' nurse. Her head, and indeed her whole torso, turn back almost violently in an ecstatic contortion. Again, this is not a gesture of avoidance, but a sign of possession. In her outstretched left hand she holds what appears to be a tympanum, which she is about to strike (?) with her open right palm. Rendered in relief on the drum's surface are the reflected images of several objects and figures. To the left of the centauress rests an overturned cantharus; from this emerges a female panther attacking a snake rising from the *cista mystica*.[108] A winged cupid stands precariously atop the cantharus playing double pipes. His body faces the mirror and the centauress, but his head and the pipes are turned skyward; he seems oblivious to everything but his music. Floating between the cupid and the centauress is a theatrical mask. Behind the child and cantharus stands a pillar on which rests a small basket filled with votive fruit.[109] The reflective surface is much smaller than the field of reference, in order to crowd in four details in full: the boy, the cantharus, the pillar, and the basket, each reversed as in a real mirror.[110]

The presence of a mirror, shown among many other Dionysiac symbols, is at least comprehensible. But why laminate it to a tympanum? Why not just

represent a mirror as such? Let us recall that lamination is not simply a marriage of compatible forms; those forms must be attached to compatible functions. In religious ritual, mirror and music were both used to achieve a common goal, a hypnotic trance. A trance is a collusion of the senses. As such it is not easy, or even desirable, to isolate seeing from hearing or taste (this sense too was alive in the mind of the wine-mad Bacchant) in the murky processes of mind-altering ritual. One thinks of the baby Zagreus in Firmicus Maternus' version of the story, equally entranced by the rattle and the mirror. These two toys "entangled his spirit" in an initial confusion that Bacchants sought to replicate in their own rush to madness. There is something profoundly suggestive about the musical instruments of the *thiasos* that seems to encourage them to slip the conventional bonds of signification. A *synthema* (an incantatory, formulaic covenant) of late antiquity gave these words to a dying initiate who wished to have access to the inner sanctum: "I ate from the tympanum, I drank from the cymbal, I learned all the mysteries of my creed"[111] – as if these instruments' imagined contribution to bodily sustenance sublimated the Titans' feast on the flesh and blood of Zagreus in a kind of Eucharistic ritual. More traditionally, Bacchic music and rhythmic dance, defined by the beating of tympana, chiming of finger-cymbals, and sounding of the pipes, accompany the mind on its journey. The rising pitch of euphoria preceding the shock of epiphany may have been facilitated by the presence of an assistant who beat the tympanum directly behind the head of the medium or novice at the moment before unveiling, as illustrated on a terracotta Campana plaque of the early Empire at the Louvre (Fig. 64).[112]

Musical instruments, like mirrors themselves, are therefore *ritual hallucinogens*, aiding the Bacchant in the journey of sensations leading to possession.[113] Iamblichus dilates at some length on the nature of ecstatic music, noting the common perception that "by some tunes the Bacchic frenzy is aroused, but by others, the Bacchic frenzy is made to cease"; and that "the unstable and irregular tune is proper to ecstasies."[114] In a hallucinatory context of flashing torches and hypnotic visual rhythms, the mirror, though not used so widely in ecstatic cult, seems to have provided a roughly equivalent experience to the inner eye as the "unstable and irregular tune" offered to the mind's auditory centers.

The tympanum is not the only symbol to which mirrors are conjoined. Greek poets, as I said earlier, laud wine as the mirror of the soul, and within the orbit of the Bacchic mysteries it plays a role similar to that of music in transforming the mind.[115] By eliminating social inhibitions, the medium serves as a portal between one state and another. Sober, one stands outside of the threshold of the liquid's surface; intoxicated, one hovers within. It is what dwells inside this Dionysiac universe of the unfettered persona that merits reflection on the surface. The wine-bowl, the drum, and the mirror are all

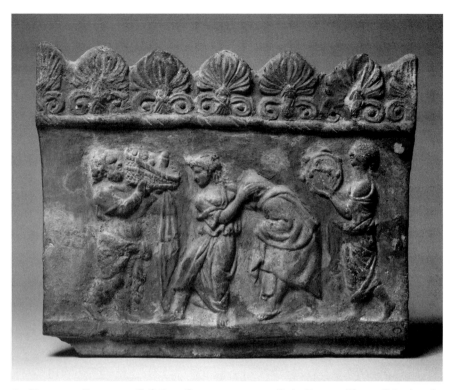

64. Terracotta Campana relief. Late first century B.C.E. Paris, Louvre. Photo: Réunion des Musées Nationaux/Art Resource, NY.

mind-altering implements. What they have in common, from the Dionysiac perspective, is the capacity to volatilize the embodied soul; to sift it from the flesh, as the purifying *liknon* filters chaff from the grain.[116] It is in this Orphic spirit, perhaps, that the poet Euphorbius extols the images emanating from "the purifying orb of mirrors" in a distich of the Latin Anthology.[117] A soul thus prepared can part with the anchoring "I" and travel about, even into the radical Other; or like a mask, it can borrow another self and create, temporarily, a composite unity of "I" and "thou."

LAMINATION: PRE-ROMAN PRECEDENTS

I have tried to suggest here that the lamination of mirror and tympanum – like that of mirror and *phiale* – is a reflection of the complementary value of these forms in conveying meaning. Because the art of marrying the functions of a mirror and a *phiale* was perfected on Apulian vases, it should come as no surprise that the more aggressive kind of lamination seen on the Berthouville *skyphos* is traceable to the south Italian tradition too, and probably even back to Greece. A number of painted vases offer evidence that the mirror–tympanum

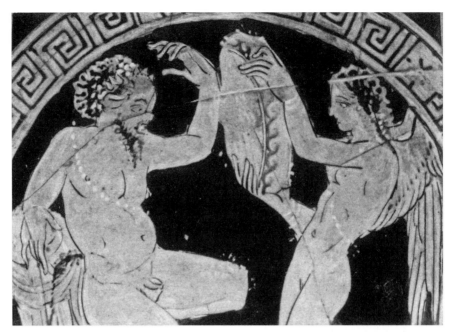

65. Faliscan-style *kylix*. Fourth century B.C.E. Rome, Villa Giulia 26013. Photo: DAI Inst. Neg. 81.3255d.

hybrid extended back beyond the Roman era;[118] I will confine my discussion to three of the best examples.

A Faliscan-style *kylix* from Vignanello features on its interior the image of a nude winged female figure presenting a tympanum to an old satyr "a mo' di specchio," as the original publication puts it (Fig. 65).[119] This image dates probably to the fourth century B.C.E., and it is extraordinary in four ways. First, the seated satyr reacts with the *aposkopein* or "reception" gesture, the pronate hand to the forehead; it could be taken as a combination of surprised reaction and an intent gaze into the depths within the tympanum.[120] Second, the tympanum is being grasped at the edge with both hands as if it were an honorific shield, an unusual combination of gesture and object that anticipates the Berthouville *skyphos* and the Thil *patera* by several centuries. Third, the figure proffering the tympanum is not a maenad, to whom the tympanum rightfully belongs, but a winged genius in the form of an adolescent girl.[121] Fourth, tympana in this genre usually are decorated with geometric patterns on the surface; yet the face of this tympanum is blank, though the edge is decorated. Scenes of maenads proffering tympana to male figures are a commonplace on "Faliscan-style" pottery, but they lack most of the features enumerated here.[122] Taken together, these features transmit an easily discerned visual code. Unmistakably, this is no conventional Dionysiac *thiasos* scene; it represents the birth of a vision. Even the satyr's hair seems to be blown back in the manner that de Grummond associates with divine afflatus. The instrument of revelation is the tympanum; its emissary, a winged angel of the Etrusco-Italic underworld.

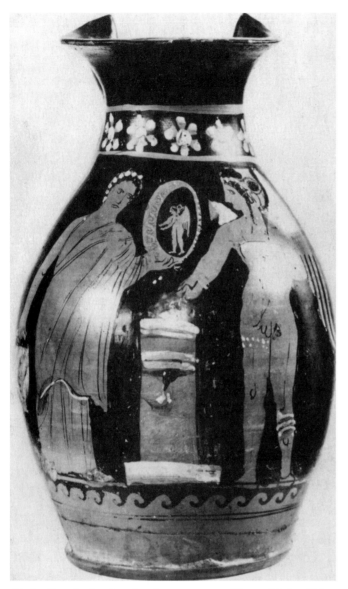

66. Apulian *oinochoe*. Late fourth century B.C.E. Warsaw, National Museum 198927.

I would not venture to guess the precise nature of the satyr's vision, but it probably involves the winged apparition itself. An interesting comparandum appears on a late-fourth-century-B.C. Apulian *oinochoe* in the National Museum of Warsaw (Fig. 66).[123] Here a woman (maenad?) and a winged Eros face each other from across an altar. In this case the woman holds upright a tympanum with a similar geometric fringe design directly over the altar at which the god seems to be sacrificing. Both gaze intently at the drum, upon which appears a full-figure miniature simulacrum of Eros in a slightly different posture. Here, as on the Arretine mold, an aligned pair of sacred objects (tympanum over altar, disk on pedestal) seems to mark the symbolic threshold between the terrestrial

and divine realms. If the simulacrum is a vision, then it operates almost as if the love god has been projected through the membrane of the drum from behind – like an Indonesian *wayang kulit* shadow puppet – and into the consciousness of the transfixed woman. Admittedly, we are guessing at a very perplexing visual game whose rules have been utterly lost.

But let us pursue the matter further. In at least two instances, tympana represented on vase paintings actually bear images of faces upon their surfaces. To my knowledge, this particular kind of lamination is found nowhere else in the corpus of ancient art, except on one anomalous mosaic in late antiquity.[124] I begin with a fragment of a late-fifth-century Attic red-figured vase in Boston (Fig. 67).[125] This is one of the few images from outside Italy, and perhaps the oldest as well, to suggest that reflectivity was an active dynamic in the cult. Here a traditional maenad wields a tasseled tympanum on which appears a frontal, epicene head framed in a wreath of small leaves – olive, laurel, or perhaps even black poplar, from which crowns of Dionysiac initiates were made.[126] The wreath occasionally appears alone as a tympanum emblem on Italian vases.[127] The head it encircles is perhaps that of Dionysus making his mystical appearance, or *parousia*. Just below the tympanum can be seen the top of a woman's head, a luxuriant mass of her black hair outlined in reserve against the black background. Like the maenad she is crowned with ivy, sacred to Dionysus: two heart-shaped leaves are visible projecting from the strands of the circlet. She carries a scepter, which passes in front of the maenad's hand. There is no epigraphic evidence that this is Aphrodite, as has been claimed;[128] the ivy-crowned head and the scepter are much more likely attributes of Ariadne, Dionysus' queen. The level of her head relative to the maenad suggests she is seated, probably enthroned. All other figures have been lost, and without them any detailed interpretation is apt to go astray. But I would suggest, tentatively, that the tympanum here may have functioned much like those shown in ritual unveiling scenes; that the enthroned woman is Ariadne engaged in her sacred wedding (*hieros gamos*) to Dionysus. The pounding of the drum behind her head, like that in initiation scenes (see Fig. 64), is an invocation of the god to possess her; and his presence, implicit in the bride's consummation of ecstasy, is signaled by his image materializing on the drum's membrane.

This is followed by an Italian example from the fourth century B.C.E. On one side of an Apulian bell crater in Zürich, a maenad is shown in the center (Fig. 68). Her right arm, wielding the short sword with which she has slaughtered an animal, curls over her head in a characteristic gesture of frenzy. The animal, rent in half, is in her left hand. To her proper left strides a satyr carrying a torch and *situla*; on the other side stands a youth, nude but for a loosely draped mantle and a white headband, holding a tympanum (to judge by the decoration of its border) out toward the maenad. On the surface of this object is represented the bust of a woman that loosely replicates that of the maenad except for one detail: the bust is adorned with a broad white headband or *taenia*.

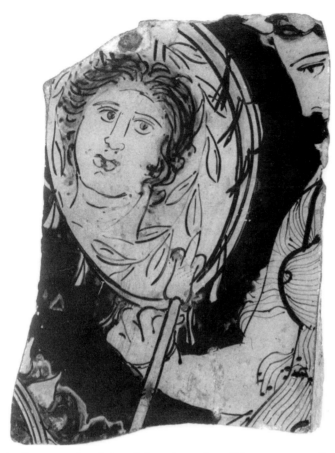

67. Fragment of an Attic red-figured vase. Late fifth century B.C.E. Boston, Museum of Fine
Arts 03.857.

Both the man and the woman gaze toward the tympanum – and through it, at
each other.

The image, it is objected, cannot be a reflection; it must represent an emblem
applied to the surface of the tympanum.[129] After all, the full-figure maenad
is without the headband; and in defiance of ordinary reflectivity, the bust
and its supposed referent are not laterally reversed. Nettlesome details, but
hardly fatal to a *magical* reflection, or even a metaphorical one. In one respect
the bust acts very much like a mirror image: the tympanum's frame crops
the back of its head. No conventional emblem or portrait behaves in this way,
whereas women's reflections in boudoir mirrors appear in just such a naturalistic
manner on other fourth-century vases from Magna Graecia (see Fig. 54).[130]
Certainly we have lost part of the code that made this picture intelligible to its
intended viewer. But it is unsatisfactory simply to dismiss its puzzling central
image as a sign denoting some unknown person or god when that image so
obviously duplicates the woman directly beside it, complete with her beaded
necklace. Whether or not the ecstatic woman has seen her slightly altered

self in the tympanum surface, that surface must be replicating her form for some iconographic purpose.[131] There is no need to carry the burden of proof into our own phenomenological domain. Because no metallic tympana have ever been found, some have argued, tympana cannot have served as mirrors in art.[132] The reader will already understand that such literalism misses the point.

Rather like the cultic disk on the Arretine bowl, and the Eros–tympanum on the Warsaw *oinochoe*, the mirror–tympanum balanced in the youth's left hand seems to open a window between the two worlds. The youth himself shows no evidence of belonging to the other world on the right, where males have pointed ears and tails and females tear animals apart. But he may be an initiate; indeed he seems almost to reach for the *thyrsus* at his side as if it were his own. Projected onto the drumskin screen is the bust of an ordinary woman, her hair done up with a *taenia*, perhaps in preparation for a wedding: the *taenia* and the mirror, taken together, are conventional features of the female trousseau.[133] Is the youth the woman's husband-to-be, and is the pair engaging in the *hieros gamos*, the sacred wedding, complete with its initiatory role-playing?

From our position of ignorance perhaps it is too much to ask who is seeing what, or whom, in this picture. There are too many possible permutations of subject and object, reflexivity and triangulation. And we must not forget that if this mirror is Dionysiac, then it is transmitting, in pictorial form, a state of inner metamorphosis and not simply a faithful mimesis of reality. The young man could be seeing the woman, filtered or altered; he could even be seeing himself as a woman. The woman may see herself altered, or another woman altogether. Or the man may be positioning the mirror so that the viewer alone sees the woman altered, or sees another woman. Leaping into this briar patch of alternatives withal, I would venture to suggest that one option is better than the others. The leftward orientation of the tympanum favors the young man; thus I am led to believe that he is the intended subject of the gaze into the mirror. What he sees on (or through!) the tympanum is his wife, a fellow initiate in the cult – once impersonating a maenad, once in her nuptial diadem. Perhaps the wedding is under way, complete with theatrical impersonations of maenads.[134] That said, it is all too possible that the man is already married and widowed – that his wife is dead, and is being summoned to his presence from the beyond.[135]

THE MIRROR AND THE MASK

Dionysus has long been recognized as the God of Masks – that is, the Greek deity par excellence whose epiphany could be achieved by the agency of a mask. In one cultic context of the Classical era in Greece – precisely which context is hotly contested – the god himself was represented by a mask hung on a post or tree, draped in religious regalia. The vases on which these scenes

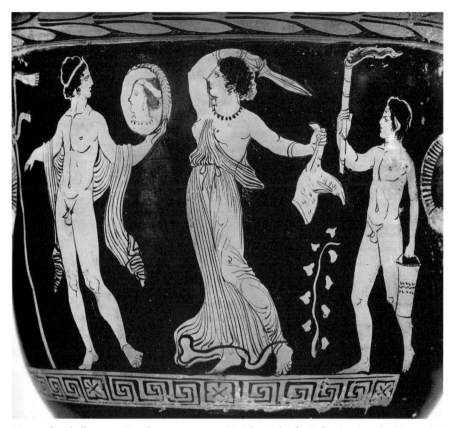

68. Apulian bell crater. Fourth century B.C.E. Zürich, Archäologisches Institut der Universität Zürich 3585. Photo: Silvia Hertig.

appear, known usually as the "Lenaia" type, have excited much discussion partly because of the primitive, schematic way in which the god is rendered.[136] As Carl Kerényi has argued, the ancient mask is not principally about deception, but about transformation. "The mask conceals, the mask terrifies, but, most of all, it creates a relation between him who wears it and the being it is made to represent."[137] It annuls the barrier between the living and the dead, even humans and gods. Only when the two mystical phenomena were activated together – the altered state, the god's arrival – was the desired effect complete. The mask seems to have been important in Dionysiac cult for its power to realize the second, epiphanic moment. Dionysus saved by confrontation.

> From earliest times man has experienced in the face with the pene-
> trating eyes the truest manifestation of anthropomorphic or theriomor-
> phic beings. This manifestation is sustained by the mask, which is that
> much more effective because it is nothing but surface. Because of this,
> it acts as the strongest symbol of presence. ... Here there is nothing but
> encounter, from which there is no withdrawal – an immovable, spell-
> binding antipode. ...

And yet this explains the significance of only half of the phenomenon of the mask. The mask is pure confrontation – an antipode, and nothing else. It has no reverse side – "Spirits have no back," the people say. It has nothing which might transcend this mighty moment of confrontation. It has, in other words, no complete existence either. It is the symbol and manifestation of that which is simultaneously there and not there: that which is excruciatingly near, that which is completely absent – both in one reality.[138]

Exactly what role the mask played in the Attic cult can only be guessed. Nor should we extrapolate from the evidence of the "Lenaia vases" – which is Attic – to the vast and long-lived cult around the Mediterranean. Even if the Athenian custom survived in Roman rites, what began as a cultic instrument may eventually have changed into a sign; the mask of the god, once having assisted in a ritual of epiphany, came eventually to represent it instead.

In some fashion, the Italian cult of Dionysus made practical use of reflections. Perhaps this practice was inspired by the Etruscan affinity for scopic divination. How reflections related to masks in ritual is unknown – there is little iconographic overlap of the two – but some affinity is likely, as scholars have long agreed.[139] It is interesting, then, that with only the slightest modification, W. F. Otto's remarks above could be applied to mirrors. The difference is not so much in their function, but in their scope: the mask encompasses a god, the mirror his entire world. The mask transforms; the mirror also transports. The person who looks deep into a mirror (the adverb and preposition are inherited from ancient belief) beholds a heterotopia that, at any moment, in the mystical reversal of *ekstasis*, he may suddenly inhabit. The figure he beholds is his other self, which he may suddenly become. Vernant characterizes the psychological mechanism as follows:

> The initiand gazing into the mirror must see himself in a Dionysiac mask, transformed into the god who possesses him, transported from the place where he is to a different place, transmuted into another who returns him to unity. In the mirror where the baby Dionysus beholds himself, the god is dispersed and divided. In the mirror of initiation, our reflection is contoured like an alien figure, a mask which in turn gazes at us, face-to-face.[140]

The mask is the essence of the god's sudden *parousia*. One might infer that the initiate's own mirror image is the only "mask" necessary – as long as he has the potential, in the surge of ecstatic afflatus, to remake the image into that of the god without special assistance. But we must presume that every measure was taken to ensure that the subject's *mania* was properly managed, and its imagery properly shaped, by suggestion. Were genuine masks used in rites of initiation to help fashion the initiand's apparitions? The evidence is meager, but powerfully evocative.

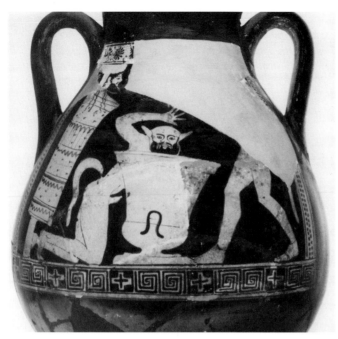

69. Scene from an Attic red-figure *pelike* by the Louvre Painter. Early fifth century B.C.E. Paris, Louvre G 238. Photo: Dist RMN / © Les frères Chuzeville.

A handful of surviving images hint that reflections played a part in Greek ritual prior to the fourth-century expansion of the practice in Italy. We have already discussed the Boston fragment; all the rest are of the Attic "Lenaia vase" type.[141] On one side of one of these, an early-fifth-century red-figure pelike in the Louvre, an ithyphallic satyr – his back to the god's effigy on the left – kneels over a large crater (Fig. 69). As he peers inside he raises his right hand, fingers splayed, in a gesture of high surprise. On the right side of the panel another male figure, his upper half obliterated by a lacuna in the surface, steps forward, perhaps in reaction to the main action.

This modest jug has a far more famous cognate in the Roman world, a scene from the Mysteries Frieze at Pompeii (Figs. 70, 71).[142] Situated on the left side of the frieze's focal wall, which forms three groupings in a kind of triptych with the drunken Dionysus in the center, it comprises a group of three seminude male figures, all identified as satyrs by their pointed ears. On the left the heavy-set, gray-bearded Silenus sits on a stone slab. He alone is crowned with ivy. Looking away to his proper right, he holds forth a whitish (probably silver) handled bowl or drinking cup, tilted so that a young satyr, leaning sharply over Silenus' left shoulder, can gaze intently into it. The youth takes hold of the cup's base with his left hand, as if to steady it or transfer it into his own possession. Another young satyr stands by; with his extended right arm he holds a theatrical mask of Silenus directly over (and behind?) the head of its living referent.

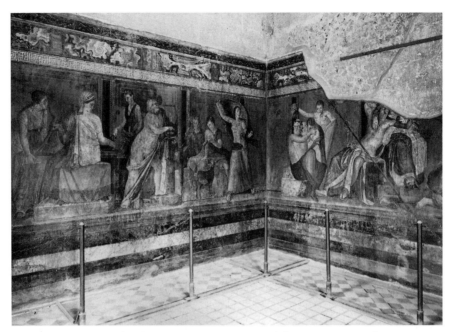

70. Mysteries Frieze, Villa of the Mysteries, Pompeii. Mid-first century B.C.E. Photo: DAI Inst. Neg. 58.1849.

This enigmatic episode has been read in many ways, but the more credible interpretations have fallen into one of two broad categories. One, the *Wein-wunder* reading, contends that the event being encountered within the cup is a Dionysiac miracle of spontaneous replenishment: the cup wells up with wine at the god's unseen command, and the witnesses react with astonishment.[143] It applies just as well to the much older scene on the Attic *pelike*, where the effigy of Dionysus behind the old satyr would simply serve to remind the viewer of the god's awesome presence at the site of the miracle. On the Mysteries Frieze, however, the mask remains the principal obstacle to this otherwise attractive theory. Were it an effigy of Dionysus himself, then it could be seen as another allusion to the god's presence. But it is a mask of Silenus, not of the god; and so weirdly prominent and captivating is this thing – a mask that is *held* in place, and does not just hang ornamentally on the painted pilaster directly behind it[144] – that it can hardly be regarded as a stage prop and nothing more. It appears to be, as Karl Lehmann notes, "a mask of revelation, more or less equivalent to the phallus which will shortly be revealed in the other wing of the triptych."[145]

Most interpreters have therefore made peace with some variant of the second reading of this scene, which proposes that the satyrs are experiencing a vision witnessed inside the cup.[146] Whether this vision is activated by catoptromancy, lecanomancy, or simply "holy drunkenness" has been endlessly debated – as

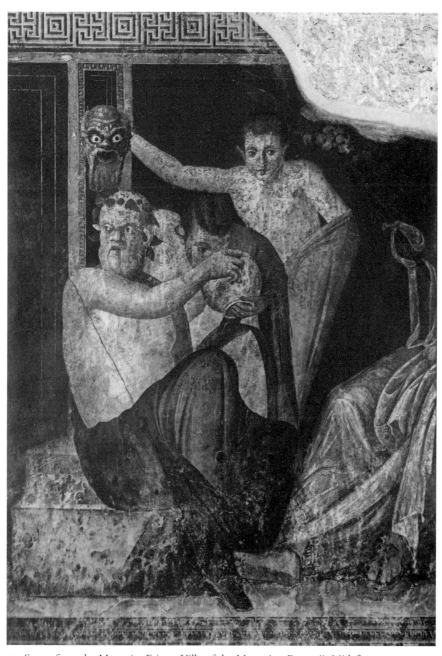

71. Scene from the Mysteries Frieze, Villa of the Mysteries, Pompeii. Mid-first century B.C.E.
Photo: DAI Inst. Neg. 54.743.

have the precise positions of the protagonists in relation to the cup, and what each can and cannot see. The insistence on determining whether the satyr is drinking or engaged in a vision seems to me misguided. The image is intentionally ambiguous, drunkenness and visions being two inseparable parts of the mystic experience. I would agree with most interpreters, however, that the mask plays a part in the vision.

Unlike its Attic precursor, the Mysteries Frieze vignette lacks an overt gesture of astonishment from any of the three direct participants. But the "sacred disk" imagery above has already admonished us not to make too much of this distinction. For one thing, it has been suggested that the woman just around the corner to the left – who does, by unanimous agreement, make a violently reactive gesture – may herself be responding to the vision in the cup.[147] As for facial expression, it is rarely a useful index of feeling in Roman art; in keeping with classicizing ideals, and with the conventions of the theater, affect is conveyed principally by gesture.[148] In turning his head away, the Silenus figure here is not necessarily distracted from the cup – quite the contrary. According to the Dionysiac code of the turned head, he may be completely immersed – "in his cups," drunk, utterly out of his head, and intensely clairvoyant: a pendant to his alter ego on the adjoining wall enraptured as he plays his harp. If there is a vision or visitation to be captured within the cup, it will come most clearly to the one who is the most inebriated – as one would likely conclude when examining a terracotta Campana relief plaque from Italy of the mid-first century C.E., on which a drunken Silenus and a winged cupid gaze intently into a *skyphos* while a psyche and a cupid look on (Fig. 72).[149] On the Mysteries Frieze Silenus has control of the cup, but is ceding it to the young satyr beside him as if to grant him a turn in the process that he has already completed. It is no accident that the obviously drunken Dionysus, sprawled nearby, brushes a single unshod foot against that of the senior satyr; the latter is, quite literally and figuratively too, being touched by the god. Another detail that frequently goes unmentioned may offer Silenus a further path of tangency to his altered state: the large tympanum at his side, upon which he props one arm to steady the cup.

So if the Silenus figure – and not the younger satyr who is catching his first peek into the cup – has advanced furthest into the vortex of the *au delà*, then the mask behind him, which is a caricature of his own face, properly refers to him alone. The mask is not, as some have argued, the younger satyr's presentiment of his future maturity through some *rite de passage*,[150] but a synchronous suggestion of the old satyr's state of mind. He has become Otto's "spirit with no back." Let us step back further and suppose, as others have suggested before, that satyrs in sacral art are often meant to represent humans who play the roles of satyrs in ritual.[151] Naturally, role-playing may often have been a path to possession. Though the human subject may not have begun the cup-and-mask ritual as a

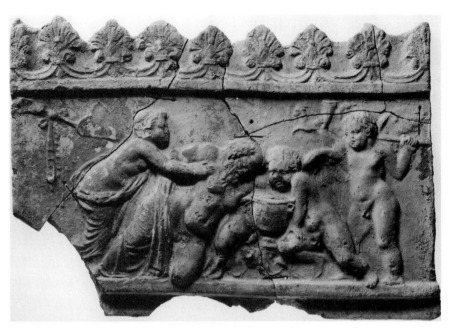

72. Terracotta Campana relief, perhaps Augustan. Munich, Staatliche Antikensammlung und Glyptothek TC 7140.

"complete" Silenus, Silenus is what he *became* – perhaps by donning a mask of the character in preparation for ecstatic possession, and by contemplating its reflection in a cup.

It is in the same spirit of multivalence that in another Pompeian fresco – this one depicting a drunken Hercules in the presence of Omphale – pipe and tympanum are sounded in either ear of the besotted hero, while a cupid in the foreground presents the polished concave inner surface of a *skyphos* for the viewer's inspection (Fig. 73).[152] Many are the instances in Roman art where an empty cup receives a demonstrative gesture to call attention to the drunkenness (or drinking prowess) of the protagonist who drained it dry. For example, a well-known mosaic of the early second century C.E. from the Atrium House at Antioch, now in Worcester, Massachusetts, shows Dionysus and Hercules engaging in a drinking contest as a servant plays the pipes and Silenus looks on (Fig. 74).[153] Dionysus has just drained another *skyphos* (several lie empty in the foreground) and he tips it almost as if he might use it for a mirror. In the Omphale fresco the viewer would surely be struck by the audacious *frontality* of the cup – as if, indeed, the viewer were being invited not just to verify the contents, but to peer deep, deep into the polished surface. (Unfortunately, the fresco is too deteriorated to show how the surface was rendered.) A playful invitation to read the reflection within, an act understood as a companion of drunkenness, would have immediate appeal to the canny Roman viewer.[154] Enriching further this icon of personal metamorphosis, the gender shift of the

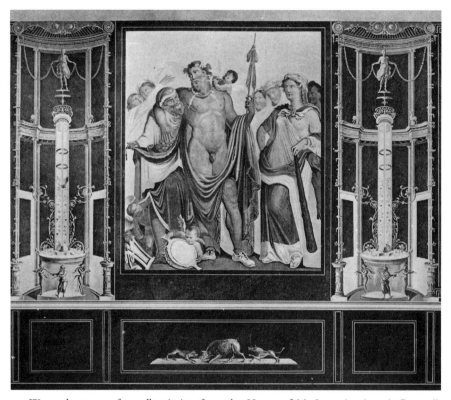

73. Watercolor copy of a wall painting from the House of M. Lucretius (9.3.5), Pompeii. Original: Naples, Museo Nazionale 8992. Photo: DAI Inst. Neg. 72.1399.

two protagonists – Hercules forced to wear the feminine garb of the queen, Omphale triumphant in the hero's lionskin – may have activated the viewer's natural association of mirror ritual with role-playing.[155] Could this reminder of a technique of Bacchic mind control introduce a comical level of literalism to the popular story depicted here? It was not beyond the bounds of the cult of Dionysus for individuals within it to transgress gender boundaries, at least for the controlled purpose of achieving ecstasy.[156] Perhaps the drunken Hercules followed his bliss just a bit too far around the bend.

CONCLUSION

Let us return momentarily to the two artworks with which we began (Figs. 48, 49). Both represent a satyr holding a hand mirror, one in rapture, the other evidently in possession of himself. If, in either case, the mirror is *in use*, that fact is not obvious (though I would argue that the state of frenzy is predicated upon the mirror's power). In these works the mirror is present, first and foremost, as a symbol. What is the nature of this symbolism, and what

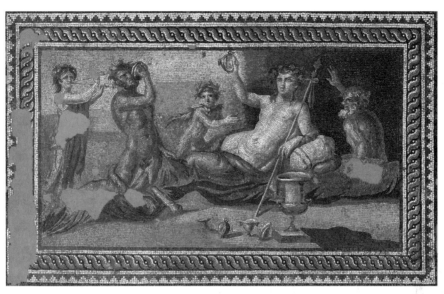

74. Early-second-century-C.E. mosaic from the Atrium House, Antioch. Worcester Art Museum, Worcester, Mass. 1933.36. Antioch excavation funded by the bequests of the Reverend Dr. Austin S. Garver and Sarah C. Garver.

message would it have conveyed to the Roman viewer? Macchioro compared the Bacchic mirror to the Christian cross; for him, it represents both an event and a promise, the transition of a human into a god and his salvific mission to the world. There may be some truth to this claim, but one would expect a symbolism of this kind to be far more widespread, and much less ambiguous, than it is. Moreover, the cross, for the most part,[157] suffices as a symbol; it has no active transformative role in ritual similar to that of, say, the elements of the Eucharist or baptismal water. Having reviewed the evidence, we have every reason to believe that the Dionysiac mirror was the part of the hierophant's or mystagogue's toolkit that made possible the most fundamental premise of the cult: the personal encounter with the divine.

The Romans who saw these artworks surely understood this at a fundamental level. Narratives of the mirror episode in Dionysus' youth are virtually nonexistent in art; what we have instead are numerous quotations of the story in depictions of ritual – quotations that often are as oblique as the presence of a child in a Dionysiac context, or the depiction of a mirror in the company of other ritual objects, or simply in the hand of a satyr. They transmitted not a mythical narrative or a ritual procedure directly, but a metonymic shorthand that denoted both the myth and the ritual founded upon it. Unlike the cross, the mirror *alone* carried no special symbolic meaning. But attached (more or less casually) to any Dionysiac imagery, it immediately evoked both a mythological narrative and – perhaps less distinctly, to a noninitiate – a ritual reenactment

of that narrative in which a novice took the role of the baby Zagreus, fixating upon it in order to achieve a hypnotic state of possession and release, perhaps even a kind of salvation.

Among the standard conduits to trancelike states – alcohol, drugs, rhythmic music, incantations, even masks – the mirror stands out as a highly artificial thing, more dependent on the power of suggestion brought about by its traditional status as a powerful, dangerous, and subtle magical device. Tradition, more or less esoteric or demotic in its origins, developed two complementary paradigms of the magical mirror. First, it was a tool of augmentation or *enhancement*: with proper preparation and supervision it made visible what otherwise could not be seen, the dorsal spirit domain. Second, and paradoxically, it was also a tool of *reduction*: it filtered and purified the souls of the living. As such it was a machine of *katharsis* so famously expounded by Aristotle, a cure effected only by way of violent emotion.[158] Thus its paths operated in both directions. As enhancer, it brought transliminal things over into the phenomenal sphere; as reducer, it allowed a properly cleansed and enraptured soul across its threshold into the world beyond. The iconographic technique of lamination consolidated the mirror's symbolic power, which may have seemed incomprehensibly esoteric to the uninitiated. Combined with the mirror's range of meanings, the *phiale* or the tympanum – and even the polished silver or bronze wine cup – gained nuance and power as metaphors of metamorphosis and implements of revelation.

FOUR

THE MIRRORING SHIELD OF ACHILLES

D ESPITE THE OVERTLY PHENOMENOLOGICAL NATURE OF MIRRORS, BOTH IN reality and in myth, what they sometimes signify in Roman culture is an inner transformation – a shock of recognition, a religious epiphany, a swing from hope to despair, from ignorance or self-deception to self-knowledge. The process of change is a subtle thing that rarely lends itself to pictorial description. Instead, depicted mirrors may occasionally disrupt the temporal continuity of the scene's narrative: the process of change is abstracted into a juxtaposition of "before" and "after," pitting the protagonist against his or her changed self in a mirror-image.[1] This presents the interesting possibility that the protagonist recognizes the other self in the mirror and is motivated by it, whether for good or ill. The represented mirror is therefore akin to didactic, which divides the self into subject and object, student and teacher. "Paradoxically," says Molly Myerowitz, "the splitting engendered by didactic heals the breach between life and art, demanding *metamorphosis*, a fluid interaction between reality and representation, what is and what seems to be, a process of dispersion and reintegration which requires, as Vernant puts it, 'that one travel in reverse the path of the mirror.'"[2]

The core experience of Dionysiac ecstasy is sometimes called peripety, a sudden and profound change in one's inner condition. The term *peripeteia* is encountered more commonly, however, in literary criticism, particularly in reference to the vicissitudes of fortune that characterize Greek tragedy. Myth

and story, Martin Nilsson often argued, tended to keep their distance from the realities of cult practice. Yet nobody would deny the capacity of fact and fable to influence each other in interesting ways – and most especially in the domain of signs. The mirror's efficacy in ritual was quickly abstracted into a repertoire of images, some of considerable sophistication. Was such a conceit as the lamination of mirror and tympanum born of its own accord, or did it borrow from the more "literary" conventions of mythic art? We cannot know the answer with any certainty. What I hope to demonstrate, however, is that the lamination of reflections to other receptive forms is as much a certainty in the pictorial realm of mythic story as it is in the art of Dionysiac ritual, and every bit as meaningful. And again, the richest collaborations of form and reflection convey the message of personal metamorphosis.

Leaving the world of wine, maenads, and song, we turn now to warfare and the lamination of a mirror with its literary vector *par excellence*, the shield.[3] These two objects are functional similars – they rebound, deflect – and metonymic opposites: one is associated with the battlefield, the other the boudoir; one betokens virility, the other femininity. Even the shield alone is not a straight-forward sign. It is a tool of war, but it averts war's worst consequence. By thwarting murderous intent, by turning the deathblow, it is a life force amid implements of death; yet the recoil can itself be baneful. As such, it sometimes plays a special role in literary and artistic symbolism, embodying the moment at which a thing is transformed into its opposite, or at least conveyed into an altered state. The shield, like the mirror itself and the Dionysiac attributes just discussed, is an agent of transformation.

It is only natural, then, that such a weapon – in essence a material rebuke – should be conflated with such a useful implement of self-awareness or self-awakening as the mirror. And the shield, like the magic mirror, has a moral force. This force is expressed in the imagery – threatening, protective, instructive, or apotropaic – rendered on its surface, and in the Hellenistic and Roman traditions of the *imago clipeata*, originally an honorific portrait of a great warrior rendered on a shield.[4] In Aeschylus' *Seven against Thebes*, the famous central episode during which a messenger describes the shield devices of each of the seven warriors at the city's gates marks what is perhaps the most precipitous change in a hero's personality and fortunes (peripety) in all of Greek tragedy. This passage conveys the thrust and parry of verbal combat. For each shield emblem reported by the tremulous messenger, Eteocles has a retort, turning the device against its bearer; but in a sense, the ripostes foretell his own demise.[5] Shields are functionally apotropaic, of course, but in literature and art they often transcend the bare function of turning away. They may be *palintropic*, turning a force or personality back against itself, even deep into itself.[6] As a signifier the reflective shield may act in favor of the man it was meant to protect, it may act against him, or it may do both at once.

THE SHIELD OF LAMACHOS

I begin with a much-discussed passage from Aristophanes' *Acharnians*. Although it is always dangerous to illustrate a cultural usage with a sample from comedy, which both upholds and subverts societal norms, the very multivalence of the passage emulates the complex ambiguities with which ordinary Greeks must have interpreted mirror images. The master Lamachos, called to war, is commanding a slave-boy to bring out his rusty and moth-eaten weapons. The snide old Dikaiopolis, in an exchange reminiscent of the thrust and parry of real weapons, echoes his master's commands and gestures mockingly:

> LAMACHOS: Bring here the gorgon-backed circle of my shield.
> DIKAIOPOLIS: And bring me a cheese-backed circle of flatbread!
> LAMACHOS: Isn't this mockery obvious to men?
> DIKAIOPOLIS: And isn't this flatbread sweet to men?
> LAMACHOS [to another servant]: Boy, pour on the oil. In the bronze I see an old man fleeing in cowardice.[7]
> DIKAIOPOLIS: You! Pour on the honey. Ah, it's clear now: an old man telling Lamachos, son of Gorgasos, to shut up.[8]

As a number of interpreters have recognized, this passage seems to preserve the vestiges of a rite of divination similar to catoptromancy or lecanomancy: Lamachos, in a fit of pique, threatens the old upstart with punishment by "forecasting" it in the oiled surface of the shield.[9] He gets as good as he gives: Dikaiopolis calls his bluff by divining in his own "shield," a circular flatbread "oiled" with honey, that his master will timidly retreat from his bluster. This interpretation seems reasonable enough, as far as it goes; but it does not take account of the whole picture, so to speak. The object of interest is, after all, a reflective *shield*, not simply a parlor mirror or a bowl of mantic liquid. As the boy rubs off the dust and rust, what is being revealed patently – for we have been told that it exists on the shield already – is the image of the gorgon head etched into its center. It is only natural to suggest, then, that Lamachos is projecting Diakaiopolis not into the future, but into the mythic past. Lamachos is Perseus, and Dikaiopolis is the (fleeing?) gorgon Medusa. Like the mythic hero, of whom I will have more to say in the next chapter, he is the pursuer armed with a polished shield – the only implement by which the hero could approach and behead the gorgon, whose face was deadly to the direct gaze. Perhaps, then, the quip is an oblique equivalent of "I'll have your head for this, you coward." It is meant to suggest the fleeing body of the old man, upon which is laminated, at the shield's center, the gorgoneion. In return, Dikaiopolis equates Lamachos indirectly with the gorgon by calling attention to his patronymic ("son of Gorgasos"). Earlier in the scene he has already made the analogy *directly*: when Lamachos laments, "I'm under a bad sign," the old

wag retorts, "Sure enough! You signed on with the big Gorgon" (1095). Here the emphasis is not on pursuer and pursued, or courage and cowardice, but on the master's congenital bellicosity and repulsiveness.

What we have, then, is a kind of hand-to-hand combat in which the verbal thrusts of both men are parried by their pseudo-mantic "shields." Adding to the complexity of the trope, however, is the conceit that the final two blows are not delivered with straightforward verbal thrusts, but with revelations extracted from the "shields" themselves. Defensive on the surface, these weapons harness within them the thunder of the offensive. There is no peripety to speak of in this scene; this is, after all, comedy, a format that scrupulously avoids examining the inner life of its characters. In more serious genres, a sobering transformation of character is implicit in mantic revelation. And even here the seeds of metamorphosis are evident: each of the principals in the scene has sought to transform his adversary into a gorgon. What is lacking, of course, is a proper sense of solemnity and acceptance; the "transformation" is mere insult.

THE ALEXANDER MOSAIC

Because of the strong magical associations with mirrors in antiquity, such as their purported power in assisting Dionysiac initiates in achieving mystical ecstasy, or the practices of catoptromancy and lecanomancy, one may reasonably surmise that reflections in a wide variety of contexts were not always taken to follow the empirical, slavishly phenomenological principles of ordinary reflectivity, but could represent a referent that was no longer in front of the mirror, or had not yet appeared, or was in some other way ominously (or happily) alien from its source. Certainly the markers of difference were embedded in the Narcissus story and in its pictorial manifestations, as well as in various interpretations of the Actaeon and Hermaphroditus myths. Let us then examine three case studies that use the principle of lamination in novel and sophisticated ways.

Without a doubt, the most poignant realization of the topos of the palintropic mirror in all of Greco-Roman art is the fallen Persian warrior on the Alexander Mosaic from the House of the Faun in Pompeii, probably adapted from a Hellenistic painting in the late second century B.C.E. (Figs. 75, 76). He catches a frozen glimpse of the forlorn relic of himself in a Greek soldier's shield at the instant before they are both to be crushed under the wheels of King Darius' chariot. As if to emphasize the insubstantial, fugitive nature of his reality, he caresses the shield's mirrored surface with his right hand. Tonio Hölscher and Ada Cohen see in the reflection and gesture a consummation of tragic pity in an Aristotelian sense: a man about to be accidentally killed by his own friends suddenly made cruelly aware of his own existence at the very moment of its annihilation.[10]

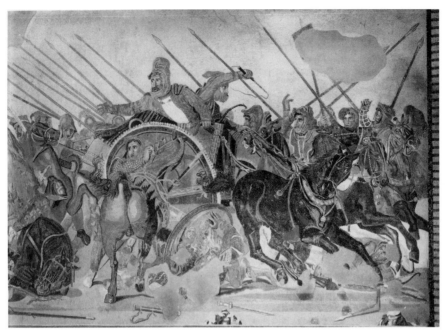

75. Right side of the Alexander Mosaic, from the House of the Faun (6.12), Pompeii. Late second century B.C.E. Naples, Museo Nazionale 10020. Photo: DAI Inst. Neg. 59.756.

This confrontation responds to a similar conjunction of face and frame nearby, the countenance of an attendant as he struggles with a panicking horse under the arc of the chariot's side panel. The second face, contorted in fear and desperation, is positioned eccentrically against the encircling border, much like the reflection on the shield below. Its features contrast markedly with the fey, expressionless reflection of the fallen soldier.[11] Are we catching a glimpse simultaneously of both sides of the ontological membrane? The living man is consumed with care; the dying man, whose feelings may match those of his terrified neighbor (we cannot see his *corporeal* face), beholds a vision of himself in a world beyond. But this world is not a rustic paradise of ecstatic release like the Dionysiac *thiasos*. It is release without condition or expectation.

That is just one way to interpret the mirror's action. The attentive ancient viewer may have recognized that this shield binds the common fate of two enemies – or, at least two men of alien circumstances, if Bernard Andreae is right to insist that the shield's owner is a Greek mercenary in the Persian army.[12] But for his bare legs and sandals, which identify him as a Greek, he is hidden behind it. The Persian sits with the shield thrust into his lap, his legs extending under it and to the left.[13] Like all apotropaic devices the shield is functionally binary; it generates both protection for the beneficiary and frustration (or worse) for the assailant or interloper. But here, as sometimes is the case in tragedy, those on both sides of the shield suffer as one. In a sense, then, the Persian is looking not

only into his own face, but also through the shield and into that of his Greek brother. One can even imagine it anatomically: the face, though diminished by the convex reflective surface, and now artificially isolated from its body by a lacuna in the mosaic, could almost belong to the legs of the Greek.[14] Not only is the face strangely featureless for a mosaic famous for its expressiveness, but also it is hairless. Most of the Persians have beards or vestigial moustaches.[15] The Hellenistic or Roman viewer, attuned to such subtleties, may have recognized a conscious composite – not, as Elisabeth Trinkl suggests, a self-portrait of the Greek artist, but a lamination of normally incompatible signifiers (clean-shaven face within the distinctively eastern headgear) on an intentionally featureless countenance to convey the universality and commonality of death. In the realm of signification, this mirror-shield is both reflective and transparent, like water.

What did the Alexander Mosaic's reflective shield convey to a discerning Roman patron that an ordinary shield would not? At least three things, I suggest. Implicitly, like the banter in Aristophanes, it substitutes for an amuletic device – the standard gorgon head, for example – the simulacrum of the enemy. There is an element of the uncanny in the result. The Persian, seeing his own reflection but perhaps expecting another, more conventionally hostile image on the shield, in effect becomes what he expects: the apotropaion against himself. At the very moment the dire glance is directed back toward him, its intent is fulfilled: the soldier is killed or grievously wounded, transfixed by his own gaze. Such is the mirroring shield's palintropic effect. But a less "primitive," more Aristotelian trope is at work too, the transmission of pathos. By seeing himself, the warrior objectifies his own death – and thereby sets in motion the mechanisms of self-pity. Witnessing a picture of his own suffering from without, he can all the more easily take the part of those who will grieve his loss. The dominion of the simple "I" wavers in the presence of the mimetic "thou" in the mirror: the subjective pain and fear of a dying man is complicated and compounded by the objective realization that his death will visit pain, pity, and fear upon others – and would bring even more if they could witness the agony that he sees himself.

Third, the mirroring surface has slyly introduced a process of filtration or refraction to complicate and enrich its capacity for simple reflection. The viewer is drawn to superimpose the reflected face of a dying Persian onto the notional body of the Greek behind the shield, who most likely was his antagonist. This process inverts the trope of self-improvement discussed in earlier chapters. A philosophic man, seeking to gain wisdom and gravitas, might invoke a great man as a moral mirror, imposing the best features (i.e., virtues) of that personage on his own. But here, in a more pictorial and imaginative way, a mortally wounded man is amalgamated with his dying enemy. Both suffer diminution by lack of moral differentiation from the other, particularly when contrasted with the triumphant Alexander in the left half of the mosaic. Here stature and deeds count for nothing; the two men are twins in misfortune.

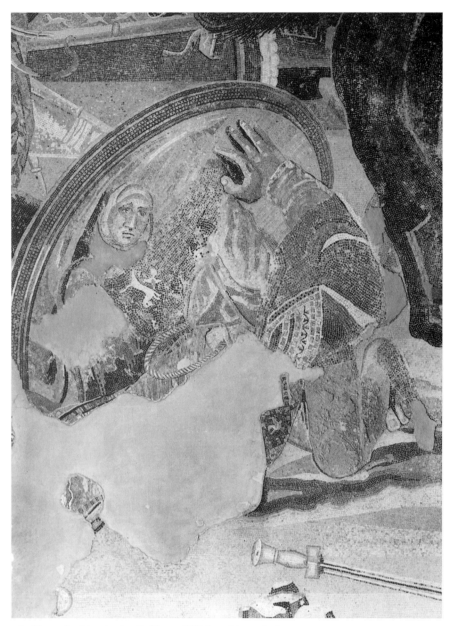

76. Alexander Mosaic, detail. Photo: DAI Inst. Neg. 58.1855.

Nobody can be shielded from his fate: and so it is strangely appropriate that, in its semiaccidental semitransparency, this shield's very substance is called into question.

ACHILLES ON SKYROS

If there is a measure of sentimentalism in the shield vignette of the Alexander mosaic, it is of a rarefied kind. A much more widespread conceit of

Greco-Roman art, one with a much broader sentimental streak, is the rivalry between love and war. Epitomized in the romance between Aphrodite/Venus and Ares/Mars, it was often reduced in art to an amusing misappropriation of symbols such as Eros/Amor playing with the weapons of the war-god or Aphrodite/Venus admiring her own reflection in her paramour's helmet or shield.[16]

Now let us turn to a strange tale of Achilles' youth, just before the outbreak of the Trojan War. This is the crucial moment of *peripeteia*, the turning point in a hero's life, and thus the kind of cusp of metamorphosis that is ripe for the mirror metaphor. Statius, in his *Achilleid*, tells the story in expansive detail. Writing in the late Flavian period, he is consolidating a tale that already resonated among Romans, as its continuous recurrence in art attests.[17] From Statius' "Flavian baroque" perspective the episode is presented as part Hellenistic romance, part warrior epic: Thetis, hoping to thwart fate, seeks to hide her son among the daughters of King Lycomedes on the island of Skyros. The dissembling mother presents the disguised Achilles as one of her daughters, and he joins the ranks of the girls. Much of the action here is subjective: Achilles swings between extremes of disgust for his ruse and desire for Deidamia, the fairest of Lycomedes' daughters; the latter urge keeps him in feminine character and disguise. At the moment he sees the girl "he drinks the unfamiliar fire into his bones"; his mother refashions him like a "waxen image" as she decks him out in a girl's outfit, teaching him the proper gait and speech. Fire will always melt wax: he succumbs to his passion, reveals himself to Deidamia, and rapes her. The ashamed girl conceals her pregnancy and the birth of Neoptolemus. Meanwhile, the Achaeans are assembling for war under Agamemnon. Suspecting that Achilles is hidden among the girls at the palace on Skyros, Odysseus, Diomedes, and their men come to seek him out. The king, unaware of the deception, allows them to search the palace. Nothing comes of this, so Odysseus/Ulysses devises a trick. He scatters on the ground feminine trinkets, but also a shield and spear. Then he orders an alarm to be sounded, and the clash of arms to be heard around the palace. The girls go after the trinkets; Achilles alone runs for the weapons, and he is revealed.

> When the fierce son of Aeacus [Achilles] spied the glowing shield chased with scenes of war – it so happened that it was reddened with the savage stains of war – leaning on the spear, he cried out and rolled his eyes, and his hair stood out from his brow. His mother's command, his secret love, were nothing; thoughts of Troy alone filled his breast. . . . But when he came closer and the mimicking light reflected his face, and he saw himself doubled in the gold, he shuddered and blushed together. Then keen Ulysses was at his side, whispering, "Why do you delay? We know you, pupil of the half-beast Chiron, scion of sky and sea. The Doric fleet,

indeed your own Greek fleet awaits you with hoisted banners, and the wavering walls of Troy herself sway for you!" (*Achilleid* 1.852–71)

Was this story in some way related to the Orphic myth of the baby Zagreus? Here again we have a male child raised as a girl to hide him from a pursuer; and again the pursuer hunts him down and distracts him with material things. Was it Statius, writing in the late first century C.E., who introduced the element of the mirror? And if so, is he consciously evoking the mirror that seized the attention of Zagreus? What cannot be denied is that a reflection – now appearing on a shield – again is instrumental in a crisis of identity. In Statius' version, Achilles is undergoing a transformation that is more than merely superficial; in Jennifer Trimble's felicitous phrase, he is at the "instant of heroic transformation, that keel of time on which destiny is poised."[18] How else to explain the ambivalence of his reaction? He shudders and blushes simultaneously (*horruit erubuitque simul*), which is to suggest that he fixes upon a single object, himself, but from two incompatible subjectivities. The warrior suddenly sees himself feminized, and shudders; the girl sees herself unmasked, and blushes. *"Horrere"* in poetry (literally "bristle") is mostly a masculine reaction, an adjunct to hairiness, which was rationalized as a marker of manliness.[19] Blushing, in this context at least, is a feminine response, a residue of sexual self-consciousness.[20]

As I have already explained, in the Greek and Roman intellectual traditions masculinity is a fragile thing that is easily corrupted by the opposing traits of hypersexuality and dissipation. The story of Achilles disguised as a girl cannot possibly have passed through the Roman cultural lens uncolored by widespread attitudes about the effects of feminine behavior upon male *virtus*. From the moment of his arrival, Achilles is assailed by unmanly weakness. It may be countered that Achilles' behavior on Skyros is driven by an unimpeachably macho intent to conquer Deidameia sexually, that his spirit scorns his disguise.[21] But the text of Statius leaves little doubt that Achilles struggles with conflicting impulses: sexual obsession and martial virtue.

The moment of Achilles' exposure on Skyros was a favorite topic in Roman art. Richard Brilliant has recognized the centrality of this scene in Roman funerary cycles of the life of Achilles, which in the second and third centuries formed "an illustrated and illustrative aretalogy for the benefit of the deceased."[22] This defining moment in the hero's vita (defining, at least, from the Roman perspective) marks a rite of passage, the transition from an ordinary to an extraordinary life. In painting and mosaic the theme remains common throughout Roman antiquity. Here I want to focus on variants of a pictorial type that come down to us from Pompeii, created only a few decades before Statius' *Achilleid*. Depicting Achilles' moment of peripety, all three of them employ an image on a shield to convey his critical moment of "reflection" in a way that is both subtle and sophisticated. Two of them are wall frescoes – one

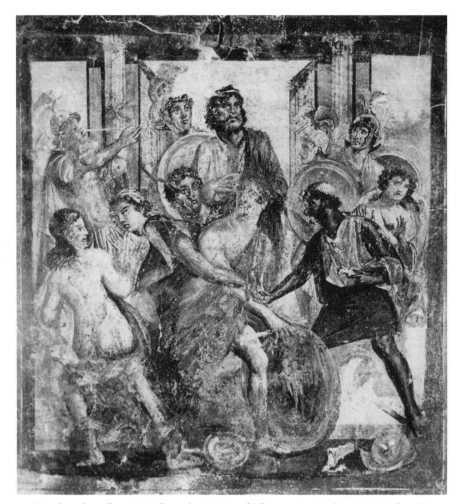

77. Fourth-style wall painting from the House of Ubonus (9.5.2), Pompeii. Naples, Museo Nazionale 116085. Photo: DAI Inst. Neg. 56.433.

from the House of Ubonus (or House of Achilles, 9.5.2); the other, which is incomplete, from the House of the Dioscuri (6.9.6–7). The third is a panel mosaic on a nymphaeum at the House of Apollo (6.7.23) (Figs. 77–79). All are thought to be loosely derived from an original by Athenion of Maronea mentioned by Pliny (*HN* 35.134). Despite many differences of composition and detail, they can be described in a rough composite.[23] A stagelike background provides a palatial setting for the action. King Lycomedes stands in the background surrounded by his bodyguard. To the left, also in the background, stands the armored trumpeter sounding the false alarm. In the central foreground Achilles, dressed in a loose woman's chiton, is shown lunging to the right to seize a sword and shield, while an Achaean reaches around him from behind and grasps his right arm. To the right Odysseus, identified by his

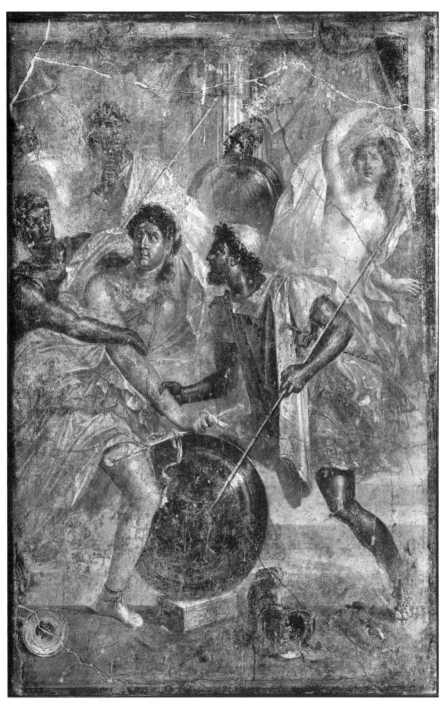

78. Fourth-style wall painting from the House of the Dioscuri (6.9.6–7), Pompeii. Naples, Museo Nazionale 9110. Photo: Alinari/Art Resource, NY.

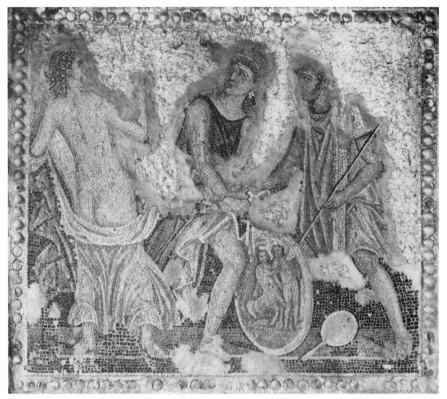

79. Mosaic on a fountain at the House of Apollo (6.7.23), Pompeii. First century C.E. Photo: DAI Inst. Neg. 56.463.

cap, leans toward Achilles to grab the same arm at the wrist. Achilles looks left toward a seminude girl who starts back in a gesture of surprise; she may be Deidamia, who is carrying his child Neoptolemus. Other female figures appear in various poses, always with hands raised to suggest fright and dismay. Masculine and feminine objects are scattered about on the ground around Achilles, sometimes in startling juxtaposition. A mirror appears in all three; a helmet in two. In the House of the Dioscuri panel, the shield is propped on a footed box, probably a pyxis or toilette case. The shield in Achilles' hand is turned toward the viewer, revealing on its surface the image of two spectral figures, one reaching around the other from behind (Figs. 79, 80).

The emblem belongs to a well-known type of figural group representing the centaur Chiron teaching his young protégé, none other than Achilles himself, to play the cithara (Fig. 81).[24] In most variants Achilles holds the cithara while the centaur reaches across the boy's body to demonstrate a musical figuration on the instrument: *leviter expertas pollice chordas dat puero* (Stat. *Achilleid* 1.187–8). Traces of Chiron's equine body can be seen only in the mosaic (Fig. 79), and the harp is visible in the example from the House of Ubonus (Fig. 77). In the

80. Detail of Fig. 78. Photo: DAI Inst. Neg. 56.497.

House of the Dioscuri version, the centaur's body is obscured, but his full beard is barely visible. Interestingly, in both pictorial and literary version Chiron is referenced at the moment of the young warrior's unveiling. Statius' Odysseus invokes the centaur at the moment of recognition; but in the picture, master and pupil appear as a silently reproachful pictorial device on the shield.

The presence of an emblem does not preclude the shield's function as a mirror, as Statius himself is at pains to observe. In his version of the tale, Achilles sees his reflection in a mirror chased with battle scenes and spattered with blood. Morevoer, as Trimble has observed, the viewer can hardly be faulted for having a visceral reaction to the shield image: whatever it "means" as an emblem, whatever the origins of its form and typology, it is *replicating the central action* of the larger scene; or rather, the main action is replicating the image.[25] As if to strengthen our inclination to see a reflection here, in all three versions a woman's mirror lies prominently on the ground nearby. Nothing intelligible registers on it; the dressing-room object seems to have yielded its reflective qualities to the masculine apparatus of shields and helmets. Recognizing that

the shield's surface *could* be understood as a mirror, Lilian Balensiefen concludes that the image on its surface is meant as a painted device and nothing more.[26] But Trimble has observed the prominent formal similarities between the principal action and the image on the shield; the latter, it seems, foreshadows the former. The image is unnecessarily spectral, as if it has been absorbed into its subsurface and hovers in a murky depth.[27] Nor is it just chance that causes Odysseus' spear to point directly at the image in two of the three variants.[28] The prominence accorded the shield, the attention drawn to the Achilles figure rendered on it, and the iterative gesture of the mentor-figure shown behind him all suggest that this is a mirror in the moral sense. To be sure, the image on the shield is not reversed, nor is the iteration perfect: the Achilles on Skyros is in motion, the Achilles on the shield static. But a *moral* mirror need not be an *optical* one; it is duplicating the two most important things in the larger painting, the act of the seizure and the identity of the seized – no more, no less. Why?

This mirror is party to an unmasking. The "false" Achilles is tricked out in full travesty, complete with an effeminate pallor. The "true" Achilles on the shield is nude; he has nothing to hide. This man, Odysseus' spear pointedly contends, is the Achilles we all know and admire, the one we have come to reclaim. If wine is the mirror of the soul, this unvarnished image, unqueered on the rebound, is the mirror of the true, uncomplicated Achilles. Chiron was the figure who did most to shape the virtuous character of the young warrior; his live-action twin is the Achaean (probably Diomedes) who accosts the unveiled hero. By seizing the "false" Achilles and exposing him, he signifies the agency of the Achaeans in reshaping the future warrior. By retrieving him for the Greek war effort, he is helping the youth to play the first halting chords *on the shield itself*, an instrument of his manhood. Achilles himself is the picture of ambivalence: a youth in the violent grip of reversal, perhaps even an identity crisis. He inclines toward the masculine but gazes back (longingly?) at Deidamia, the essence of emollient femininity, who returns his gaze. None of this registers on the shield: it is the picture of manly reticence and decorum. It is the picture of what must be.

Let us then review the shield's various modes of signification:

1. *The shield as prosthesis.* A prosthesis, as Umberto Eco formulates it in his semiotic essay on mirrors, is "an apparatus extending the range of action of an organ."[29] Any functional shield acts in this way: it corrects or extends a bodily deficiency. It is first and foremost an aid to self-defense. What the arm can do defensively, the shielded arm can do much better.

2. *The shield as symbol.* It is a universal adjunct of warfare and manly virtue. Its *form* is by metonymy representative of warfare. And its *application* is at once a stern rebuke to, and protection from, the temptations of luxury.

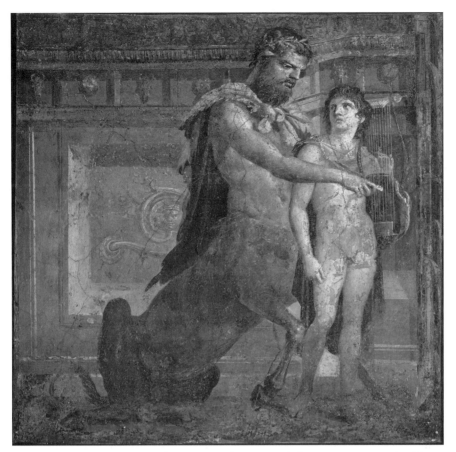

81. Wall painting from the "Basilica" in Herculaneum. Mid-first century C.E. Naples, Museo Nazionale 9109. Photo: Erich Lessing/Art Resource, NY.

3. *The mirror as prosthesis*. The mirror facilitates self-recognition and is a catalyst of shame, even if the mechanism works in two ways: Statius' Achilles sees the effeminacy he has acquired, and is ashamed; the pictorial Achilles senses the masculinity he has lost, and is ashamed.

4. *The mirror as symbol*. In the frescoes and the mosaic, the shield-mirror contradicts the ordinary dressing-room mirror lying on the ground nearby. The shield provides a mirror into which a man can look without succumbing to effeminate self-absorption. He will see himself, but (in this case) his horror will be salutary and he will simultaneously recognize the personal image to which he must aspire. The shield-mirror, in a word, is Socratic: it is an admonition for a man to know himself.

To these functions of the shield we can add the additional element of the device it carries, which is partly pictorial and partly catoptric in nature. In either case, it lies at one remove from the ontological plane of the mirror and shield; thus it acts as a sign but not as a prosthesis:

5. *The device as symbol.* The device, showing Chiron and Achilles in the ideal relationship of tutelage, collaborates with the shield itself to augment the corrective and admonitory tone of the episode. It turns out to be a reflection of sorts, in which Diomedes takes the part of Chiron and Achilles plays himself.

It should be clear by now that I do not find this characterization of the Skyros incident to be simply the most picturesque of numerous popular episodes in the Roman Achilles cycle – a scene in which a youth trained in manly virtue, chafing under the misguided protection of anxious elders, finally slips the bonds of his concealment and meets his glorious destiny. Rather, it is a kind of morality play representing a very Roman struggle between two possible destinies, each with its own attractions. The "female" in this story is nothing so simple as the absence of maleness; Achilles, after all, has a girlfriend, and a pregnant one at that. Nor does it have to do with a longing for peaceful domesticity with Deidamia. It is instead tied into the traditional vices of luxury, wantonness, and decadence, the bugbears of Roman public moralism. *Vestis virum reddit.* Achilles sits on the razor's edge of two possible identities. The moral of the story is that, with some timely help, he chooses the "right" one, reversing the abasement of feminization. Like the images of Hercules and Omphale in the same period, these first-century depictions of the womanized man may still deal some of the sting of Octavian's war of images against Mark Antony nearly a century earlier.[30]

In order to follow the path of the moral mirror, Achilles must renounce his hybrid nature. Man impersonating woman, pupil of half-man and half-beast, "scion of sky and sea" – he is a man divided between higher and lower natures. The "higher" nature to which he ultimately reverts is signified on the martial artefact, while the woman's mirror at his feet remains a cloudy pool of indeterminacy.

THETIS

Who initiated all this trickery on Skyros? The answer, of course, is Thetis, the mother of Achilles. Being a goddess she is fully aware of the fate her son will suffer, but she tries to avert it anyway. Although her plan on Skyros is thwarted early, she has recourse later to one of the most famous of all parental interventions in Greek myth, the forging of Achilles' armor. The episode is depicted in a splendid wall fresco from House 9.1.7 in Pompeii, now in Naples (Fig. 82). In the Achilles pictures a shield figured prominently; here it dominates the entire scene. But where Homer lavishes his attention on the narrative devices chased in gold and silver on the shield's surface (*Iliad* 18.478–608), we are confronted here with a shield dominated by a single sedentary,

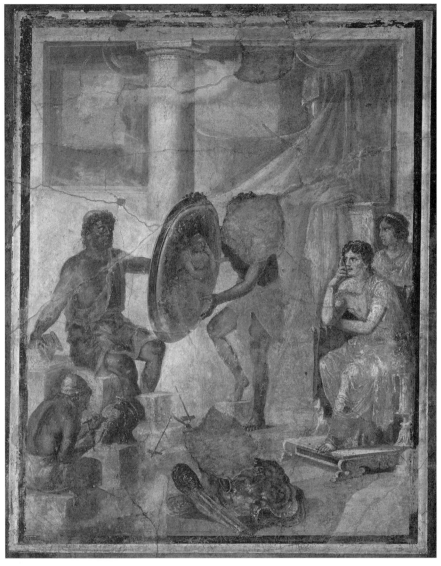

82. Fourth-style wall painting from House 9.1.7, Pompeii. Naples, Museo Nazionale 9529. Photo: Erich Lessing/Art Resource, NY.

enigmatic figure, the reflection of Thetis herself as she waits in the forge of Vulcan.

This is one of eight known Pompeian paintings on the theme, of which six survive.[31] Predictably, there are many variations among them, but only two – the one under consideration and one from the House of the Cryptoporticus – depict the shield with a visibly polished surface; and of these, only this one has a true reflection. Such variation should come as no surprise. Outside a handful of myths featuring a reflective image that is central to the story, there are no strong

typological traditions for the representation of mirror images in art. Reflected images are a "freelance" tradition, applied to more traditionally fixed schemata as the situation dictates. But this fact does not mean that reflections were less thoroughly encoded in the cultural consciousness, or that their meaning was entirely up to the whims of the artist. There are a number of *hapax horomena* among the instances where a mirror image is laminated onto a mythological setting.[32]

Evidence from numerous representations of Achilles' shield, as well as the interpretation of scholiasts and commentators on the *Iliad*, indicate that from Hellenistic times onward the shield of Achilles was interpreted as a *clipeus caelestis*, symbol of the cosmos – either earthly, heavenly, or both.[33] Variants of the Vulcan–Thetis scene show a winged figure at Thetis' side holding or pointing at the shield. The details on the shield itself vary, but in some instances the zodiac is given special prominence. In several cases the nymph reacts with either wonderment or dismay, her hand drawn up to her mouth (Fig. 83). Françoise Gury has demonstrated conclusively, in my opinion, that the attendant figure is an embodiment of fate, perhaps Themis. The larger subgroup of these paintings, she reasons, represents a distinctly Roman variant of the tale that emphasizes the mother's sad encounter with her son's destiny forged on the shield. But the two frescoes depicting polished, relatively uncluttered shields stand apart.[34] Our fresco in particular shifts the emphasis from the shield to Thetis herself, whose brooding mirror image is framed in the circle like a funerary portrait. In doing so, it departs significantly from the traditional meaning of the forging scene.

Thetis' very being, at least in the *Iliad*, is tied up in the glory of her son Achilles; but she awaits a fate even worse than her son's, relegation to eternal bitterness and loss. Martin Robertson suggests that the picture before us, portraying an enigmatically impassive protagonist reflected in the brightly polished shield, is in the midst of divination:

> The tragic mother, trying to arm her son against a fate which she in fact knows he cannot escape, should not, one feels, sit looking at her own reflection in the shield, or even just admiring its workmanship. It is possible that in this we do the goddess and the artist less than justice. Catoptromancy – reading the future in a mirror – was a widespread Greek practice for which a shield was often used; and the pose and expression here of Thetis, with the glances of her attendant and of Hephaestus [Vulcan], suggest that the mother may be looking once more for an assurance against hope that her son may cheat his fate.[35]

It is an attractive suggestion. One may be seduced further by Gury's argument, which places the Pompeian forge scenes, and other images of Thetis, in a context that is saturated with symbols and allegories of fate and foreboding. There does appear to be an unimpeachable precedent for Thetis' attachment to a magical divinatory mirror, too. A well-known Etruscan bronze mirror

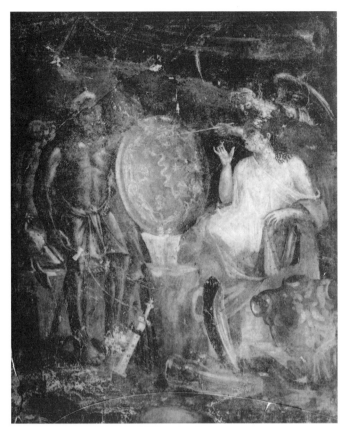

83. Fourth-style wall painting from the House of Ubonus (9.5.2), Pompeii. Photo: DAI Inst.
Neg. 48.26.

represents her husband Peleus reacting with horrified surprise as they both
gaze into her "mantic" mirror (Fig. 84).[36] The primping bride sees nothing
out of the ordinary – and we, the viewers, are compelled by the ordinary
reflection to take her point of view. Only the groom reacts, and he is literally
bristling with horror.

But let us recall from the previous chapter Delatte's cardinal rule about
catoptromancy, both in antiquity and in the middle ages: it is principally a
hallucinatory phenomenon, not an ominal one. Personal encounter, not orac-
ular knowledge, is its object. Nancy de Grummond has likened Peleus' gesture
to the "divine wind" trope, in which the frenzy of possession is signaled by
billowing clothing and especially hair standing on end.[37] It is well to observe
further that among the eight Pompeian representations of Thetis in the forge
of Vulcan, none of the shields that can be called mantic is reflective, whereas
the single truly reflective shield – the one we are examining here – is not obvi-
ously mantic; Thetis registers no response whatever. Indeed why would Thetis,
seeking information about her son, find *herself* at the center of an oracular disk?
The Etruscan mirror, though it features a seemingly normal image of Thetis

in her mirror, at least conveys a terrible presentiment of fate by the violent reaction of her husband. In our Pompeian fresco, there is no reaction whatsoever. In the Greco-Roman Thetis cycle, it is probably a shield's representation of the *heavens* that lends it oracular power, not its reflectivity per se. In one respect Robertson is mistaken: apart from the episode in Aristophanes, which is more oblique than most interpreters have thought, there is little evidence for divination in reflective shields.

Balensiefen reviews a number of hypotheses that have been put forward to explain this scene, none of them entirely persuasive.[38] Noting, as others have,[39] that the damaged figure of a "cyclops" assisting in the presentation of the shield bears a passing resemblance to the Aphrodite of Capua in its pose, she extrapolates the notion that Thetis' self-regard is the central theme of the picture. Leaving aside the obvious questions of why a cyclops should be a stand-in for a paradigm of femininity, and why this figure does not (as Venus always does) admire its *own* reflection in the shield, one is still left to wonder why Thetis, of all goddesses, who lives for her son and not for herself, would countenance such an exercise in self-absorption.

The shield is not exclusively reflective; its rim is decorated with fragmentary battle scenes.[40] In customary Pompeian fashion, the pigment was applied *al secco* to the surface of the fresco and has since disintegrated. The touches of luminosity that appear around Thetis' reflected head, it would seem, all belong to the border motifs; the outline of a rearing horse in three-quarter view is still clearly visible on the left side. There is no sure evidence that *anyone but Thetis* appears in the reflection – not Vulcan's assistant, not the handmaid. In essence the shield is a full-body portrait enframed in a lost, but perhaps ancillary, battle narrative.

Why does this picture seem so inscrutably oblique to modern analysis? Perhaps because not much is happening: the figures simply exist in relative space. We learn little of importance by looking at the details around the periphery of the shield or of the painting. (What is Vulcan doing with his right hand? What are the devices on the armor? It does not seem to matter.) The picture's iconographic simplicity seems almost to be its very raison d'être: the viewer is drawn to the smooth, adamantine surface enframing the principal character. Yet Thetis, rather like her son, is the embodiment of a tragic duality. She is a denizen of the water; let us recall that in the *Iliad*, no less, it was Thetis herself who gave shelter in her watery refuge to the fleeing Dionysus (6.135–7). She was forced not only to marry into the human race, but also to seek affirmation in the earthly pursuits of her husband and son. Immortal, she is burdened with the sufferings of mortals. Her glory and her suffering are activated by the institution for which the shield stands, warfare, and the man for whom it was created, her son Achilles.

We are beholding, then, nothing more than the two faces of Thetis' dual nature. Even her pose is ambiguous, in both an informal and an iconographic

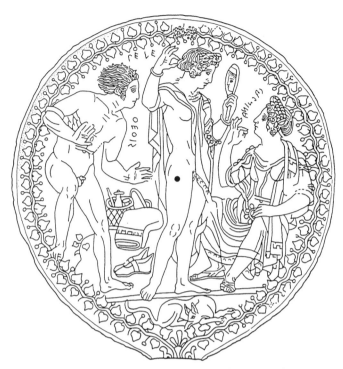

84. Etruscan engraved bronze mirror. New York, Metropolitan Museum. Drawing After *CSE* U.S.A. 3.14, courtesy of N. de Grummond.

sense. In Roman usage it resembles both the *pudicitia* stance of the privileged matron and the tragic contemplation of mourning figures or the female allegories of defeated nations.[41] Both identities are applicable to Thetis, *dysaristotokeia*, or "mother of doomed greatness"; and it has been argued more than once that this particular stance evolved into a conventional Thetis type.[42] In the former guise, she appears as the queen of her narrative realm, surrounded by those who serve her. In the latter, she is all alone in the mirror, timeless, an eldritch luminosity against a darkness reminiscent of the "dusky veil" in which the goddess enshrouds herself before her final, despairing visit to Achilles in the *Iliad* (Il. 24.93–4). The reflective shield is mantic after all, but not in the way Robertson imagines. As Mary Beard and John Henderson have recently suggested, "in looking into the shield that spells her son's destiny, she sees her own."[43] On earth, Thetis has a story; but when that story is over, she will be reduced to the solipsistic, virtual state of her image in the shield. The shield itself can be taken as a sign of the inner mechanism that brings home the futility of Thetis' delays and subterfuges – that brings resignation and perhaps even acceptance.

But it is not that alone. The wedge driven between Thetis' two states is her son, "scion of sky and sea," and the Trojan War in which he participates. It is appropriate, then, that Achilles and his war should be represented by a shield,

and that a frieze of martial scenes decorate its surface. It reifies the divide, reminding the viewer that the war actualized both sides of Thetis: first her glory, through her son's exploits, and then her grief and decline after his death. The scenes of warfare floated on the watery surface almost as if they were the Achaean ships themselves, launched despite Thetis' pleas and subterfuges. In Statius' *Achilleid*, Thetis wishes to roil the flat, impassive surface of the sea, to smear the clearly defined threshold between worlds (1.30–32); but Neptune warns her, "Do not try vainly to sink the Dardanian fleet, Thetis; the fates forbid it" (1.80–81). This quiet, still image, then, is itself a metamorphosis. It is the goddess enshrined in her grief, without her son and thus shorn of her vitality and ambition – relegated again to her lonely, watery world inside the mirror. If the Dionysiac reflection conveys *ekstasis*, this one reveals the opposite: a retreat into the stasis of the self.

Between her two states, and coextensive with the mirror, stands the agent of her metamorphosis, the shield. Its maker, Vulcan, may also be embroiled in this catoptric metaphor. Like the Cretan master-craftsman Daedalus, he is a maker of snares, a wizard of entrapment.

> Indeed, Daedalus and Hephaestus, his divine double, are makers of marvelous things that fascinate the beholder, many of these by imitating life in an almost catoptric sense; but, as Eliade points out, these mythical artisans are above all master binders. . . . We may well wonder if at the core of this fascination is again a kind of mirroring: the manifestation in objective space of a self-image and the consequent enslavement to it.[44]

By Vulcan's artifice, Thetis is drawn spellbound into the mirror, animating its surface narrative with her own static reflection. In a sense, the shield may resemble the doors of the temple of Apollo at Cumae wrought by Daedalus. As many commentators on *Aeneid* 6.14–33 have noted, their bronze reliefs tell a heroic story – the slaying of the Minotaur in the Labyrinth – without its hero. Willard McCarty sees here a spell in the act of binding: into the reflecting bronze the fascinated Aeneas casts *himself* as the absent Theseus.[45] But rather like the Athenian hero, he is able to thread his way back from the magnetic center of his fantasy, shaking off the spell with his own journey through a very different kind of labyrinth, the underworld. Thetis' destiny is otherwise. She swirls inexorably and irretrievably toward the molten core of the mirror. There is no escape.

BOSCOREALE

It remains to discuss a celebrated image on the famous megalographic frieze taken from the grand triclinium of a luxury villa of Boscoreale near Pompeii, now divided between museums in New York and Naples (Figs. 85–87).

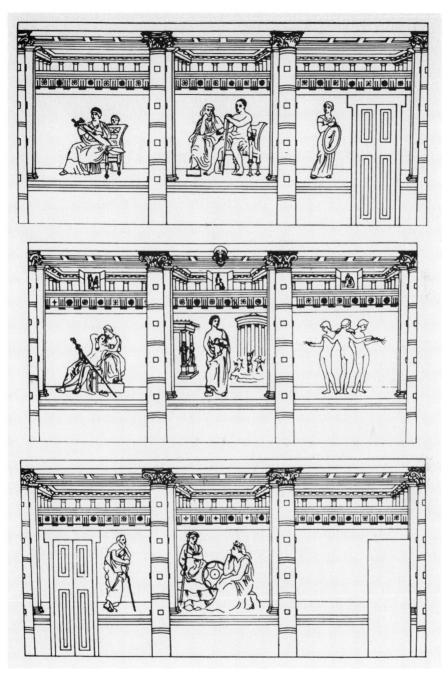

85. Schematic drawing of the three walls of the great frieze of triclinium H in the Villa of
Publius Fannius Synistor at Boscoreale. Mid-first century B.C.E. After A. Gaviria. Little 1964,
pl. 25. Courtesy of Archaeological Institute of America/*American Journal of Archaeology*.

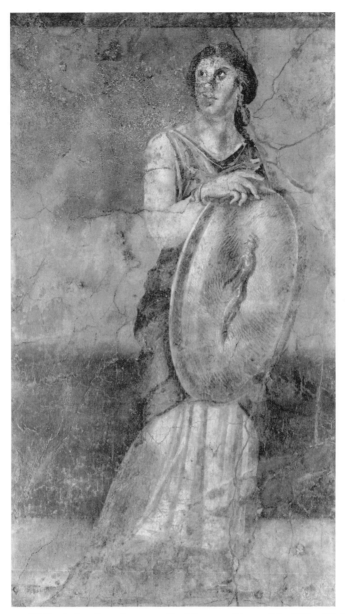

86. Wall painting from the east wall of the great frieze of the Villa of Publius Fannius Synistor at Boscoreale. New York, Metropolitan Museum 03.14.7. Image © The Metropolitan Museum of Art.

Since the publication of monographs by Phyllis Lehmann and Erika Simon in the 1950s, many scholars have taken this image, isolated somewhat from its companions on the right side of the room's east wall, to represent a scene of divination.[46] The young woman holding the shield, it is argued, is a priestess, the interpreter of the mantic image appearing in the shield's polished reflective surface (Fig. 86). The *mise en scène* for this reticent tableau is putatively a royal wedding; to the left of this figure is the central and most important group

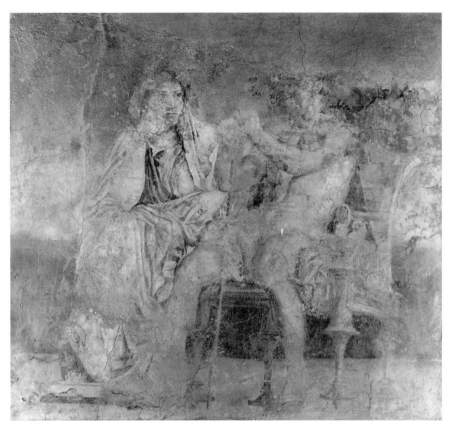

87. Wall painting from the east wall of the great frieze of the Villa of Publius Fannius Synistor at Boscoreale. New York, Metropolitan Museum 03.14.6. Image © The Metropolitan Museum of Art.

on the wall, a seated royal couple, the woman in a pensive pose reminiscent of Thetis in the forge of Vulcan,[47] the man heroically nude but for some loose drapery in his lap (Fig. 87). In the Hellenistic world, a divination ritual may indeed have taken place at royal weddings in order to lend an auspicious air to the union. The sketchy male nude appearing in the shield – variously identified as Alexander the Great or some other Hellenistic ruler – has thus been understood as a premonition of a future heir.

This interpretation has been questioned.[48] Balensiefen recognizes that the vaunted "ghostliness" of the shield-figure – his body fades away at the ankles – is a technique used on painted shield blazons elsewhere in the Pompeian region, including those in the Achilles on Skyros frescoes. To her it appears to be a naturalistic device to represent the loss of detail in the glint of the shield's surface. Frank Müller, on the other hand, argues that the young woman's clothing is not that of a priestess.[49] Moreover, one might observe further, the young woman seems to be gazing at nobody in particular; certainly she is not in the act of conveying the good news to the couple next door. If she were a priestly

interpres, why would she be looking away from the image, rather than observing it intently? (Those who read the previous chapter have already anticipated my response.) Müller contends that the young woman is a naiad in the retinue of Thetis who carries the shield of Achilles itself. Such figures are occasionally enlisted to serve as *hoplophoroi* for the famous shield in Roman art. Accordingly the scene to the left depicts not newlyweds, but rather Achilles enthroned next to his veiled and anxious mother. To establish the shield's identity, it is emblazoned with the image of Achilles himself, identified by his white diadem and a heroic nudity. However, R. R. R. Smith has contended that the seated male figure, who wears no diadem but holds what appears to be a scepter, must be interpreted as a Hellenistic dynast – perhaps Demetrios Poliorketes – before his ascent to the throne; the shield bears a vision of his future son (Antigonos Gonatas?), whose diadem marks him as a king. Müller dismisses any suggestion that Romans paid such overt attention to the Macedonian epigones of Alexander, preferring to read both figures as Achilles.

The truth, I believe, falls somewhere between the stools of the seers and the skeptics. Balensiefen deems it essential to decide whether the image on the shield is an emblem or a reflection. As the reader will already know, I find such binary divisions, at best, too constraining; at worst they set up a false dichotomy. With the Skyros shields, for example, it has been possible to construe the encircled image as both emblem (thereby broadening the circle's play within the universe of shield-meanings) and reflection (which enriches the circle's meaningfulness within the greater sphere of possibilities encompassing mirrors). That said, as a shield device this image has nothing to recommend it. It has none of the monochromatic flatness of Greek blazons (and we must remember that every *round* shield in Roman art is an anachronistic concession to the Greeks); it is in full color, and seems to make every effort to project both illusionistic naturalism and an aura of mystery. Frontality is avoided; instead the man's bronzed nude body stands in static profile. Graphic clarity and simplicity are rejected, and the body conforms to no known figural type. As if caught off guard, the figure stands slouching in a purposeless flaccidity that seems almost radically accidental. Even the halfway-reflections on the Skyros shields, which do conform to figural types, do not advance this far toward the annulment of almost every convention of a shield device.

On the other hand, it is awfully hard to declare this nebulous figure a reflection when there is neither an implied referent (the *real* young man is nowhere to be seen, at least not in a synchronous stance) nor an implied audience within the frame of action. We would expect a referent if we were viewing an ordinary (nonmagical) reflection. We would expect an audience if this were a scene of catoptromancy or the like. It could be countered that *we* are the only audience necessary; we stand in for the protagonists, who are busy elsewhere, or compositionally could not be accommodated into the

shield-bearer's tableau, which is constrained by a painted column to the left and a doorway to the right. But such excuses are unnecessary. The immediate "audience" may well be none other than the woman herself. It has been easy to mistake her sidelong glance for inattention or disengagement from the object she holds (in favor of the "Macedonia" scene on the opposite wall, perhaps). Instead, like the similar gesture of Silenus in the "divination" scene of the Mysteries frieze (see Fig. 71), or of the centauress on the Berthouville *skyphos* (Fig. 63), she is engulfed in the mystery of the mirroring shield, to which she has been *more* than attentive. Her rapture is not explicitly Dionysiac, but it borrows from Dionysiac convention.[50] Is she therefore having a vision of future greatness, as many have believed?

If the man on the shield is meant to be a great hero, his heroism (and every appurtenance of heroism, but for his diadem) has temporarily gone missing. That is not to say that he is *not* a hero or a king; I simply want to suggest that there is a disjunction between the man and his *dignitas*. Here he conquers no enemy, rides no triumphal quadriga. Nor does he stand in a regal frontal contrapposto, leaning on scepter or spear. (I do not go so far as to think him a caricature, despite his minatory nose.) Presuming that the woman who sees him is thoroughly *manic*, one may fairly suggest that she is not altogether *mantic*; that is, the future is not her concern. What she beholds in the mirror, I believe, is the dejected shade of a dead man. That is to say, the shield-bearing woman, who is indeed some kind of *interpres*, is channeling the spirit of a prince in the time-honored Italiote tradition. But rather than render him emparadised in Elysian grandeur, as the Apulian vase painters invariably did, the artist has chosen here to emphasize the pathos of an early death and bereavement. It is only natural to regard the couple in the neighboring tableau either as the deceased youth's parents, or as the young man himself with a female relative who has assumed the proleptic gesture of mourning, so similar to the figure of Thetis that I discussed earlier. The man in the shield, the implicit object of the draped queen's grief, represents nothing if not greatness interrupted – and deeply disappointed.

Of course Greek greatness generally amounts to military prowess. The Apulian staples of hand mirror and *phiale* have thus given way to a shield, an appropriate enough symbol of conquest perfectly in keeping with the theme of "spear-won" Asia across the room. But the figure appearing within it can be no Hellenistic prince, for Macedonian royalty – even if they died early – found a place in heaven with the gods, not a dubious eternity in the underworld. Much as Smith has advanced our understanding of the historical context of the frieze overall, it is hard to argue with Müller's conviction that the hero on this side of the room is Achilles – shown in the center enthroned with Thetis during life. On the shield, he is encountered unawares, like the dejected warriors skulking about Hades in book eleven of the *Odyssey*.

88. Fragmentary wall painting depicting Aphrodite Hoplismene from Building 7, Corinth. Late second century C.E. American School of Classical Studies at Athens, Corinth Excavations Inv. A-1990-8.

The dichotomy of nations established on the opposite wall, in which an allegory of Greece is shown as the conqueror of Asia by planting her spear across the blue trickle of the Hellespont,[51] resonates with this frieze; for Achilles was a great Greek who conquered an Asian foe, Troy, beside those very straits. The Macedonian dynasty claimed descent from Achilles, and Alexander developed this genealogy into an obsession.[52] If such overt pathos as the shade of Achilles, untimely slain, seems out of place when paired with a program of Hellenophile propaganda, it is wise to remember that we are in Roman Pompeii, not Hellenistic Alexandria or Antioch. Even the triumphalism of the Alexander Mosaic, found only a few miles away, is tempered with pathos,

as we have seen; here the sentiment is magnified to the extent that it applies to the conqueror. Like the precocious hero of the Trojan War, Alexander – Achilles reborn – died young. Such reminders are perfectly in step with the Roman virtues as they were understood by the Pompeian aristocracy ca. 40 B.C.E., when this frieze was created or loosely adapted from a pattern book.

The shield of Achilles has again emerged as a literary mirror of metamorphosis and a tool of moral instruction. Almost by accident, we have followed an arc in the hero's career from his extreme youth, through the doomed mission of his

89. Bronze coin of Corinth. Circa 211 C.E. American Numismatic Society 1956.174.73.

mother, to the aftermath of his death. Perhaps we, the viewers, are meant to take the part of Thetis, to goad the priestess into her vatic trance for the sake of a final viewing of the beloved dead.

"LOOK BEHIND YOU": THE RELAMINATION OF THE SHIELD–MIRROR

Relamination, I would argue, is an important part of the evolution of the shield as a sign in Roman art. The act of replacing one lamina with another is nowhere so openly represented as in the mutation of the late-Classical Aphrodite of Capua type. Associated most closely with the Aphrodite *hoplismene* cult statue at Corinth, it represents the standing, seminude love goddess gripping a shield by its top and bottom as she admires herself in its reflection (Figs. 88, 89).[53] In the Roman period the type was transmuted into a Victoria in a virtually identical pose writing on a shield (Fig. 90).[54] In itself, the latter image conveys a simple votive message. But to the educated Hellenistic or Roman viewer, it would have evoked the earlier tradition of Venus preening in the armor of Mars – a figural type so well known that it even made its way into literary ekphrasis. Apollonius, describing the images woven into Jason's mantle, encounters "Cytherea [Aphrodite] with drooping tresses, wielding the swift shield of Ares; . . . opposite in the shield of bronze her image appeared clear to view as she stood" (*Argonautica* 1.742–6).[55] The irony of this odd pairing of personae in a single figural type is delicious: Aphrodite/Venus, conqueror in love, and Nike/Victoria, conquest personified. Normally these two figures stand on either side of the ontological divide I have just described; for one

goddess sees a reflection, the other obliterates the anticipated reflectiveness with writing.

I suggested earlier that a shield can be an ambiguous thing, a weapon that may turn back the hopes of either defender or attacker. As such it is dangerously unstable. A mirror or even a painted device laminated on its surface characterizes this instability, whether it appears in Aeschylus' *Seven against Thebes* or the Alexander Mosaic. That which failed the defeated could very well fail the victor in turn; it must be remade to protect the victor. The act of writing, of issuing a proclamation on the shield's surface, may be seen as a distinctively Roman way to overmatch this instability, the vertiginous magnetism of the mirror, by sheer force of will. Writing on a mirror – and Victoria's shield, cradled in precisely the same way by the vain Aphrodite, would undoubtedly have called to mind the mirroring shield of the love goddess – completes the victory by banishing the ghost-image of defeat, or the possibility that defeat will rebound upon the victor. The mirror becomes a lamp. Like the related *imago clipeata*, it proclaims the victor's virtues and his good fortune; its function as a reverser of fortune is eliminated. It is now a prophylactic tool of unidirectional moral suasion, or of a glorious fait accompli.[56] The glistening eye of alterity winks shut and its lids are sutured with words.

The words themselves are hardly important. Normally they are triumphal platitudes, sincere or not. It is the *act* of writing, clothing the notional mirror in epigraphic habit, that ratifies peace and negates the ambiguities of war.[57] The mirror is a dangerous channel of truth, even a portal of death. Folklore is full of evidence that these "soul catchers" were to be treated with caution; that a baleful double might beckon from inside the mirror, or step through it into the phenomenal world.[58] Converting Venus into Victory, and self-contemplation into triumphalist proclamation, should not be taken as simply a crude attempt to destroy nuance or to avoid self-knowledge and empathy with the fallen. It is a genuine apotropaic act, like setting up a trophy on the battlefield as a kind of scarecrow to confound the ghosts of the dead.[59] As I suggested earlier, Roman triumph was both arrogance and its antithesis. The *triumphator* was allowed to play-act at being a god; yet simultaneously a human surrogate of Victoria, holding the crown of victory over his head as he rode in his ceremonial chariot, repeatedly whispered in his ear, "Look behind you; remember that you are human."[60] To impersonate a god is to invite immediate reprisal from the *real* gods; in principle, the triumphant general must be a veritable Uriah Heep, humble to perfection. The attendant, like countless images of a winged, hovering Victoria, suspends the crown over the triumphator's head. Why not simply allow the victorious general to wear the crown unmolested? The message seems to be this: "I grant you the privilege of glory, but I can also take it away." The upshot of these rituals is that victory, for all its jubilation and bravado, was undergirded by fear – fear of *invidia*, of the ghosts of the dead, of blood pollution left uncleansed, of the turning of

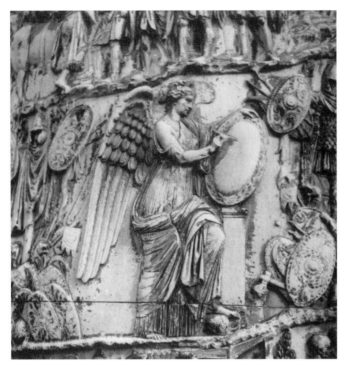

90. Relief from the Column of Trajan, Rome. Circa 115 C.E. Photo: DAI Inst. Neg. 41.1480.

the tables. The quasi-magical act of writing on the shield offered a way of simultaneously drawing a curtain on the other world and granting the curtain a semblance of the moral force and symbolism of the now-forbidden images of otherness.

CONCLUSION

The Helleno-Roman convention of inverting the symbolism and function of weapons in the bedroom found an appreciative audience in the Renaissance. The mirror-shield, memorably, appears in Tasso's *Gerusalemme liberata*, when Rinaldo's men, led by Ubaldo, set out to reclaim their hero from the bewitchment of his lover Armida.[61] This episode was surely inspired by Statius' account of Achilles on Skyros:

> Meanwhile Ubaldo approaches; now he wheels against him the polished adamantine shield.

> Toward the glowing shield he turns his eyes; it mirrors the thing he has become, and how wholly decked in wanton luxury. His hair, his mantle breathe perfume and decadence; And his sword – his sword! (to speak of nothing else) – he sees, by unchecked luxury womanized at his side: so decorated that it seems a useless trinket, no fearsome tool of war.[62]

The corrective mirror, laminated onto the shield, reverberates through the ages, resurfacing even in the final moments of *Man of La Mancha* to activate the *peripeteia* of the spent Don Quixote. This reproachful, diamond-hard tool, like any good shield of song and story, is many-layered. It consists of multiple meanings laminated into a single, coextensive whole, each retaining a discrete and complementary function. In most of these cases the artefact encompasses a functional dialectic between the shield itself (martial, manly) and the mirror (domestic, womanly) to activate a similar moral conflict within the protagonist. Achilles and Rinaldo owe everything to their encounter with mirroring shields, which have protected them from *themselves*. In each case the hero's schizoid personality takes its position, in effect, on both sides of the shield simultaneously: one persona is put to flight, one remains holding the shield. Thetis carries within her the seeds of Achilles' dilemma, but hers is even more ambiguous and vexing. The very thing that saves her son from himself will eventually destroy him. This fate is of no great concern to Achilles himself, who is assured of unrivaled glory in the field. His mother, on the other hand, must live with the Faustian bargain that determines the course of her son's life.

Only at Boscoreale does the asymmetrical diptych break down with the disappearance of the shield-mirror's human referent. But not entirely, for the young man who lurks in the gloomy depths of the priestess's shield may be the shade of the seated figure directly to the left. There is no formal symmetry, no duplication of stance, gesture, or scale. Nor is there interaction between a principal and his reflection. What remain, though, are two powerful and mutually referential images, one of Achilles in life, the other of the hero in death. Differentiation again is the operative principle governing this pair, here not so much a moral dilemma as a simple memento mori. Beside the "living" Achilles sits his mother Thetis, who appears already to be contemplating her dead son enshrined in the adjacent vignette, much as she appeared in the forge of Vulcan. Like a fifteenth-century Madonna,[63] she visibly anticipates the suffering and loss of the blessed child in her presence.

THE MIRRORING SHIELD OF PERSEUS

T HE STORY OF PERSEUS AND MEDUSA, LIKE THAT OF NARCISSUS, HAS remained an inexhaustible object of commentary over the years, inspiring an extraordinary wealth of analysis and speculation.¹ The core story is familiar enough, although there are many variants. In brief, it goes as follows.

Born of Zeus/Jupiter and Danaë, Perseus was exiled with his mother on the island of Seriphus. To make good on a boast to Polydectes, king of Seriphus, the hero Perseus went in search of the three gorgon sisters in order to kill the single mortal among them, Medusa, and return with her head. Any mortal who saw Medusa's face was turned to stone. The causes of this phenomenon are not easily traced. In early versions of the story the gorgons are hideous, bestial creatures; but in later variants Medusa, at least, was aestheticized into a stunning beauty. When Poseidon raped her in Athena/Minerva's sanctuary, the enraged virgin goddess rendered her beauty lethal to human eyes.² Along his journey Perseus had been equipped with an arsenal of magical aids necessary to hunt her down: a hooked sword from Hermes/Mercury; from some of his hosts along the way, winged shoes; an expanding bag that would enclose the severed head and shield humanity from its mischief; and the magic hat belonging to Hades (or Hermes/Mercury) that made its wearer invisible. From Athena/Minerva he borrowed a polished, reflective shield.

Perseus sought out the hermitlike Graiae, who alone knew the whereabouts of Medusa. These three aged sisters shared among themselves a single eye and a single tooth, each passed along by hand when one of them wished to see

or speak. By intercepting these precious organs in transit Perseus extracted the information he sought. Coming upon Medusa and her two gorgon sisters while they slept, the hero was unable to approach them directly for fear of being turned to stone at the sight of Medusa's face. While holding the shield before him as a mirror (sometimes Athena is said to have held the mirror), he guided the death stroke behind his back, beheading Medusa in her sleep. From the wound were born the winged horse Pegasus and the hero Chrysaor. Perseus thrust the head into the bag with averted gaze, and then took advantage of his invisibility to make his escape from the pursuing sisters. He came to Ethiopia, where he encountered the lovely young Andromeda shackled to a rock by Poseidon/Neptune because her mother, Cassiopeia, had boasted of being more beautiful than the nymphs. In exchange for the surety of Andromeda's hand in marriage, Perseus promised the distraught parents that he would deliver her from bondage. Keeping guard over Andromeda was a fearsome sea serpent. Perseus killed this monster with the sword (in one version he petrified it with the gorgon's head for good measure).[3] As promised, Perseus and Andromeda were married. Returning to the land of his childhood exile, the island of Seriphus, Perseus learned that his mother Danaë and her protector Dictys were taking refuge from the aggressive advances of King Polydectes. Brandishing the head of Medusa at the wedding feast, Perseus dispatched the king and his supporters, leaving them as stony statues. Changing his role from impetuous hero to man of affairs, Perseus became a power broker among kings and eventually king of Tiryns himself. His heroic deeds done, he gave the head to Athena and returned the shield. The goddess inserted the gorgon's head in the middle of her aegis or her shield.[4]

The purpose of this chapter will be to examine the special role of the mirroring shield in the story of Perseus and to use this unique episode in ancient myth to help explicate the origins and nature of Medusa. I will suggest that the mirror metaphor in this story also plays a unique role. Far from the instrument of metamorphosis that we have explored in all its complexity, this mirror worked precisely *against* metamorphosis – against the petrifaction that befell anyone unlucky enough to have an unmediated encounter with the gorgon. This polished shield was doing its shieldly duty – protecting the bearer from harm – but not in the same way as the shields of Achilles. As the "format" upon which the mirror was laminated, the shield was not necessary to the story at all; a sheet of water would have worked just as well, or even a hand mirror. It probably entered the story by analogy with other reflective shields, or through the longstanding metonymic relationship between shields and the gorgon device – or even through the suggestiveness of the shield's primary function: after all, shields protect.[5] The mirror, on the other hand, became a necessity, probably because it was as appropriate a metaphor as could be found to explain the way that phenomenal experience – the encounter of the world

with our senses – shields us from raw, unmediated reality. Medusa, in short, was a metaphor for that reality, the embodiment of the terrifying and unknowable world outside of Plato's cave.

The story of Perseus as we recognize it – like any other longstanding myth – was an agglomeration improvised from a multitude of sources, accidents, and conscious processes reworked by poets, artists, and raconteurs along the way.[6] The gorgon's power of petrifaction first appears in the early fifth century B.C.E., when Pindar writes of the "stony death" she visited upon the men of Seriphus (*lithinon thanaton, Pyth.* 10.48). The abrupt loss of power that befell her image when reflected on a mirroring surface is an idea seemingly introduced in the late fifth or early fourth century B.C.E., to judge from the theme's appearance on painted vases at that time.[7] Naturally the harmful effect of her face on any human who beheld it is an older idea; Archaic and early Classical renderings sometimes show Perseus looking sharply away as he clutches Medusa's severed head; and when he does not look away, it is often because the head is safely veiled in his prophylactic bag.[8] But the effect of the human gaze in the early myth, it is safe to surmise, was a more conventional, stoneless death, or the less drastic fate of fascination: the viewer was transfixed in a dementia of fear and loathing.

The modern notion that Medusa's petrifaction is really a primordial trope for male sexual frustration has little to recommend it: the incarnation of Medusa as a bodacious, sexy man-eater was a rationalization of the Classical period, and probably was not fully articulated until the Roman Imperial period, when Lucian specifically equated Medusa's beauty with her power of petrifaction.[9] Nor am I persuaded by the recent contention that Perseus' conquest of Medusa was a patriarchal reclamation of the male gaze from a monstrous femininity, achieved by fictionalizing the gorgon on the shield's reflective surface.[10] The mirror arrived in the Classical period as an etiology for the older narrative, and therefore cannot be part of it. The Perseus story, with its central episode involving Medusa, carries no single core meaning or Aesopian moral, but like many a popular folk tale it has accumulated, distorted, rearranged, and discarded meanings along the way. Even the word *medousa* or *medeousa* ("mistress" or "guardian" in the feminine) has no obvious attachment to *gorgo* ("grim," "growler").[11] If Medusa did in fact begin life as a guardian, we have lost irrevocably the strand of the tale that explains what she guarded or controlled. Arguments for the origins of her iconography from an early goddess of the Great Mother or Potnia Theron type are often advanced, and India too has been cited as a likely source of the gorgon's iconography;[12] but there has always been a danger that in our analysis of Greek usage, as opposed to the Eastern, we will confuse the *potnia*, the goddess, with the *therai*, her bestial sentinels – much as the Artemis of Corcyra is often presumed to be assimilated to the running gorgon that appears on her temple pediment.[13] Moreover, as David Napier has

argued, the gorgon construct was probably developed by the Greeks not for cult purposes but for ideological ones that carry little religious content apart from the essential identification of the Other.[14] Could Medusa have guarded a grim magic weapon, perhaps – which, when she was merged with the gorgon, became her very face?

FREUD

It is not my task to review the many modern theories about the Medusa story. But one, the most famous of them all, will serve as an object lesson for the dangers of essentialist interpretations of myth. Sándor Ferenczi, Sigmund Freud, and a diverse array of scholars they have influenced framed the encounter of Perseus and Medusa as an allegory of castration anxiety.[15] Although their theory has inspired some brilliant interpretations of modernity, such as Neil Hertz's foray into the gorgon-woman in the literature of revolutionary France, it utterly misrepresents the ancient myth. Freud really was not interested in the story at all, or in its mechanisms of agency, cause, and effect, being satisfied with the isolated images of Medusa's severed neck (a sort of *vagina dentata*), the head rendered polyphallic by its serpentine hair, and the transposition of the gorgon head to Athena's shield. In his estimation Medusa's truncation represents the horrifying prospect to the male child, upon first seeing his mother naked, that her genitals are a gaping wound, and that her discarded penis portends his own dismemberment. Bizarrely, petrifaction for Freud signals not the child's dismay but his reassuring sensation of an erection. In fact many elements of the Freudian interpretation do not bear scrutiny and cannot be reconciled to the myth in any meaningful way.[16]

As Rainer Mack has recently suggested, the beheading is something of a sideshow.[17] Although it impairs the gorgon's autonomy (if such a thing as autonomy can be ascribed to such an incomplete being), it does *not* kill her, or at least it does not kill her most potent member, the head. If anything, it makes Medusa more dangerous than before, for now her lethal weapon, undiminished by its separation from the body that had been confined to exile in a barren land, can hitch a ride on Perseus' winged feet and scourge the world at large.[18] The beheading, though it may preserve vestiges of a ritual of death and revivification,[19] is one of the most conventional parts of the tale: Perseus must accomplish a martial feat to make good a boast. It is a tale told in a thousand variations, the quest for a magic weapon. Snatching the head from the body is not very different, really, from drawing Excalibur from the stone. Is it sheer serendipity that Chrysaor, "Golden-Sword," emerged from Medusa's neck?

If Perseus' story has a central meaning at all, it is not rooted specifically in masculinity – either its attendant anxieties or the banality of male prowess. I am going to argue instead that the myth is rooted in a more universal anxiety

that has to do largely with seeing and being seen. Even this aspect of the story is a magpie's nest of meanings. It is only in the spirit of eclecticism that I would dare to approach the mirror of Perseus. But that is not to say that the mature myth's core episode lacked coherence, or that its meaning was so fragmented as to welcome an infinitude of interpretations.

How, then, should we interpret the shield-mirror in this narrative? Certainly it is a sophisticated cultural contrivance interpolated into an older narrative and subsequently enriched by a progressive lamination of signifiers akin to the ones discussed in previous chapters.[20] But in this story we are confronted with a mirror event that does not overtly accompany a profound change in the beholder's identity. If anything, the mirror *prevents* an otherwise inevitable metamorphosis, from flesh to stone. Perseus, at least as he is presented in our surviving sources, is something of a cardboard messiah, exempt from the foibles and failings that bedevil more subtly drawn heroes such as Achilles and Hercules. Certainly we would know his vulnerabilities better if we possessed Aeschylus' lost trilogy on his life and exploits, among other works; but in the preclassical myth, to the extent that we can reconstruct it from vase paintings and literary accounts of his exploits, he has none of the complexities of the great heroes of Greek epic and drama. Like an early James Bond, he moves insouciantly from one conquest to another, aided at every turn by local agents (either willing or coerced) and an absurd abundance of gadgets.[21]

PERSEUS, ANDROMEDA, AND THE MIRROR

It has been suggested that the mirror motif began as a means for Perseus and his acquaintances to behold Medusa's head *after* the beheading, and that Ovid invented the scene in which the reflective shield was used as a tool to carry out the beheading.[22] The case for this argument is made largely on the basis of surviving artworks. No reflections, direct or implied, are featured in the robust body of Archaic representations of the story. When a reflection episode does finally appear, in the late Classical period, it involves the severed head of Medusa, not her sleeping form. A number of fourth-century vases show Perseus, Athena, the gorgon or gorgon head, and the mirror-shield in various configurations.[23] Sometimes one of them holds the head over the shield while they both contemplate its reflection (Fig. 91).[24] In a few south Italian, Praenestine, and Etruscan representations, the reflection is observed in a pool of water.[25] A Pompeian variant, popularized centuries later, portrays Perseus holding the head aloft while he and Andromeda gaze at the reflection in a pool (Fig. 92).[26] Yet the mirror as an aid in the beheading scene does not appear until the Roman period – or at least that is our best guess, given that actual representations of Perseus' encounter with Medusa, relatively numerous in the Archaic and Classical periods, decrease over time. Hellenistic and Roman narrative art

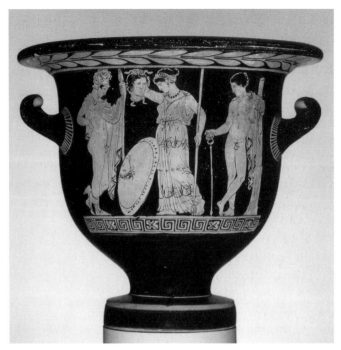

91. Scene on an Apulian bell crater. Early fourth century B.C.E. Boston, Museum of Fine Arts 1970.237.

often avoided representing the critical moment of a well-known myth in favor of more quiet, allusive episodes preceding or following it; consequently few Roman scenes of the beheading, or of Perseus' use of the reflective shield, are known to us today.

In the carefully chosen episodes of restraint and equilibrium surrounding it, an act of violence can be characterized in far more subtle and interesting ways than in the decisive moment itself. Let us take, for instance, a recently discovered mosaic from Zeugma, dated to the early third century C.E. (Fig. 93).[27] It shows the moment when Perseus liberates Andromeda from her chains after he has dispatched the sea monster. The Roman viewer would be familiar with most of the components of this picture, which are drawn from centuries of pictorial tradition:[28] Perseus assisting Andromeda down from her rocky perch, her manacles hanging broken in the background; her guard and tormentor, the serpentine monster, dead or dying at his feet; his left hand gripping the gorgon head by its hair; the falcate sword resting in the crook of the same arm. His hat of darkness has long since given way to a Phrygian cap, a generic "exotic" feature often worn by Andromeda's father Cepheus as well.[29] In various representations of this scene extending back to the early fourth century B.C.E., Andromeda's confinement, it seems, is rarely without feminine amenities.[30] In Roman versions she typically stands shackled on a grim, rocky promontory,

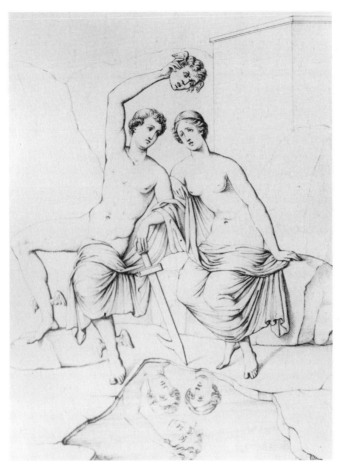

92. Drawing of a wall painting from House 7.4.57, Pompeii. From *Real Museo Borbonico* XII (1839) pl. 49. Photo: DAI Inst. Neg. W 43.

but well dressed and bejeweled, sometimes with a tiara in her coiffed hair; such pleasant adjuncts as a toilette box and a garland stand ready nearby.[31] The combination of objects shown here, though, is unusual in a Roman context: a hydria for ablutions and refreshment; a cockle shell (drawn from the iconography of Venus) on which to pose fetchingly in her manacles; and, hovering between the protagonists like a shimmering signpost – a mirror. This is not Minerva's reflective shield, which makes no appearance in the scene; it is an ordinary hand mirror, which in the Roman repertory rarely appears in this context. Is the mirror just another part of Andromeda's trousseau of feminine attributes, or does it refer back to the reflection that disarmed the gorgon?

Though Roman tastes tend to downplay the luxury of Andromeda's setting, Apulian vases of the fourth century B.C.E., with their penchant for the baroque, emphasize the topos of the gilded cage. Shackled to two trees, the princess is shown on a fourth-century-B.C.E. loutrophoros in Naples standing on an

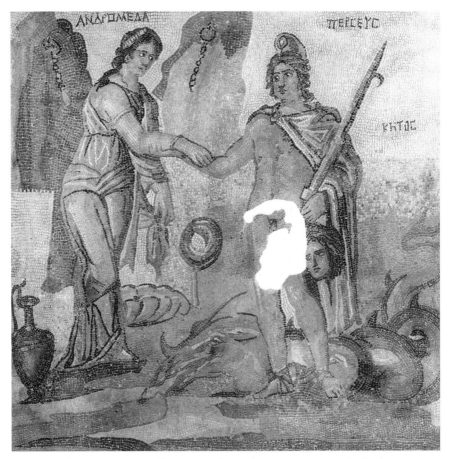

93. Mosaic from the western villa (House of Poseidon) at Zeugma. Early third century C.E. Gaziantep Museum (Turkey). Photo courtesy of M. Önal.

elegant footed stool, toilette box and lekythos hanging nearby, and a handled mirror propped at her feet (Fig. 94).[32] Her gaze seems to be directed not at her dejected parents on either side, but down at the mirror – in this case perhaps not a reference to Perseus' ruse, which may have been in the early phases of formation at this time, but to remind her, and by extension the viewer, of the event that got her into trouble in the first place: Cassiopeia's extravagant claim to beauty, which Poseidon avenged by forcing the daughter into her present circumstances. A *loutros* in Bari takes the motif of splendid bondage even further (Fig. 95).[33] Here Andromeda is shown sitting shackled on a jewel-studded throne and surrounded by feminine luxuries: toilette box propped on a *kalathos* or hamper, fan, and so forth. She looks to her proper left with an intense gaze at Perseus, who stands in a conventional heroic pose, brandishing his hooked sword. Between them, teasing Andromeda's empty hand, is an ornate mirror of a kind frequently seen on Apulian vases. Sword and mirror stand ready for use, each athwart the axis of the reciprocal gaze.

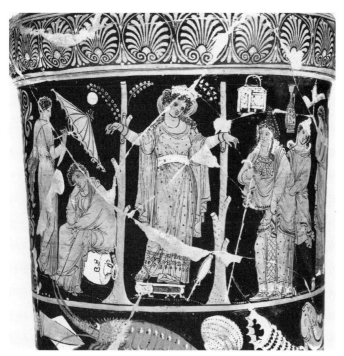

94. Scene on an Apulian loutrophoros. Fourth century B.C.E. Naples, Museo Nazionale 3225. Photo: Naples, Museo Nazionale.

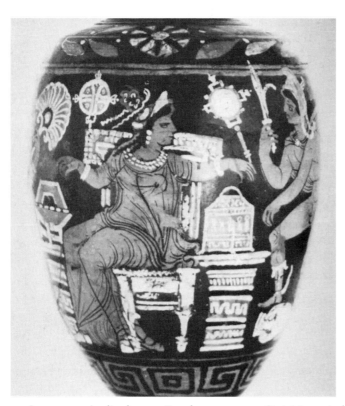

95. Scene on an Apulian loutros. Fourth century B.C.E. Bari, Museo Archeologico 1016.

Though far removed from the busy aesthetic and esoteric visual language of fourth-century-B.C.E. south Italy, the Zeugma mosaic clearly has retained and reworked some of the traditional grammar of this popular scene. The Bari loutros, in particular, draws attention to the mirror not only by its position between the protagonists but by the way in which the pair size it up in relation to the sword, as if to ask, Which is mightier, beauty or valor?[34] Yet even the casual viewer of the fourth century B.C.E. was aware of the importance of reflections in the Medusa story. Precisely how they figure in the pre-Ovidian myth we do not know, but several of the vase paintings depicting Perseus or Athena holding the gorgon head aloft over a shield or pool come from approximately the same time (the late fourth century) and region, south Italy.[35] Eventually the grip mirror, enriched by its associations with beauty and death, may have become a dual signifier that not only denoted Andromeda's self-conscious and brooding loveliness, or her mother's vanity, but also recalled the mirroring shield. In the Zeugma mosaic its centrality, its prominent isolation from the background, and its strange indifference to gravity attract attention immediately. Standing erect, it presides over the fond caress directly above it that prefigures the *dextrarum iunctio* (joining of right hands) of matrimony. But it also is the visual fulcrum in a whirl of symbolic and formal alliances and oppositions. It forms an isosceles triangle with the faces of the betrothed. Just to its right, the hooked axis of Perseus' sword advances diagonally down to the hooked rhinoceros snout of the monster: bane and victim aligned, one rigidly vigilant, the other heaped in the detumescent involutions of defeat and death. A similar ratio of slayer to slain governs the mirror and the head of Medusa, positioned to either side of the hero's body. Down from the gorgon's head trails a dark line in the hero's cloak, an antiphonal response to the mirror's handle. The gorgon eyes are as blank as the mirror's surface (the hero and heroine, observe, have lively eyes with irises). The mirror, positioned equidistant from the dead serpent, the gorgon head, and the caress of nascent love, is both killer and uniter. It has triumphed in both love and war, for it has stolen Medusa's only weapon, and − through its artful complicity in Andromeda's charm − it has captured the heart of Perseus. Cleverness and wiles, granted to Perseus by Minerva, converge with the beauty and grace of his bride-to-be.

The mirroring shield, which in its dual function blends the masculine and the feminine, is given a significant part in the story's telling in its maturity. This duality may be due partly to the gender ambiguity of its owner, Athena/Minerva − the virgin warrior-goddess whose martial dress and demeanor defy conventional ideals of femininity, yet who is both vain and comely enough to be a contestant in the Judgment of Paris.[36] A hand mirror, as opposed to a reflective shield, was probably never part of the dominant literary and oral versions of the beheading episode; otherwise it would have appeared in some of the many renditions of this scene on Greek and south-Italian vases.[37]

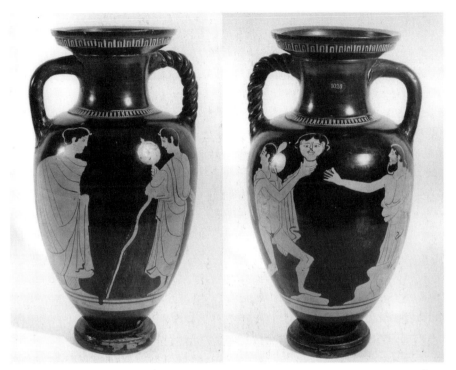

96. Attic red-figure amphora. Fifth century B.C.E. The State Hermitage Museum, St. Petersburg Б.2077.

But it may well have played some auxiliary part in early versions of the story now lost to us. The merest hint of its involvement in the broader narrative, as opposed to its distinctly pictorial symbolism just discussed, may be evident in a single vase painting, which unaccountably has received little attention from scholars pursuing the Perseus myth. This is a fifth-century amphora in the Hermitage depicting two episodes from myth, only one of which is readily intelligible to the modern viewer (Figs. 96, 97).[38] The more straightforward scene depicts Perseus, nude except for his cape and doffed sun hat, exposing Polydectes to the gorgon head. As the bearded king reaches out to the head, either in fascination or in horror, the lower part of his body becomes embedded in a rising mass of rock. Perseus prudently looks away to his proper right – and over to the scene on the opposite side of the amphora. At his heels, bridging the gap between scenes, dances a frontal winged Eros displaying a *taenia* with his outstretched arms. He too engages with the scene to his right in which a young man and a woman, both heavily cloaked, stand facing each other in profile. The man is a traveler – that much is clear from the walking stick on which he props his left arm. His obvious resemblance to the nude Perseus would lead the viewer to conclude that this must be the hero in another episode of the tale. With his right hand he holds a grip mirror before him. Framed within the mirror's circle is the outlined bust of a woman in profile. The gazes

and expressions of the two figures are ambiguous, yet the gesture is startling nonetheless. In Greek art, even more than Roman, a male with a mirror is radically incongruous.[39] In the hand of a young man, this overtly feminine object cannot be dismissed as simply an ornamental prop borrowed from genre scenes. Perseus does not engage with it, at least not in the way characteristic of Apulian vase painting, which often represents humanoid figures, both male and female, gazing deep into an ornate mirror held in the hand.[40]

It is useless to try to fit this second scene precisely into the myth as we know it. Perhaps it is not even a full-fledged episode of the literary narrative itself, but a concocted tableau offering a kind of commentary on its companion piece and drawing upon the viewer's knowledge of the Perseus myth in general. Indeed, its formal relationship to the first scene seems a product of high artifice: the cross references are obvious and compelling.[41] In the first vignette Perseus holds the frontal head of Medusa aloft, petrifying the man before him. Nowhere else is Perseus shown gripping the head in this way, almost as if it were itself a mirror, though both hands are required to make a handle of the neck. In the opposing scene, disposed in bilateral symmetry to the first, Perseus again holds forth a head, this time a generic female bust in profile, displayed on the surface of the mirror in his hand. A standing woman heavily cloaked is the evident object of his interest and of his gesture – but unlike Polydectes, she stands unharmed by the thing in front of her. Eros binds the two scenes figuratively with his outstretched *taenia*: a diadem of victory for men, a band of betrothal for women. Eros' head is turned toward the scene with the mirror, creating an asymmetry in the overall composition and a natural momentum toward the static, ambivalent second scene.

Perseus presented the head of Medusa to King Polydectes as a wedding gift – a sort of booby-trapped boutonniere, as it were, which he deployed to avenge the king's coercion of Danaë into the unwanted union. The fact that the little love god has turned his attention to the other scene strongly suggests that it too bears a theme of matrimony. Barring the possibility that this second tableau is simply drawn from some other figural vase type of which we remain ignorant, it seems to me that there are two possible ways to interpret it from a narrative point of view. On the one hand, it could represent Danaë entrusting her mirror to her son as an offering to Aphrodite or Athena. Greek women – especially those who traded on their beauty – sometimes presented their personal mirrors as votives to a patron goddess once they had passed their physical prime.[42] Danaë's gesture would effectively end her prospects for marriage; the act of consecration would be an announcement of retirement from marriage proposals. The need for Perseus' intervention is obscure, however. Did the son demand that his mother swear off marriage after the debacle on Seriphus? The written sources are silent on this matter, as they are on Danaë's marital status after Seriphus.

More probably the woman in the cloak is Andromeda, to whom Perseus is presenting a mirror as a token of betrothal.[43] Because the hero's wedding took

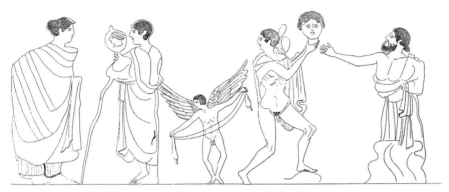

97. Drawing of the scenes on the amphora in the previous figure. From Jahn 1868.

place before the episode with Polydectes (or so Ovid relates), such a reading presents the interesting possibility that Perseus in the Seriphus episode is physically looking backward in time to his recent wedding as a model for connubial propriety – and as chastisement of Polydectes' effrontery, which he is in the process of avenging. In the second vignette Perseus has clothed his nudity to accord with a "civilian" code of behavior. Whereas Athena attached the gorgoneion frontally to her shield as a dreadful implement of repulsion, Perseus has emerged with a comparable tool of attraction, its device rendered not frontally but in profile. He does not himself gaze into it but instead looks past it to engage Andromeda. The feminine bust on its surface principally denotes not a reflection, but a decorative device on the back of the mirror, much like the classicizing relief bust on a silver mirror from the House of the Menander at Pompeii (Fig. 98).[44] Its very iconicity, inherently ambiguous and layered with various possibilities of interpretation, extends this mirror's meaning beyond mere realism. Cut off at the neck, the feminine bust cannot but evoke the gorgon head lurking just around the bend; but if anything, this cameo profile of a respectable Greek woman is an anti-gorgoneion – attractive where its opposite is repellent, emollient where the gorgon hardens, dorsal and lateral (back of the mirror, sidewise view of the face) as opposed to frontal, synecdochic in opposition to the iconic completeness of the disembodied gorgoneion. The mirror's back, turned to view almost as a precaution to prevent Perseus from inadvertently encountering himself on the polished surface, nevertheless *connotes* a reflection, but a reflection of his betrothed – the magnetic pull of culturally constructed desires, an ideal to which the young woman must aspire. It is seeing in the gerundive. To see herself obliquely, rather than *en face*, is to see herself as a man might wish to see her, free of the complicating countergaze.[45]

Because this amphora dates to the third quarter of the fifth century,[46] we are possibly encountering an early experiment – the earliest we possess – in the conceit that became the reflective shield of Athena. To the contemporary viewer, this hand mirror may have been one of the various reflective tools by which Perseus (and Andromeda too?) beheld the head of the gorgon without

harm. Or it may have simply *evoked* Medusa's reflection, which viewers knew to have appeared in another medium, such as the pool of water or the shield that appeared a few decades later on other vases of south Italy. Perseus would thereby be shown on this vase holding an offensive weapon and a defensive one in turn: the head, which operates like a poisoned dart, and the mirror, like a shield against it. Surely the very "shielding" property of the reflection eventually suggested its lamination to a proper shield. The mirror's beneficial effect would reinforce its positive moral force: on the one reflective side, *it deconstructs the horrifying Other*, in effect stripping the poison from the dart; on the other sculpted side, *it constructs the beautiful self*, enabling a woman to augment her persona in the direction of the preapproved ideal.

THE REFLEXIVE EVIL EYE: WAS MEDUSA A VICTIM OF HER OWN GAZE?

If one accepts that Medusa is an especially deadly conduit of the evil eye, then it is possible to suggest that the mirror was originally the death-dealing weapon itself; and indeed numerous modern critics have suggested precisely that.[47] If Medusa's open-eyed *stare*, not her appearance, is the lethal component of her being, and if it is only lethal when the victim's gaze meets hers (only then can her deadly emanations enter his eye and eviscerate his soul), then what better way to kill the gorgon than to lance her with her own poisoned dart?[48] The basilisk, a reptilian monster probably inspired by the gorgon myth, was said to have died by its own gaze in the mirrors borne by its hunters.[49] The idea of the harmful reflexivity of the gaze on a mirrorlike surface has received significant scholarly treatment, and its presence in many societies is beyond dispute.[50] The phenomenon even appears at a moment of crisis in a novella by Théophile Gautier about the social effects of the evil eye, *Jettatura*.[51] The ancient Greek concept of the reflexive evil eye, little different from its modern counterpart, appears in Theocritus' sixth *Idyll*, in a monologue of the cyclops Polyphemus:

> Surely now my looks aren't as bad as they say! For just now I looked into the sea; calm it was, and lovely did my beard, lovely did my single pupil appear, or so I have judged; the gleam of my teeth gaped whiter than Parian marble. Lest I be bewitched, I spat three times in my lap. This is what the old woman, Kotyttaris, taught me.[52]

The unstated presumption in this passage is that Polyphemus' gaze is a channel of the evil eye that can be turned against itself. To this day spitting is a means of countering the desiccating effect of the evil eye, which is thought to attend words of praise and envious gazes.[53] Plutarch gives credence to the phenomenon of self-bewitchment in the mirror, claiming that "reflections rise like vapour and return to the beholder, so that he is himself injured by the same

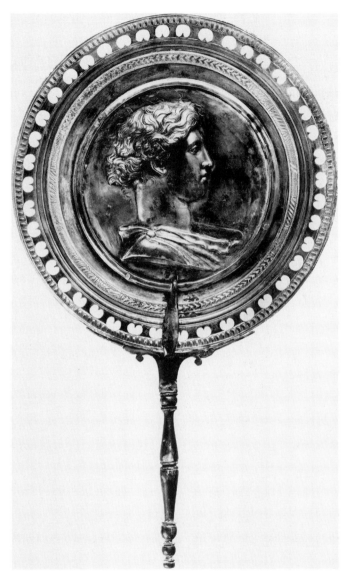

98. Mirror from the silver hoard at the House of the Menander (1.10.4), Pompeii. First half of the first century C.E. Naples, Museo Nazionale 145524.

means by which he has been injuring others."[54] He cites the poet Euphorion on the Narcissus-like fate of the handsome youth Eutelidas, who "seeing himself in an eddy of a river, bewitched himself."[55]

Although there is no literary evidence whatever to support the rationale that Medusa died by her own gaze, such an interpretation may not have been unknown in antiquity. On the handle of a splendid bronze Roman oenochoe found in the Saône River near Chalon (Fig. 99),[56] the decapitation scene is rendered, for the most part, in the conventional Roman fashion: Perseus strides toward the gorgon from the left and looks sharply away as he completes the

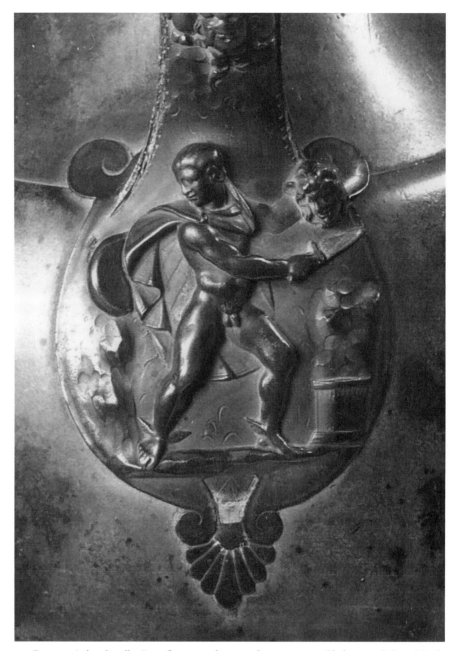

99. Bronze pitcher handle. Late first or early second century C.E. Chalon-sur-Saône, Musée Denon 82806.

100. Drawing of a wall painting from the House of Perseus and Medusa, Herculaneum. From Loeschcke 1894.

death stroke. With his left hand he grasps the freshly severed head by the locks. His gaze meets the polished shield, which sits partially obscured by his flowing cloak upon a shapeless rocky outcropping. What makes this abbreviated scene so unusual, however, is that the pair is shown at the exact moment of decapitation — and yet the body from which the head has been severed is nowhere to be found. In the few related scenes available to us from the Roman period, Medusa at the moment of her decapitation is shown as a seminude female figure; for example, in a heavily restored fresco from Herculaneum illustrated by Loeschcke, where Minerva has made an appearance to assist with the shield (Fig. 100), or in a funerary frieze in the Budapest National Museum.[57] But here the only vestige of her body, it would seem, is a mass of rock rising up from a small altar. Perseus' sword inscribes the interstice between form and formlessness, isolating the head at the very moment before it is engulfed in rock. Significantly, the head is oriented directly toward the reflecting shield: Medusa has transfixed herself on the recoil of her own gaze. Her body has not just died; it has come unformed from the ricochet of her glance. Not even a truncated statue remains to commemorate her demise.

This deforming kind of petrifaction had been represented visually before, as the Polydectes scene on the St. Petersburg amphora (see Figs. 96, 97) and other Greek vase paintings demonstrate.[58] Bodily metamorphoses in Greek and

Roman representation begin at the extremities; gorgonization would seem to progress upward from the feet. But to the viewer unaware of the arcane and artificially interpolated phenomenon of Medusa's self-petrifaction, this little tableau, for all its grace and beauty, would have seemed disturbingly unresolved. It remained to be understood that the body congealed beneath the head as it was amputated. The murderous metamorphosis took place directly atop a small altar. Is this conjunction meant to suggest that Perseus' deed was an act of sacrifice? Though unsupported by the literary record, it is an intriguing idea.

This is the only evidence I have found to support the principle of the palintropic mirror in the original Medusa tale, despite its obvious appeal to later interpreters. The idea that Medusa died of her own reflected stare was never a popular component of the Perseus myth, and with good reason. For one thing, it obviates Perseus' most universal attribute, much older than the mirror: his sword cum pruning hook, designed expressly for the purpose of harvesting the gorgon head. More important, Medusa's death-by-mirror contradicts the logic of Perseus' survival-by-mirror. The shield as we know it from various accounts does not effect "automorphosis," as Louis Marin terms the gorgon's death by friendly fire; it achieves precisely the opposite. Its reflectivity kills the killing glare, just as it would absorb a sword blow. It lops off Medusa's bad vibrations as neatly as Perseus harvests her head.[59] Rather like water under the dazzling sun, it filters and dilutes as it reflects, making the unseeable accessible to sight. Therein it augments the viewer in proportion to the diminution of the viewed: "the reflection reverses the power dynamic, opening up a vantage point that without reflection cannot be occupied by a living person."[60] And like the philosopher's mirror, it provides information and enhances knowledge that otherwise would be out of reach. For Perseus, knowledge is power; for Medusa, being known leads to weakness and loss of autonomy.

Two opposing weapons, Perseus' sword and Medusa's face, act on the same phenomenological plane. Neither weapon works on the rebound: Medusa's face has no effect in the reflection, and Perseus (of course) cannot kill Medusa simply by smiting her image reflected on his shield. Both weapons, then, are akin in their limitations. But in one respect they are crucially different. Perseus' gadgets are pure prostheses, working in concert with his will. Medusa's blight is not an extension of her will; it was imposed upon her by an enraged Athena. Nowhere does she show evidence of malice aforethought. Even if she is assimilated to an ancient apotropaic monster, Medusa does not, and probably never did, embody the traditional evil eye.

The gorgon's perceived association with the evil eye (the Italian *malocchio* or *jettatura*, the Greek *kako mati*) has a long history.[61] The popularity of this misconception in modern criticism seems to have been fueled by the casual advocacy of Jean-Paul Sartre in *Being and Nothingness*.[62] In his discussion of the

genesis of the self, Sartre never developed the Medusa analogy; but others, such as Marin, Roger Caillois, and Tobin Siebers,[63] carried it forward. As interpreted by the Sartre scholar Hazel Barnes, the Existential Medusa's stare

> reveals to me my object side, judges me, categorizes me; it identifies me with my external acts and appearances, with my self-for-others. It threatens, by ignoring my free subjectivity, to reduce me to the status of a thing in the world. In short, it reveals my physical and my psychic vulnerability, my fragility.
>
> The Medusa complex represents my extreme fear that by denying my own freely organized world with all of its connections and internal colorations, the Other's look might reduce me permanently to a hard stone-like object. My most obvious recourse against this threat is precisely that of the Greeks. I don a menacing mask. I seek to stare the Other down, to neutralize the hostile countenance with my own, to reduce him to an object before he can objectify me.[64]

I fear that the existential self has hitched a ride on a specious analogy. For one thing, the gorgon of ancient myth is a totality of several dire properties, of which her gaze is only a part. Second, Medusa's powers have nothing to do with the victim's recognition of her subjectivity.[65] Not only does this mythological creature, a veritable beast of a woman, possess no subjective faculty with which to objectify the victim, but (Sartre would surely insist on the distinction) she projects no *semblance* of such a faculty. It is striking that no version of the myth – not even that of Ovid, who liberally endows the creatures of his stories with interiority through expression, or of Lucan, whose bilious witches seethe with malice – seeks to endow Medusa with a will, a personality, or even the capacity of speech, the proof of personhood. Through every ancient version of the narrative Medusa remains mute (but for her shriek) and betrays not a single spark of affect. She and her two sisters are something quite apart from sorceresses, harpies, sirens, furies, and the like. They are more akin to basilisks, creatures whose noxiousness is systemic and operates without cause or reason. Euripides' adjective *marmaropos* ("stony-eyed," "marble-faced," *HF* 884) captures not just Medusa's balefulness, but also her stony opacity; Apollodorus characterizes the dead gorgon as "an empty phantom" (*kenon eidolon*, 2.5.12). Her face is the paradox of effect without cause, action without agency: sensational banality, expressionless expression. There is no engine under that steaming hood.

In the appendix to this volume I lay out my argument against the common perception that Medusa embodies the evil eye. Here I will merely suggest that if we take the perspective I have proposed – that is, that the gorgon is the quintessential Other, but never establishes a subjectivity or a personal identity – then we ought to acknowledge a corollary proposition: she had a long life as an amulet against evil intent, but never embodied evil herself. First characterized

by a talisman, only later was the gorgon embedded in a story in which she acquired a partial identity as a monstrous foe of humanity, but no autonomy to accompany it. That for which Medusa stood, and the reason it was stymied by the mirror, are altogether different.

TWO KINDS OF INVISIBILITY

It is tempting to retreat from Sartre's intersubjectivity, which recognizes the birth of two subjects (the "I–thou" correlative) in the act of perceiving the face, into the arms of Jean-Pierre Vernant's radical alterity – where in the moment of the encounter the self is annihilated and two subjects are fused, or "doubled," into one. Vernant sees the same kind of chiastic movement, or *dédoublement*, between mortals and gods in a mask of Medusa as in the mask of Dionysus.[66] In his analysis, at the moment of petrifaction the individual figuratively puts on the gorgon mask and a god assumes the individual's mask:

> The face of Gorgo is a mask; but you do not wear it in order to mimic the god. Instead, this figure produces the effect of a mask simply when you look it in the eye. . . . In place of your simply transmitting your own image in return, of refracting your gaze, she would represent, by her grimace, the terrifying horror of a radical alterity, with which you will identify yourself in turning to stone. . . . When you stare at Gorgo, it is she who makes of you this mirror where, in transforming you into stone, she sees her terrible face and recognizes herself in the double, the phantom which you have become from the moment you encounter her eye.[67]

In short, the transfixed viewer assumes that the gorgon's mask is possessed by the god underlying it. "The act of doubling the face with the mask . . . presupposes a self-alienation, a takeover by the god who puts bridle and reins on you, sits astride you, and drags you along in his gallop."[68] But of what god does Vernant speak, and where does this god dwell? Though her sister gorgons are immortal, Medusa herself is a mortal, possessing no godlike properties. The ubiquitous gorgon head has been compared to early imagery of great-mother goddesses; but as Napier puts it, "the worship of ambivalent monsters was not, after Homer's time, to Greek taste, or at least to the taste of Greek intellectuals."[69] The Perseus–Gorgon story probably did not achieve coherency until about the early seventh century B.C.E.,[70] and the mirror almost certainly was introduced later – too late to have the effect Vernant postulates. Although something like Vernant's psychological process may have driven human encounters with painted or sculpted masks according to the protocols of ecstatic cults,[71] I see no similar possibility for reciprocity in the myth of Medusa, because unlike a god she has no subjectivity and therefore no faculty to take possession of a human subject. She is the ineffable Other to

which no selfhood can be attached. Medusa is a mask – but a mask with no referent.

What of the mirrored mask, seen either on water or on metal? Vernant suggests that the reflected image is more potent than it seems in the conventional story. A popular Greek optical theory equated the emanations of the eye with color and light itself; so, according to Aristotle, a woman who looks in a mirror during her menstrual period will tarnish the surface with a bloody film (*De insomn.* 2.459b–60a). A similar understanding of optical theory, Vernant believes, underlies the part of the story where Athena attaches the face of Medusa to her shield: the mirror image is *in fact* potent, even damaging, because it can become confused with the shield device, the gorgoneion, with its obvious apotropaic function.[72]

This argument is dubious on two grounds. Pliny the Elder's discourse on female effluvia in the *Natural History* is evidence that almost every aspect of the female body – indeed, merely the female *presence* – during menstruation was deemed to have the magical power to stain, blight, or damage a wide range of things.[73] Second, Vernant seems to violate a simple and unambiguous premise on which the myth is constructed. Nowhere in the many tellings of the Medusa story does the gorgon's reflection on the shield (*eikon*) merge functionally into the gorgon's proper face; nor do they become confused in art. They are fundamentally distinct phenomena, so distinct in fact that any attempt to commingle them would render the reflection episode meaningless.[74]

When Athena glues that death mask to her shield, she is effecting a fundamental shift in the shield's function and nature. One cannot imagine Perseus' perception of Medusa's face in the mirror as a trope for the "doubling" effect of self-regard and self-fascination: the mirror explicitly destroys the power of the mask, preserving Perseus as a single, unbifurcated, one-dimensional and unidirectional subject. Can it be otherwise in the older images on south Italian vases depicting Medusa's face reflected in water? I think not: to all appearances the effect is exactly the same. By applying the face to her shield, the goddess makes it the functional equivalent of her aegis – which also traditionally carries the gorgoneion. The power to disarm harmful emanations gives way to the power of emanation itself.

But the mirror is not the only filtering agent at work here. To call upon a Greek hero to consult a reflection in order to achieve his goal is anomalous in the extreme. A male does not normally interact with a reflection unless he is in a state of imbalance, or seeks self-improvement. Despite the "manliness" of the mirror's laminar adjunct, the shield, the mirror remains dangerous to the masculine gaze; its very magnetism threatens to imprison a man within himself. Innocent of Socratic philosophy, the action hero must not be allowed to admire himself for fear he will be unmanned or dissolved, like Narcissus – a

fate worse than the freezing glare of Medusa.[75] How does Perseus see Medusa without seeing himself? Simple! He dons the magical hat of darkness that makes him invisible to the world, and thus (presumably) invisible to himself in the mirror. As such – the unseeable man who sees, but who must avoid the greatest dangers of seeing, such as self-seduction – he is the quintessential virile subject, resolute, stripped of this arresting conduit to self-consciousness, self-obsession, or self-doubt, and in full control of the power he wields: the distillation of imperturbable righteousness. In short, Perseus achieves invisibility not only to avoid being seen by the gorgons, but also to avoid the entrapment of seeing himself.[76]

If, like Arno Strine – Nicholson Baker's protagonist in *The Fermata* – the invisible Perseus is pure subject, released of the responsibility of the self-for-others – if in effect he becomes a self-against-others, or self-for-self – then Medusa is a pure object, so potent that she can annihilate subjectivity: the Other-without-self. For all intents and purposes the tale establishes two distinct kinds of invisibility, their difference perfectly characterized, as it happens, by the two historical functions of the Greek verbal adjective: that which *cannot be seen* – Perseus in his cap – and that which *must not be seen* – Medusa unfiltered, the unseeable as the visual equivalent of "unspeakable" (*arrhêton, nefandum*).[77] But this is not to say that as pure object she is an utterly lifeless and unresponsive thing. She and her mischief are merely predicates to provocation. Her power is passive, or more precisely, reactive, incited only by the viewer. This is why snakes are so suitably emblematic of her character, for they are generally not aggressive to humans unless provoked and they are forever cast as the irredeemable Other. She acts with the simple, undivided consciousness of the beast.

Of course, in the visual arts, Perseus' invisibility is transmitted no more literally than the mayhem radiating from Medusa's head. The hero's peculiar state is suspended in the interest of making the story intelligible to the viewer. But even though ancient artists invariably chose to depict Perseus in full bodily form, they conveyed his invisibility figuratively. From an early phase in the history of the story's pictorial representation the conventional way to do this was to show him wearing his hat of darkness, which took various forms but in early renditions, usually resembled Hermes' winged sun hat (*petasos*). In the late Classical period this was genericized into the (often winged) Phrygian cap, which does not specifically denote invisibility. Around the time of Augustus, I would suggest, a new conceit was introduced, if only sporadically, to denote Perseus' invisibility. The power was transferred from his hat to his cloak.

An example of this contrivance appears on a Campana plaque of the early Augustan period (Fig. 101).[78] Self-consciously hieratic and heavily archaizing, the relief minimizes the narrative momentum of conventional mythological art; nonetheless its content is easily recognized. Here Medusa's head has reverted to a huge, pseudo-archaic gorgoneion. Athena is present to hold the shield; upon it

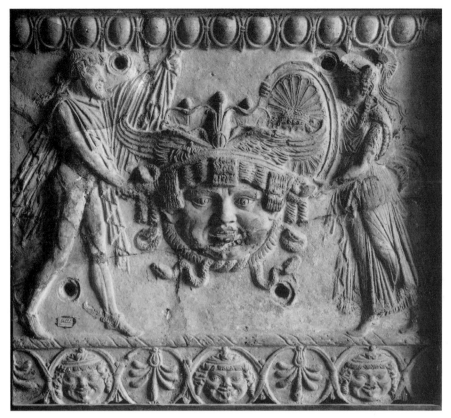

101. Terracotta Campana relief. Augustan. Naples, Museo Nazionale 24224. Photo: DAI, Inst. Neg. 66.3787.

the gorgon's face appears more as a blazon than as a reflection. As usual, Perseus wields the sword with his right hand; but with his extended left hand, rather than grasp the gorgon by her hair, he holds out his chlamys as a kind of shield.

The second instance appears on a splendid gilded silver plate from Portugal, the most opulent and iconographically complex among surviving Roman renditions of the encounter (Fig. 102).[79] At the left, the helmeted Minerva holds the shield before her by its edges, presenting its mirrored surface to view. In the center, Perseus strides right on winged feet, turning his head back as if to observe the shield. A reduced mirror image of his figure appears in gold on the shield's surface. Behind and to his proper left stands a nude, mantled Mercury, identified by his winged *petasos* and caduceus. The god gazes right and downward into a grotto where three snaky-headed gorgons lie asleep, and with both hands holds Perseus' cloak aloft like a billowing sail between the antagonists.

The gesture of the raised cloak or mantle in these scenes has been interpreted as a screen to protect Perseus from inadvertently catching sight of Medusa as he completes his task.[80] In other words, it is taken to be a screen against *that which must not be seen*. But instead, this attribute may have replaced the hero's

hat to become a "cloak of darkness" rendering Perseus invisible to mortals and gorgons – a marker for *that which cannot be seen*. Invisibility was conceived not as bodily transparency, but rather as environmental and sensory opacity, a tenebrous blanket cast upon anyone with eyes to see: a defect of perception, experiential nullity – the bystander's equivalent of sleep or death, hence its association with Hades.[81] Unlike Medusa's effect, this is a selective sleep, editing the figure out of the continuum of experience. In Roman art the billowing cloak of darkness or oblivion is often shown engulfing the heads of sleeping figures, particularly Endymion and Ariadne; sometimes it is the cloak of Night, sometimes it is held in place by erotes.[82] Moreover, the *petasos* in Greek art was an especially appropriate signifier of invisibility because of its capacity to cast a deep shadow over its wearer. As a barrier of darkness, the cloak denies any potential viewer the capacity to experience Perseus' otherness, skewing the experiential compass with which to orient the self.

Lacking the material to construct a self, Medusa seems an unlikely source of malice, and at best a deeply compromised agent of the evil eye. How then can we characterize her danger? It is interesting to observe that *her lethal emanations only take effect when provoked by a gaze*.[83] Anyone who can avoid looking at that face, even when it is directed toward him, will survive unscathed. This principle is consistent throughout the surviving versions of the story, written or visual: it is as close to a universal rule as can be found in the gorgon tale's formation. Most modern interpreters seem to have skirted the implications of this principle.[84] Paradoxically this object – the mask of Medusa – is simultaneously an anti-object, for the very faculty by which it is objectified – vision – annihilates the subject! Whereas the gorgon may be the instrument of ruin, the one who beholds it is both victim and agent, an unwitting suicide. If anyone can be accused of initiating the destruction of being, it is the subject who inadvertently observes Medusa directly. In seeing, one ceases to see, as if one were looking directly at the sun.

The solar analogy is apt. Seneca observes that it is only on the reflective surface of water that we may behold the weakened image of the sun, an object we could never observe directly without going blind.[85] Surely water, not metal, was the substance on which the image of Medusa was first proofed. Its genuine depth and the partial transparency of its reflections offer a splendid rationalization of the psychosocial phenomenon that is signified in the Medusa encounter. As Edward Phinney contends, Athena's shield took no part in the early myth and the mirror had no complicity in the murder of Medusa.[86] But the shield quickly suggested itself as a substitute by two fortuitous connections: Athena's patronage of Perseus, and its longstanding tradition of carrying a gorgoneion as a device. Thus Athena's shield is, like the moral mirror of water, a dual mechanism of filtration and reflection.

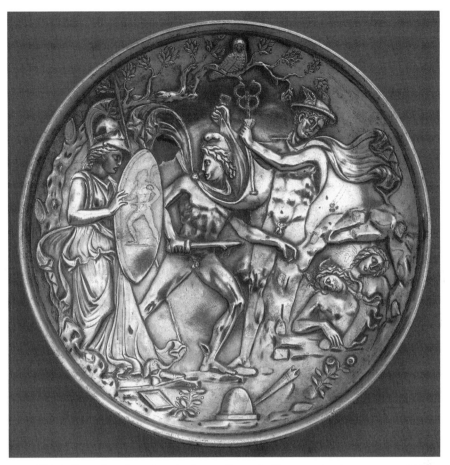

102. Gilded silver plate from Lameira Larga, Portugal. First or second century C.E. Lisbon, Museu Nacional de Arqueologia Au 690. Photo: Instituto Português de Museus, Divisão de Documentação Fotográfica Inv. No. 5280/11/41.

THE MASK ON THE SHIELD

The analogy of sun on water dissolves entirely when the shield ceases to act as a mirror and the actual face of the gorgon is applied to its surface.[87] Athena's act of relamination – replacing the mirror function with a gorgoneion – represents a sea change in the semiosis of the myth and its component parts. To paraphrase Napier, the shield is transmuted from a device that wards off the gorgon's power to one that embodies it.[88] When the face that was once a reflection is affixed to the outer surface, it undergoes a reverse iconopoesis: it enters the shield's domain of being and ceases to be a reflection. The mirror is extinguished. Suddenly the shield, formerly a protective device made more protective by its capacity to reflect and thereby deflect, becomes a weapon. We have crossed

the ontological gap between the harmless image of Medusa *reflected* and the harmful image of Medusa *projected*.

I discussed the relationship of the mirror and the mask with regard to the Dionysiac mysteries. If ever there were a mask embodied, it would be Medusa.[89] Her power, even her very being, emanates from her head, and this is equally true when her head is severed from her body or even when her face is detached from the head and affixed to an apotropaic device, such as the aegis or the shield. But now the shield is no longer a mirror. There is no interaction between a mask and a reflection because reflectivity has been annulled. The mask, so different from that of Dionysus, is empty of numinous power. In the Dionysiac cult the mask signifies, and invites, the absent god; but there is no god answering to the dead Gorgo. The potency behind this device is no longer her own; her face has become a projectile, a channel without signification.

For us observing from without, the face is a sign. But if we imagine ourselves momentarily in the world of Perseus and Athena, we understand that *for them*, their newly adorned shield is not a sign at all, but the real thing; as Umberto Eco, drawing from Stoic philosophy, formulated it, a sign cannot be its own referent, which must be absent.[90] That is why the image on a fourth-century bell crater in the Hermitage (Fig. 103) creates momentary confusion.[91] It shows the shield already gorgonized in a very painterly fashion (in white strokes on a black roundel at the center of the shield) at Athena's side. She holds out the hooked sword to a seated Perseus, who is tying on his winged shoes, apparently *in advance* of the decapitation. Is this a radical undoing of contingency, an interpolation of the reflected image of Medusa, or the gorgoneion itself, before either actually appeared in the narrative? Of course it is none of these things singly; it is a sign meant to prefigure them, and intended exclusively for the viewer. But in a cognitive sense it recalls a famous optical illusion discussed by Wittgenstein, which alternately appears as a duck and a rabbit, but never as both concurrently.[92] The mind cannot encompass both modalities – the face and its reflection – on the shield at once.

It is well to remember that there are two Medusas roughly corresponding to this dual representation – one embedded in the story and deadly to everyone therein, and one a pure representation, capable of functioning outside of narrative but inimical only to the Other: no living person, it seems, was troubled by the apotropaion staring back at him from the center of a drinking cup or a temple pediment, for, in his mind, it looked *past* him to any malicious entity scheming his downfall behind his back.[93] This iconic Medusa, as I suggested above, is purely a precautionary or reactive talisman; in no sense can it be associated with the initiation of harmful intent. But how are we to interpret the embedded gorgon, the one who kills everyone, harmful or harmless, on sight? Perhaps she is so hard to understand because she represents a primordial human riddle that is as abstract as it is ubiquitous, and surely as old as

103. Scene on an Apulian bell crater, fourth century B.C.E. The State Hermitage Museum, St. Petersburg 637 (1723).

religion itself. Medusa, to a greater extent than any god or monster in the Greco-Roman pantheon, is an early manifestation, perhaps, of epistemological angst about the "thing in itself."[94] Can I, the subject, survive an encounter with the noumenon – with unmediated reality? In a society where beholding a god undisguised often meant certain blindness or annihilation, such a question was not a mere school exercise. The fear of such an encounter, more than any other factor, may account for the gorgon's unmistakable early associations with the underworld.[95] Under special and carefully defined circumstances, such as Dionysiac ritual, the direct encounter could be endured, but even then only through such mediating implements as the mask, the wine cup, or the mirror.

This is not to suggest that Medusa was construed as a deity; she was not. Introduced perforce as an assault on the senses, Medusa is utterly impersonal; a representation not of godhead itself, but of direct experience without the buffer of sensation. Any attempt to ask the Kantian question, "How does it appear when it doesn't appear?" is doomed.[96] Tiresias was struck blind upon seeing the naked body of Athena; Semele was vaporized by her encounter with Zeus; ordinary humans are consigned to blindness if we try to see the sun

by gazing directly at it. We, the remote surveyors of the myth, are saved from the dire effects of the gorgon head by the cushion of iconicity, as Françoise Frontisi-Ducroux has observed.[97] Perseus' mirror is not so different from that envisioned by Christian and Neoplatonist apologists who – though they lacked any construct comparable to a Gorgon – nonetheless saw the need for a mirror to mediate the image of God, who must remain unseen and unseeable. That mirror was the righteous man, or Christ himself.[98]

The moment that face is translated into a representation it is weakened – but not entirely, for as an apotropaic device it still vitiates the vectors of harm slung about by unseen and unspoken malice, which somehow operate both within and without the phenomenal world. Those dwelling inside the story have fewer precautions against the unmediated gorgon than we do; the most memorable recourse is the mirroring shield. The death ray dies in the reflection precisely because, for the cast of characters within the story (though not for us, of course), this is the moment when Medusa acquires iconicity and her direct menace is disarmed. At that moment she leaps from noumenon to phenomenon. Only then can she be controlled. Why by a mirror, and not by some other device? Because the mirror is a vivid reminder that we exist for others, and others for us, only through the negotiation of surfaces; that what appears to lie deep within can only be perceived, and thereby known, by way of an exquisite tangential flicker on the outer walls of our being through which some plasmic simulacrum, loosened from its host substance, is transmitted.

SIX

CONCLUSION

I F A MIRROR IS SIMPLY A SURFACE THAT TRANSMITS OTHER SURFACES OPTI-
cally, in itself that fact does not distinguish it from other modes of visual
representation. It is the mirror's passive mimicry and the mutability of its con-
tent – and thus its special relationship to time – that probably account for its
perceived mystery and mischief. Painting and sculpture cannot achieve such
effortless, real-time naturalism as a water-smooth surface; they betray their
limitations through time and space. Nevertheless art, as it was contemplated in
the Helleno-Roman ideal, strove to outstrip its medium – to engender in the
viewer the illusion of a direct encounter with the subject matter. The ekphrast
Philostratus invited the reader to step into the world of pictures he described;
the painter Parrhasius flummoxed his rival Zeuxis with a painted trompe-l'oeil
curtain. Pygmalion drew breath from the chiseled stone.

Mirrors were different. By virtue of the limitations on their size and pro-
duction techniques, or of their imperfect reflectivity, they were capable of
verisimilitude, but they rarely caused genuine optical deception in real-world
situations. Such was the case too in the realms of art, myth, and moral lit-
erature. If a story required deception by duplication, it was easier, and more
credibly illusory, to manufacture a counterfeit of the precious original – be it
a replica of the Palladium of Troy, eleven decoys of the heaven-borne shield of
Numa, or the live-action double of Aeneas, concocted to fool his archenemy
Turnus.[1] The moral mirror was not for deceiving. The evident exception to
this generalization – the case of Narcissus – merely upholds it, for its moral

turns upon the very outlandishness of catoptric self-deception. (Did the youth see no strangeness in a lover beckoning from beneath him rather than before him? Or a lover who aped his every gesture perfectly?). The fool Narcissus, understood from a Roman perspective, would more resemble an animal, which is prone to be duped by reflections, than a complete human being, who is not.[2]

Because its fidelity to the source is decidedly not exact or absolute, reflection in Roman culture turns upon the principle of difference, not sameness. It is the mirror image's very otherness that makes it magnetic – that draws the viewer's attention away from its referent, and toward itself, in the expectation of seeing something different informing the similitude. The question then becomes, how to account for the difference. Is there a continuity of identity between the referent and the reflection? Then we must think of the mirror as mediating a metamorphosis. In such circumstances the duplication marks two decisive moments along the continuum of a conscious subjectivity. The clearest instance of such a phenomenon is the Dionysiac mirror, in which the subject crosses the metallic threshold experientially and becomes the object, which (I have postulated) is the subject's own reflection transformed by hallucination into the image of the deity. Transformation of this kind is undoubtedly one of the oldest roles that mirrors have played outside the dressing room.

The moral mirror may cause another kind of change within the subject: augmentation, wherein the mirror is essentially an epistemological tool, a path to knowledge for the purpose of moral growth. The philosophic man may wish to be the mirror of an idealized hero in the sense that he refashions himself in the pattern of his model. Or he may pronounce history (e.g., his own biographical writings) to be the mirror, as Plutarch does. In either case it is implied that successive generations of right-minded men, and the lives that they lead on the world stage, may serve as a chain of mirrors. The reader of history will fashion himself, and the very life he lives, to be a second mirror in the didactic sequence, so that he in turn will transmit his own recension of great men to younger generations, and so on. This is an arresting analogy, because the locus of change is in the mirror itself, which stands both for the tool of transmission and for the seeing subject: as a man perfects his capacity for moral emulation or celebration, he is like an ever more polished surface that becomes incrementally more faithful to its referent. But to the post-Cartesian mind the analogy is strange. Today we cannot disregard the categorical distinction between a mirror and the image it produces: surely, we suppose, the emulator of great men means to suggest that he strives to be the mirror *image* of his heroes, not the mirror itself. But this is not so. The mirror in Greek philosophy is an epistemological metaphor for the faculty of the mind that reproduces the outer world within itself. As Richard Rorty has argued, the Greeks and their successors in Western thought perceived the intellect as "both mirror and eye in one."[3] Accordingly the part of intellect that we would call sensation, or

ideation, or representation, was left undefined and inseparable from the physical world of form, matter, and extension. The ancient mirror metaphor is a subtle one, for the form and quality of a mirror *image* – which, after all, is essential to the success of the metaphor – indeed is predicated entirely on the state of the mirror itself. A poorly forged mirror, badly ground or polished, of inferior alloy, will do no justice to its referent. And so the locus of improvement – the philosophic man himself, his writings, his body, its gestures and utterances – must be equated with the material *thing,* the mirror, and only incidentally with the image represented within it. A copy is only as good as the matter on which it is made.

This model only works in the case of triangulation. If the mirror is reflexive – whether as a tool of diagnostic self-improvement or of self-indulgence – the tool must be isolated from the locus of transformation, the seeing subject, in order to realize the change. There are several variants of the reflexive mirror of augmentation. In one, the subject (Socrates' philosophic man) consults his imperfect duplicate to adjust his self-perception and behavior to suit his appearance. In another, the subject (the conventional woman, the actor, the orator) uses the mirror to work toward a cosmetic ideal. In a third (Venus, or the female triumphant) the image is already ideal, like its referent – but reinforces, on the one hand, the desires of the imperfect but aspiring woman who beholds the ensemble, and on the other hand, the expectations of the men to whom her surface existence is committed. In a fourth, the male subject (Hostius Quadra, or the generic *cinaedus*) is corrupt and effeminate, and uses the mirror strictly to indulge his perversions. But he is not an entirely static exception to the general rule that mirrors provoke change. Hostius is a hybrid, both reflexive and triangulative. The mirrors he uses as sexual aids in his lair suggest to the reader that the *man himself* is a funhouse mirror of the anti-ideal. The bodily deformations in his warped mirrors signal the deformity of his soul and its inability to transmit virtue. Hostius may himself be a lost soul, but Seneca uses his biographic sketch to hold the mirror of depravity up to posterity, in order to instruct by *bad* example.

For philosophers from antiquity to the Enlightenment, the mirror has seemed the best metaphor of the mind. In John Locke's estimation, the intellect passively receives sensations that it can "no more refuse to have, nor alter when they are imprinted, nor block them out and make new ones itself, than a mirror can refuse, alter, or obliterate the images or ideas which the objects set before it do therein produce."[4] The mind, like the mirror, dictates the form of its image: think of the variations on a single referent created in mirrors with different contours. But it does not dictate the content, which is contingent upon circumstance. The form that sensations take depends heavily on the quality of the "mind-stuff" – the mental metal, if you will – upon which they alight. Personal growth, the accumulation of knowledge through sensation, the development

of character – all would be deemed correlates of man's "glassy nature," which, like mirrors in general, enframes an endless variety of particulars. If we are all mirrors, we each have our own shape, material, and surface contours, which in turn have their effect on the way we construct knowledge. If my mind's mirror is convex and yours concave, or dimpled, or astigmatic, or pitted, we will formulate the same experiences into different shapes.

Only in a third stage, after the primordial preoccupation with ritual transformation and the metaphysical one with mental augmentation, I would suggest, was the moral mirror reinvented as the gadgetry of *diminution* that we see in the Medusa myth. Here reflection is isolated from the mind altogether and becomes a principle of pseudoscientific mechanics in a fashion probably inspired by the filtration and dilution of overhead light striking water. Perseus' reflective shield still effects change; but *what* it can change is altogether new. It does not intervene in the interiority of a protagonist or beneficiary. It has a physical effect, while leaving all psychic states untouched. Used in a triangulative fashion on Medusa, it controls not the entity itself, but the entity's effect on other sentient beings. Despite this evolution of the moral mirror into an almost cartoonish utility, its metaphorical power remains robust. The laminated mirror mimics its vehicle. Just as the shield *duplicates* a spear-blow by its recoil, and simultaneously *diminishes* its force by absorbing and distributing it, so the reflective surface mitigates the phenomenon of Medusa even as it reproduces it. The scope of this mirror, like that of the shield, is limited. It parries the effect – if used according to instructions – but leaves the source of aggression unscathed.

The moral mirror may be transparent or opaque, diagnostic or cryptic, beckoning or repulsive, protective or destructive. But always, in some sense, it is metamorphic; it attends or assists in a change, whether it be transformation, augmentation, diminution, or something else. This tendency may have to do with the nature of representation as it emerged in the art of religious ritual. The continuum of change was represented visually by discrete states of being: before and after, inner and outer, human and divine. By the time mirrors came to be used in rituals of personal transformation, there may already have been a Greek tradition of representing that transformation by means of two simultaneous but nonidentical states. A fourth-century-B.C.E. relief from the Asklepieion in Athens, for example, represents an "outer–inner" or "human–divine" split in experience.[5] In one of its two scenes, a young man is shown lying on his side in bed. As a bearded male figure looks on, a sacred snake – the surrogate of the healing god Asklepios – bites the youth on the top of his right shoulder. This is probably a fair representation of an actual ritual, which may have called for a therapeutic snakebite. Almost certainly – for the literature and epigraphy of the Asklepios cult preserve dozens of such testimonials – during his healing regimen the young incubant would have been drugged and coached by the attendant priests to expect a visitation in his dreams. To the

left of this vignette the dream is enacted in parallel. Now the young man is standing (and thus healed!) in his loose tunic; the god Asklepios stands at his side and touches the same shoulder with a scalpel, as if to draw the malaise from it. These two juxtaposed episodes present a split narrative being played out in parallel, representing both sides of the sacred contract between the worshiper and the physician-god. One side (the outer ritual) is prior; the other (the inner experience) is contingent upon the ritual; but it is dominant, even magnetic.

Although mirrors are not known to have played a part in the Asklepios cult, their properties of simultaneous but contingent duplication, and of preserving sameness while expressing otherness, must have suggested themselves as a splendid metaphor for certain kinds of religious experience. The mirror offered a powerful expression of the binary nature of the human relationship to the mysterious domain across the threshold of ordinary existence. As a metaphor it proved to be highly flexible; for example, it could convey not only simultaneous, but also sequential, states. The divinatory mirror at Patras, also associated with a healing cult, revealed the future condition of an ailing patron, thereby presenting to the oracle a diptych of temporal states from which could be extrapolated a natural or induced course of change.[6] Once established as an index or agent of change in the welfare of human beings, the mirror as metaphor was easily adapted to suit the needs of moral philosophers, storytellers, and artists in the several cases that this book has sought to investigate.

APPENDIX

MEDUSA AND THE EVIL EYE

REMOTE, INDEED, IS MEDUSA'S ESSENCE FROM THE EVIL EYE, A PHENOMENON predicated upon zealous malice, projected either by the viewer himself or by some (usually) ill-defined catalyst of bad will through an innocent agent. In classical literature the evil eye is characterized best by Mestrius Florus in Plutarch's *Quaestiones convivalium* as an active, offensive property:

> Envy, which naturally roots itself more deeply in the mind than any other passion, contaminates the body too with evil. . . . When those possessed by envy to this degree let their glance fall upon a person, their eyes, which are close to the mind and draw from it the evil influence of the passion, then assail that person as if with poisoned arrows; hence, I conclude, it is not paradoxical or incredible that they should have an effect on the persons who encounter their gaze. . . . What I have said shows why the so-called amulets are thought to be a protection against malice. The strange look of them attracts the gaze, so that it exerts less pressure upon its victim.[1]

Are any of these processes manifested in Medusa? In fact, the literary sources only occasionally draw attention to her gaze;[2] the eye is *not* an all-embracing synecdoche of Medusa. More important to her persona in the dominant versions of the tale are the snaky hair, the clear, piercing shriek, and other monstrous features. The name Gorgo, cognate with such words as "gurgle" and "gargle," seems to evoke her guttural cry, thereby defining her not by her glance but by her voice.[3] In some sources her blood is poisonous, or alternately poisonous and beneficial.[4] Sometimes Athena's aegis consists not of Medusa's head, but of her flayed skin;[5] and in a tale recounted by Apollodorus, the (snakeless) *hair* of the gorgon, quite independent of her face, has apotropaic powers. Eyes averted, the princess Sterope is able to turn back the Lacedaemonian army by holding this fetish in front of the advancing soldiers. Pausanias relates that Cepheus, father of Andromeda, defended Tegea in the same way.[6]

By about 500 B.C.E., in pictorial narrative at least, Medusa's head had ceased to be that of the traditional apotropaic gorgon and had become that of a normal woman, sometimes with snaky hair, sometimes not. In many Classical Greek instances the eyes of her severed head are shown closed, like Cellini's famous re-creation, or simply blank.[7] From this point onward the gorgoneion – the

disembodied frontal gorgon head with bestial (or as Stephen Wilk has argued, corpselike) features – is increasingly alienated from narrative figuration of Medusa. She becomes a woman, often a beautiful one, whose one visible abnormality is a proclivity for snakes. But from the beginning the gorgon's eyes were merely part of an arsenal of terrifying traits, among them large tusks, a manelike beard, and a protruding tongue, and of course snakes. Wilk has recently argued with some justification that the worldwide tendency to represent gorgoneia on buildings and food vessels has more to do with scaring off animals than chasing away the malice of the evil eye.[8] Certainly it would be absurd to deny the magical apotropaic function of this device, and that is exactly the point: there is a difference between the device and the entity against which it is deployed. We should pay closer attention to the disparate types and mechanisms of repulsion in myth and folklore. Several properties of Medusa's strange penchant for petrifying her viewers defy the folk malady (and cure) of the *malocchio*:[9]

1. You do not have to behold the evil eye to be cursed by it. Yet, Medusa's weapon has no effect unless the victim looks at her.
2. Conversely, you can disarm the evil eye's malice with an intense gaze in return: *similia similibus curantur*.[10] But not Medusa's eye! Against her, a preemptive glance (in Jane Harrison's terms, "the prophylactic eye") would be suicidal.
3. The apotropaion counteracting the evil eye works just as well with a sign as with its referent. In other words, the prophylactic eye can take the form of an amulet; this is why fearsome faces and glaring eyes are painted and graven by the million in dozens of countries. Against Medusa such things are never even contemplated. There is no evidence that any kind of *fascinum,* or apotropaic tool, confounds the gorgon. Medusa may be an amulet herself, but she is not harmed by amulets.
4. With few exceptions outside ancient Egyptian folklore,[11] in order to have an effect the evil eye must be projected from a sentient agent, whether or not the agent is the source of malice.[12] But Medusa's face has the same effect whether she is awake, asleep, or dead.
5. That sentience is a function of the evil eye's fundamentally teleological nature. It is powered by envy or malice, of which Medusa has no trace.[13]
6. The evil eye is duplicitous: it does not convey malice overtly, and is often attended by praise of the victim-to-be, who may be affected only after some passage of time. Medusa's blasts are dead earnest – and instantaneous.
7. According to Siebers, the agent of the evil eye is not a mere stranger, but "a citizen who has become strange in the eyes of the community."[14] The original, apotropaic Gorgo, whose remote lair is known only to the Graiae, can hardly be defined as "citizen-alien." Only over time was she sentimentalized into the beautiful outcast.

No doubt Medusa is radically talismanic, but not in any specific way encoded in the tradition of the evil eye. For example, it has become a commonplace

to assume that she embodies both malice and its cure, just as one gaze can be undone by a countergaze. Siebers in particular characterizes the gorgon, like the anthropological phenomenon it supposedly represents, as a single phenomenon oscillating between the offensive and the defensive: "infection and remedy merge in the head of Medusa and its related language."[15] In effect, this means there are two Medusas: one a character embedded in narrative, the other a mask that can transcend the story; one existing a priori, the other a posteriori; one endowed with volition and projection, the other iconic and capable only of palintropic repulsion. It is right to posit a split in Medusa's identity; but I contend that only the second identity is correctly characterized.

Medusa has no offensive tendencies. But as an amulet against the evil eye, and probably against a much broader range of afflictions too, her head operates splendidly both inside and outside the story. Thus Perseus used it to petrify Phineus, who as Andromeda's first betrothed felt *envy* toward the hero; likewise the head was deployed upon Polydectes, who projected either *envy* or *malice* toward the young upstart who had made good his boast. In short, Medusa provides a useful remedy, but not a persuasive infection. Even if we retreat from the emic world within a belief system to the etic world of anthropological analysis, it is easy to observe that infection and remedy are actually quite distinct phenomena. After all, does it really make sense that a fortunate person would answer the envious gaze from an outcast by doling out an equal measure of envy? The fascinator, or infector, is both a notional outcast and a member of society for a good reason. His "otherness" must be disguised in "sameness" and his misdeed couched in praise or admiration: the evil eye is duplicitous. But the remedy against fascination is typically divided between a devious and a sincere act: quickly inoculate the victim by falsely devaluing him ("oh, don't say that, he's really quite ugly"), but also retaliate directly and unambiguously against the agent with an intense gaze, an amulet, or a curse. In short, the asymmetry of the relationship – the relative positions of deficiency and surfeit that define it – do not encourage identical strategies or weapons. It can even be argued that the evil eye is never contemplated as a tool or a technique available to the self – only as a blight initiated by the Other – because no sane person claims to possess it. It is an autonomous impulse requiring no mediation through witchcraft or sorcery; the remedy, on the other hand, is often a formulaic magical process.[16] In essence, then, all *practical* provisions relative to the evil eye are defensive.

NOTES

INTRODUCTION

1. Eco 1984, 1987.
2. Melchior-Bonnet 2001: 192–5.
3. Berthelot 1893: 2.260–66; Reitzenstein 1916: 243–55, 262; Achelis 1918; Heinemann 1926; Behm 1929; Hugedé 1957; Baltrusaitis 1978: 74–5; McCarty 1989: 164, 168–72; Nolan 1990: 1–2, 5–6; Jónsson 1995: 64–81; Hamburger 2000; Melchior-Bonnet 2001: 108–15.
4. Frazer 1911: 92–6; 1931. Cf. Dreger 1940: 2.91–110; Balensiefen 1990: 168–73 challenges this hypothesis.
5. Lilyquist 1979: 97–9.
6. *De speculis* 18 (Schmidt); Jónsson 1995: 58–60.
7. Frontisi-Ducroux and Vernant 1997: 195–7.
8. Haberland 1882; Negelein 1902; Róheim 1919; Marmorstein 1932; Meslin 1980; Gandolfi 2003b.
9. *Peri arêtês pros Theosebeian* 12; Berthelot 1893: 2.262–3 (French transl. from Syriac); Behm 1929: 317–18; Baltrusaitis 1978: 72; Jónsson 1995: 95–6. For other examples of mantic or magical mirrors in culture see Maury 1846; Delatte 1932; Pansa 1960.
10. *The Book of Gifts* paragraph 202.
11. Spenser's contemporary, Catherine de' Medici, was supposed to have a mirror in which she could see all that happened in France and neighboring countries; see Maury 1846: 161.
12. Alhazen the Arab (965–c. 1040) and Witelo, a Polish scientist who published a treatise on optics (c. 1250–175).
13. Miller 1998: 91 observes that if we reimagine the left-right axis as an east-west axis, the perceived reversal is eliminated; for a hand extended laterally points in the same direction as its reflection. But it does not resolve the conundrum, for none of the three axes of spatial differentiation – top–bottom, front–back, left–right – refers to direction.

14. Observing one day that a cat would not cross the street over a puddle, Jonathan Miller concluded that it was responding not to the depth of the puddle, but to the depth of its image – which, being a (partial but compelling) reflection of the trees and sky above, was infinite; see Miller 1998: 10–11.
15. Stob. Ecl. 49 (G.M. 41) p. 420 W. "For he regards the souls to be like images appearing in mirrors or mingling in water; they are like us in every respect and mimic our movements." My transl.
16. On the soul's manifestation as a shadow or image (*eidolon*) see Negelein 1902; Ninck 1921: 56–80; Bremmer 1983: 78–9 and bibliography; Stoichita 1997: 18.
17. On ancient theories of vision and optics see Van Hoorn 1972: 42–107; Lindberg 1976: 1–17; Simon 1988; Jónsson 1994: 49–53; Smith 1996, 1999.
18. Simon 1988: 191. My transl.
19. Euclid (probably a compilation of Theon of Alexandria): Ver Eecke 1959 (French transl.). Ptolemy: Smith 1999: 79–126 (English transl. with commentary). Hero of Alexandria: Teubner edition (Schmidt, German transl.); Cohen and Drabkin 1958: 261–71 (selections in English). Lucr. 4.269–323. On ancient catoptrics in general see Lejeune 1957.
20. Simon 1988.
21. *NatQ* 1.5.1; Frontisi-Ducroux and Vernant 1997: 133–46; Bartsch 2000.
22. Frontisi-Ducroux and Vernant 1997: 156–76.
23. Myerowitz 1992.
24. Frontisi-Ducroux and Vernant 1997: 167–9. On the schism of subject and object see Myerowitz 1992.
25. Porphyry, *ad Marcellam* 13: "Hereby can God best be reflected, who cannot be seen by the body, nor yet by an impure soul darkened by vice. For purity is God's beauty, and His light

is the life-giving flame of truth" (transl. Zim-
mern).

26. Aesch. frag. 383 Nauck, in Ath. 10.427;
Alcaeus 104 Diehl; Frontisi-Ducroux and Ver-
nant 1997: 114–16.

27. This idea was widespread in the Middle Ages;
an especially memorable expression of it is Jean
de Meung's thirteenth-century version of Nar-
cissus, steeped in knowledge of optics, who
gazes into a "fountain of life" that offers abso-
lute knowledge. Here a mirror, like art, renders
the image more recognizable, and better under-
stood, than the reality; see Melchior-Bonnet
2001: 115–16.

28. Melchior-Bonnet 2001: 256.

29. Greek: Schefold 1940; Karouzou 1951;
Oberländer 1967; Congdon 1981; de Grum-
mond and Hoff 1982. Etruscan: Beazley 1949;
Mayer-Prokop 1967; Rebuffat-Emmanuel
1974; Pfister-Roesgen 1975; de Grummond
1982b, esp. 8–11, 1982c.

30. Netoliczka 1921; Zouhdi 1970; Zahlhaas 1975;
Lloyd Morgan 1977, 1978, 1981a, 1981b,
1982; Cappelli 1987. On Greek mirror types
that continue in the Roman period, see
Züchner 1942; Oberländer 1967; Schwarz-
maier 1997.

31. Lloyd Morgan 1981a: 3–35, 1982: 40–42.

32. Pliny HN 36.193; Schefold 1940: 15; Zouhdi
1970; Lloyd Morgan 1981a: 104–6, 1981b: 152–
4, 1982: 47–8.

33. Pendergrast 2003: 15.

34. Lloyd Morgan 1981a: 36–67, 1982: 42–4.

35. Lloyd Morgan 1981a: 68–87, 1982: 45–6;
D'Amicis 2003.

36. Gambetti 1974: 38 no. 67, 51–6 nos. 107–24;
de Grummond 1982a.

37. Lloyd Morgan 1977 Groups W and X. Simon
1986: 30–31; Lloyd Morgan 1981a: 90–93,
1981b: 146–52, 1982: 47; Baratte and Beck
1988: 101–2; Baratte 1990: 86–90; Sennequier,
Ickowicz, Zapata-Aubé, and Frontisi-Ducroux
2000: 54, 89–90 cat. 66–7. An example
was recovered from Pompeii (Antiquarium
2158/4).

38. PPM 8.456 no. 11, 459; Disegnatori 422
no. 250.

39. Simon 1986: 26–37; Ling 1991: 195–6; and bib-
liographies.

40. Macchi and Vitale 1987; Miller 1998; Sen-
nequier et al. 2000; Campanelli and Pennetta
2003.

41. Hartlaub 1951; Baltrusaitis 1978; Grabes 1982;
Nolan 1990; Melchior-Bonnet 2001; Phay-
Vakalis 2001; Pendergrast 2003.

42. Conventionally abbreviated as ES and CSE.
See also Beazley 1949; Mayer-Prokop 1967;
Rebuffat-Emmanuel 1974; Wiman 1990; Zim-
mer 1995; de Grummond 2002; Carpino 2003.

43. Matthies 1912.

44. Ridder 1897; Schefold 1940; Züchner 1942;
Karouzou 1951; Oberländer 1967; Cameron
1979; Congdon 1981; Zimmer 1991; Schwarz-
meier 1997.

45. Zahlhaas 1975; Lloyd-Morgan 1977, 1978,
1981a, 1981b, 1982.

46. Ridder 1919; Netoliczka 1921.

47. Lejeune 1948, 1957; Knorr 1985; Simon 1988;
Smith 1996, 1999. Jónsson 1995: 49–60 offers
a useful summary of ancient catoptric theory.

48. Heinemann 1926; Pépin 1970; Hardie 1988;
Jónsson 1995; Stoichita 1997: 20–29; Schuller
1998; Bartsch 2006.

49. Reitzenstein 1916: 243–55, 262; Achelis 1918;
Behm 1929; Hugedé 1957; Nolan 1990: 1–2,
5–6; Jónsson 1995: 64–81; Hamburger 2000;
Melchior-Bonnet 2001: 108–15.

50. Jónsson 1995: 85–99.

51. Maury 1846; Haberland 1882; Negelein 1902;
Róheim 1919; Marmorstein 1932; Meslin
1980.

52. Macchioro 1920; Delatte 1932; Simon 1962;
Gallistl 1995; Cassimatis 1998.

53. De Grummond 2000, 2002.

54. Vernant 1987, 1990a, 1990b, 1991b, 1991d,
2003; Frontisi-Ducroux 1989, 1991a, 1991b,
1993; McCarty 1989; Jónsson 1995; Frontisi-
Ducroux and Vernant 1997; Schuller 1998;
Bartsch 2006. On mirrors or reflections in par-
ticular authors see Callahan 1964; Pépin 1970;
Too 1996; Assael 1992. Treatments of Narcissus
are too numerous to name here; see Chapter 2.
I am grateful to Dr. Bartsch for allowing me to
read her book in proof.

55. Elsner 1995.

56. Sauron 1998: 37–8. My transl.

ONE. THE TEACHING MIRROR

1. Sen. QNat. 1.17.4–5. Transl. Corcoran.

2. Pl. Alc. 1.132d–133b; Diog. Laert. 2.33, 7.19;
Bias, in Diels and Kranz 1951 1.65 fragm.
10.73a.

3. Sen. De ira 2.36.1–3; Hugedé 1957: 101–4;
McCarty 1989: 172–3; Jónsson 1995: 32–6,

47–9; Leitão 1998: 135–60; Bartsch 2006: 183–229.

4. Elsner 2000: 105–6.

5. Bartsch 1994, 2006: 195–9; Gleason 1995; Kellum 1999; Barton 2002; Platt 2002. On the sociological phenomenon of acting and power see Scott 1990: 28–36.

6. Sen. *QNat.* 1.17, *De ira* 2.35.4–2.36.2, *EM* 52.12; Phaed. 3.8.14–16; Plut. *Timoleon* 1, *Mor.* 85a; Apul. *Apol.* 15.7–16.14; Lucian *Salt.* 81; Hugedé 1957: 101–14; Cancik 1967; McCarty 1989: 168–9; Jónsson 1995: 47–8; Too 1996: 141–4; Schuller 1998: 1–11; Bartsch 2006: 15–56. Cato made essentially the same point, but without the metaphor of the mirror; see Plut. *Mor.* 198f; Barton 2002: 219–20.

7. Lucian, *Ind. 29, Pisc.* 45; de Grummond 1982d: 166–8; Wyke 1994: 138; Frontisi-Ducroux and Vernant 1997: 63.

8. For example, see Mart. 9.16–17 on a catamite of Domitian who supposedly dedicated his mirror to Aesculapius. On pathic subcultures in Rome see Taylor 1997.

9. Diog. Laert. 2.32; Foucault 1990: 2.31, 78–93; 3.39–68.

10. Bartsch 2006: 25.

11. On the active–passive divide in gender roles see Gleason 1995: 58–81; Parker 1997 and bibliographies. Some would extend the principle to dominant applications of the gaze in Western society in general; see Sharrock 2002b: 268–9.

12. Schuller 1998: 5–10.

13. The idea is at least as old as Pindar (*Nem.* 7.14); see Assael 1992: 563–4. Jónsson 1995: 52–84 formulates a similar dichotomy, between speculation for self-regard and that for "indirect vision." The latter is roughly analogous to the "prosthetic" function proposed by Eco (1984).

14. As in Ter. *Ad.* 415–16, 428–9; Cic. *Rep.* 2.42.69. See Callahan 1964: 6.

15. Jónsson 1995: 83.

16. Paul: I Cor. 13.12 (King James transl.); cf. 2 Cor. 3.18. Plutarch: *Mor.* 382b (*De Iside et Osiride* 76); 765a–766b (*Amatorius* 19–20). Cf. *Mor.* 591e (*De genio Socratis* 22). On Paul see Berthelot 1893: 2.260–66; Reitzenstein 1916: 243–55, 262; Achelis 1918; Behm 1929; Hugedé 1957; McCarty 1989: 164, 168–72; Nolan 1990: 1–2, 5–6. On Paul and Plutarch see Jónsson 1995: 64–81. On the early Christian principle of the righteous man as a mirror of the unseen and unseeable God, see Jónsson 1994: 95–9.

17. *Timoleon* 1.1 (transl. Perrin). Cf. *Mor.* 85a–b, 967d; Cic. *Rep.* 2.42.69, *Fin.* 5.22.61, 2.10.32; Philo *De Jos.* 16.54.87; Hugedé 1957: 106–9; McCarty 1989: 170; Jónsson 1995: 83–4; Frontisi-Ducroux and Vernant 1997: 118–20. Apuleius presents a fascinating variant on this model that seems to rely on the mirror's capacity to distort as a trope for the fugitive nature of the self; see Too 1996. For a parody of the instructive mirror see Mart. 2.41.8; Wyke 1994: 147.

18. *Mor.* 172d. Cf. Pl. *Tht.* 206d; Cic. *Pis.* 7; Philo *De Abrahamo* [29].153; Hugedé 1957: 121; Jónsson 1995: 64–5. More interestingly, Plutarch sees in nature a Platonic mirror of a divine creator and the world of pure ideas, a theme partially taken up by early Christians; see Jónsson 65–123.

19. 1.1.1 (transl. Bartsch). McCarty (1989: 168–9) proposes that the metaphor is offered "in the hope that Nero will find himself reflected in the image of mercy, hence it in himself, and thus become merciful"; but Leitão (1998: 155–8) suspects a more complex ambiguity in this passage. Bartsch observes, "*this* mirror encourages the viewer to self-congratulation rather than self-correction." She proposes that Seneca has mingled the two mirror traditions – one of self-indulgent vanity, the other of restraint – into this deeply problematic introduction (2006: 183–8). Frontisi-Ducroux and Vernant refer to the mirroring of manly virtue as a "contagion of mimesis," by which they evidently mean an extension of Aristotelian poetics, with its emphasis on the artistic replication of reality, into the realm of action.

20. Schuller 1998: 8–9; Barton 2002: 223.

21. Ar. *Thesm.* 136–40; Eur. *Or.* 1111–12, 1528; *Anth. Pal.* 6.307, 11.54; Phaed. 3.8.14–16; Dion. Hal. *Ant. Rom.* 7.9.4; Sen. *QNat.* 1.16–17, *De Clem.* 1.1.1; Juv. 2.99–103; Artem. 5.67; Diog. Laert. 7.17; Frontisi-Ducroux and Vernant 1997: 59–65; Bartsch 2006: 18–41.

22. *QNat* 1.16, transl. Corcoran.

23. Myerowitz 1992: 149–50; Frontisi-Ducroux and Vernant 1997: 177–81; Bartsch 2000: 82–7, 2006: 106–14 and bibliography. Suetonius seems to have borrowed wholesale from this model of vice to describe the dissipated private life of Horace: "It is said that he positioned whores in his mirrored bedroom so that wherever he looked the image of copulation

would be returned to him" (*V. Hor.* Loeb ed. 489, my transl.).

24. Barton 2002; Bartsch 2006: 115–82 and bibliography.

25. Dio 56.30.4; cf. Suet. *Aug.* 99.1.

26. Plut. *Dem.* 11.2; Quint. 11.3.68; Aeschin. *In Ctes.* 174, *Emb.* 88, 99, *In Tim.* 131. Aeschines does not specifically mention the mirror.

27. *Apol.* 15.7–16.14; Abt 1908: 98–101; Too 1996: 141–3; Bartsch 2006: 18–23.

28. Myerowitz 1992: 148–50.

29. *Poet.* 1–2, 4, 15.

30. Edwards 1997.

31. Garton 1972: 170.

32. Beacham 1991: 155; cf. Bieber 1961: 164. On Roscius' life and reputation see esp. Vonder Mühll 1914; Garton 1972: 158–88, 209–29. Roscius wrote a short treatise comparing the actor and the orator; see Garton 211.

33. Cic. *De or.* 3.59.221. On the problem of the introduction of masks in Roman theater see Saunders 1911.

34. Foucault 1985–6.

35. Lacan 1966.

36. Böttiger 1850; Jessen 1894–7; Reinach 1912; Burckhardt 1930; Leclercq-Neveu 1989; Balensiefen 1990: 36–8, 89–98; Vernant 1990b: 55–9; Frontisi-Ducroux 1994.

37. Plut. *Mor.* 456b. Transl. W. C. Helmbold. This seems to be the version of the story that inspired the famous statue group by Myron that represents Athena casting the pipes down at the satyr's feet; see Plin. *HN* 34.19.57; Paus. 1.24.1; Jessen 1894–7: 2446–8; Bulle 1912; Schauenburg 1958: 56–8; Robertson 1975: 341–3; Daltrop 1980; Ridgway 1984: 53–4; Rawson 1987: 17–19; Stewart 1990: 147, 256; Weis 1992: 369 nos. 9–12, 15–17; Gauer 1995. Contra the Myronian attribution: Carpenter 1941.

38. Ov. *Fast.* 6.697–705.

39. Ath. 14.616e. Transl. C. B. Gulick. Cf. Ov. *Ars am.* 3.505–7.

40. Vernant 1990b: 58.

41. *Lav. Pall.* 15–21.

42. Vernant 1990b: 56–8; Hyginus (*Fab.* 165; cf. Fulg. *Myth.* 3.9.726, 729) relates that her facial distortions brought the other gods to laughter. One of Athenaeus' principals, citing Telestes of Samos, will have none of it: "'For how could sharp yearning for lovely beauty have troubled her, to whom Clothô had assigned virginity unwedded, unchilded?' Obviously she could not have been frightened at the ugliness of her

looks, because of her virginity!" (14.617f, transl. C. B. Gulick). Aristotle's skepticism takes a different tack: "Now it is not a bad point in the story that the goddess did this out of annoyance because of the ugly distortion of her features; but as a matter of fact it is more likely that it was because education in flute-playing has no effect on the intelligence, whereas we attribute science and art to Athene" (*Pol.* 8.6.8, transl. H. Rackham).

43. Jessen 1894–7; Schauenburg 1958; Rawson 1987: 189–224; Weis 1992; and bibliographies. The scene with Athena piping is only occasionally shown before the Roman period. An Apulian bell crater in the Museum of Fine Arts in Boston (00.348), in which an attendant holds an ordinary mirror for the piping goddess, is a particularly fine example; see Dreger 1940: 1.67 no. 92; Schauenburg 1958: 43–4, 46; Herrmann 1968: 668; Demargne 1984: 1914 no. 620; Rawson 1987: 18–19, 192 no. A5; Balensiefen 1990: 27, 30, 36–8, 89–98, 225–6 K 19.

44. Fantar 1987: 154–61. A fragmentary mosaic in Somerdale near Bristol has a similar composition, but here Minerva is shown gazing into the pool as she pipes. The reflection is equally well defined; see Rawson 1987: 114–15 no. 3.

45. Pind. *P.* 12.6–8; Frontisi-Ducroux 1989: 159; 1995: 74–5; Vernant 1990b: 56–8.

46. Rawson 1987: 63–4, 77, 171–2; Fantar 1987: 161–4; Weis 1992: 369 nos. 13–14. Particularly interesting is a bronze coin or medallion from Apameia Kibotos in Phrygia (14). The composition sometimes bears formal similarities to Actaeon scenes, where the youth's reflection, rather than the goddess's, typically appears in the water; see Balensiefen 1990: 70–71, 72–5, 105–12, 241–3 K 44, 46–7; Guimond 1981.

47. Fantar 1987: 161–6; Rawson 1987: 22–3, 115 no. 4; Ben Khader et al. 2003: 251.

48. This motif appears elsewhere, particularly on sarcophagi; see Sande 1981, figs. 7, 19.

49. Dreger 1940: 1.67 no. 98, 81; Poulsen 1951: 549–51 no. 782; Rawson 1987: 22, 24, 31, 37, 40, 62, 77–83, 179–80 no. XV; Sande 1981: 59–60, 68; Weis 1992: 369 no. 14c; Østergard 1996: 82–4.

50. Sichtermann and Koch 1975: 40–41 no. 36; McCann 1978: 82–3; Sande 1981: 67–8; Rawson 1987: 22, 24, 31, 40, 59–60, 77–83, 183–4 no. XIX.

51. Mau 1890: 266–8; Mau 1891: 72; Dawson 1944: 90 no. 23, 130; Rawson 1987: 19–20, 37–8, 77, 163–4 no. I; Weis 1992: 369 no. 13; Rambaldi 1998; Bergmann 1999: 93–6; *PPM* 3.842 no. 22.

52. Gods of the place are sometimes included in this scene; see Dreger 1940: 1.67 no. 96, 77–8; Koch and Sichtermann 1982: 158, 226, 233 no. 83; Balensiefen 1990: 62–3, 238 K 40.

53. Mau 1891: 72 and Dawson 1944: 90 no. 23 suggest that this figure is playing the pipe, but I see no clear evidence of this. Mau 1890: 268 accurately describes a gesture of the hand to the chin. Typically when Marsyas is shown spying on Athena, it is to be understood that he does not yet have the pipes.

54. Rambaldi 1998: 111–12 suggests that the human figures in the backgound are the people of Nysa, who according to one variant of the myth served as judges of the contest (Diod. Sic. 3.58.3, 59.1–5). Apollo sits enthroned to their right.

55. Or we may shift the center of subjectivity, applying it to Marsyas instead of the goddess. Under such circumstances the Pompeian fresco may represent the satyr encountering his lethal, feminine alter ego in the reflection. Willard McCarty (1989: 179) proposes that just such a polarization of gender is a standard device in the *Metamorphoses*, "where the implicitly catoptric revelation, often in the form of a goddess, will constitute a 'forbidden vision' of the protagonist's intolerable secret self, which is catastrophic to encounter." As such, the goddess operates rather like a muse, the spontaneous and mysterious apparition of inspiration. But I do not see Marsyas as the protagonist in this episode; relative to Minerva he emerges *a posteriori*. Nor do I agree with McCarty that the metaphorical mirror in ancient literature serves to "transgender" the viewing subject.

56. Leary 1990, 1993.

57. Myerowitz 1992; Wyke 1994; Stewart 1996: 139 n. 8, 143; Carson 1990, 1999.

58. Spier 1992: 61 no. 118. Three other examples are known from Boardman's Phi Group: Paris Bib. Nat. 1104; Munich A1432 (Boardman 2001: 316–17, 354, fig. 298, pl. 906); and a gem on the London market in 1987 (see Spier citation).

59. Leitão 1998.

60. Cf. Juv. 2.36–70.

61. Frontisi-Ducroux and Vernant 1997: 126–32; Bartsch 2006: 57–114.

62. Wyke 1994. Cf. Irigaray 1985: 133–51, 203–13; Myerowitz 1992; Stewart 1996, 1997: 171–81.

63. Downing 1999: 240. This article deals with Ovid's interesting process of "artifaction" of the female, rendering her statue-like in her perfection. Cf. Wyke 1994: 146–48.

64. Ov. *Ars am.* 3.135–6: "quod quamque decebit/ elegat et speculum consulat ante suum"; Mart. 9.16.1: "consilium formae speculum." On Plaut. *Most.* 248–51 and the notion of the mirror that "teaches" beauty, see Callahan 1964.

65. On the erotic surface value of clothing in Greek antiquity, and weaving and spinning as metonyms both for chastity and for eroticism, see Frontisi-Ducroux and Vernant 1997: 92–106.

66. Barton 2002: 222.

67. Biagiotti 1990: 86–7 nos. 37–40; Sennequier et al. 2000: 94–6 nos. 75–9; Diebner 2003.

68. Biagiotti 1990: 87 no. 40; Wyke 1994: 142.

69. Pl. *Tim.* 50b–d; Arist. *GA* I.2.716a.4–7, 1.21.729b.14–22; *Phys.* 1.9.192a.22–25; Carson 1999: 79.

70. Frontisi-Ducroux and Vernant 1997: 126–30.

71. Balensiefen 1990: 49–52. De Grummond 2002: 77–8 suggests that the Eros figure is actually a Psyche with butterfly wings.

72. Biagiotti 1990: 88 no. 44. Also from the same room is an older woman in matronly garb sitting pensively on an ornate stool; see Borriello et al. 1986: 144–5 nos. 153–4.

73. On this genre see Miller 1998.

74. Kellum 1999.

75. Caputo 1959: 21–2. Cf. Schmidt 1997: 214 no. 232.

76. McCarty 1989: 180.

77. Sennequier et al. 2000: 79 no. 45. Cf. Schmidt 1997: 204 no. 106, 208 no. 166, 210 no. 186, 226 no. 367; Sennequier et al. 2000: 80 no. 46 (Hellenistic); 94 no. 74 (third century C.E.). A fine bronze Venus admiring herself in a similarly outsize mirror, perhaps of the first century C.E., is in the Cabinet des Médailles; see 92 no. 71. For Venus in proximity to a symbolic mirror, see Schmidt 1997: 209 no. 177; Toynbee 1964: 287–8, pl. LXIVa.

78. Havelock 1995, esp. ch. 4; Spivey 1996: 177–86; Stewart 1997: 97–107, 222; Sharrock 2002b: 274–5. For authoritative discussions of

numerous Aphrodite/Venus types see Ridgway 1984, 1990 vol. 1.

79. This motif recalls the image of Cleopatra, in the guise of Venus surrounded by ministering Cupids, sailing up the Cydnus to meet Antony (Plut. *Anton.* 26). Venus sometimes had been presented in triumph before the emergence of this type, but not in an overtly sexual way – for example, at shop 9.7.7 in Pompeii; see Kellum 1999: 289. She had also been served up on the half-shell at least since the first century C.E., though not specifically in a triumphant context; for example, at the eponymous House of Venus Marina in Pompeii (2.3.3). See Dreger 1940: 2.24–33. Traditionally this simple type is called "Birth of Venus," though usually without justification. For the various "watery" Venus types see Schmidt 1997: 218–21 nos. 292–3, 301, 307–23 and bibliography.

80. Picard 1941–6; Lassus 1965; Germain 1969: 48–50 no. 56; Février et al. 1970: 50–59; Blanchard-Lemée 1975: 74–84, esp. 74–6; Dunbabin 1978: 154–8, 250 (Bulla Regia 3a), 251 (Carthage 14a), 256 (Djemila 1c), 268 (Sétif 2); Balty 1981: 396–9; Balensiefen 1990: 76–8, 243–4 K 49–52; Schmidt 1997: 220–21 nos. 312–19; Dunbabin 1999: 65, 125–6, 166–7, 184, 243–4, 322; Önal 2002: 8. The cortege may be on boats; see Blanchard-Lemée et al. 1996: 120 fig. 80, 158 fig. 113, 160 fig. 115; Schmidt 1997: 221 nos. 322–3; Ben Khader et al. 2003: 255. At times the thiasos is dispensed with, and Venus is back in her bathing mode: see Blanchard Lemée et al. 1996: 150, 151; Schmidt 1997: 208–9 nos. 167–71; 221 nos. 320–21. Many marine *thiasoi* do not feature Venus at all, but are populated instead by generic nude nereids; for one famous example, see Carandini et al. 1982: 258–8, fig. 158; Balensiefen 1990: 76–8, 243 K 49; and bibliographies. On the possible Eastern origins of the coronation and triumph of Venus/Aphrodite, see Picard 1941–6.

81. 4.31; transl. J. A. Hanson. See Slater 1998: 19–20.

82. Dreger 1940: 2.24–25; Picard 1941–6: 62–3; Allais 1957; Lassus 1965: 181, 187–8; Blanchard-Lemée 1975: 61–84; Dunbabin 1978: 156, 256 (Djemila 1c); Balensiefen 1990: 76–8, 244–5 K 52.

83. Blanchard-Lemée 1975: 75; Balty 1977: 16–19, 1981: 396–9, 1995: 35, 143; Balensiefen 1990: 76, 244 K 50; Dunbabin 1999: 166.

84. Shelton 1981: 72–5 no. 1; Biagiotti 1990: 117 no. 223; Kiilerich 1993: 162–5; Elsner 1998: 16–17; and bibliographies. Cf. a fourth-century *patera* at the Petit Palais in Paris: Pirzio Biroli Stefanelli 1991: 229 fig. 243, 304–5 no. 186. In the Byzantine tradition, the motif appears as late as the mid-seventh century; see Leader-Newby 2004: 174–7, fig. 4.4.

85. Vat. Mus. Cortile Ottagono PS 30. Andreae 1998: 222–3.

86. Symbolism of Venus Triumphans without the goddess's appearance can be found in other Roman contexts as well. For example, a square mosaic from a villa at Yonne, preserved in the Château de Chastellux, represents in its center an empty cockle shell, below which stands a dove; in four surrounding panels are shown hybrid sea creatures. See Darmon 1975.

87. Versnel 1970: 56, 65, 70. On apotropaic phalli see Barton 1993: 95–8 and bibliography.

88. Tertullian *Apol.* 33.4; Zonaras *Epitome* 7.21. See Versnel 1970: 65, 70; Künzl 1988: 28; Holliday 2002: 28–9.

89. *Rapitur quocumque videt, Epithal. Hon.* 108. My transl. Some editions prefer *capitur*, in which case the image would be "captured" in the mirrors.

90. Carson 1999: 81.

91. Mirror: Züchner 1942: 90–91 KS 152; Schwarzmeier 1997: 101, 107, 183, 323 Kat. 217. Gem: Babelon 1897: 28–30 no. 42; Sennequier et al. 2000: 85 no. 56.

92. Toynbee 1973: 259, 260; Pollard 1977: 16, 29, 146–7; Bevan 1989: 166–7. The imagery on Hellenistic mirrors themselves is quite telling in this respect. Aphrodite or Eros is shown with a duck or goose on a number of the mirror covers catalogued in Schwarzmaier 1997: Kat. 26 (Athens); 68, 72, 75 (all in Boston). Eros holds a dove (?) on Kat. 85 (Harvard University). For Roman representations of Venus with various birds see Schmidt 1997: 218 nos. 297–9, 221 no. 323, 224 nos. 350, 352. A cameo in Boston (Museum of Fine Arts 99.101) represents a wedding of Cupid and Psyche; see chapter 3, n. 91 below. The groom, Cupid, holds a dove in one hand. Cf. also a fresco from Herculaneum (Naples, Mus. Naz. 9210; Borriello et al. 1986: 154 no. 225), which depicts two cupids flanking the throne of Venus, on which sits a dove.

93. Sennequier et al. 2000: 96 no. 77. Cf. an altar in the Museo Nazionale Romano dedicated to

Venus Augusta. On its front side appear prominently a pair of doves drinking from a cup or basin; see Zanker 1988: 134, 136 fig. 112.

94. Mansuelli 1958: 95–6.

95. Santa Maria Scrinari 1972: 129 no. 368.

96. Ascione 2004. House of the Colored Capitals: Levi 1947: 194; *PPM Disegnatori* 200–202 nos. 84–6. Cf. the "nest of erotes" scenes known from the House of the Tragic Poet (6.8.3) and the House of M. Holconius Rufus (8.4.4) in Pompeii: Levi 1947: 61; *PPM Disegnatori* 422–3 no. 251. Levi 1947: 195 cites Headlam's translation of Meleager (*Anth. Pal.* 5.178): "Let him be sold, though still he sleeps/upon his mother's breast!/Let him be sold! Why should I keep so turbulent a pest?/For winged he was born, he leers,/and sharply with his nails/he scratches, and amid his tears/oft laughs the while he wails. . . . /An utter monster: on that ground/sold he shall be today:/if any trader outward bound/would buy a boy, this way!/But see, in tears beseeches he:/nay, thee no more I sell:/fear not, with my Zenophile/remain thou here to dwell."

97. Levi 1947: 191–5; Cimok 2000: 172.

98. Dunbabin 1999: 26–8 (with bibliography in n. 29), 47, 66, 249, 270.

99. Pompeii: Borriello et al. 1986: 118 no. 20; *PPM* 5.49. Ampurias/Emporion (Barcelona, Museu d'Arqueologia Inv. Gral. 4.031): Balil 1961: 50–52, fig. 3; Parlasca 1963: 267–8, Abb. 9; and bibliographies. Balil incorrectly interprets the object as a necklace. In a similar vein, cf. a mosaic *emblema* from the House of the Faun (6.12.2) in Pompeii, which depicts three doves, one extracting a necklace from a toilette box (Borriello et al. 1986: 116 no. 5; Pernice 1938: 165, Taf. 65.2). A third-century mosaic from the Isola Sacra near Ostia introduces Venus herself into a similar scene; see Schmidt 1997: 224 no. 350. In this case the bird has pulled a necklace partway our of her jewelry box.

100. Arist. *HA* 5.541a.27–31, 6.560b.11–16, 8[9].613b.23–36; Ael. 17.15; Ath. 388f–390d; Pollard 1977: 60–61.

101. Ath. 389e–f, transl. Gulick. Athenaeus also records a tradition in which the Pygmies waged war against not only the cranes (their traditional foe in myth), but also the partridges (390b). In a Nilotic mosaic from El Alia in Tunisia, now at the Bardo Museum, which appears to represent the war of the Pygmies

and cranes, the human combatants are shown holding small, shieldlike mirrors in the left hand and maces in the right; see Dunbabin 1978: 20, 48, 110, 257; Fantar and Jaber 1994: 128–9. No partridges are present.

102. A.946; cf. A.878. My transl. See Frontisi-Ducroux and Vernant 1997: 131.

103. *Mosella* 230–39.

TWO. MIRRORS MORTAL AND MORBID: NARCISSUS AND HERMAPHRODITUS

1. On the phenomenon of Narcissus in Western culture, see Hartlaub 1951: 67–73; Vinge 1967; Rosati 1983: 17–20; Mori 1987; Orlowsky and Orlowsky 1992; Regopoulou 1994; Renger 1999; Auraix-Jonchière and Volpilhac-Auger 2000: 179–298; Spaas 2000; Melchior-Bonnet 2001: 112–13, 116, 148, 158–62, 221, 231; Renger 2002; Bettini and Pellizer 2003.

2. Wesselski 1935; Vinge 1967: 1–41; Bettini 1991b; Bettini and Pellizer 2003 (with six pages, 94–9, on art); Nelson 1999–2000; Elsner 2000. Literary analyses of the Narcissus episode in Ovid are far too many to enumerate in detail here. See Wieseler 1856; Eitrem 1935; Pfandl 1935; Fränkel 1945: 82–5; Schickel 1962; Skinner 1965; Dörrie 1967; Dietz and Hilbert 1970; Manuwald 1975; Borghini 1978; Rosati 1983: 1–50; Rudd 1986; Nicaise 1991; Anderson 1997: 371–88; Stoichita 1997: 31–5; Schuller 1998: 138–78; Nelson 1999–2000; Andréoli 2000; Bartsch 2000; Vogt-Spira 2002; Di Nisio 2003; Bartsch 2006: 57–114. Studies emphasizing Echo from semiotic or feminist perspectives include Ritter Santini 1978; Spivak 1993; Berger 1996.

3. Frontisi-Ducroux and Vernant 1997: 200–241; Frontisi-Ducroux 2000.

4. Greve 1897–1902: 16–21; Eitrem 1935: 1729–33; Dreger 1940: 1.6–27; Levi 1947: 60–66; Guerrini 1963; Zanker 1966; Schefold 1981: 209–11; Sichtermann 1986; Balensiefen 1990: 50–53, 130–66, 230–33 K 32, 241–2 K 45; Rafn 1992; Colpo 2002: 11–86; Platt 2002: 91–4; Iaculli 2003; Small 2003: 100–104; Marcattili 2004. Zimmerman 1994: 13–18 is essentially a distillation of Levi and Zanker.

5. Ov. *Met.* 3.424. Transl. F. J. Miller. All subsequent translations of Ovid's account are from this source unless otherwise attributed.

6. Conon *Narr.* 24 ap. Phot. *Bibl.* 134b28–135a3; Paus. 9.31.7–9. Full text of the Conon story in

Greek with English translation in Vinge 1967: 19–20. Oxyrhynchus: *POxy* 69, forthcoming.

7. Cf. *IG* 7.1828, which seems to draw from this tradition: "Bow-carrying child of shrill Cypris, dwelling in Heliconian Thespiae beside the blooming garden of Narcissus, be gracious...." (transl. Zimmerman 1994: 18). On a famous statue of the Thespian Eros by Praxiteles, and its possible influence on the explosion of interest in Narcissus imagery under Nero, see Colpo 2002: 54–7.

8. In light of Pausanias' story, Bettini 1991b argues that the twin is part of a binary construction of the self that should be understood in much the same terms as the "we" of an erotic relationship. Perhaps, but such a perspective does not eliminate the tang of incest from this passage; see Hadot 1976: 95, who draws an apt analogy to Siegfried and Sieglinde; Borghini 1994: 202; Elsner 1996b: 256–7; Frontisi-Ducroux and Vernant 1997: 217–21, who see the relationship not as full-blown eroticism, but as a bond between siblings who have not yet reached sexual maturity. Here the famous story of the origin of sexes recounted in Plato's *Symposium* serves as a model for the construction of Narcissus' desire: the twins, like lovers, seek to merge into their former dual selves.

9. According to Benjamin Henry in http://www.papyrology.ox.ac.uk/POxy/papyri/4711.html. The translation used here is Henry's.

10. Schachter 1986: 180–82; Hardie 1988: 74; Anderson 1997: 372; Bettini and Pellizer 2003: 37–9, 48–50, 82–5. Although Hyginus' account does not survive in his lacunary *Fabulae*, its title does: "Son of the River Cephisus, who fell in love with himself" (heading for ch. 214). Pausanias' hints that the story was of some antiquity in the region of Thespiae may be nothing more than an etiology established well after the fact of its popularization in the Augustan period. Even the given name *Narkissos* or *Narcissus* does not appear before the turn of the first millennium, whereas it is fairly common thereafter; see Nelson 1999–2000: 369 n. 21; Bettini and Pellizer 2003: 95. But cf. Zimmerman 1994: 18–22, who postulates that the poet Corinna of Tanagra may have popularized the Narcissus myth in the fourth century B.C.E.

11. Fränkel 1945: 84, 224 n. 242; Dörrie 1967; Vinge 1967: 11–12; Ritter Santini 1978: 151;

Rosati 1983: 22–3, 26; Hardie 1988: 74–5; Balensiefen 1990: 149; Anderson 1997: 372.

12. Neugebauer 1927; Guerrini 1963: 351; Schefold 1981: 210–11; Rafn 1992: 711; Hafner 1994; De' Spagnolis 1995; Colpo 2002: 31 n. 87, 38–41; Iaculli 2003: 14–15.

13. Helbig 1892; Orlowsky and Orlowsky 1992: 435, no. 127; Bettini and Pellizer 2003: 96–9; Iaculli 2003 15, n. 4.

14. The most comprehensive surveys of this material are Vinge 1967: 1–41 and Bettini and Pellizer 2003: 43–114.

15. Col. 6.35. See Hadot 1976: 92; Rosati 1983: 15; Frontisi-Ducroux and Vernant 1997: 206–8; Bettini and Pellizer 2003: 117.

16. Philostr. *Imag.* 1.23; Callistr. 5. All references, except where otherwise indicated, are to the Loeb edition, transl. A. Fairbanks. Altekamp's authoritative study of Callistratus establishes his *floruit* in Constantinople after its founding ca. 330 C.E. (1988: 82; 95–7). On the Narcissus *ekphraseis* in particular see Levi 1947: 64; Hadot 1976: 92–3; Rosati 1983: 46–7; Conan 1987: 167–8; Bann 1989: 105–14; Balensiefen 1990: 154–60; Elsner 1996b; Frontisi-Ducroux and Vernant 1997: 225–34; Bettini and Pellizer 2003: 88–94.

17. *Enn.* 1.6.8. Eitrem 1935: 1728–9; Lehmann 1962: 67–8; Renard 1966: 806–13; Hadot 1976; Bann 1989: 117–19; Balensiefen 1990: 148; Jónsson 1995: 92–3, 98; Frontisi-Ducroux and Vernant 1997: 222–3; Bettini and Pellizer 2003: 99–101. On centrality of mirrors to Neoplatonic theory of *logos* and light see Heinemann 1926; Jónsson 1995: 88–99.

18. 1.1.26, 134–36, 210, 259–60 (Shackleton Bailey).

19. Nonn. 48.584–6. See Hadot 1976: 88–9; Borghini 1994: 205–6; Frontisi-Ducroux and Vernant 1997: 234–5.

20. Narcissism as a psychological pathology has a vast bibliography; for example, an entire issue of the *Nouvelle revue de psychanalyse* (vol. 13, 1976) is entitled *Narcisses*. See also Pfandl 1935; Freud 1957; Dörrie 1967; Bann 1989: 119–26; Nouvet 1991; Regopoulou 1994; Renger 1999; Melchior-Bonnet 2001: 145–55; Bettini and Pellizer 2003: 103–7.

21. Nouvet 1991; Brenkman 1976.

22. Siebers 1983: 71–86.

23. Nelson 1999–2000.

24. Bartsch 2000: 70–72; 2006: 57–114. As Anderson (1997: 374) observes, "Narcissus will not

'know' anything more profound than that the figure he sees in the water is the reflection of himself. That discovery does kill him, granted, but it is not the self-knowledge that Delphi and moral philosophers meant."

25. Hardie 1988; Bartsch 2006.

26. *Alcib.* 1.132c–133c; *Phaedr.* 255b–e; Schickel 1962: 486. The link between Plato's theory of love and Narcissus is made almost explicit by the setting in which Philostratus places his Narcissus: a grotto of Achelous, who is also the dedicatee of the sanctuary in which the *Phaedrus* takes place (230b–c). See Koller 1973, 1976; Rosati 1983: 15–17; Pellizer 1987: 117; Borghini 1994; Frontisi-Ducroux and Vernant 1997: 122–4, 139–40, 227, 233, 249–50; Bettini and Pellizer 2003: 118–21. On the Platonic theory of forms as it applies to the *ekphraseis* of Philostratus and Callistratus, see Balensiefen 1990: 156–8. At stake is a proper understanding of the realism of the reflected image; cf. Elsner 1996b. On the cult of Anteros at Athens see Frontisi-Ducroux and Vernant 1997: 202–3.

27. Bartsch 2000, 2006: 57–114.

28. Comparing the prophet's words to the famous dictum at Delphi ("know thyself"), which has been interpreted to mean "take heed of your mortality," Cancik (1967) argues that Ovid intentionally meant to play out this maxim in the person of Narcissus.

29. Narcissus' pool admits no sunlight (*Met.* 3.412); Lake Avernus is also impervious to the sun (*Aen.* 6.238). Narcissus' pool is undisturbed by bird or beast (*nulla volucris nec ferus turbarat, Met.* 3.409–10); Avernus kills any bird outright that flies over it (*Aen.* 6.236–42). See DiSalvo 1980; Hardie 1988: 79–81. On Tartarus cf. Bettini and Pellizer 2003: 55.

30. The language of imprisonment and enclosure is relatively prominent in the Narcissus story, beginning with the account of the impregnation of Liriope, "whom once the river-god, Cephisus, embraced in his winding stream and ravished, while imprisoned in his waters" (3.342–4).

31. DiSalvo 1980: 22–4.

32. On the baneful charms of water nymphs see Ninck 1921: 48; on the possible connection of this phenomenon to Narcissus, Schuller 1998: 143–4.

33. None of these female figures can be positively identified as Echo, except in the rare case of an inscription; see Rodenwaldt 1909: 192–3;

Colpo 2002: 44–6. For a careful analysis of the various configurations of all known Narcissus scenes see Colpo 2002: 33–53.

34. Rodenwaldt 1909: 190–92, 242–6; Dreger 1940: 1.17–19; Levi 1947: 61; Lippold 1951: 138; Zanker 1966: 156; Mielsch 1975: 45–6; Balensiefen 1990: 50–52, 61–2, 63–5, 75; Colpo 2002.

35. Zanker 1966: 159–66; Balensiefen 1990: 239 K 41; Rafn 1992: nos. 16, 17, 21–3, 35, 38, 41–3.

36. Amelung 1903–8: 1.288–9 no. 169; Sichtermann and Koch 1975: 47–8 no. 45; Sichtermann 1986: 240 no. 4; Balensiefen 1990: 239 K 41.1; Rafn 1993: 706 no. 37.

37. *Hymn. Hom. Cer.*; Soph. *OC* 681; Pliny *HN* 21.128; Artemid. 1.77; Plut. *Quaest. Conv.* 3.1.647b; Clem. Al. *Paed.* 2.8.71.3; Eust. *Il.* 1173.49; Eitrem 1935: 1726–7; Hadot 1976: 82–8, 90; Rosati 1983: 13–14; Balensiefen 1990: 147; Zimmerman 1994: 1–2; Frontisi-Ducroux and Vernant 1997: 236–8; Schuller 1998: 154–6; Di Nisio 2003: 31, n. 20, 21. Some have focused on the flower's power to fascinate, or to invoke the gods in divination; see Siebers 1983: 59–63; Nelson 1999–2000: 380–83.

38. Nouvet 1991: 126–7.

39. Bettini and Pellizer 2003: 74–5, 100, 111.

40. Elsner 2000: 9 notes the symbolic tension of the hunting imagery, which represents the two sequential moods of Narcissus: its associations with the chaste and frigid Diana, and its long-standing connection to sexual pursuit. Anderson 1997: 375 observes the proximity of another story in which the hunter becomes the hunted, that of Actaeon. Nearly every pictorial representation of Narcissus incorporates attributes of the hunt, usually spears or dogs, sometimes both. On a gem of unknown provenance, the conventional scene is enlivened by a little Eros who emerges from the spring, aiming his arrow at Narcissus (Furtwängler 1900 Taf. 50.31; Levi 1947: 64 n. 34; Rafn 1993: no. 56). In several frescoes from Pompeii, Eros either points to spears in the youth's hand, or actually holds a spear himself. Eros holding the spear: Pompeii, Antiquarium (from House 7.15.2) = Balensiefen 1990: 232 K 32.26.

41. Balensiefen 1990: 233 K 32.35; Rafn 1993: 705 no. 28; Colpo 2002: 62–3 no. 2.

42. Rafn (1992) identifies the flowers as narcissi in three cases: nos. 28, 31, and 36. But in truth these are mere guesses.

43. 1.23.28–9; Sharrock 1996: 127.

44. 1.23.9–10. Transl. J. Elsner.

45. Frontisi-Ducroux and Vernant 1997: 225–32. Callistratus, on the other hand, presents a different picture: the reflection of the stone statue of Narcissus "is . . . instinct with life and breath" (5.4.16–17), giving life to the stone. On certain gems, Narcissus holds a branch (species uncertain) in his hand. Levi (1947: 64) remarks that this signifies his impending death, but he offers no further elaboration.

46. Levi 1947: 60–65; Balensiefen 1990: 241 K 45.1; Rafn 1993: no. 9. Cf. an Antonine-era *puteal* from Ostia (lost; plaster cast in Thorwaldsen Museum, Copenhagen): Levi 1947: 63; Zanker 1966: 155–6, fig. 1; Gonzenbach 1975: 124; Balensiefen 1990: 141–2, 238 K 39; Rafn 1993: no. 53. An early-third-century-C.E. mosaic from a villa near Orbe in Switzerland: Levi 1947: 66; Renard 1966: 806–13; Koller 1973, 1976; Gonzenbach 1975; Balensiefen 1990: 75, 148–9, 241–2 K 45.3; Rafn 1993: 704 no. 14. The reverse side of the *puteal* represents the myth of Hylas, which also features a youth who comes to grief at a spring. Both scenes are perfectly appropriate for adorning a wellhead. There is little to recommend Koller's hypothesis, however, that the youth on the Orbe mosaic is Hylas rather than Narcissus. For Eros reacting in a similar way, see Rafn 1992: 705 no. 27.

47. Neumann 1965: 97–102.

48. *stat, stupet, haeret, amat, rogat, innuit, aspicit, ardet,/blanditur, queritur, stat, stupet, haeret, amat* (Anth. Lat. 1.259.7–8 Shackleton Bailey). My transl.

49. De Grummond 2002. I am grateful to Nancy de Grummond for discussing her ideas on "prophecy made visible" with me at length.

50. *Suda* s.v. *polloi* (no. 1934); see Bettini and Pellizer 2003: 111–12, 194.

51. Bettini and Pellizer 2003: 85–6, 94–9. Rafn (1992: 707–8, 710) is mistaken, however, in identifying attendant nymphs in many of these scenes as Echo; often they are clearly water nymphs, perhaps representing, among others, Narcissus' mother Liriope. On the digression of pictorial types from the known literary versions, see Small 2003: 100–104.

52. As documented by Rafn 1992. Rafn's *LIMC* catalog is by no means complete; it has overlooked some material cited in Balensiefen 1990. See also Parise Badoni 2001, which adds another fresco, from the House of the Four Styles in Pompeii (1.8.17), to the total.

53. *PPM* 9.205 no. 94, *Disegnatori* 364 no. 179, 461–4 no. 42, 823–6 no. 2; Schefold 1957: 246; Balensiefen 1990: 231 K 32.2; Rafn 1993: 706 no. 36; Colpo 2002: 82–3 no. 38; Marcattili 2004: 145. Cf. the Narcissus scene from Pompeii 10.2.10: *PPM Disegnatori* 408 no. 232.

54. Narcissus is occasionally depicted at a spring presided over by a statuette of Diana-Hecate with her two torches; see Levi 1947: 64; Rafn 1992: nos. 56–60. Pellizer's hypothesis (Bettini and Pellizer 2003: 94) that this is Nemesis is unlikely. Such statuettes and shrines are common features in Roman sacral-idyllic art, and often seem to signify little more than rusticity; Diana, mistress of the woods and the hunt, dominates Hecate, her more sinister alter ego.

55. *primoque extinguor in aevo*, 3.470, my transl. See Anderson 1997: 385. Specially prepared torches that lit spontaneously after immersion in water may have been used as symbols of death and miraculous rebirth in the Dionysiac cult at Rome famously documented in Livy; see 39.13.

56. *PPM* 4.34–5 no. 60; *PPM Disegnatori* 916–18 nos. 46–7; Schefold 1957: 92; Zanker 1966: 157–8; Schefold 1981: 209–11; Balensiefen 1990: 231 K 32.1; Rafn 1993: 706 no. 33; Colpo 2002: 80 no. 34. On the symbol of the inverted torch see Pfandl 1935: 295; Levi 1947: 63; Balensiefen 1990: 141; Rafn 1992: 710; Colpo 2002: 44; Marcattili 2004: 145. On Roman sarcophagi, standing "funerary erotes" sometimes extinguish torches at their feet; e.g., Museo Nazionale Romano 125891 or Metropolitan Museum 24.97.13. See McCann 1978: 34–8; Giuliano 1981: 86–8 no. 4, 1984: 382–3 no. XII, 15.

57. On Narcissus' self-entrapment and the degradation of the idealized Platonic homoerotic impulse, see especially Bartsch 2000; Bettini and Pellizer 2003: 68–9; and bibliographies.

58. On what is known of the "spring of Narcissus" in this region see Bettini and Pellizer 2003: 45.

59. *Met.* 3.370–74; Elsner 2000: 104.

60. *invenit proprios mediis in fontibus ignes/et sua deceptum urit imago virum*, *Anth. Lat.* 1.134 (ed. D. R. Shackleton Bailey, my transl.). The same motif appears in reference to Venus; e.g., by Meleager: "It is a wonder to me, Cypris, how thou, who didst rise from the green sea, didst bring forth fire from water" (*Anth. Pal.* 5.176, transl. W. R. Paton).

61. Hardie 1988: 81–5; Bartsch 2006: 57–114.

62. Lucr. *DRN* 4.1097–1102. Transl. W. H. D. Rouse. On the metaphor of unquenchable thirst see Brown 1987: 236–9 and bibliography.
63. Pellizer 1991: 13.
64. I am grateful to Kathleen Coleman for suggesting that the supine image could carry erotic as well as morbid intimations.
65. Spinazzola 1953: 1.379; Balensiefen 1990: 231 K 32.5; Rafn 1993: 704 no. 2; Scagliarini Corlaita 2001; Colpo 2002: 72 no. 19. For opinions about the gorgon effect in Narcissus paintings, particularly this one, see Elsner 2000: 103–4; Platt 2002: 92–4. With Richardson 2000: 147, I suspect that nothing gorgonlike was intended by the artist.
66. *PPM* 8.503–4 no. 94; Zanker 1966: 157–8; Rafn 1992: no. 34; Colpo 2002: 81–2 no. 36. According to Fiorelli, the huge hole in the fresco was created by looters breaking through the wall shortly after the eruption.
67. Zanker 1966: 156–8.
68. Close parallels to Narcissus types appear frequently in Pompeian representations of Endymion, Hermaphroditus, Adonis, Kyparissos, and Ganymede, all adolescents of a distinctly effeminate type but with a male identity. See Levi 1947: 61; Rafn 1993: 710. A particularly interesting comparandum is the "nest of erotes" scene from the tablinum of the House of M. Holconius Rufus (8.4.4) in Pompeii, in which a figure identical in every way to Narcissus – except for the apparent lack of a reflecting pool beneath him – gazes at a handful of tiny Cupids being held out for display by a seated female figure. See *PPM Disegnatori* 423 no. 251; Levi 1947: 61. The scene appears to be combining the Narcissus theme with the famous "peddler of erotes" theme.
69. Only at the moment before his death do we learn that Narcissus was clothed; he rends his tunic in order to beat his naked breast (482–3). In 497–8 he also beats his upper arms; see Anderson 1997: 386–7.
70. Moller 1987; Nussbaum 2002. "At sixteen, Narcissus was hardly below the age of puberty; but the adjective [*inpubes*, 3.422] had an extended meaning of 'youthful,' and here with the noun [*genas*] would mean 'beardless'" (Anderson 1997: 380). The ephebe in Roman art is quite a distinct creature from the man, and is repeatedly depicted with pale skin, soft musculature, and no trace of a beard or pubic hair.

71. Again, *forma* is an ambiguous term, not necessarily implying the whole body.
72. Zanker 1966: 167–9; but cf. Balensiefen 1990: 142.
73. Philostratus presents alternate subjectivities in two successive ekphraseis. His description of Narcissus takes the viewer's viewpoint; but the previous sketch, which describes Olympus piping at the edge of a pool, exhorts the youth to pay no heed to his reflection, for it is bound to be grossly foreshortened; see Bann 1989: 108–9.
74. Typically the *skia* or the *umbra* is perceived as a double carrying within it something vital that belongs to its referent, perhaps the soul; see Schickel 1962: 488; Mori 1987: 115; Vernant 1991c, 1991e; Guidorizzi 1991: 36–7. But both a shadow and a reflection in water are darkly transparent: they imprint a persona onto a medium (water, the ground) without entirely denaturing the medium. On the persistence of tying reflections to shadows in the middle ages, see Stoichita 1997: 35.
75. Prehn 1997: 107, 109.
76. Schefold 1957: 345; Balensiefen 1990: 233 K 32.42; Rafn 1993: 707 no. 47; Colpo 2002: 70–71 no. 17.
77. Prehn 1997.
78. Elsner 1996b, 2000: 101–5.
79. Colpo 2002: 51–2, 81 no. 35. *PPM* 2.937 no. 3 incorrectly interprets these two forms as the independent figures of Selene and Endymion. Lorenzo Fergola (in Guzzo 1997: 121 no. 72) suggests that this is a Venus borrowing from the conventions of Narcissus scenes. Venus does appear on another wall of the same room in this tiny house (*PPM* 2.936 no. 1), but such duplications in a single room are rare. See Prehn 1997: 108, 110 n. 18.
80. Prehn 1997: 108 ascribes overt femininity to another Narcissus from the Villa of C. Siculius at Torre Annunziata: Naples, Museo Nazionale 9385; Zanker 1966: 166–7, fig. 14; Rafn 1992: no. 49. In truth, all these figures are ambiguous by comparison with the image under discussion.
81. Nussbaum 2002.
82. The dominance of gender role in Greco-Roman sexual constructions has been confirmed in a blizzard of publications beginning with Foucault 1990; e.g., see Halperin 1990; Halperin et al. 1990; Konstan and Nussbaum 1990; Winkler 1990; Richlin 1992; Hallett and

Skinner 1997; Larmour et al. 1998; Porter 1999; Fredrick 2002; Nussbaum and Sihvola 2002. On the persistence of sexual orientation despite the norms, see Taylor 1997.

83. Prehn (1997: 109) and Pellizer in particular (1991; Bettini and Pellizer 2003) have held on to the notion that one mode is distinct from the other. More interesting is Elsner's suggestion (1996b: 249) that there is an element of taboo in the exact parity in age between Narcissus and his "beloved"; cf. Bartsch 2000: 75–82; Bettini and Pellizer 2003: 141. In Ovid, he stands between the age of *puer* and *iuvenis*, but his male admirers are all *iuvenes*. (The ages of the *puellae* who also chase after him are less determinate.) Whatever the realities of real life, acceptable relationships between male coevals almost never appear in Roman art or literature (Taylor 1997; Williams 1999: 183–8).

84. McCarty 1989: 179–82; Robinson 1999: 213–14; Williams 1999: 125–59. For an interesting but flawed contrarian view see Parker 1997, esp. 58–9.

85. Eur. *Hec.* 923–6. Cf. Eur. *El.* 1069–75, *Tro.* 1105–9; McCarty 1989: 180.

86. On the problematics of gender in Ovid, and on his carefully wrought sympathies for feminine adornment, see Wyke 1994: 145–7; Sharrock 2002a. On the self-objectification of women in Ovid's erotic verse, see Myerowitz 1992.

87. Gleason 1995: 59.

88. Jeanmaire 1951: 153; Edwards 1993: 63–97; Gleason 1995: 55–130; Williams 1999: 138–42; Sharrock 2002a. On the Greek perception of female insatiability, or femininity as animal nature, see Carson 1990; Stewart 1996: 139 n. 8, 143; Brisson 2002: 119. On the anthropological literature see Delcourt 1992: 5–27; Williams 1999: 141 n. 62; and bibliographies. On the intellectual grounding for somatotypes in Greek and Roman antiquity see Klimowsky 1972.

89. Ps.-Hes. *Fr.* 275 Merkelbach–West (Hes. *Melampodia* fr. 3 in Loeb edition); Apollod. 3.6.7; Ov. *Met.* 3.316–38; Brisson 2002: 115–30.

90. Wyke 1994: 137; Williams 1999: 133. Here Roman norms depart from Classical Greek sensibilities, which allowed no woman an opportunity to distinguish herself except occasionally as a courtesan. On the possible representation of such an exercise of female distinction on a pair of embossed mirrors reputedly from Corinth, see Stewart 1996.

91. *Ep.* 9.115–18; transl. G. Showerman. Cf. Juv. 2.99–103.

92. Baratte 1986: 12; Sennequier et al. 2000: 56, 87 no. 60. About a dozen of these "Hercules-club" mirrors (Lloyd-Morgan 1977, Group J) survive, most or all of them from Campania; see Lloyd-Morgan 1982: 44, 47. Cf. a cup from the Berthouville treasure representing Omphale with attendant erotes sleeping on the lionskin: Pirzio Biroli Stefanelli 1991: 189–90 fig. 185, 276 no. 106.

93. Robertson 1975: 551–2; Haskell and Penny 1981: 234; Ajootian 1990: 277 no. 56; Ridgway 1990: 1.329–30.

94. The so-called Hermaphroditos *anasyromenos* type: see Ajootian 1990: 274–6, nos. 30–53; Ajootian 1997: 221–31.

95. Ajootian 1990: 278–9 nos. 63–63w, 1997: 231–5.

96. Richardson 1955: 124; Ajootian 1990: 280 nos. 65–7.

97. Gleason 1995: 62–7. Sourvinou-Inwood 2004: 69–73 contends that the original myth of Hermaphroditus had no erotic content, and that his androgyny in the local cult of Halicarnassus was a strictly positive representation. The Roman variant, she believes, construed the youth's civilizing effect as a "softening," and thereby a feminization.

98. *ta men alla gunis ôn, echôn de ti andromorphon,* Suet. *Peri blasphemiôn* 61 (ed. J. Taillardat; my transl.).

99. Robinson 1999: 215–17.

100. Anderson 1997: 448.

101. Delcourt 1992: 65–103; Ajootian 1997: 228–31; Robinson 1999: 214–15; Brisson 2002: 50–57; Sourvinou-Inwood 2004: 60. An earlier divinity named Aphroditos, who was represented as a bearded and probably ithyphallic Aphrodite, seems to have been worshiped on Cyprus and perhaps introduced to Athens in the fifth century B.C.; see Macr. *Sat.* 3.8; Serv. Ad *Aen.* 2.632; Hesych. s.v. *Aphroditos*; Herrmann 1886–90: 2314–15; Jessen 1912: 715; Laurenzi 1960: 421–2; Delcourt 1992: 43–7; Brisson 2002: 54. Pre-Ovidian evidence suggests that Hermaphroditus was born with both sexual characteristics; see esp. Diod. 4.6.5;

La Penna 1983: 242–3. His earliest surviving visual manifestations present him as an ithyphallic herm with feminine characterisitics. Brisson (2002: 53–4) suggests that the *herma* in "Hermaphroditus" refers to ancient phallic boundary stones (herms). The famous inscription found at the spring of Salmacis says nothing of Hermaphroditus' sexual ambiguity, emphasizing instead the civilizing effect of the spring and of Hermaphroditus himself; see Sourvinou-Inwood 2004.

102. Cic. *De off.* 1.61; Ov. *Met.* 4.285–7, 15.319–21; Strabo 14.2.16; Vitruv. 2.8.11–12; Festus 329 L; Vibius Sequester *Font.* 152; Robinson 1999: 212–13; Brisson 2002: 50–53.

103. 4.294–5. All translations from this passage are from F. J. Miller's Loeb edition unless otherwise noted.

104. This is foreshadowed by her habit of gathering flowers by the pool (4.315). The moment before she rushes to embrace the youth in the water, he is compared to a lily encased in glass (4.355). The floral simile is interesting for another reason: the lily (Greek *leirion*) may have been identical to the narcissus; see Schickel 1962: 495. If so, Ovid may be intentionally evoking Narcissus (son of Liriope, *leiri–ope*, "lily-faced"). For a reading that problematizes the "ultrafeminine" nature of Salmacis see Nugent 1990, which analyzes Salmacis from a Freudian perspective.

105. Robinson 1999: 219–20; Brisson 2002: 59.

106. 4. 354–79. *Tenet, tangit, carpit, inplicat, adligat, continet, permit, inhaerebat* are among the verbs used to describe Salmacis' actions in this passage. The boy resists, but in vain. In 360 he *circumfunditur*, reminding us "that Salmacis, both water and nymph, can 'pour around' him all by herself" (Anderson 1997: 450). Contra: Nugent 1990.

107. Otis 1966: 156.

108. Such is often the presumption, e.g., Ajootian 1997: 229.

109. Klein 1926: 90–91; Dreger 1940: 2.35; Schefold 1957: 100; Balensiefen 1990: 53, 234 K 33, who suggests that the bearded mirror-bearer is Priapus. More likely, his Parthian-looking headgear betrays him as a generic Asiatic, reminding the viewer of the Carian locale of the spring of Salmacis; on the cap see Müller 1994b: 77–9. A similar fresco from a villa in Boscoreale resides in Stuttgart (Landesmuseum Arch 83/1c); see Balensiefen 1990: 53. This cognate version includes the mirror but lacks the mirror image.

110. *PPM Disegnatori* 615 no. 52.

111. A preliminary sketch, or "lucido," is much less detailed; it is reproduced alongside the final drawing in *PPM Disegnatori* 615 no. 51.

112. *PPM Disegnatori* 848–9 no. 14.

113. Nussbaum 2002: 73–6.

114. La Penna (1983: 241) reads Ovid's negative judgment in his use of language such as *semivir*, *incestum medicamen*, *infamis Salmacis*, and so forth.

115. *PPM Disegnatori* 848–9 no. 14.

116. A bad omen, according to Bömer 1969–86: 2.118.

117. 4.347–9, transl. S. G. Nugent 1990: 173).

118. 3.755–60. Transl. R. C. Seaton (Loeb ed.).

119. Callistratus imitates this effect in his own description of the sculpted Narcissus, "which flashes lightning" (*astrapen . . . apolampôn*, Callist. 5.1.19–21, my transl.).

120. *Phaedr.* 255b–e. On Platonic visual erotics and competing theories see Bartsch 2000; Goldhill 2002; Nussbaum 2002; Bartsch 2006. One likely Epicurean source is Lucretius 4.269–323 (Loeb edition), which coins the rare word *translucere* (309), used again by Ovid to describe the swimming Hermaphroditus (4.354). See Anderson 1997: 450.

121. Plut. *Mor.* 139b; cf. Artemid. 2.4. Frontisi-Ducroux and Vernant 1997: 126–30. Cf. Irigaray's feminist perspective on this paradigm (1985); Nugent 1990: 172–6.

122. Slater 1998. See also Peden 1985.

123. *Met.* 3.155–252; Balensiefen 1990: 105–12, 241–3 K 44, 46–7; Guimond 1981, esp. nos. 106–7, 114–19. For an interesting approach to the reflection in Ovid's Actaeon story see McCarty 1989: 187–8.

124. The translations of Apuleius cited here are from J. A. Hanson's 1989 Loeb edition.

125. Slater 1998: 36. Cf. Platt 2002: 98–103, which similarly draws the viewer into a divided Actaeon-and-Diana tableau at the House of Octavius Quartio in Pompeii (2.2.2–5).

126. Slater 1998: 37; cf. Searle 1980; Snyder and Cohen 1980; Alpers 1983: 31–3; Snow 1989: 40–41.

127. Winkler 1985: 170.

128. Slater 1998: 44.

129. This idea also permeates Apuleius' *Apology*, in which mirrors and statues (and even a statue mirrored in water) emphasize the mutability of personal identity; see Too 1996. "Underlying Apuleius' discourse of the *speculum* is the recognition . . . that – indeed, unlike the modern looking-glass – the ancient mirror was recognized to be a place of multiple or plural representation, as an object which juxtaposed and superimposed different images, whether related or not" (Too 1996: 144).

THREE. THE MIRROR OF DIONYSUS

1. Cyril of Alexandria observes that the women of Egypt entered the sanctuaries of Isis "with mirror in the left hand, *sistrum* [the Egyptian rattle] in the right" (*De adoratione* 9.314 = Migne, *PG* vol. 68, 133). Whether this practice was primarily functional or symbolic, it may have been influenced by the cult of Dionysus, but the little we know about the use of mirrors in the Isis cult suggests a principally symbolic role confined exclusively to the feminine domain; cf. Apul. *Met.* 11.9.2.

2. Burkert 1977: 8.

3. Rohden and Winnefeld 1911: 247, Taf. 15, 16; Simon 1962: 1420–24, Abb. 1, 3; Kerényi 1977: 271–2, figs. 68, 69; Rauch 1999: 55–6, 58–60, Kat. 158–66, 171–6, Taf. 8.1–2, 9.1. Cf. the mirror dance in Egyptian art: Lilyquist 1979: figs. 106, 107.

4. I intentionally use the terms "ecstasy" and "ecstatic" in the traditional sense referring to an altered state achieved by a variety of means. I do not adopt Rouget's carefully parsed distinction (1985: 3–12) between ecstasy (achieved in quietness and solitude, hallucinatory) and trance (achieved in a group, often with great sensory agitation, nonhallucinatory). Rouget acknowledges that these are the poles of a continuum and that any given experience of an altered state may have elements of each. If his formulation can be trusted, then "telestic madness" of the Dionysiac kind is decidedly a hybrid, involving hallucination, music, and dance. I fear that the Greek and Roman experience so exceeds in complexity the model of "trance" he advances, and is so inapt to his model of "ecstasy," that it threatens to undermine the usefulness of his dichotomy. Telestic trance, it would appear, was rarely just a visitation in which the god overtook the identity

of the subject *tout court*; it emphatically involved visions, fearful encounters, and states of wandering or indeterminate subjectivity. Moreover, Rouget insists that, as a universal rule, the person possessed does not will the state of possession, and does not even know in advance which god will choose to possess him (34–8). Such conditions cannot have existed in ancient mystery cults, which "targeted" the particular god to which they were attached.

5. Papi 2003.

6. See Chapter 1.

7. Wiles 1991: 113.

8. Otto 1981: 76–7, 160–70.

9. On Perseus' traditional opposition to Dionysus see Gallistl 1995: 6–8.

10. On the Athens cult site see Thuc. 2.15.3–4; Ar. *Frogs* 215–19; Strabo 8.5.1; Pseudo-Demosthenes *In Neaeram* 73–8. See Kerényi 1977: 291–3.

11. Plut. *Mor.* 364 F. Transl. F. C. Babbitt (Loeb edition).

12. Alcaeus 104 (ed. E. Diehl); Aeschylus, fragment 383 (ed. Nauck). My transl.

13. Macchioro 1920; Festugière 1935: 372–81 (rigorous but dated); Linforth 1941: 307–64; Burkert 1977; Kerényi 1977: 262–72; Sorel 1995: 64–87; Sauron 1998: 126–8. For treatment of the collected Orphic texts see Kern 1922; Fol 1993.

14. Linforth 1941: 308–12; Jeanmaire 1951: 370–90; Boyancé 1966: 56; Burkert 1977: 4–5; Detienne 1979: 68–9; Sorel 1995: 64; Frontisi-Ducroux and Vernant 1997: 186–8. Beginning around the same time, maenadism – the promotion of rituals in which women flew into violent ecstatic frenzies on the god's behalf – may have originally constituted a reenactment of the killing, eating, and reassembly of the young Zagreus. On maenadism's origins, perhaps in the sixth century B.C.E., see Henrichs 1978: 147–8. In Roman cult practice it gradually disappeared, giving way apparently to more hermetic rituals. On the diffusion of the Zagreus myth see Henrichs 1984: 220–21.

15. "First they beguiled him with childish toys, and then, – these very Titans – tore him to pieces, though he was but an infant. Orpheus of Thrace, the poet of the Initiation, speaks of the 'top, wheel and jointed dolls, with beauteous fruit of gold from the clear-voiced Hesperides.' And it is worth while to quote the worthless symbols of this rite of yours in order

to excite condemnation: the knuckle-bone, the ball, the spinning-top, apples, wheel, mirror, fleece!" Clem. *Protr.* 2.15. Transl. G. W. Butterworth (Loeb edition). Some of the other toys with which Zagreus amuses himself, such as the bull-roarer, also have a transformative, salvific significance; see, for example, Kern 1922: no. 34. For interpretations of the toys see Kerényi 1960: 155–8; West 1983: 140–61; Tortorelli Ghidini 2000; and bibliographies.

16. Kern 1922: no. 209; West 1983: 156.

17. Nonnus 6.169–76. My transl.

18. Firm. Mat. 6.2–5; cf. Clem. *Protr.* 2.15; Schol. Lycophron 355. For a thorough survey of the literary epigraphic sources available at the time, and a welcome digestion of the Neoplatonist hermeneutics of Orphism, see Linforth 1941: 307–64; see also Macchioro 1920, esp. 105–15 (which often misreads the Greek primary sources); Pépin 1970: 305; Kerényi 1977: 265–72; Frontisi-Ducroux and Vernant 1997: 186–90; Detienne 1979; West 1983: 154–9; Burkert 1987: 73, 77–8, 86, 100–101; Gallistl 1995: 16–22.

19. Kern 1922: nos. 31, 34, 208–9. See West 1983: 154–9; Burkert 1987: 78; Fol 1993: 85–6, 104–10.

20. Macchioro 1920: 109; my transl. He (112–15) makes much of a reference in Aristophanes' *Thesomophoriazousai* (134–45) to Aeschylus' lost play *Lykourgeia*, in which King Lycurgus evidently mocked the effeminate nature of Dionysus. The line "What is this communion of mirror and sword?" (140) has led a few scholars, most vocally Macchioro, to suggest that Aeschylus was referring to the Orphic Dionysus. But this passage presents a parody of Aeschylus, not his very words; and these objects, only two among many other distinctly feminine or masculine things in Aristophanes' passage, probably should be taken only to emphasize the interlocutor's hermaphroditic appearance.

21. West 1983: 163. Corybantic dances often strove to mimic the Curetes, even to the point where the participants danced in arms; see Linforth 1946a: 157 and citations.

22. Linforth 1941: 307–64; Pépin 1970; Hadot 1976: 98–108; Brisson 1991.

23. Iamblichus speaks of a number of optical methods of divination that he terms evocation by light. "This somehow illuminates the aether-like and luminous vehicle surrounding the soul with divine light, from which vehicle the divine appearances, set in motion by the gods' will, take possession of the imaginative power in us" (*De myst.* 3.14; transl. Clarke 2003). [23] Proclus remarks that long before his time theologians had adopted the mirror as a symbol of the universe. He seems to suggest that the model for this analogy is not just any mirror, but specifically the one responsible for Zagreus' transfiguration: "they say that Hephaestus made a mirror for Dionysus into which the god, when he beheld his image, went forth into the whole divided universe" (*In Plat. Tim.* 3.163f = Festugière 1966: 3.80.20–24; my transl.). Olympiodorus says much the same thing (*In Plat. Phaed.* B. 128 = Norvin 1913: 111). According to Plotinus, "the souls of men, seeing their images in the mirror of Dionysus as it were, have entered into that realm in a leap downward from the Supreme: yet even they are not cut off from their origin, from the divine intellect" (*Enn.* 4.3.12. Transl. MacKenna 1991). On mirrors in Plotinus' cosmology see Heinemann 1926.

24. Apul. *Apol.* 55–6; Kern 1922: no. 34; *Pap. Gurob*; see Burkert 1987: 78; 100.

25. Firm. Mat. *Err.* 6.5. My transl.

26. Gallistl 1995: 17–18. Harpocration (s.v. *apo-mattôn*) remarks that "they plastered the initiates with clay and chaff, imitating those myths recounted by some – how the Titans murdered Dionysus after plastering themselves with gypsum to avoid being recognized" (p. 48.5 Dindorf, my transl.). On the evidence for various rituals reenacting Zagreus' play, see Tortorelli Ghidini 2000.

27. Lindner 1997. Other noisemakers, such as the bull-roarer and the *rhombos*, also are counted among Zagreus' toys. They too had ritual significance; see Tortorelli Ghidini 2000.

28. Bologna, Mus. Civ. Pal. 693. Gerhard 1846; Ronchaud 1887: 1626; Immisch 1890–97: 1617–18 fig. 4; Reinach 1909–12: 3.59; Macchioro 1920: 21–2, 110–12; Eisler 1925: 98; Rostovtzeff 1927: 46; Delatte 1932: 193–5; Bovini and Ottolenghi 1956: 21 no. 7; Volbach 1976: 71 no. 95; Kerényi 1977: 265–6; Simon 1962; Gallistl 1981: 239, Abb. 13; Gallistl 1995: 17; Lindner 1997: 305 no. 3. Delatte insists that the "mirror" held by the servant is actually a small disk or tympanum being beaten by a stick, which has been mistaken for a handle. He seems to make this assessment entirely on the basis of Gerhard's line drawing of the scene, not from autopsy or photographs. Gerhard's drawing is an "interpretation" offering

refinements where none exist; the illustrations of Reinach, Immisch, de Ronchaud, and Eisler are clearly drawn from the same source. The object is unmistakably a mirror, as Volbach's study confirms.

29. Professor Natalie Kampen has suggested to me that the type may be influenced by representations of Gallic cross-legged gods, such as Cernunnos.

30. Simon 1962: 1420. Most famously, on the Borghese Crater in the Louvre and other "replicas"; see Fuchs 1959: 108–18, Taf. 23b, 26a, b. Similar dancing "warriors" of the cult of Cybele appear on a fourth-century plate from the Kaiseraugst treasure; see Pirzio Biroli Stefanelli 1991: 294, no. 159, pl. 224–5; *Milano capitale* 184, 347–8; Cahn and Kaufmann Heinimann 1984: 206–24, no. 62, figs. 111–13; Kent and Painter 1977: 94, no. 81. Cf. similar figures on a relief amphora from Baratti in *Milano capitale* 185.

31. Simon 1962: 1423 sees here a residue of the syncretistic rite in which Titans, corybants, and satyrs are all combined together in ecstatic dance. If the faces of these two Curetes were originally painted in lieu of the plaster disguise, there is no trace of coloring today.

32. Even Plotinus the formalist seems to grasp this metamorphosis; prior to his exegesis he remarks that mirrors can seize or entrap forms (4.3.11.7–8). "Loin d'être inertes, le miroir de Dionysos et l'image qui s'y reflète exercent donc une attraction sur le jeune dieu et précipitent la catastrophe. Cette idée se rattache à une vieille croyance selon laquelle le miroir aurait une aptitude magique pour piéger les âmes" (Pépin 1970: 319).

33. In this idea Delatte (1932: 154) sees the vestiges of the Platonic idea that the world is created from divine images combined with the Neoplatonic doctrine of emanationism, the mind's exteriorization of an inner divine force that has provoked the contemplation of its own image. Cf. Jónsson 1995: 88–9.

34. Plato *Phaedr.* 244a–e; Linforth 1946a, 1946b; Dodds 1951: 64–101; Rouget 1985: 192–206.

35. On crisis see Rouget 1985: 38–44, 66–71. Unfortunately he does not consider how crisis might operate in hallucinatory states, which he relegates to the category of ecstasy (as opposed to trance; see n. 4 above.)

36. Eur. *Her.* 894–5 (my transl.); Vernant 1990b: 59–60.

37. Celsus *ap.* Orig. *c. Cels.* 4.10; West 1983: 155.

38. Maury 1846; Haberland 1882; Negelein 1902; Frazer 1911: 92–6; Róheim 1919; Macchioro 1920: 98–101; Ninck 1921: 56–80; Frazer 1931: 134–5; Hartlaub 1951: 21–30.

39. McCarty 1989.

40. Delatte 1932: 151–2; Eitrem 1935: 1728; Renard 1966: 807.

41. According to one tradition, probably the authentic Orphic account, the young Zagreus was remade in the image of his destroyers – as a gypsum effigy; see Firm. Mat. *Err.* 6; West 1983: 163. The masks the Titans applied to their faces during their murderous approach were of the same chalky stuff as the remade god. Dionysus, by way of a masking substance, became his murderers – an irony not without logic, for the image that held his attention in the mirror, and drew him into the breach of death and rebirth, must have been his own. See Frontisi-Ducroux and Vernant 1997: 186–90; here the seed of destruction is the boy's self-objectification. Cf. Kerényi (1977: 268) and West (1983: 154–5), who interpret the gypsum as a fearsome element intended to frighten. Nonnus, though admittedly a very late interpreter, takes it to be a deception (6.169–73); cf. Harpocr. P. 48.5 Dindorf.

42. For a summary of the development and general character of Bacchic perceptions of ecstasy and salvation, see Grieco 1979: 433–4 with bibliography.

43. Cassimatis 1998. Schneider-Herrmann (1977: 35) remarks that "as far as is known, the mirror was believed to reflect the eidolon [the image of the deceased], when held toward a funeral monument." The only sources he cites are Delatte 1932 and Hartlaub 1951, neither of whom gives special attention to Apulian sources. For a fascinating venture into the (much rarer) mirror imagery in Sikeliote vase painting, see Bell 1995. In two Orphic scenes, on vases at Lentini and Syracuse, Bell associates the prominence of handled mirrors in these scenes with the central presence of the enthroned Persephone, mother of Zagreus. He suggests that Persephone's mirror may be the very one that addled and ensnared her child; alternatively, it might be a magical tool by which Persephone would trap the soul of Eurydice within her orbit, the underworld.

44. For example, see Trendall 1978–82, 1983, 1991; Schneider-Herrmann 1977.

45. Frontisi-Ducroux and Vernant 1997: 72–100.

46. Smith 1972. Various attempts, more or less systematic, have been made; see also Schmidt, Trendall, and Cambitoglu 1976; Schneider-Herrmann 1977–8. It is a pity that Smith's unparalleled erudition and astute insights are entombed in an impenetrable English prose that leaves even the native speaker aghast. Nevertheless, his "ablution pan" argument is tolerably intelligible. An implacable foe of most "Orphic" interpretations, he seeks a practical application for these objects; so he contends that the upright orientation of the telamones on the handles betokens an identical orientation for the pan in use. In the final analysis, this explanation is no more satisfactory than it would be for a *phiale*; both instruments should be held horizontally, or tipped from a horizontal position, in their ordinary functions. Nor is his "pan" as distinct from *phialai* as he claims: there is a whole class of ceramic *phialai*, cataloged by Schneider-Herrmann, that feature pairs of looped handles on the rims, much like those depicted on the vases. What these lack is a third, long handle; ceramic would be an unsuitable material for it anyway. On the other hand, long-handled Apulian bronze "pans" do exist, some with anthropomorphic handles; but these invariably lack the superfluous looped handles on the rim. Is the iconographic version a fictive hybrid of these two types?

47. Cassimatis 1998: 298–304. My transl. On ancient catoptromancy: Ganschinietz 1921; Delatte 1932. Catoptromancy in Etruscan society: de Grummond 2000, 2002. Its influence in Paul's epistles: Achelis 1918. Catoptromancy around the world: Róheim 1919: 34–81. Mirrors in Greek and south Italian cults of the dead: Dreger 1940: 2.91–101; contra, Balensiefen 1990: 169–73. On the widespread folk belief that reflections harbor the soul, and thus offer access to the dead, see Negelein 1902; Róheim 1919; Ninck 1921: 56–80; Hartlaub 1951: 21–30; Lissarrague 2000. The most extensive and up-to-date bibliography on forms of scrying (i.e., hallucination by optical fixation on an object), along with a discussion of the tradition as it was practiced by young mediums, can be found in Nelson 1999–2000. See also Besterman 1924.

48. Cassimatis 1998: 347. My transl.

49. Dioscorides *Anth. Pal.* 7.485; Nonnus 19.167–97; *SEG* 31.633, 32.488, 33.563; *IG* 2/3²11674, 7.686; Burkert 1987: 23–4.

50. Paus. 7.21.12. See Delatte 1932: 135–9; Balensiefen 1990: 177–8; Frontisi-Ducroux and Vernant 1997: 194–5. Pausanias continues by mentioning another sanctuary in which hydromancy is practiced, that of Apollo Thyrxeus at Lycian Cyaneae. For a remarkably similar medieval ritual see Delatte 1932: 167–8.

51. Tuchmann 1888–9; Negelein 1902; Róheim 1919: 62–7; Ninck 1921: 63–4. Tuchmann's monthly column entitled "La fascination" occasionally touched on the topic; see especially Tuchmann 1888–9: 278–81. Of particular interest are practices in Thuringia and the region of Baden-Württemberg, apparently still alive in the nineteenth century, involving the invocation of the dead through mirrors. Negelein, Róheim (1919: 206–22), and Ninck observe an interesting complementary tradition. In some societies a mirror was hung in the room of a gravely ill person, but was covered over when the sick person died; in fact, this practice is immortalized in Thomas Mann's *Buddenbrooks* (9.1), and is still favored in some Ashkenazic Jewish communities. In effect, the mirror captured the fleeing soul of the newly dead, rendering it an object of ill omen to the living. Ill-omened, certainly – but useful. Perhaps such a wondrous and dangerous artifact, capable of absorbing and harboring souls of the dead, could be tapped at a later time, with due precaution. (Otherwise, why keep mirrors around the dying at all, if they only imperiled the living?) Cf. Stat. *Silv.* 3.4.97–8; Frazer 1911: 92–6; Callahan 1964: 8.

52. Rapp 1884–90: 1331; Cook 1914–1940: 2.206–7 n. 2; Dreger 1940: 2.3–5; Hugedé 1957: 86 n. 5; Trendall 1967: 113–14, 588; Junge 1983: 60; Balensiefen 1990: 34–6, 168–73, 223 K 12; Frontisi-Ducroux and Vernant 1997: 190, 238. On the avenging ghosts of Clytemnestra and the Erinyes see Harrison 1899; Harrison 1922: 213–56. The face appearing in this mirror is unambiguously a reflection, not a device represented on its back or case. Devices are never represented on mirrors held obliquely; nor do they represent an incomplete or cropped head. See my discussion on p. 93.

53. Herrmann 1968: 669; Schneider-Herrmann 1977: 35; Bell 1995: 9–10. Contra, Rahmanyi (1964) sees grave mirrors as principally apotropaic. Cf. Gandolfi 2003a.

54. Vernant 1990a: 99–103, 209–34. The goal of ecstasy is the chiastic movement of possessor and possessed: on the one hand, *ho enthousiasmos,*

the state wherein the god possesses the mortal, reconstituting himself from the fragments in which he found himself when (as Zagreus) he had his own adventure with a mirror; and on the other, ecstatic release, the mortal's vacation of self to visit – and indeed become – the god. In Rouget's terms (1985: 17–25) this is an act of possession, not shamanism; the encounter is expressed as a visit from the spirit world, not as a journey to it. However, I think Rouget's insistence on a polarization of these states is too reductive, even if the opposing view of I. M. Lewis (1971) ventures too far in denying the distinction.

55. Cf. Rouget's argument for an orderly and choreographed element of possession dance, which he calls "symbolic," to complement its random "abstract" movements (1985: 209–13).

56. Kerényi 1964; Nilsson 1957: 120–22. Most of these scenes are strewn liberally with Dionysiac signifiers: canthari, grape clusters, tympana, pan pipes, and so forth; see Cassimatis 1998: 327–8. Gallistl (1995: 19, Abb. 17) briefly discusses a scene on an "underworld crater" in Munich (Staatliche Antikensammlungen 3297) which represents a nude satyr holding a handled phiale in the "mirror" position toward a seated (presumably deceased) youth, perhaps assimilated to Dionysus; the man-god, in the process of being crowned by a winged victory and garlanded by a female attendant, looks back toward the phiale and its bearer. For a minority opinion see Smith 1972: 248–57, fig. 1b.

57. Daremberg and Saglio 1877–1919, s.v. "Phiala" (E. Pottier); RE s.v. "Phialê" (H. Miltner).

58. Berlin Antikensammlung F 2538. Roscher 1884–1937, s.v. "Themis" (L. Weniger): 579–80; Mudie Cooke 1913: 167–9; Delatte 1932: 185–6; Hartlaub 1951: 124; Hugedé 1957: 84–5; Gury 1986: 452–3. Balensiefen (1990: 183–4) contends that she means to drink from the bowl, which contains the inspirational waters of the nearby Kastalia spring. A relief in the Lateran Museum shows three women gathered around a tripod, evidently preparing for a sacrifice. One of the women bends down and looks intently into the cauldron. Cook (1914–1940: 2.1.211 n. 2, fig. 147) considers this scene to refer to the boiling of Pelias. On the use of phialai in hydromancy see Dunbabin 1951.

59. Schol. Pind. P. 1 (ed. A. B. Drachmann 1910: lines 5–14); Rohde 1925: 288–91, 310 n. 36, 312 n. 51. In one case Dionysus is said to have delivered oracles "in" the tripod, in the other "from" it (apo tou tripodos).

60. Hugedé 1957: 84–7, fig. 1–9. On several of these examples, including the well-known Ficoroni cista, a bird or birds perch by the extended phiale, probably to emphasize its connection to augury and auspication.

61. I am grateful to Nancy de Grummond for the suggestion that some of these devices may be oracular heads. In either case, the idea of introducing a frontal face into phialai probably is borrowed from the traditional Archaic and Classical kylix type that features a gorgoneion in the center of the cup.

62. Wallis Budge 1907: 49, 63, 346, cat. 242. This side is not shown in the illustration; the catalog descriptions of both sides are incorrect.

63. The distant memory of a divination rite with phialai may underlie a puzzling passage in the Chronographia of Malalas, which claims that the mythic hero Perseus learned from Zeus and his father Pikos "the miserable error of witchcraft" (manganeia) and "the miserable and ungodly skyphos of Medusa," which he taught to the Persians (35.5–9, 37.14–15, my transl.). Hörling (1980: 101–3) takes skyphos here to mean "skull"; and although this reading is certainly possible, only the second passage speaks of the "skyphos of Medusa." In the first, Perseus is simply taught "to practice and perfect the deception of the miserable skyphos," as if it were a kind of magic trick. A skyphos is literally a drinking cup, and it makes sense in reference to Medusa if it is understood to have borne the image of the gorgoneion. Many Greek clay drinking cups (mainly the shallower kylikes) carry this device, as do the phialai of a similar size and shape. The context of magic suggests lecanomancy as Malalas' intended meaning.

64. Abt 1908: 98–101, 245–51; Boehm 1914; Macchioro 1920; Delatte 1932; Cunen 1957; Hugedé 1957: 75–88; Cunen 1976; Balensiefen 1990: 174–209; Nelson 1999–2000: 365–9; de Grummond 2002. For bibliography of the cup scene in the Frieze of the Mysteries see below. Some of the most important primary sources for divination in bowls or liquids: Apul. Apol. 42.6; Augustine Civ. Dei 7.35; Damascius Vita Isidori (Epitoma Photiana 191 = Zintzen 1967: 268); Hippolytus Refutatio omnium haeresium 4.35.1–2 (Marcovich 1986: 123); Iambl. De myst. 2.10, 3.14; Pliny HN 30.14, 37.192; Strabo 16.2.39; Theodore Balsamon In Can. LXV conc.

in *Trullo* (Migne *PG* 137.742b). For divination by mirrors: Ar. *Acharn.* 1124–30; Artemid. 2.7; Greg. Naz. *Or.* 7 (Migne *PG* 35.775c); *HA Did. Iul.* 7.10–11; Iambl. *De myst.* 2.10; Lucian *Ver. Hist.* 1.26; Paus. 7.21.12.

65. Transl. Betz 1996. My translation of 4.220–22.

66. *ES* 5.60, 5.120. Sestieri 1939: 253–5; de Grummond 2002: 67–8, figs. 11–12.

67. Villa Giulia 43800. See Giglioli and Barbieri 1925: vol. 2 IV B r ("Stile falisco"), tav. 13.3, 17.3. Cf. tav. 12.4.

68. Another distinguishes the upright Apulian *phiale*: its long handle, more often than not, is represented as a miniature Atlas, his arms splayed up and out to support the circle above (Smith 1972: 15–17). What better trope for the orb of the universe than the reflective circle that offers the possibility of experiencing a whole new world?

69. Rohde 1925: 2.260.

70. Burkert 1977: 4.

71. On the evidence for preparatory "knowledge" that an initiand was expected to master, as well as prescribed "accounts" (*logoi*) that might "set the table" for certain sensory experiences, see Burkert 1987: 69–73. Rouget 1985 (esp. 3–124, 187–226) seeks (artificially, I believe) to separate ecstasy (what he would call trance or possession) from epiphany. On performative aspects of Dionysiac ritual see Ricciardelli 2000.

72. Sestieri 1939; de Grummond 2000, 2002.

73. Macchioro 1920: 135–71.

74. The medieval sage Ibn Khaldoun, himself an adept at the practice, explained the phenomenon as interposing between the subject and the mirror a mist-like diaphragm upon which the images were impressed; see Macchioro 1920: 135–6.

75. Delatte 1932.

76. Delatte 1932: 136–8; 191. Mudie Cooke 1913: 167–8 makes essentially the same distinction between the diagnostic and the "intuitive"; cf. Rohde 1925: 2.289–93 on divination by "art" and by "inspiration."

77. *Phaedr.* 244c, 265b.

78. Cunen 1957, 1976.

79. The object of attention in scrying can take on almost any form; see Nelson 1999–2000: 365.

80. *Rhipsaucheni klonô*, Pind. Dith. 2.13–14 (Loeb ed., my transl.); Jeanmaire 1951: 239–40. Rouget 1985: 209 interprets this motion as a mimesis of the god's "fury," his "terrible and redoubtable nature."

81. Knox 1994: 11–12.

82. Tertullian *Apol.* 33.4; Zonaras *Epitome* 7.21. A direct glance behind one's back was often considered dangerous, even deadly; see Tuchmann 1890–91: 57–8.

83. Róheim 1919: 169–73; Hartlaub 1951: 149–57, figs. 160–63; Zuccari 1987: 157; Melchior-Bonnet 2001: 157–8, 187–221.

84. Burkert 1987: 89–114.

85. Mudie Cooke 1913: 167–8. Specifically, Hdt. 7.3; Aristotle *apud* Macrob. *Sat.* 1.18.1; Eur. *Hec.* 1267; *Bacch.* 297–300; *Rhesus* 970–73; Suet. *Aug.* 94.5; Paus. 10.33.10; Dio 54.34.5. Olympiodorus *In Plat. Phaed.* 1.6 (transl. L. G. Westerink 1976): "In a different way, Dionysus is the patron of genesis, because he is also the patron of life and death; of life, as the patron of genesis; of death, inasmuch as wine brings about ecstasy, while, on the other hand, we also become more susceptible to ecstasy when death is drawing near, as it is seen in the case of Patroclus in Homer [*Il.* 16.851–4], who in his last moments receives the gift of prophecy." *In Plat. Phaed.* 6.13 (transl. Westerink): "The God to whom he is referring here is Dionysus, who is in charge both of life and of death, of life because of the Titans, of death because of the gift of prophecy that we receive when death draws near." On Silenus' associations with prophecy in the Etruscan and Roman traditions, see Verg. *Ecl.* 6; de Grummond 2002: 67–8.

86. Dodds 1951: 64–75. Balensiefen 1990: 193 sees little evidence for the presence of the mantic in Dionysiac art. On the other hand, the mantic is hard to convey pictorially, and thus is equally rare in the art of overtly oracular gods such as Apollo, or mystically revealed gods like Asklepios, Demeter, and Kore. For a corrective see de Grummond 2002.

87. Or, as Sauron (1998) would have it, the *domina* of the household takes the part of Semele, the mother of Dionysus who dies by a thunderbolt from the father, Jupiter, and is reborn as a goddess.

88. Rouget 1985: 206–13.

89. *Laws* 815c; Burkert 1987: 19.

90. On the evidence for role playing in Dionysiac ritual see Macchioro 1920: 24–8. On the indeterminacy of "real" and "mythical" figures in Dionysiac art, see Kirk 2000: 105–8.

91. We are told that the emperor Didius Julianus performed rituals of divination "before a mirror, into which boys are said to gaze, after bandages have been bound over their eyes and charms

muttered over their heads" (*HA Did. Iul.* 7.10–11, transl. D. Magie); presumably the bandages were removed from the eyes of these young mediums just before the moment of revelation. A panel from cubiculum B of the Farnesina villa in Rome (Museo Nazionale 1072) shows a veiled child (probably either a medium or an adult initiand role-playing as the child Dionysus) facing the standing figure of Silenus, who evidently is about to undrape the phallus in the sacred winnowing basket, the *liknon*. A similar scene appears in other contexts as well, including a fresco from Nero's Domus Aurea preserved only in a sixteenth-century copy. A Campana plaque type and a repoussé relief on a gladiatorial helmet from Pompeii include the detail of a tympanum being struck behind the back of the veiled subject. A layered onyx cameo in the Boston Museum of Fine Arts (99.101, signed by Tryphon) represents a Dionysiac wedding of Cupid and Psyche. They stand jugate with completely veiled heads while an attendant cupid rests a *liknon* bearing fruit upon their heads. On the repertory of ritual scenes see Rizzo 1918: 47–60; Rostovtzeff 1927: 54, 94–8, 118–26, pls. V, XX, XXVI.1; Bieber 1928: 308–22; Nilsson 1957: 77–98; Matz 1963: 1391–1405; Bragantini and de Vos 1982: 138–9, figs. 71–9; Burkert 1987: 94–7; Turcan 1993; Boyancé 1966; Sauron 1998: 122–30; Rauch 1999: 94–7; Davis 2000. On the use of children as interpreters in hallucinogenic rites, see esp. Delatte 1932. On the possibility that they were initiated into the mysteries see Nilsson 1957: 106–15; Matz 1963: 1404–5.

92. Alexander 1943: 13–14. See Chase 1908: 39–44; Rizzo 1918: 41; Cumont 1933: 239–40; Nilsson 1957: 93–5, several of whom also discuss a similar vessel in Florence. The bowl from New York that they discuss is actually a variant on the one shown here; it features tall volute craters on the columns rather than plain disks. But these vessels are crowned with a smaller disk, which is more easily visible in the Florence bowl. See also Matz 1963: 1404–5; Pailler 1982: 798–805 and bibliography. Elsewhere I have disagreed with Pailler about the supposed irrelevance of background objects in cultic scenes; see Taylor 2005.

93. As on an Arretine relief fragment in the Metropolitan Museum; see Alexander 1943: 23, pl. XXXIX.

94. Good examples appear on sarcophagi at the Uffizi in Florence and the Museo Nuovo in Rome; see McCann 1978: fig. 134; Wrede 2001: Taf. 3.3. Helmets also appear; see Baratte and Metzger 1985: 186, cat. 96.

95. They have recently been interpreted as eggs; see Venit 2001: 140–41, Pl. XXIII.

96. Spinazzola 1953: 367–434; Clarke 1991: 194–201 and bibliography.

97. See Taylor 2005: 98 n. 36. The motif also appears on the Corbridge *lanx*; see Pirzio Biroli Stefanelli 1991: 231 fig. 244, 300–301 no. 177 and bibliography; Leader-Newby 2004: 144–6, fig. 3.12.

98. The combination of catoptromancy and unveiling is evident in modern practice. For example, Abbé Thiers in his *Traité de superstitions* of 1697 describes a rite in which a mirror is covered with a white towel opposite a candle or the sun. A virgin boy or girl serves as the medium. The mirror is unveiled as a priest invokes the angels of heaven and hell, which appear to the child and (one presumes) deliver messages, perhaps from the dead whom they oversee; see Tuchmann 1888–9: 280–81. A constant theme through this and many similar rites is that of the purity and virginity of the medium, characteristics that apply metaphorically to the mirror as well, which must be clear and unblemished.

99. Taylor 2005.

100. Taylor 2005. In addition to the material cited there, cf. a fragmentary mosaic in Naples (Museo Nazionale 6146) depicting a large disk (tympanum?) hanging over the head of a comic actor; see Bieber 1961: 103–4, fig. 401.

101. Rostovtzeff 1927: 66–8; Delatte 1932: 196–7, 199; Hartlaub 1951: 126; Spinazzola 1953: 507–10, fig. 571 (probably the most authentic photograph, made before restoration); Hugedé 1957: 88; Matz 1963: 1418–19; Little 1975; Balensiefen 1990: 184–6; de Grummond 2002: 75–6.

102. Little 1975: 148–50 claims that Silenus is holding a mask aloft in his raised right hand, as if to view its reflection in the disk. Yet all five fingers of Silenus' raised hand are visible, separated and unengaged. Where, then, would the mask be, unless it was overpainted as an afterthought and has since partially flaked off?

103. Walters 1921: 283, cat. 132; Feugère and Martin 1988: 67–9, no. 5; Pirzio Biroli Stefanelli 1991: 283 no. 132; Taylor 2005: 96.

104. Cf. an intarsia plaque featuring a similar disk-tympanum (Naples, Museo Nazionale 9977); see Ward-Perkins and Claridge 1978:

174, cat. 156; Borriello et al. 1986: 36, 122 no. 54.

105. E.g., the eponymous mosaic from the House of the Dionysian Procession at El Djem, now in the Museum of El Djem. See Foucher 1963: 60, pl. XIX; Dunbabin 1978: 175–6; Blanchard-Lemée et al. 1996: 88–9, fig. 57.

106. Reinach 1909–12: 1.73.1; Babelon 1916: 88–91; Dreger 1940: 2.36–8; Byvanck-Quarles von Ufford 1973: 90–91; Van de Grift 1984; Balensiefen 1990: 66–70; Pirzio Biroli Stefanelli 1991: cat. 105, fig. 184; Sennequier et al. 2000: 93, cat. 73. Much of this imagery had become canonical in the Dionysiac cult in pre-Roman times. Callixenus of Rhodes described many of the elements depicted on these vessels in the great religious procession instituted by Ptolemy Soter at Alexandria; see Athenaeus 5.196–203.

107. Van de Grift 1984: 385.

108. The pairing of panther and overturned cantharus is a common one, though more typically the panther laps wine from the vessel, as on the Coupe des Ptolémées in the Cabinet des Médailles of the Bibliothèque Nationale; see Cain 1988: Abb. 56.

109. On representations of mystical likna see Nilsson 1957: 21–45, 66–98.

110. Balensiefen 1990: 69.

111. De tympano manducavi, de cymbalo bibi, et religionis secreta perdidici (Firm. Mat. Err. 18.1). Firmicus quotes a slightly different formula in Greek, which ends with, "I have become an initiate of Attis."

112. Rohden and Winnefeld 1911: 56–8, 305, Taf. 139.2; Sauron 1998: 123–5; Rauch 1999: 94–7, Kat. 404–48, Taf. 14.1.

113. The Christian apologist Hippolytus describes a quasi-Dionysiac ritual in some detail (Refutatio omnium haeresium 4.28.6–10; Marcovich 1986: 116–17). In one part of the ritual, a boy is made to lie prone on the floor in complete darkness. A mystagogue delivers messages into his ear by talking through musical pipes – either a bronze auliskos or, preferably, an improvised instrument made from the windpipe of a long-necked bird. While many of Hippolytus' details appear to be fanciful, the practice of using musical instruments as channels of mystical transformation and (in this case) of induced epiphany seems to have a long history in the practice of mystery cults. Macchioro 1920: 103–4 completely misreads this passage, due in part to Dunker and

Schneidewin's defective Latin translation of the Greek.

114. De myst. 3.9. Transl. Clarke et al. 2003. Each god had his or her "own" tune, or motto: see Rouget 1985: 102, 204–5, 211–12. Aristotle theorizes that the Phrygian mode is especially suited to "enthusiasm," or trance; see Pol. 1339b–1342a; Rouget 1985: 220–26.

115. Assael 1992: 562; Frontisi-Ducroux and Vernant 1997: 114–16; Frontisi-Ducroux 2000: 35–6. On music and ecstatic trance see Rouget 1985: 213–26.

116. On the purifying nature of the mysteries see Burkert 1987: 96–7, 103. According to Servius, the baby Dionysus was placed in the liknon when he was born, and the basket itself symbolizes the purification of the soul in the mysteries (Serv. ad Georg. 1.5.166). Jung recognized a similar tendency of volatilization in the elements of the Christian liturgy, which Fierz-David (1988: 68) applies to the scene with the cup. On purification and the flagellation scene in the Frieze of the Mysteries see Mudie Cooke 1913: 165; Toynbee 1929: 78–9; contra, Sauron 1998: 100–106.

117. Forma repercussus liquidarum fingit aquarum,/ qualis purifico speculorum ex orbe relucet (Anth. Lat. 526; my transl.).

118. In addition to those to be discussed, see CVA Italy, Villa Giulia vol. 2, IV B r ("Stile falisco"), tav. 9.4, 15.5, 16.1–2.

119. CVA Italy, Villa Giulia vol. 2, IV B r ("Stile falisco"), tav. 15.3, 17.6; Jucker 1956: 105; Balensiefen 1990: 216. Jucker takes this scene to be a parody of Eros and Aphrodite with a mirror, but there is no sound basis whatsoever for such a relationship. A similar scene in a more conventional setting, in which a torch-bearing satyr is startled by something he sees in the tympanum of an ecstatic maenad, appears on a fragment of a large crater at the Hermitage (St. 1975); see Jucker 1956: 38–9, Abb. 8.

120. On the meaning of the aposkopein gesture see Jucker 1956. The satyr's gesture does not suggest that he means to strike the tympanum; that is almost always done with the right hand, and only by the bearer of the tympanum.

121. Although the sex characteristics are not entirely clear, she has the cleft pudenda characteristic of Etruscan representations of females. A similar kylix from another tomb at Vignanello (Villa Giulia 43971) has a striding nude male figure holding out a patterned tympanum to the gaze

of a seated man. The striding man has a pan-
ther (?) skin draped over one arm, and may be
drunk; see *CVA* Italy, Villa Giulia vol. 2, IV B
r ("Stile falisco"), tav. 15.5.

122. For example, see, in the same *CVA* volume,
under the same style category, Tav. 16.1–2: here
the same general stances are taken by the male
and female figures.

123. Bernhard 1970: 15–16; Pontrandolfo 1987: 56.

124. An elaborate mosaic from Pedrosa de la Vega
in Spain. See Palol 1975; Kiilerich 2001. Dun-
babin (1999: pl. 27) has a color photograph,
which also appears on the dust jacket. An elab-
orate border surrounding a central mythologi-
cal tableau includes eighteen "medallions" rep-
resenting portraits of men and women. The
medallions are without parallel in Roman art.
Kiilerich equates them to imitations of cameos,
bronze busts, and other portrait forms that
appear in earlier Roman art, particularly in
the ceilings of the Domus Aurea in Rome.
But notwithstanding the unusual presence of
portrait faces, which on this mosaic sometimes
are rendered in full color, at other times in a
bluish metallic sheen, the identity of their fram-
ing devices is forthright: these are not cameo
settings, but tympana, easily identified by the
thongs or tassels around the periphery. Kiilerich
is surely correct to suggest that the busts on
the tympana (which, strangely, she never iden-
tifies as tympana) are portraits, perhaps of fam-
ily members associated with the villa own-
ers. But why laminate portraits to an expressly
Dionysiac fixture? And given the evidence
already presented for the lamination of mirror
and tympanum, can these portraits be deemed
reflections, or their host objects mirrors? Cer-
tainly not in any conventional sense: there are
no pairings of referent and image, no embedded
protagonists to generate or perceive the images.
Nevertheless, these tympanum-mounted por-
traits may borrow from the same visual vocab-
ulary as the much earlier Boston and Zürich
examples, particularly if the portraits are of
deceased ancestors to whom the patrons of the
mosaic felt a particular bond through the cult
of Dionysus.

125. Neumann 1986: 107–8; Balensiefen 1990: 217.

126. Burkert 1987: 78, 100.

127. E.g., as shown on a volute crater from Ruvo,
now at Naples (2411/82922); Matz 1963:
Taf. 35; Boyancé 1966: pl. II.2; Kirk 2000:
fig. 10.6.

128. Beazley 1918: 189; Neumann 1986: 106–8. A
tiny triangle, perhaps a delta, has been neatly
incised over the head just to the right of the
break, and may be the final character in an
identifying inscription. But nomenclature on
Attic red-figure pottery is typically applied in
slip with a fine nib, not simply incised in the
black glaze. Even if this is an inscription, it
is much more likely to signal *Aria]d(ne)* than
Aphro]d(ite). In the Attic repertory at least,
an Aphrodite crowned with ivy is virtually
unheard of. Aphrodite appears as consort of
Dionysus only in Italiote iconography. In Apu-
lian practice she may have been merged ritu-
ally with the bride; see Davis 2000; Longfellow
2000; Smith 1972, esp. 37, 47–55, 80–86, 126–
32, 264–8.

129. Schauenburg 1960: 25 n. 158; Balensiefen 1990:
216–18.

130. See Balensiefen 1990: Taff. 5, 43; Frontisi-
Ducroux and Vernant 1997: 69, 79–87, pl. 2.

131. I suspect that the woman is not to be under-
stood as seeing herself. Direct interaction of
referent and reflection seem to require optical
reversal to generate the necessary balance and
tension.

132. Jucker 1956: 105; Balensiefen 1990: 216–18.

133. For example, a bell crater in Naples shows a
woman being invited by Eros to play ball, while
on the other side of the same panel a more
mature version of the same (?) woman gestures
to her younger self with these two objects in
hand; see Kerényi 1977: 365–7, fig. 118. He dis-
cusses the *taenia* in the context of the wedding
ritual.

134. Maenadism was undeniably practiced in Greek
communities and occasionally in western
Roman contexts as well; but it is sparsely
attested and poorly understood. Henrichs
(1978) downplays the wildness of historical
maenadism. It is indeed salutary to consult the
collective evidence and find nothing to suggest
that real maenads ever tore animals, let alone
humans, limb from limb. On the other hand,
Henrichs leaves open the question of a mae-
nad's state of mind. Certainly the Italian cult of
Dionysus, suppressed in 186 B.C.E., is portrayed
by Livy as a true bacchanal full of wine-induced
frenzy.

135. That leaves one to ask, in turn, why the proce-
dure is not presented in the traditional Apulian
way, with ordinary mirror or upright *phiale* –
and why a painted tympanum renders up a

painted image on its surface, whereas mirrors and *phialai* never do.

136. The name is merely convenient; there is no consensus that the mask was associated with the festival known as the Lenaia. See Vernant 1990a: 208–47; Frontisi-Ducroux 1991a; Carpenter 1997: 93–8. The theatrical mask is a related but hardly identical phenomenon. Wiles 1991: 112–14 recognizes in this kind of "Dionysiac" mask the embodiment of transience and liminality, in strong distinction to the Japanese Noh mask, which denotes permanence. On the popular motif of theater masks in Roman reliefs see Cain 1988. On the development of the theater mask in honor of Dionysus see Wiles 1991: 127.

137. Kerényi 1960: 153, 1964; Gaillard 1982: 138–40. On the distinction between the ancient and the modern western semiotics of the mask see Wiles 1991.

138. Otto 1981: 90–91.

139. Gallistl 1995; Vernant 1990a: 118–31, 208–46. *Le masque et le miroir* was the theme of Vernant's course at the Collège de France in 1979–80.

140. Vernant 1990a: 135. My transl. Vernant's exploration of the meaning of the Dionysiac mask, derived largely from the evidence of Attic vase painting and Euripides' *Bacchae*, leaves unresolved precisely how, if at all, he believes masks were used in cult practice; see esp. 211–46. The historicity of Vernant's somewhat allusive, generalizing style is open to criticism. For example, he underemphasizes the fact that evidence of mirror use in a Dionysiac context comes almost exclusively from Italy, whereas the vases featuring masks of Dionysus in cultic contexts are exclusively Attic.

141. Paris Louvre G 227; ARV² 283.2. See Frickenhaus 1912: no. 12; Frontisi-Ducroux 1991a: 149–52, Cat. L 62, fig. 88; Gallistl 1995: 18, Abb. 15. On a red-figure *lekythos* in Krakow, a maenad makes a similar gesture of surprise as she gazes into a *kantharos* on a table in front of the god's effigy; see Frontisi-Ducroux 1991a: 152–4, cat. L 63, fig. 89. Several other vases illustrated in this study depict satyrs or maenads fixing their gazes downward into drinking cups, *lekythoi*, or craters. The theme is resurrected centuries later in Roman terracotta Campana reliefs, which show pairs of satyrs standing or crouching in mirror-image profile as they peer intently into a central cantharus. See Rohden

and Winnefeld 1911: 71–2, 291, Taf. 104; Rauch 1999: 113–18, Kat. 812–45, Taf. 20, 21.

142. The sources relevant to the present study include Mudie Cooke 1913: 167–9; Rizzo 1918: 71–2; Macchioro 1920: 94–121; Comparetti 1921: 22–3; Rostovtzeff 1927: 51, 66–8; Toynbee 1929: 74–7; Sogliano 1930; Maiuri 1931: 148; Delatte 1932: 189–202; Spinazzola 1953: 507–10; Hugedé 1957: 87–8; Herbig 1958: 28, 42–4; Kerényi 1960: 161–3; Simon 1961: 152–9; Lehmann 1962: 66–8; Houtzager 1963: 38–9, 76–9; Matz 1963: 1414–20; Zuntz 1965: 184–8; Brendel 1980a: 105–7; Eitrem 1968: 12; Bastet 1974: 220–24; Little 1975; Grieco 1979: 427–34; Gaillard 1982: 154–7; Sauron 1984: 170–73; Hundsalz 1991: 75–6; Gallistl 1995; Sauron 1998: 138–44; Ricciardelli 2000: 278–9; de Grummond 2002: 73–5. Many of these are reviewed briefly by Balensiefen (1990: 186–95), who offers her own alternative interpretation.

143. Zuntz 1965; Bastet 1968: 220–24; Eitrem 1968; Sauron 1984: 171; Balensiefen 1990: 193–4; Sauron 1998: 140–44.

144. The young satyr is sometimes said to be leaning against the pilaster, but this is not so. His hand clearly passes in front of the pilaster and behind the mask.

145. Lehmann 1962: 66.

146. Mudie Cooke 1913: 167–9; Macchioro 1920, esp. 94–110; Rostovtzeff 1927: 51, 66–8; Toynbee 1929: 74–7; Sogliano 1930; Delatte 1932: 189–202; Hartlaub 1951: 126–7; Herbig 1958: 28; Kerényi 1960: 161–3; Simon 1961: 152–9; Lehmann 1962: 66–8; Matz 1963: 1414–15; Hundsalz 1991: 75–6; Gallistl 1995: 1–3; de Grummond 2002: 73–5. Contra, cf. Guidorizzi 1991: 39, who interprets the distorted mask appearing in the young satyr's cup as "la tema del respecchiamento. . . . Un segno di una doppia personalità umana e ferina." Grieco 1979: 427–34 dismisses any special optical role for the cup, but suggests that the mask and "l'ivresse sacré" are enough to induce an ecstatic state – not for any of the satyrs, but for the unspecified human initiate.

147. De Grummond 2002: 74–5. The mask may be of the "talking" prophetic kind that appears on Etruscan mirrors.

148. The most notable exception to this rule is Pergamene Hellenism, in which facial expression plays a large role.

149. Rohden and Winnefeld 1911: 49–50, Abb. 93; Gallistl 1995: 3, Abb. 2; Rauch 1999: 76–8, Kat. 225, Taf. 10.1.

150. Herbig 1958: 28; Kerényi 1960: 161–3; Zuntz 1965. Nor is it likely to represent Akratos, the god of unmixed wine, despite Brendel's ingenious arguments (1980a: 106 and n. 38).

151. On the evidence for role-playing in Dionysiac ritual see Macchioro 1920: 24–8.

152. The fresco is badly degraded in this area and the cup's interior cannot be made out with any certainty.

153. Levi 1947: 21–4; Campbell 1988: 19–22; Dunbabin 1999: 160–62; Cimok 2000: 26–7; Kondoleon 2000: 62, 170–71 no. 55; and bibliographies.

154. In another Pompeian painting, from house 10 in the *Insula occidentalis*, the invitation is taken up by a little Eros himself, who stares keenly into the empty cup of the drunken Hercules. The scene is only preserved in watercolor copies; see *PPM Disegnatori* 404 no. 227.

155. Kampen 1996a.

156. Members of the Dionysiac *komos* could transgress social norms of status and gender; see Vernant 1990a: 214–15. The Dionysus cult was far from unique in allowing men or youths to dress as females in its festivals; see Delcourt 1992: 5–27; 39–40.

157. Apart from apotropaic functions and exorcisms, perhaps.

158. *Politics* 1341b.32–1342a.18. On the purifying effect of *bakchikai teletai*, see Quint. 3.25.

FOUR. THE MIRRORING SHIELD OF ACHILLES

1. I am grateful to Bettina Bergmann for her thoughts on this matter.

2. Myerowitz 1992: 149.

3. On the reflecting shield see esp. Dreger 1940: 2.47–9, 61–79.

4. Gross 1954; Winkes 1969.

5. Vidal-Naquet 1988: 295–7.

6. McCarty 1989: 182–4 expresses a similar phenomenon, which he calls catoptric thanatosis. Wrongly, in my opinion, he cites the Medusa myth as an example. See my discussion below.

7. For this interpretation, rather than the legal term "indicted for cowardice," see Balensiefen 1990: 176.

8. Ar. *Acharn.* 1124–30. My transl.

9. Macchioro 1920: 112–15, 138–9; Delatte 1932: 133–5; Hugedé 1957: 77–8; Balensiefen 1990: 174–7 (who sees no specific reference to divination here); Frontisi-Ducroux and Vernant 1997: 191–2; Nelson 1999–2000: 366–7. The scholiasts, as Frontisi points out, are divided between those who see a process of lecanomancy in which oil is the medium of divination, and those who see the polishing as a means of rendering the shield so dazzling as to discomfit the enemy. Second sight, she argues, is itself a kind of bedazzlement, a blinding to the phenomenal world, by way of an excess of light, in order to see beyond it.

10. Cohen 1997: 108–10; Slater 1998: 41; Hölscher 2004: 23–34. Smith 1994: 117 cites Artemid. *On.* 2.7: when a sick man dreams he sees his own reflection, he is approaching death. Cf. Hartlaub 1951: 93.

11. Although the face in the mirror has a certain air of melancholy, it does not reflect, in my opinion, the "pain and helplessness" of its referent, as Balensiefen suggests (1990: 46).

12. Andreae 1961: 1–5. On the likelihood that the shield and its owner are Greek, see Dreger 1940: 2.65–6.

13. The mosaic is severely damaged in this area, and shows evidence of extensive restoration and modification in the Roman period. See Donderer 1990; Trinkl 1997: 104–5. The face itself is partly restored, but correctly positioned.

14. At one time scholars disagreed about whether the face did in fact belong to the man with the bare legs, who accordingly had to be positioned *in front* of the shield, between it and the dying Persian. See Dreger 1940: 2.66–8 and bibliography.

15. Dreger 1940: 2.64; Trinkl 1997: 104–5.

16. Delivorrias, Berger-Doer, and Kossatz-Deissmann 1984: 636–9; Schmidt 1997: 192–207.

17. Ghedini 2004.

18. Trimble 2002: 239.

19. Gleason 1995: 67–70.

20. In men the blush was often seen as a mark of virtue and modesty; see Barton 1999. But with some exceptions, in strictly erotic situations the blush was generally conceded to females and adolescent males only. The blush was a sign of good character, but it could be manipulated.

21. Cyrino 1998 (226–38) argues that a powerful macho subcurrent persists in Achilles as a counterpoint to his feminization.

22. Brillliant 1984: 134–45.

23. *PPM* 4.507–8 nos. 64–5 (House of Apollo); 4.904–6 no. 84, 908–10 no. 88 (House of the Dioscuri); 9.393 no. 51 (House of Ubonus). See Klein 1926: 76–81; Robertson 1975: 583–4; Ling 1991: 133–4; Beard and Henderson 2001: 26–9; Trimble 2002: 230–45. The House of Ubonus fresco is particularly interesting in context because it is juxtaposed with another shield-image from the life of Achilles, depicting Thetis observing the freshly forged shield of Achilles. See my discussion below.

24. Sichtermann 1957: 98–110; Robertson 1975: 583–4; Balensiefen 1990: 200–201.

25. Trimble 2002: 233–4.

26. Balensiefen 1990: 201. For her, the possibility of the shield being a mirror is grounded exclusively in the unproven tradition of divination in polished shields.

27. Balensiefen draws a parallel to the similarly vague image at Boscoreale, which Simon 1958 and Smith 1994 take to be a mantic apparition on the shield's surface.

28. Gury 1986: 447; Trinkl 1997: 112 and bibliography; Beard and Henderson 2001: 28. Trinkl recognizes this privileged image as nothing more than an "Anspiegelung auf die Erziehung des Helden" with no special reference to the action around it. Beard and Henderson see intimations of a symbolic, if not formal, parallel between image and context: Chiron's instruction provides "the discipline and harmony of music as the perfect training for [Achilles'] epic future of irresistible massacre, and a young man's death."

29. Eco 1984: 208.

30. Zanker 1988: 57–60; Kampen 1996b.

31. See esp. Brendel 1980b; Dreger 1940: 2.80–90; Lauter-Bufe 1969: 33–40; Hardie 1985; Gury 1986; Balensiefen 1990: 56–9. For additional bibliography and discussion see Müller 1994b: 42 n. 150, 55–63. In addition to the two lost examples mentioned by Schefold 1957: 173, from the House of the Quadriga (7.2.25) and the House of Epidius Sabinus (9.1.22), there are examples from the House of Meleager (6.9.2), the House of the Gilded Cupids (6.16.7), the House of Siricus (7.1.25), House 9.1.7, the House of Ubonus (9.5.2), and the House of the Cryptoporticus (1.6.2). Illustrations can be found in *PPM*. An interesting adjunct appears in *oecus* 43 of the House of Dioscuri (6.9.6–7), where on a small panel Thetis is shown borne on the tail of a triton. She props the shield upright in her lap, while the triton turns back to look at it. No detail can be made out on the shield's surface.

32. Among these are Balensiefen 1990: 225–6 K 19; 229–30 K 30; 240 K 43.

33. Brendel 1980b: 67–74; L'Orange 1953; Lewis 1973; Hardie 1985; Gury 1986.

34. Gury 1986: 469. For one thing, one of the secondary female figures in the House of the Cryptoporticus is labeled with the name Euanthe, which does not appear in any known version of the myth. These two also seem to belong to a distinct tradition compositionally.

35. Robertson 1975: 585–6; similarly with regard to the shield image in panel 5 of the great hall at Boscoreale, Simon 1958: 29; Smith 1994: 117–20.

36. *ES* 5.96; De Grummond 2002: 68–9.

37. See previous note.

38. Balensiefen 1990: 98–105. The important article by Gury is not cited.

39. Dreger 1940: 2.84–5 and bibliography.

40. Hardie 1985: 19 and n. 64. The image of a rearing horse is still easily discerned.

41. For the gesture of meditation or lamentation see Settis 1984: 205–8; Gury 1986: 443–4; Corbeill 2004: 77–80. Both meanings are to be found in the famous friezes of the great hall of the luxury villa at Boscoreale. Panel 2 on the west wall depicts an allegory of a subdued eastern nation, probably Asia, seated with chin in hand, whereas panel 4 represents a queen in a similar pose next to her royal husband. See Smith 1994; and, for a variant interpretation, Müller 1994b: 73–115. The gesture of leaning forward with chin on fist goes back at least to the Classical period; Neumann 1965: 116–40 ascribes it variably to attentiveness, worried deliberation, inner conflict, anxious expectation, and grief.

42. Fittschen 1975; Müller 1994a, 1994b: 41–3, 53–4.

43. Beard and Henderson 2001: 42.

44. McCarty 1989: 175.

45. McCarty 1989: 175–6.

46. Lehmann 1953: 31 n. 17; Simon 1958: 27–32; Fittschen 1975; Balensiefen 1990: 195–208; Smith 1994; De Grummond 2002. Cf. Robertson 1955.

47. Thetis may appear yet again on the little frieze of the House of the Iliadic Shrine in Pompeii (1.6.4). On the back wall of the shrine a female figure is shown in a similar pose, accompanied by

a woman usually interpreted as Venus. Both are watching attentively the battle of Achilles and Hector in the center of the frieze. See Blanc 1997: 38.

48. Balensiefen 1991: 200–201; Müller 1994b: 39–40, 55–63.

49. Müller 1994b: 57, esp. n. 198.

50. A tableau virtually identical to the central scene of the Mysteries Frieze was painted on the far side of the adjacent (unbroken) wall, but this was added long after the frieze to which the shield scene belongs, and it is only one part of a triptych that includes Venus in the center and the three Graces on the right.

51. Smith 1994.

52. Fittschen 1975.

53. Broneer 1930; Edwards 1933: nos. 101, 158, 175, 208, 216–18; Dreger 1940: 2.47–9; Soles 1976; Williams 1986; Gadbery 1993. A possible variant on this type is to be found in a reassembled fresco from Cerro de los Infantes, Pinos Puente in the province of Granada, Spain (now in the Museo Arqueológico de Málaga). It depicts a seminude female figure (Venus?) seated on an elaborate stool with a standing handmaiden arranging her hair from behind. Venus looks down toward a smooth, unadorned shield propped at her feet, as if the shield were her mirror. No image is visible on the shield's surface. See Blech and Rodríguez Oliva 1991: 178, Abb. 2.

54. On the Aphrodite of Capua type see Delivorrias et al. 1984: 627–41 (and a related type, "Venus" 30–35, 192–207); Ridgway 1990: 89–90; Kousser 2001, 2005: 237–9; Moreno 2002; Hölscher 2004: 59–65; and bibliographies. A recently discovered fresco fragment at Corinth conforms to the type; see Gadbery 1993. Generally attributed either to Scopas or to Lysippus, this type is often dated to the end of the fourth century B.C.E. On the later "Nike/Victoria" of Brescia type see esp. Hölscher 1960: 102–12, 1970; Vollkommer 1997: 29–40. On the votive coinage featuring Victoria writing on a shield, see Mattingly 1950. The origin of this tradition may lie with the Augustan clupeus virtutis; see Augustus, RG 34.2. Sometimes Athena/Minerva is in the same pose: see Canciani 1984: 1093 no. 238.

55. My transl. Occasionally Aphrodite/Venus is shown writing on a shield herself; see Schmidt 1997: 35, 210. Even the "Victoria" of Brescia may fit this type; the figure had no wings originally, and is unmistakably in the act of writ-

ing. Hölscher argues that the type begins with Aphrodite admiring herself in a shield; a possible prototype was the cult statue of the temple of Aphrodite on Acrocorinth. A writing Nike, and shield inscriptions, hearken back to the Classical period; all the elements seem to come together in the second century B.C.E.

56. From the Severan period onward, Victoria inscribing a shield (often with a vow, such as VOT X, expressing the prayer for a ten-year reign) was frequently depicted on imperial coinage issued at the beginning of an emperor's principate; see Mattingly 1950. The shield is a symbol not just of war, but of protection.

57. Victoria, like her Greek counterpart Nike, is in no sense a goddess of warfare. She never wields a sword or a spear, and never wears armor.

58. Róheim 1919: 163–87; Frazer 1931; Marmorstein 1932: 40; Eitrem 1935: 1727–9; McCarty 1989: 173–6, 179–82.

59. Picard 1957: 27–32. Certainly the Greek name, tropaion, "turning" or "change," could refer as much to banishing spirits of the dead, though ancient commentators insist that the term is derived from putting enemies to flight. Perhaps it was meant to assimilate the dead to the living in order to hoodwink the ghosts of the battlefield into believing the dead were alive, or simply to scare them off. Conversely, it may have served as a lightning rod of supernatural malice, deflecting the fury of the spirits of the dead away from the victor and onto an empty android.

60. The Roman triumphal procession is rife with the ritual manifestations of anxiety; see Versnel 1970: 65, 70; Künzl 1988: 28; Barton 1993: 95–8; Holliday 2002: 28–9; and bibliographies. The triumphant general's chariot is fitted with a fascinum, a phallus meant to avert the evil eye, and he wears a bulla (Pliny HN 28.7). In a social reversal worthy of the Saturnalia, his men are encouraged to shower him with insults and ribald invective during the procession: a continuous reminder to the general that he is all too human. In this respect the triumph resembles the procession of the Delian Dionysia, in which the phallus-bearers were required to hurl insults at the audience; see Athenaeus 622.

61. Melchior-Bonnet 2001: 214. See Biavati 1987 for Renaissance artists' interpretations of Tasso's episode.

62. Intanto Ubaldo oltra ne viene, e 'l terso/ adamantino scudo ha in lui converso./Egli al lucido scudo il guardo gira,/onde si specchia in

lui qual siasi e quanto/con delicato culto adorno;
spira/tutto odori e lascivie il crine e 'l manto,/e
'l ferro, il ferro aver, non ch'altro, mira/dal
troppo lusso effeminato a canto:/guernito è sì
ch'inutile ornamento/sembra, non militar fero
instrumento (16.29–30, my transl.). Tasso pre-
pares the way for this episode in 16.20–22 with
an elaborate conceit on a boudoir mirror, which
during Rinaldo's dalliance with Armida hung
like a weapon (estranio arnese) at her side, ever
ready to return her ravishing beauty-blows. This
"chosen minister for the mysteries of love" (a i
misteri d'Amor ministro eletto), along with all
the other reflective surfaces in this passage, is
selective: Armida, and Armida alone, appears in
them. Rinaldo, appropriately enough, sees only
himself in his shield, also with a pendent bauble
at his side: his phallic sword, rendered flaccid
(perhaps) by the distorting and reductive curva-
ture of the reflective surface.

63. I am grateful to an anonymous reader for sug-
gesting this analogy.

FIVE. THE MIRRORING SHIELD
OF PERSEUS

1. Testifying to the story's popularity among mod-
ern intellectuals is a new collection of essays, *The
Medusa Reader* (Garber and Vickers 2003). For
a review of a vast array of interpretations since
antiquity see Wilk 2000: 87–104. For detailed
treatments of the ancient sources, literary or
pictorial, see Hartland 1894–6; Kuhnert 1903;
Catterall 1937; Woodward 1937; Dreger 1940:
1.37–67; Schauenburg 1960; Phinney 1971;
Krauskopf and Dahlinger 1988; Vernant 1990a:
85–131; Roccos 1994; Frontisi-Ducroux 1995:
65–75; Schuller 1998: 12–47; Mack 2002. On
the origins and development of the Perseus myth
see, among others, Howe 1954; Croon 1955;
Phinney 1971; Napier 1986: 83–187. The clas-
sic study of the myth from the perspective of
comparative folklore is Hartland 1894–6.

2. Ovid *Met.* 4.793–803; Lucian *Dial. D.* 14 (323).

3. Lucian *Dial. D.* 14 (323) features both weapons,
the sword to kill first, the gorgon head to petrify.
A mosaic in Conímbriga depicts the head alone
deployed against the serpent; see Schauenburg
1960: 69, Taf. 28.1. A black-figure Corinthian
amphora of the sixth century seems to depict
Perseus attacking the beast with rocks: he holds
a circular outlined object in each hand (one of
them is poised to throw), and a pile of opaque

objects of similar form lie at his feet. See Wood-
ward 1937: fig. 9a; Hopkins 1961: pl. 15.1.

4. The principal sources for the story are Hes.
Th. 270–83; Ps.-Hes. *Sc.* 220–37; Strab. 10.5.10;
Lucian *Dial. D.* 14 (323–4), *[Philopatr.]* 8–9;
Paus. 2.16.3, 2.21.5–6; Pherecydes in schol. Ap.
Rhod. 4.1090–91, 4.1515; Apollod. 2.4.3; Ov.
Met. 4.604–803; Luc. 9.696–9. Most of the
Greek sources (but strangely, not the Latin) are
collected in English by Woodward (1937: 3–23).
Several of the most important accounts are in
Garber and Vickers 2003. On the origins of the
myth see especially Howe 1954 and Feldman
1965 with bibliographies.

5. Some Greek shields, however, were decorated
on the inside as well as the exterior, and
the iconography of the interior often was
more offensive than defensive. Occasionally
the shield straps carried imagery representing
Perseus beheading Medusa, perhaps to inspire
the warrior "to treat the enemy as he treated
the Gorgon" (Schuller 1998: 36–7; cf. Langlotz
1960: 33–4).

6. For example, it is uncertain if the idea of Perseus
approaching the *sleeping* gorgons, as opposed to
gorgons who are fully awake but unable to see
him in his cap of invisibility, is older than the
fifth century B.C.E. For the development of var-
ious versions and phases of the myth see Phinney
1971. For a recent discussion of hypotheses on
the nature of the gorgon and the *gorgoneion* see
Schuller 1998: 26–32.

7. Ziegler 1926; Schauenburg 1960: 25, 78–81;
Phinney 1971: 458–60; Balensiefen 1990: 117–
20.

8. Looking away: Schauenburg 1960: Taf. 5.1, 6.1,
17.2, 17.4, 18.2, 32.1, 34.1, 37.2, 38.1, 40.1, 41.
Head in the bag: 14.2, 15.2,

9. Lucian *Dial. D.* 14 (323). Howe 1954: 221 takes
a modified Freudian approach by suggesting that
Medusa is intended for male victims only. There
are exceptions: Iodama in Paus. 9.34.2, who
seems to be a relic of a mask ceremony akin to
that of Dionysus, was turned to stone by the face
of Medusa on Athena's aegis. But this led to a
resurrection or apotheosis, for the local women
at Boeotian Koroneia, when praying at the altar
of Iodama, repeated three times that she was
alive. See also Nonnus 47.499–612, 666; but this
version, in which the maenads and even Ariadne
are turned to stone in the war between Dionysus
and Perseus, is probably a late adaptation of the
myth recounted in Paus. 2.20.4, 2.22.1, 2.23.7,

where only the satyrs are petrified; the maenads are put to the sword. See Howe 1954: 220 and bibliography.

10. Mack 2002. This subtle and theoretically informed argument gains my admiration if not my support. It is founded on the proposition that Medusa, in story (but not in art), "does not allow another to occupy the position of subject of the gaze; or, to put the stress elsewhere, . . . does not allow herself to be the object of another's gaze" (576). The difficulty with this proposition is that Medusa's capacity to see has no role whatever in constituting her power; and that, conversely, her power lies precisely in her capacity to *be seen*. Of course there is a nuanced middle ground to be found on the second point: in seeing, the unfortunate observer immediately ceases to see (and to live, even), and so this phenomenon may fulfill, as Mack suggests, a dire interdiction. But the abrupt end simply confirms that it was activated, however briefly, by the objectification of Medusa. The real difficulty lies with the first presumption, of the narrative Medusa's subjectivity. Her only power is to kill, and she does not do this by seeing – or indeed by any extension of consciousness at all. Dead and sightless, she murders still.

11. Many have presumed the name Medusa to mean simply "queen," because according to some versions of the myth, she and her sisters were the daughters of Phorcys. The names of her sisters, Sthenno and Euryale, have no similar cachet, however, and none of them oversees any subjects or realm.

12. Near Eastern or Egyptian influence: Frothingham 1911; Petazzoni 1921; Marinatos 1927–8; Hopkins 1934; Goldman 1961; Hopkins 1961; Boardman 1968: 27–44; Phinney 1971. Several hypotheses are reviewed in Croon 1955 and Napier 1986: 92–134. Indian influence: Napier 1986: 135–87.

13. Rather, the identity of the figure as Medusa/Gorgo is demonstrated by the partially preserved figures of Pegasus and Chrysaor at either side of her running figure. Croon's excellent critique (1955) of earlier Medusa theories suffers from this tendency. He presumes two things above all: that the gorgon began as a ritual mask to represent a goddess of the underworld; and that the existence of gorgon cults at various sites may be presumed from the appearance of the gorgoneion on their coinage. But in fact there is no evidence that gorgon masks ever were man-ufactured to be worn by humans, and there is no direct evidence whatsoever that the gorgon was worshiped in any form anywhere.

14. Napier 1992: 101–11. Napier 1986: 91–134 proposes that the gorgon is essentially a Greek invention which, in order to justify an etiology for her necessary "Otherness," borrowed her iconography from Eastern types. He suggests that the Perseus legend already existed in some form when the *image* of the gorgon, derived specifically from Indo-Iranian and Indian figural ideas, was superimposed upon it.

15. Ferenczi 1923; Róheim 1940; Freud 1941 [1922]; Howe 1954; Róheim 1955; Hertz 1983; Kofman 1985; Napier 1986: 89–90 (which also interjects a Lacanian note). For additional bibliography on Medusa and psychoanalysis see Garber and Vickers 2003: 300–301. Contra: Cixous 1976; Warner 1985: 108–14; DuBois 1988: 87–92.

16. The main difficulty is that Freud refuses to establish a bond between signifier and signified, thereby violating the allegory's need for a consistent semiotic modality. For example, in myth and representation Medusa's snaky hair always belongs strictly to her severed head (the "penis"), not to her truncated neck (the "vagina"); yet what the child sees, and responds to, is the pubic hair surrounding the vagina. If, as Freud says, "decapitation = castration," then the metaphor's simple modality would require that the head = the penis, the thing that the child values most – and the thing that he does *not* see on his mother. Yet somehow the severed head has reverted to the vagina: it "takes the place of a representation of the female genitals, or rather it isolates their horrifying effects from their pleasure-giving ones." If castration is the operative object of anxiety, shouldn't the head's *absence*, and not the head itself, be the source of terror? This is the same kind of dubious logic ("representation of the opposite") that leads Ferenczi to explain the polyphallic head as a symbol of the *absence* of a penis on the mother. Freud's breathtaking tergiversation is apparently necessary to account for the fact that the head is such a noxious thing in the myth. For a more sympathetic reading see Barton 1993: 95–8.

17. Mack 2002: 588.

18. The difference, presumably, is that Perseus uses the weapon in the cause of righteousness; see Napier 1986: 90. But a few good men do die along with many of the bad, and the idea of a

mythical hero being a purely positive force, like a modern superhero, is a dubious one.

19. Croon 1955; Napier 1986: 89.

20. On the rationalization of the myth in the sixth and fifth centuries see especially Napier 1986: 97.

21. Wilk 2000: 27–8 suggests that this overkill is the result of a kind of smorgasbord of variant versions of the story. On the associations of Perseus with death, the other, and the underworld, see Vernant 1990a: 94–5 and bibliography. On the Near Eastern fondness for heroic gadgetry and Perseus' similarities to Gilgamesh see Hopkins 1934; Napier 1986: 87. Contra: Croon 1955: 12–13.

22. Phinney 1971. But note that Apollodorus' version of the story includes the shield in the killing; and this author, though writing after Ovid, is scrupulous in his transmission of old versions of the story; see Wilk 2000: 18–22. The reflective nature of the shield receives emphasis in a number of Greek vase paintings, and also perhaps in Callim. *Lav. Pall.* 15–21. In Athena's possession, as in Perseus', the reflective shield is never used for personal grooming; such is not the nature of the warrior goddess.

23. Kuhnert 1903: 2042–3; Dreger 1940: 1.34–6 nos. 65–84, 50–60; Schauenburg 1960: 78–82, 1981: 783–5, nos. 102–26; Balensiefen 1990: 124–30, 227–8 K 23–6, 234–6 K 35; Gasparri 1994: 122 fig. 183; Roccos 1994: 336–7, nos. 64–80 (cf. nos. 95, 108, 132a, 134 for interesting uses of the shield); Frontisi-Ducroux 1995: 71–4; Gallistl 1995: 3–5, Abb. 4–10. On one of its relief panels the famous Roman tomb at Igel near Trier pairs this scene with the episode of Perseus killing the sea monster; see Dragendorff and Krüger 1924: 68–71; Gallistl 1995: Abb. 9.

24. Balensiefen 1990: 32–4, 223–4 K 13–15; Roccos 1994: 336–7, nos. 66, 69–71.

25. *ES* 5.221 no. 18 (British Museum B 620); Balensiefen 1990: 42–3, 227–8 K 23–6; Roccos 1994: 337, nos. 74–5. On a forgery on this theme see Carpino 2003: 73, pl. 103.

26. Balensiefen 1990: 54–6, 234–6 K 35.1–14; Roccos 1994: 344–5, nos. 224–8.

27. Abadie-Reynal 2001: 243–5, fig. 1.1, westernmost room in *chantier* 12; Önal 2002: 38–9.

28. Phillips 1968.

29. The link in myth between Perseus and Persia may simply be derived from the fortuitous similarity of their names. At any rate, one of Perseus'

sons, Perses, is said to have founded the Persian nation; see, e.g., Hdt. 7.61, 7.150; Apollod. 2.4.5. Additional sources are cited in *RE* "Perses 3."

30. Schauenburg 1981: 75–83, nos. 1–96.

31. E.g., Schauenburg 1981: 778–83, nos. 31–41, 55, 67–73, 91.

32. Woodward 1937: 87, fig. 31; Phillips 1968: 10; Schauenburg 1981: 777, no. 13. From Canosa. Cf. a volute crater at the Getty Museum, 85. AE.102: Simon 1994: 391, no. 1, in which a mirror hangs from the wall behind Andromeda's head.

33. Bari, Museo Archeologico 1016: Phillips 1968: 13–14; Schauenburg 1981: 777, no. 16.

34. On the literary conceit comparing the mirror to the sword see Macchioro 1920: 112–15; McCarty 1989: 177–8; Frontisi-Ducroux and Vernant 1997: 60.

35. E.g., Balensiefen 1990: 223–4 K 13–15.

36. Frontisi-Ducroux and Vernant 1997: 70–71. Callim. *Lav. Pall.* insists that the goddess never used a mirror, presumably because her motives must be made to contrast with Aphrodite's vanity.

37. Dreger 1940: 1.44–6 is probably mistaken to suggest the presence of hand mirrors in a scene of the beheading of Medusa on a Campanian amphora in the Berlin Altesmuseum (F 3022; Schauenburg 1960: fig. 18.1). The two objects to which she refers dangle above the scene in a zone that is often filled with unidentifiable or highly stylized decorative shapes on south Italian vases. Schauenburg 1960: 39–41 correctly rejects Dreger's related hypothesis that the scene represents a parody of the episode. Although attempts have been made to demonstrate that a hand mirror preceded the reflective shield as Perseus' principal aid in the Greek literary tradition, they have failed; see Phinney 1971.

38. For brief discussions see Jahn 1868: 15–16, Taf. III; Schauenburg 1960: 83; Balensiefen 1990: 25–6.

39. See chapter 1; Frontisi-Ducroux and Vernant 1997: 59–67; Bartsch 2006.

40. See my discussion in chapter 2.

41. Jahn 1868: 15–16: "Offenbar ist hier durch den vorgehaltenen Spiegel und das vorgehaltene Gorgoneion ein Gegensatz beabsichtigt, dem sich verschiedene Pointen abgewinnen lassen."

42. *Anth. Pal.* 6.18, 6.20; Stewart 1996: 143; Frontisi-Ducroux and Vernant 1997: 53–4, 63, 68–9.

43. Cf. a red-figure column crater in Syracuse (Museo Orsi 2408), which depicts Penelope's suitors presenting her with gifts. One of the men holds a mirror, while others offer a toilette box, a himation, and a *phiale*. An image is available online at the Beazley Archive, vase number 206072.

44. Pirzio Biroli Stefanelli 1991: 269; Painter 2001: 64 M15. Greek examples of this motif, particularly among box mirrors, are quite numerous; see Züchner 1942: 75–9 KS 111–25, 138–9 Abb. 64–5, 146–7 Abb. 71–2, 192–3 Abb. 106–7, 197–9 Abb. 108–12, Taf. 29–32; Stewart 1996: 140 n. 11, fig. 62; Frontisi-Ducroux and Vernant 1997: 77, 86–7, figs. 3, 19, 20; Schwarzmeier 1997: Kat. 2, 4, 31, 40, 84, 113, 119, 130, 150, 173, 178, 193, 218, 237, 240, 246, 248, 261, 262, 270, 273, Taf. 62–71, 89; Sennequier et al. 2000: cat. 34 (F. de Callatay). Mirrors bearing this motif appear on a few other vases as well, notably lekythoi at the Bibliothèque Royale in Brussels (10) and in the Museum of Fine Arts in Boston (13.189).

45. "The frontal relationship with the mirror is a relationship with the same, just as the relationship with the profile was a relationship with the other" (Stoichita 1997: 41).

46. Trendall 1967: 667, 2.

47. E.g., Caillois 1964; Siebers 1983; McCarty 1989: 182–4; Marin 1995; Schuller 1998: 19. McCarty perceives Medusa as a paradoxical embodiment of the male (repulsive) and female (seductive) characteristics of the apotropaion: "it is tempting indeed to think that this paradoxical nature reflects that of the mirror, that she is essentially a catoptric figure: on the one hand, alluring beauty; but especially, on the other, the forbidden, indeed *gorgonian* vision which so often lurks at the heart of catoptric experience." The mirror as an apotropaion against the evil eye is known in a number of societies, perhaps most prominently the Kalbeliya Gypsies of India.

48. It is generally accepted that Medusa's immortal sisters do not have the same deadly effect as Medusa herself, though they have a similar appearance.

49. Siebers 1983: 58.

50. Tuchmann 1890–91: 55–7; Meerloo 1971: 51–2; Siebers 1983: 57–86, and bibliography.

51. "He [Paul, an innocent man publicly accused of the evil eye] went to the mirror and looked at himself with dreadful intensity: his dissonant perfection, composed of beauties not often found together, made him more than ever like the fallen archangel, and gleamed sinisterly in the black depths of the mirror. The tiny vessels of his pupils twisted like vipers; his eyebrows quivered like a bow from which a deadly arrow had just been shot; the white crease of his forehead recalled a scar from a thunderbolt, and his reddish hair burned with infernal flames; the marble pallor of his skin accentuated even more each feature of this absolutely terrifying face. Paul frightened himself. It seemed to him that his glances, reflected by the mirror, returned to him like poisoned darts. Imagine Medusa looking at her own hideous yet charming head in the reflection of a brazen shield." Transl. Siebers 1983: 88. See 87–109 for a discussion of the story from an anthropological perspective.

52. 6.35–40. The old woman is a *graia*, just like the crones who directed Perseus to the gorgons' domain.

53. Dundes 1981b. For a more traditional understanding of spitting (as ritual disparagement of the object of the evil eye) see Siebers 1983: 57–8.

54. Plut. *Mor.* 682e–f. Transl. H. B. Hoffleit.

55. Plut. *Mor.* 682b. Transl. H. B. Hoffleit.

56. Tassinari 1975: no. 172; Michel and Rolley 1984: 93–5, no. 137, pl. LXXI; Roccos 1994: 340, no. 134. Bonnamour 1969: 288–91 arrives at a date of the late first or early second century and proposes that the oenochoe was imported from Italy.

57. Fresco: Loeschcke 1894: 8, fig. 4; Roccos 1994: 340, no. 130. Three reliefs in the Hungarian National Museum in Budapest – two framed tomb reliefs and the third a sarcophagus fragment – depict the scene in various grades of simplicity. All three are pictured in Hekler 1937: figs. 43–5. On the best-preserved and best-known of these reliefs, see Loeschcke 1894: 9; King 1933: 72 no. 11; Dreger 1940: 1.34 no. 59, 47; Schauenburg 1960: 27; Balensiefen 1990: 121–3; Roccos 1994: 340 no. 132a. The motif also appears on a coin of Caracalla from Sebaste in Galatia; see Loeschcke 1894: 9 and Fig. 6; *BMC Greek Coins, Phrygia* (Sebaste): 375, 33, pl. 43; Dreger 1940: 1.34 no. 64; Schauenburg 1960: 27; Balensiefen 1990: 122 n. 577. This compositional grouping is derived from Greek prototypes that seem to lack the mirroring shield, such as a pelike at the Metropolitan Museum of Art (45.11.1: Schauenburg 1960: 130–31, Taf. 6.1) and a

fragmentary clay rhyton of the mid-fourth century B.C.E. in Bonn (Akademisches Kunstmuseum 1764); see Loeschcke 1894: 5–8, Taf. 2; Ziegler 1926: 2–3; Dreger 1940: 1.39–44; Lippold 1951: 70–72; Schauenburg 1960: 24–9; Balensiefen 1990: 123.

58. E.g., a bell crater in Bologna, Museo Civico (325), on which a bald, bearded man, gesturing like Polydectes, is engulfed in rock up to his waist; see Schauenburg 1960: Taf. 37.2.

59. Vernant 1991d: 147–50 attempts to reconcile the Greek science of optics with the behavior of Athena's mirroring shield.

60. Slater 1998: 44.

61. Hartland 1894–6: 3.146–7; Elworthy 1895; Róheim 1940, 1952; Caillois 1964; Siebers 1983; McCarty 1989; Marin 1995. A string of treatises on the evil eye beginning in the Renaissance and continuing into the nineteenth century compared the evidence from Greek and Roman antiquity to modern folklore. They are surveyed in Dundes 1981b: 259–62.

62. Excerpted in Garber and Vickers 2003: 92–3.

63. Caillois 1964; Phinney 1971; Marin 1977; Siebers 1983, esp. 27–56.

64. Barnes 2003: 126.

65. This fact alone gives ample cause to question Mack's premise (2002) that the reflection is a means of stealing the *subjectivity* of the gorgon's gaze.

66. Vernant 1987, 1990a, 1991a, 1991b.

67. Vernant 1990a: 114–17. My transl. Siebers 1983: 12 seems to adopt a variant of this idea.

68. Vernant 1991b.

69. Napier 1992: 103–4. He observes additionally that in the Perseus–Gorgon story, "the evidence is everywhere that an older order is being overturned and that the visual vocabulary of the foreign is the medium for making social change permanent." If the gorgon was introduced, as he suggests, as an aid to redefining Greek social identity *against* her otherness, she is unlikely to have had the status of a goddess among the Greeks.

70. Howe 1954; Napier 1986: 83–5.

71. See especially Harrison 1922: 187–97; Croon 1955: 13–14.

72. Vernant 1990a: 118–38; 1991b.

73. Pliny *HN* 7.64, 28.70–82; cf. 11.170. For an interpretation of this belief see Dundes 1981: 285–6.

74. Marin 2003: 146–51 makes a persuasive case that Caravaggio's head of Medusa is painted in such an ambiguous way that it oscillates between the harmless image lurking *en abîme* and the nasty, aggressive device Athena applied to her shield. But there appears to be no such intentional ambiguity in ancient representations of the story.

75. On catoptric entrapment see McCarty 1989 179–82; on Narcissus as self-fascinator, and the duplication embodied in narcissism as a societal strategy similar to accusations of witchcraft, see Siebers 1983: 57–86.

76. In this respect my interpretation conflicts with that of Napier 1986: 89–90, who proposes that Perseus sees himself in the mirror and thereby comes to terms "with his complete self-image," as if Perseus were the Lacanian child.

77. To my knowledge, nobody has investigated the iconographic idea expressed by the wings sometimes depicted on Medusa's head, particularly in Roman art. Unlike harpies or sirens, she has no birdlike features; she is land-bound until Perseus flies off with her head. It is possible that these wings, and perhaps those on Perseus' hat too, express the swift displacement implied by invisibility: in Perseus' case, a fugitive evanescence, and in Medusa's, a lethal projection. To describe Medusa's particular brand of anti-visibility Frontisi-Ducroux 1995: 72 coins the term *pseudo-visibilité*.

78. Rohden and Winnefeld 1911: 14–17, 251–2, 255–6, Taf. 26, 34; Schauenburg 1960: 29–30; Borbein 1968: 178–81; Balensiefen 1990: 60–61, 120–21, 237 K 37; Roccos 1994: 340, nos. 133a–d.

79. Dreger 1940: 1.34 no. 60, 48–9; García y Bellido 1949: 461–4, no. 491; Schauenburg 1960: 26; Strong 1966: 150; Balensiefen 1990: 121, 240 K 42 with bibliographies. For an excellent color photograph see Nünnerich-Asmus 1993: Farbtafel 14. Intended for a sophisticated audience, the scene is full of symbolism. Rising behind Minerva, an olive tree (with which she founded Athens) arches overhead; a gilded owl perches directly over Perseus' head, as if to guide his way with the goddess's wisdom. In the exergue of this group lie various votive objects indicating that the setting is a sanctuary, perhaps to be associated with Minerva: a small *pinax* or votive tablet; a sprig of laurel or olive; a mound of incense and a torch. At the bottom right lies the leafy double stem of a flower, perhaps a poppy to signify the deep sleep engulfing the sisters above. But for the flower, these objects are a reminder of the origins of Minerva's

involvement in the tale; according to Ovid, it was in her sanctuary that Neptune raped the beautiful young Medusa, inducing the horrified goddess to convert the locks of her hair to deadly serpents.

80. Balensiefen 1990: 121.

81. Ps.-Hes. *Sc.* describes the cap "bearing the baleful gloom of night" (*Aidos kunee nuktos zophon ainon echousa*, 227), an expression that evokes the murky realm of Hades, who provided the hat.

82. Lochin 1990; Koortbojian 1995: 77, fig. 36.

83. There are exceptions to this principle in later sources, but they do not involve human victims at all. Lucan (9.619–99), for example, has the lands being rendered sterile and rocky by Medusa's face, both before and after her death.

84. With the honorable exception of Mack 2002.

85. *Nat.* 1.17.2. See also Pliny *HN* 37.165–6; Jónsson 1995: 56–7. Ptolemy (*Opt.* 2.18–19) postulates that all vision by reflection is weaker than direct vision.

86. Phinney 1971.

87. For divergent discussions of this phenomenon see Ziegler 1926; Phinney 1971; Balensiefen 1990: 33–4, 113–30; Frontisi-Ducroux 1995: 72–3.

88. Napier 1986: 88.

89. Vernant 1990a: 85–131. Croon 1955: 9–16 argues that the gorgon was a Greek chthonic deity represented and invoked in ritual by a mask near hot springs, which were traditionally regarded as doors to the underworld. Cf. Howe 1954, who contends that the gorgon began as a head to which a body and a decapitation myth were later added. For her the head represents "an animal fear that has been overcome and diverted to fend off other fears." Both articles review earlier hypotheses of the meaning of the gorgon head.

90. Eco 1984: 214.

91. Schauenburg 1960: Taf. 1.2; Roccos 1994: 338, no. 95.

92. Wittgenstein 1958: 194–7; Miller 1998: 113.

93. Frontisi-Ducroux 1986, 1989: 154, 159, 1995: 97–103 suggests that the gorgon heads and eyes on drinking cups not only play this role but also serve as a kind of mirror-image to the drinker, serving "to exorcise the interior demons, the fears, the anguish, the terror before the definitive alterity of death"; cf. Schuller 1998: 33–40. Mack 2002: 576–8 sees a purely reflexive relationship between image and viewer, without the

triangulative presence of external spirits. But his model of negotiating alterity by appropriating its supposed subjectivity through the image of the gorgoneion is vexed, as I have suggested already.

94. Compare Olympiodorus' commentary on Plato's *Phaedo*, in Westerink 1973: 82–3: "... otherness results in knowledge that is necessarily falsified; in fact, the senses are not proof against sensory phenomena in their purest form, e.g. extreme whiteness, for excessive qualities in the objects destroy the senses. For this reason, then, sense-perception is said to be always deceptive; you could equally well maintain that it is always reliable and accurate, if compared to the apprehension of images, for example those in a mirror."

95. Croon 1955; Vernant 1990b: 47–54, 59. Not only does Odysseus fear encountering the gorgoneion during his journey among the dead (Hom. *Od.* 11.633–5), but a well-known painted tomb at Paestum, Andriuolo Tomb 47 (Paestum, Museo Archeologico Nazionale), depicts the winged gorgon as a ferryman of souls to the underworld. In Vernant's words, "son [i.e., Medusa's] masque exprime et maintient l'altérité radicale du monde des morts qu'aucun vivant ne peut approcher. Pour en franchir le seuil [i.e., of the underworld] il faudrait avoir affronté la face de terreur et s'être, sous son regard, transformé soi-même, à l'image de Gorgô, en ce que sont les morts: des têtes, des têtes vides, désertées de leur force, de leur ardeur. . . . " (1990b: 47).

96. Nolan 1990: 2 n. 2 recognizes this dictum equally in the Judeo-Christian and pagan traditions.

97. Frontisi-Ducroux 1989: 159–60.

98. *I Clem.* 36; Porph. *ad Marcellam* 13; Greg. Thaum. *Pan.* 11. See Hugedé 1957: 52–7, 109–12; Jónsson 1994: 94–9.

SIX. CONCLUSION

1. Dion. Hal. 1.69.3; Plut. *Num.* 13.3; Verg. *A.* 10.633–62.

2. Cf. Taylor forthcoming for another Narcissan situation, in Ausonius' *Mosella*.

3. Rorty 1979: 45.

4. *An Essay Concerning Human Understanding* 2.1.25.

5. Kaltsas 2002: 209–10 no. 425.

6. See p. 102.

APPENDIX. MEDUSA AND THE EVIL EYE

1. Plut. *Mor.* 681e. Loeb translation. Democritus' atomistic theory of harmful *eidola* is also broached briefly in this discussion. On ancient notions of *fascinatio* and *baskania* see Ael. *NA* 1.35, 11.18; Ap. Rhod. 4.1669–70; Heliod. 3.7.2–8.2; Pliny *HN* 7.16–18, 8.80, 13.40, 19.50, 28.22, 28.35, 28.101, 37.145; Plut. *Mor.* 538.7, 681b–683b; Ps.-Arist. *Problemata inedita* 3.52 (Bussemaker 4.333); Ps.-Alex. Aphr. *Problemata* 2.53 (Ideler 1841 1.67–8). On the early Christian period see Dickie 1995 and his principal sources: Bas. *De invidia*, Migne *PG* 31.380 (extracted in Dundes 1981a: 259); Hier. *Commentarius in epistulam ad Galatas*, Migne *PL* 26.372–3; Ioann. Chrys. *De invidia*, Migne *PG* 63.677–82.

2. E.g., Hom. *Il.* 8.349, 11.36–7; Eur. *HF* 990; Ov. *Met.* 5.240–41. Luc. 9.683–99 gives equal weight to the poison of Medusa's eyes, her breath, and her blood. Although his story emphasizes the deadly glare of her eyes, he declares that the snakes in her hair "were the only part of the luckless Medusa which one could study without being turned to stone" (transl. R. Graves), implying that her entire body, short of the serpents, had the petrifying effect. Cf. Ap. Rhod. 4.1515–17. Ath. 5.221, a credulous account attributed to Alexander of Mydnos of a sheeplike Libyan beast that destroyed men "by the influence which emanates from the peculiar nature of its eyes," but also kills with its breath, seems to suggest that its power ceased when it was killed, though it was called "gorgon" by Marius' soldiers.

3. Sources are collected in *RE*, "Gorgo 5: Beschreibung." On the voice and other attributes see Howe 1954: 210–12; Napier 1986: 88. The cry is featured again when Athena invents the double pipe in order to replicate its sound; see Pind. *Pyth.* 12.11–21.

4. Eur. *Ion* 1002–17; Ov. *Met.* 4.617–20; Lucan 9.696–9.

5. Eur. *Ion* 989–95; Ps.-Apollod. 1.6.1–2; Diod. Sic. 3.69.

6. Apollod. 2.7.3; Paus. 8.47.5. Nowhere in Apollodorus' extensive telling of the Medusa myth do her eyes appear as a component of her appearance. On the gorgon's hair and its possible association with masculine battle-worthiness in Laconia, see Vernant 1990b: 42–6.

7. Roccos 1994: 335, 342, nos. 29a, 31–3, 161, etc.

8. Wilk 2000: 161–81. This chapter is somewhat incompatible with the following one, however, which argues that the gorgon represents the head of a bloated corpse. Corpses do not repel animals; quite the opposite.

9. On the widespread belief in the evil eye see Maloney 1976 and Dundes 1981b. On the evil eye in Roman society see Barton 1993: 85–106 and bibliography; on its purported connection to gorgons see Harrison 1922: 187–97; Siebers 1983; Wilk 2000: 121–2 and bibliography.

10. On the purported oscillation of the evil eye between harm and protection see Siebers 1983: 7–26.

11. Some evidence suggests that the dead could be the conduits of the evil eye in Egyptian folklore; see Borghouts 1973: 147–8. On the evil eye of the dying, see Siebers 1983: 4–5.

12. On the widespread belief that the malice of the evil eye is inadvertent, see Siebers 1983: 48–56.

13. Borghouts 1973 investigates the particularly ancient record of the malice of gods, especially of Seth and Apopis, as projected through the evil eye.

14. Siebers 1983: 40.

15. Siebers 1983: 12.

16. Maclagan 1902: 216.

BIBLIOGRAPHY

All abbreviations of titles can be quickly looked up in J. S. Wellington, *Dictionary of Bibliographic Abbreviations Found in the Scholarship of Classical Studies and Related Disciplines*, 2nd ed. (Westport, CT and London 2003).

Abadie-Reynal, C. 2001. "Zeugma: Rapport préliminaire des campagnes de fouilles de 2000." *Anatolia antiqua* 9:243–305.

Abt, A. 1908. *Die Apologie des Apuleius von Madaura und die antike Zauberei*. Giessen.

Achelis, H. 1918. "Katoptromantie bei Paulus." In *Theologische Festschrift für G. Nathanael Bonwetsch*, ed. H. Achelis, 56–63. Leipzig.

Ajootian, A. 1990. "Hermaphroditos." *LIMC* 5:268–85.

———. 1997. "The Only Happy Couple: Hermaphrodites and Gender." In *Naked Truths: Women, Sexuality, and Gender in Classical Art and Archaeology*, ed. A. O. Koloski-Ostrow and C. L. Lyons, 220–42. London and New York.

Alexander, C. 1943. *CVA United States of America 9. Metropolitan Museum of Art, fasc. 1: Arretine Relief Ware*. Cambridge, MA.

Alexander, R. M. 1963. "The Evolution of the Basilisk." *GaR* 10:170–81.

Allais, Y. 1957. "Mosaïque du Musée de Djemila (Cuicul): La toilette de Vénus." In *Archéologie et histoire de l'art: Actes du 79e Congrès National des Sociétés Savants, Alger 1954*, 67–84. Paris.

Alpers, S. 1983. "Interpretation without Representation, or, the Viewing of *Las Meninas*." *Representations* 1:31–42.

Altekamp, S. 1988. "Zu den Statuenbeschreibungen des Kallistratos." *Boreas* 11:77–154.

Amelung, W. 1903–8. *Die Sculpturen des Vatikanischen Museums im Auftrage und unter Mitwirkung des Kaiserlich Deutschen Archäologischen Instituts*. 2 vols. Berlin.

Anderson, W. S. 1997. *Ovid's Metamorphoses: Books 1–5*. Norman, OK.

Andreae, B. 1961. "Zermalmt von Wagen des Großkönigs." *BJb* 161:1–5.

———. 1998. *Museo Pio Clementino: Cortile Ottagono*. Berlin.

Andréoli, M. 2000. "Narcissus and His Double." In Spaas 2000, 13–23.

Ascione, G. C. 2004. "Wer kauft Liebesgötter? (Anyone for Gods of Love?)" In *In Stabiano: Exploring the Ancient Seaside Villas of the Roman Elite*, ed. P. G. Guzzo, T. N. Howe, B. Bonifacio, and A. M. Sodo, 87–9. Castellamare di Stabia.

Assael, J. 1992. "Euripide et la magie des miroirs." *RÉG* 105:561–71.

Auraix-Jonchière, P. and C. Volpilhac-Auger, eds. 2000. *Isis, Narcisse, Psyche, entre Lumières et Romantisme: Mythe et écritures, écritures du mythe*. Clermond-Ferrand.

Babelon, E. 1897. *Catalogue des camées antiques et modernes de la Bibliothèque Nationale*. Paris.

———. 1916. *Le trésor d'argenterie de Berthouville, près Bernay (Eure)*. Paris.

Balensiefen, L. 1990. *Die Bedeutung des Spiegelbildes als ikonographisches Motiv in der antiken Kunst*. Tübingen.

Balil, A. 1961. "Arte helenistico en el levante español." *AEsp* 34:41–52.

Baltrusaitis, J. 1978. *Le miroir: Révélations, science-fiction et fallacies*. Paris.

Balty, J. 1977. *Mosaïques antiques de Syrie*. Brussels.

———. 1981. "La mosaïque au proche-orient I: Des origines à la Tétrarchie." *ANRW* 2:12:2:349–427.

———. 1995. *Mosaïques antiques du proche-orient: Chronologie, iconographie, interprétation.* Paris.

Bann, S. 1989. *The True Vine: On Visual Representation and the Western Tradition.* Cambridge and New York.

Baratte, F. 1986. *Le trésor d'orfèvrerie romaine de Boscoreale.* Paris.

———. 1990. *Le trésor de la place Camille-Jouffray à Vienne (Isère): Un dépôt d'argenterie et son contexte archéologique.* Paris.

Baratte, F. and F. Beck. 1988. *Orfèvrerie galloromaine: Le trésor de Rethel.* Paris.

Baratte, F. and C. Metzger. 1985. *Musée du Louvre: Sarcophages en Pierre d'époques romaine et paléochrétienne.* Paris.

Barbet, A., ed. 2001. *La peinture funéraire antique: IVe siècle av. J.-C.–IVe siècle ap. J.-C.* Paris.

Barnes, H. 2003. "Sartre and the Existentialist Medusa." In Garber and Vickers 2003, 124–7.

Barton, C. 1993. *The Sorrows of the Ancient Romans: The Gladiator and the Monster.* Princeton, NJ.

———. 1999. "The Roman Blush: The Delicate Matter of Self-Control." In Porter 1999:212–34.

———. 2002. "Being in the Eyes: Shame and Sight in Ancient Rome." In Fredrick 2002:216–35.

Bartsch, S. 1994. *Actors in the Audience: Theatricality and Doublespeak from Nero to Hadrian.* Cambridge, MA: Harvard University Press.

———. 2000. "The Philosopher as Narcissus: Vision, Sexuality, and Self-Knowledge in Classical Antiquity." In *Visuality before and beyond the Renaissance: Seeing as Others Saw*, ed. R. S. Nelson, 70–97. Cambridge and New York.

———. 2006. *The Mirror of the Self: Sexuality, Self-Knowledge, and the Gaze in the Early Roman Empire.* Chicago.

Bastet, F. L. 1974. "Fabularum dispositas explicationes." *BABesch* 49:206–40.

Beacham, R. 1991. *The Roman Theater and Its Audience.* Cambridge, MA.

Beard, M. and J. Henderson. 2001. *Classical Art from Greece to Rome.* Oxford and New York.

Beazley, J. D. 1918. *Attic Red-Figured Vases in American Collections.* Cambridge, MA.

———. 1949. "The World of the Etruscan Mirror." *JHS* 69:1–16.

Behm, J. 1929. "Das Bildwort vom Spiegel, I Kor. 13, 12." In *Reinhold Seeberg Festshchrift*, 1:315–42. Leipzig.

Bell, M. 1995. "Orpheus and Eurydike in the Underworld." In *Byzantine East, Latin West: Art-Historical Studies in Honor of Kurt Weitzmann*, ed. C. Moss and K. Kiefer, 5–10. Princeton, NJ.

Ben Khader, A. B. A., E. de Balanda, and A. Uribe Echeverría. 2003. *Image de Pierre: La Tunisie en mosaïque.* Paris and Tunis.

Berger, A.-E. 1996. "The Latest Word from Echo." *New Literary History* 27:4:621–40.

Bergmann, B. 1999. "Rhythms of Recognition: Mythological Encounters in Roman Landscape Painting." In *Im Spiegel des Mythos: Bilderwelt und Lebenswelt. Lo specchio del mito: Immaginario e realtà*, ed. F. de Angelis and S. Muth, 81–107. Wiesbaden.

Bernhard, M.-L. 1970. *CVA Pologne 5: Varsovie – Musée National.* Warsaw.

Berthelot, M. 1893. *Histoire des sciences: La chimie au moyen âge.* 3 vols. Paris.

Besterman, T. 1924. *Crystal-Gazing: A Study in the History, Distribution, Theory, and Practice of Scrying.* London.

Bettini, M., ed. 1991a. *La maschera, il doppio e il ritratto: Strategie dell'identità.* Rome and Bari.

———. 1991b. "Narciso e le immagini gemelle." In Bettini 1991a, 40–60.

Bettini, M. and E. Pellizer. 2003. *Il mito di Narciso: Immagini e racconti dalla Grecia a oggi.* Turin.

Betz, H. D. 1996. *The Greek Magical Papyri in Translation, Including the Demotic Spells.* 2nd ed. Chicago.

Bevan, E. 1989. "Water-Birds and the Olympian Gods." *Phoenix* 84:163–9.

Biagiotti, L., ed. 1990. *Bellezza e seduzione nella Roma imperiale: Roma, Palazzo dei Conservatori, 11 giugno–31 luglio 1990.* Rome.

Biavati, G. 1987. "Rinaldo e Armida." In Macchi and Vitale 1987, 139–44.

Bieber, M. 1928. "Der Mysteriensaal der Villa Item." *JdI* 43:298–330.

Bieber, M. 1961. *The History of the Greek and Roman Theater*. 2nd ed. Princeton, NJ.

Blanc, N. 1997. "L'énigmatique 'Sacello Iliaco' (I 6,4 E): Contribution à l'étude des cultes domestiques." In Scagliarini Corlaita 1997, 37–41.

Blanchard-Lemée, M. 1975. *Maisons à mosaïques du quartier central de Djemila (Cuicul)*. Paris.

Blanchard-Lemée, M., M. Ennaïfer, H. Slim, and L. Slim. 1996. *Mosaics of Roman Africa: Floor Mosaics from Tunisia*. Translated by K. D. Whitehead. New York.

Blech, M. and P. Rodríguez Oliva. 1991. "Fragmente römischer Wandmalerei vom Cerro de los Infantes, Pinos Puente (Prov. Granada) im Museo Arqueológico de Málaga." *4. Internationals Kolloquium zur römischen Wandmalerei (Köln, 20–23 September 1989). KölnJb* 24: 177–82.

Boardman, J. 1968. *Archaic Greek Gems: Schools and Artists in the Sixth and Early Fifth Centuries B.C.* London.

———. 2001. *Greek Gems and Finger Rings: Early Bronze Age to Late Classical*. 2nd ed. London.

Boehm, F. 1914. "Hydromanteia." *RE* 9:1:79–86.

Bömer, F. 1969–86. *P. Ovidius Naso, Metamorphosen: Kommentar*. 7 vols. Heidelberg.

Bonnamour, L. 1969. "Découvertes gallo-romaines dans la Saône en aval de Chalon, à Thorey (S.-et-L.)." *RA* 287–300.

Borbein, A. H. 1968. *Campanareliefs: Typologische und stilkritische Untersuchungen*. Heidelberg.

Borghini, A. 1978. "L'inganno della sintassi: Il mito ovidiano di Narciso." *MatTestiCl* 1:177–92.

———. 1994. "Narciso e la luna." *Athenaeum* 82:201–7.

Borghouts, J. F. 1973. "The Evil Eye of Apopis." *JEA* 59:114–50.

Borriello, M. R., M. Lista, U. Pappalardo, V. Sampaolo, and C. Ziviello, eds. 1986. *Le collezioni del Museo Nazionale di Napoli: I mosaici, le pitture, gli oggetti di uso quotidiano, gli argenti, le terrecotte, i vetriate, i vetri, i cristalli, gli avori*. Rome.

Böttiger, C. A. 1850. "Pallas Musica und Apollo der Marsyastödter." In *Kleine Schriften archäologischen und antiquarischen Inhalts*, ed. J. Sillig, 2nd ed., 1:3–60. Leipzig.

Bovini, G. and L. B. Ottolenghi. 1956. *Catalogo della mostra degli Avori dell'alto medio evo*. Ravenna.

Boyancé, P. 1966. "Dionysiaca: A propos d'une étude récente sur l'initiation dionysiaque." *RÉA* 68:33–60.

Bragantini, I. and M. de Vos, eds. 1982. *Museo Nazionale Romano 2:1: Le pitture. Decorazioni della villa romana della Farnesina*. Rome.

Bremmer, J. 1983. *The Early Greek Concept of the Soul*. Princeton, NJ.

Brendel, O. F. 1980a. "The Great Frieze in the Villa of the Mysteries." In *The Visible Idea: Interpretations of Classical Art*, 91–138. Washington, DC.

———. 1980b. "The Shield of Achilles." In *The Visible Idea: Interpretations of Classical Art*, 67–82. Washington, DC.

Brenkman, J. 1976. "Narcissus in the Text." *Georgia Review* 30:293–327.

Brilliant, R. 1984. *Visual Narratives: Storytelling in Etruscan and Roman Art*. Ithaca, NY.

Brisson, L. 1991. "Damascius et l'Orphisme." In *Orphisme et Orphée: En l'honneur de Jean Rudhardt*, ed. P. Borgeaud, 157–209. Geneva.

———. 2002. *Sexual Ambivalence: Androgyny and Hermaphroditism in Graeco-Roman Antiquity*. Translated by J. Lloyd. Berkeley.

Broneer, O. 1930. "The 'Armed Aphrodite' on Acrocorinth and the Aphrodite of Capua." *CPCA* 1:65–84.

Brown, R. D. 1987. *Lucretius on Love and Sex: A Commentary on De rerum natura IV, 1030–1287, with Prolegomena, Text, and Translation*. Leiden and New York.

Bulle, H. 1912. "Eine neue Ergänzung der Myronischen Athena zu Frankfurt a. M." *JDAI* 27:175–99.

Burckhardt, J. 1930. "Marsyas (6)." *RE* 28:1986–95.

Burkert, W. 1977. "Orphism and Bacchic Mysteries: New Evidence and Old Problems of Interpretation." In *Orphism and Bacchic Mysteries: New Evidence and Old Problems of*

Interpretation: Protocol of the Twenty-Eighth Colloquy, 13 March 1977, ed. W. Burkert and W. Wuellner, 1–8. Berkeley.

———. 1987. *Ancient Mystery Cults*. Cambridge, MA.

Byvanck-Quarles van Ufford, L. 1973. *Zilveren en gouden vaatwerk uit de Griekse en Romeinse oudheid*. Amersfoort.

Cahn, H. A. and A. Kaufmann Heinemann. 1984. *Der spätrömische Silberschatz von Kaiseraugst*. Derendigen.

Caillois, R. 1964. *The Mask of Medusa*. Translated by G. Ordish. New York.

Cain, H.-U. 1988. "Chronologie, Ikonographie und Bedeutung der römischen Maskenreliefs." *BJb* 188:107–221.

Callahan, J. F. 1964. "Plautus' 'Mirror for a Mirror.'" *CP* 59:1–10.

Cameron, F. 1979. *Greek Bronze Hand-Mirrors in South Italy with Special Reference to Calabria*. Oxford.

Campanelli, A. and M. P. Pennetta, eds. 2003. *Attraverso lo specchio: Storia, inganni, e verità di uno strumento di conoscenza*. Pescara.

Campbell, S. 1988. *The Mosaics of Antioch*. Toronto.

Canciani, F. 1984. "Minerva." *LIMC* 2:1:1074–1109.

Cancik, H. 1967. "Spiegel der Erkenntnis (zu Ovid, *Met*. III 339–510)." *AU* 10:42–53.

Cappelli, R. 1987. "Il 'mundus muliebris' nel mondo antico." In Macchi and Vitale 1987, 234–41.

Caputo, G. 1959. *Il teatro di Sabratha e l'architettura teatrale africana*. Rome.

Carandini, A., A. Ricci, and M. de Vos. 1982. *Filosofiana, the Villa of Piazza Armerina: The Image of a Roman Aristocrat at the Time of Constantine*. Palermo.

Carpenter, R. 1941. "The Marsyas of the Lateran." In *Observations on Familiar Statuary in Rome. MAAR* 18:5–18.

Carpenter, T. H. 1997. *Dionysian Imagery in Fifth-Century Athens*. Oxford and New York.

Carpino, A. A. 2003. *Discs of Splendor: The Relief Mirrors of the Etruscans*. Madison, WI.

Carson, A. 1990. "Putting Her in Her Place: Woman, Dirt, and Desire." In Halperin, Winkler, and Zeitlin 1990, 135–69.

———. 1999. "Dirt and Desire: The Phenomenology of Female Pollution in Antiquity." In Porter 1999, 77–100.

Cassimatis, H. 1998. "Le miroir dans les représentations funéraires apuliennes." *MÉFRA* 110:297–350.

Catterall, J. L. 1937. "Perseus." *RE* 37:978–92.

Chase, G. H. 1908. *The Loeb Collection of Arretine Pottery*. New York.

Cimok, F. 2000. *Antioch Mosaics: A Corpus*. Istanbul.

Cixous, H. 1976. "The Laugh of Medusa." Translated by K. Cohen and P. Cohen. *Signs* 1:4:875–93.

Clarke, E. C., J. M. Dillon, and J. P. Hershbell, eds. and transls. 2003. *Iamblichus: De mysteriis*. Atlanta.

Clarke, J. R. 1991. *The Houses of Roman Italy, 100 B.C.–A.D. 250: Ritual, Space, and Decoration*. Berkeley.

Cohen, A. 1997. *The Alexander Mosaic: Stories of Victory and Defeat*. Cambridge and New York.

Cohen, M. R. and I. E. Drabkin, eds. 1958. *A Source Book in Greek Science*. Cambridge, MA.

Colpo, I. 2002. "La formazione del repertorio: Lo schema del giovane eroe seduto nella pittura pompeiana." Dissertation, Archaeological Sciences, University of Padua.

Comparetti, D. 1921. *Le nozze di Bacco ed Arianna: Rappresentazione pittorica spettacolosa nel triclinio di una villa suburbana di Pompei*. Florence.

Conan, M. 1987. "The *Imagines* of Philostratus." *Word and Image* 3:2:162–71.

Congdon, L. O. K. 1981. *Caryatid Mirrors of Ancient Greece: Technical, Stylistic, and Historical Considerations of an Archaic and Early Classical Bronze Series*. Mainz.

Cook, A. B. 1914–40. *Zeus: A Study in Ancient Religion*. Cambridge.

Corbeill, A. 2004. *Nature Embodied: Gesture in Ancient Rome*. Princeton, NJ.

Croon, J. H. 1955. "The Mask of the Underworld Daemon: Some Remarks on the Perseus–Gorgon Story." *JHS* 75:9–16.

Cumont, F. 1933. "La grande inscription bacchique du Metropolitan Museum II: Commentaire religieux de l'inscription." *AJA* 37:232–63.

Cunen, F. 1957. "La lécanomancie: Ses origins et son développement." Dissertation, University of Liège.

———. 1976. "Lecanomancy and Lapidaries." In *Acta Omnium Gentium ac Nationum Conventus Latinis Litteris Linguaeque Fovendis*, 559–67. Valletta.

Cyrino, M. 1998. "Heroes in D[u]ress: Transvestism and Power in the Myths of Herakles and Achilles." *Arethusa* 31:207–41.

Daltrop, G. 1980. *Il gruppo mironiano di Atena e Marsia nei Musei Capitolini*. Vatican City.

D'Amicis, A. 2003. "Specchio a scatola." In Campanelli and Pennetta 2003, 70.

Daremberg, C. and E. Saglio, eds. 1877–1919. *Dictionnaire des antiquités grecques et romains*. 5 vols. Paris.

Darmon, J. P. 1975. "Sur deux mosaïques de l'Yonne." In Stern and Le Glay 1975, 307–16.

Davis, J. M. 2000. "The Search for the Origins of the Villa of the Mysteries Frieze." In Gazda 2000, 83–95.

Dawson, C. M. 1944. *Romano-Campanian Mythological Landscape Painting*. YaleClasStud 9. New Haven, CT.

De Grummond, E. 2000. "Bacchic Imagery and Cult Practice in Roman Italy." In Gazda 2000, 74–82.

De Grummond, N. T. 1982a. "Covered Mirrors in Wooden Boxes." In De Grummond 1982b, 21–4.

———, ed. 1982b. *A Guide to Etruscan Mirrors*. Tallahassee, FL.

———. 1982c. "The Meaning of Mirrors." In De Grummond 1982b, 180–86.

———. 1982d. "The Usage of Etruscan Mirrors." In De Grummond 1982b, 166–7.

———. 2002. "Mirrors, Marriage, and Mysteries." In *Pompeian Brothels, Pompeii's Ancient History, Mirrors and Mysteries, Art and Nature at Oplontis, & the Herculaneum "Basilica,"* ed. J. H. Humphrey, 62–85. Portsmouth, RI.

De Grummond, N. T. and M. Hoff. 1982. "Mirrors of the Mediterranean: Greek." In De Grummond 1982b, 32–3.

Delatte, A. 1932. *La catoptromancie grecque et ses dérivés*. Liège and Paris.

Delcourt, M. 1992. *Hermaphrodite: Mythes et rites de la bisexualité dans l'antiquité classique*. 2nd ed. Paris.

Delivorrias, A., G. Berger-Doer, and A. Kossatz-Deissmann. 1984. "Aphrodite." *LIMC* 2:1:2–151.

Demargne, P. 1984. "Athena." *LIMC* 2:1:955–1016.

De' Spagnolis, M. 1995. "Sulle statue del c.d. *Narciso* e delle Venere diademata (c.d. *Venus Sallustii*), provenienti da Formia, in musei stranieri." In *Formianum: Atti del Convegno di Studi sull'Antico Territorio di Formia*, 3:49–56. Marina di Minturno.

Detienne, M. 1979. "The Orphic Dionysos and Roasted Boiled Meat." In *Dionysos Slain*, translated by M. Muellner and L. Muellner, 68–94. Baltimore and London.

Dickie, M. W. 1995. "The Fathers of the Church and the Evil Eye." In *Byzantine Magic*, ed. H. Maguire, 9–38. Washington, DC.

Diebner, S. 2003. "La presenza dello specchio sui monumenti funerari di età romana." "Ara funeraria romana di Poppaedia P. F. Secunda." "Ara funeraria romana di L. Sextus Albanus." In Campanelli and Pennetta 2003, 84–7, 102–3.

Diels, H. and W. Kranz, eds. 1951. *Die Fragmente der Vorsokratiker: Griechisch und Deutsch*. 3 vols. 6th ed. Berlin.

Dietz, G. and K. Hilbert. 1970. *Phaethon und Narziß bei Ovid*. Heidelberg.

———. 2003. "Narciso delle mie brame." In Campanelli and Pennetta 2003, 28–33.

DiSalvo, M. 1980. "The Myth of Narcissus." *Semiotica* 30:15–25.

Dodds, E. R. 1951. *The Greeks and the Irrational*. Berkeley.

Donderer, M. 1990. "Das pompejanische Alexandermosaik – Ein östliches Importstück?" in *Das antike Rom und der Osten: Festschrift für Klaus Parlasca zum 65. Geburtstag*, ed. C. Börker and M. Donderer, 19–31. Erlangen.

Dörrie, H. 1967. "Echo und Narcissus: Psychologische Fiktion in Spiel und Ernst." *AU* 10: 56–75.

Downing, E. 1999. "Anti-Pygmalion: The *Praeceptor in Ars Amatoria*, Book 3." In Porter 1999, 235–51.

Drachmann, A. B. 1910. *Scholia vetera in Pindari carmina. Vol. 2: Scholia in Pythionicas.* Leipzig.

Dragendorff, H. and E. Krüger. 1924. *Das Grabmal von Igel.* Trier.

Dreger, L. 1940. "Das Bild im Spiegel: Ein Beitrag zur Geschichte der antiken Malerei." Dissertation, University of Heidelberg.

DuBois, P. 1988. *Sowing the Body: Psychoanalysis and Ancient Representations of Women.* Chicago: University of Chicago Press.

Dunbabin, K. 1978. *The Mosaics of Roman North Africa.* Oxford.

———. 1999. *Mosaics of the Greek and Roman World.* Cambridge and New York.

Dunbabin, T. J. 1951. "The Oracle of Hera Akraia at Perachora." *BSA* 46:61–74.

Dundes, A. 1981a. *The Evil Eye: A Folklore Casebook.* New York and London.

———. 1981b. "Wet and Dry, the Evil Eye: An Essay in Indo-European and Semitic Worldview." In Dundes 1981a, 257–312.

Eco, U. 1984. "Mirrors." In *Semiotics and the Philosophy of Language,* 202–26. Bloomington, In.

———. 1987. "Intorno e al di là dello specchio." In Macchi and Vitale 1987, 19–25.

Edwards, C. 1993. *The Politics of Immorality in Ancient Rome.* Cambridge and New York.

———. 1997. "Unspeakable Professions: Public Performance and Prostitution in Ancient Rome." In Hallett and Skinner 1997, 66–95.

Edwards, K. M. 1933. *Corinth VI: Coins 1896–1929.* Cambridge, MA.

Eisler, R. 1925. *Orphisch-dionysische Mysteriengedanken in der christlichen Antike.* Leipzig and Berlin.

Eitrem, S. 1935. "Narkissos." *RE* 16:2:1721–33.

———. 1968. "Milch- und Weinwunder in den Dionysosmysterien." In *Stockholm Studies in Classical Archaeology: Opuscula* 5:11–14.

Elsner, J. 1995. *Art and the Roman Viewer: The Transformation of Art from the Pagan World to Christianity.* Cambridge and New York.

———, ed. 1996a. *Art and Text in Roman Culture.* Cambridge and New York.

———. 1996b. "Naturalism and the Erotics of the Gaze: Intimations of Narcissus." In Kampen 1996b, 247–61.

———. 1998. *Imperial Rome and Christian Triumph: The Art of the Roman Empire, 100–450.* Oxford.

———. 2000. "Caught in the Ocular: Visualizing Narcissus in the Roman World." In Spaas 2000, 89–110.

Elworthy, F. T. 1895. *The Evil Eye: An Account of This Ancient and Widespread Superstition.* London.

Fantar, M. H. 1987. "Le mythe de Marsyas sur deux nouvelles mosaïques de Tunisie." In *L'Africa romana: Atti IV Convegno di Studio, Sassari 1986,* ed. A. Mastino, 151–66. Sassari.

Fantar, M. H. and S. Jaber. 1994. *La mosaïque en Tunisie.* Tunis and Paris.

Feldman, T. 1965. "Gorgo and the Origins of Fear." *Arion* 4:484–94.

Ferenczi, S. 1923. "On the Symbolism of the Head of Medusa." In *Further Contributions to the Theory and Technique of Psycho-Analysis,* ed. J. Rickman, translated by J. I. Suttie et al., 360. London.

Festugière, A. J. 1935. "Les mystères de Dionysos." *Revue biblique* 44:192–211, 366–96.

———, ed. 1966. *Proclus, In Timaeum. Commentaire sur le Timée.* Translated by the editor. 5 vols. Paris.

Feugère, M. and M. Martin. 1988. "Le trésor d'argenterie gallo-romaine de Thil (Haute-Garonne) dit 'Trésor de Caubiac.'" In *Argenterie romaine et byzantine: actes de la table ronde, Paris 11–13 octobre 1983,* ed. F. Baratte and N. Duval, 63–84. Paris.

Février, P. A., A. Gaspary, and R. Guéry. 1970. *Fouilles de Sétif (1959–1966): Quartier nord-ouest, rempart et cirque.* Algiers.

Fierz-David, L. 1988. *Women's Dionysian Initiation: The "Villa of the Mysteries" in Pompeii.* Translated by G. Phelan. Dallas.

Fittschen, K. 1975. "Zum Figurenfries der Villa von Boscoreale." In *Neue Forschungen in Pompeji,* ed. B. Andreae and H. Kyrieleis, 93–100. Recklinghausen.

Fol, A. 1993. *Der thrakische Dionysos, erstes Buch: Zagreus.* Translated by R. Ivanova. Sofia.

Foucault, M. 1985–6. "Of Other Spaces: Utopia and Heterotopia." *Lotus* 48–9:9–17.

———. 1990. *The History of Sexuality.* 3 vols. Translated by R. Hurley. New York.

Foucher, L. 1963. *La Maison de la procession dionysiaque à El Jem.* Paris.

Fränkel, H. F. 1945. *Ovid: A Poet between Two Worlds.* Berkeley.

Frazer, J. G. 1911. *The Golden Bough, Part II: Taboo and the Perils of the Soul.* London.

———. 1931. "Some Popular Superstitions of the Ancients." In *Garnered Sheaves: Essays, Addresses, and Reviews,* 128–50. London.

Fredrick, D., ed. 2002. *The Roman Gaze: Vision, Power, and the Body.* Baltimore and London.

Freud, S. 1941. [1922]. "Medusa's Head." *International Journal of Psychoanalysis* 22:69–70. Selection (translated by J. Strachey) reprinted as "The Classic Psychoanalytic Reading" in Garber and Vickers 2003, 84–6.

———. 1957. "On Narcissus." In *The Standard Edition of the Complete Psychological Works of Sigmund Freud,* ed. and translated by J. Strachey, 19:73–102. London.

Frickenhaus, A. 1912. *Lenäenvasen.* Berlin.

Frontisi-Ducroux, F. 1986. "La morte en face." *Métis* 1–2:197–217.

———. 1989. "In the Mirror of the Mask." In *A City of Images: Iconography and Society in Ancient Greece,* translated by D. Lyons, 151–65. Princeton, NJ.

———. 1991a. *Le dieu-masque: Une figure du Dionysos d'Athènes.* Paris and Rome.

———. 1991b. "Senza maschera nè specchio: L'uomo Greco e i suoi doppi." In Bettini 1991a, 131–58.

———. 1993. "La Gorgone, paradigme de création d'images." In *Les Cahiers du collège iconique: Communications et débats* 1:71–86. Selections (translated by S. Graebner) reprinted as "Medusa as Maker of Images" in Garber and Vickers 2003, 262–6.

———. 1994. "Athéna et l'invention de la flute." *Musica e storia* 2:239–67.

———. 1995. *Du masque au visage: Aspects de l'identité en Grèce ancienne.* Paris.

———. 1996. "Eros, Desire, and the Gaze." In Kampen 1996b, 81–100. Translated by N. Kline.

———. 2000. "Narcisse, à travers le miroir." In Sennequier et al. 2000, 27–43.

Frontisi-Ducroux, F. and J.-P. Vernant. 1997. *Dans l'oeil du miroir.* Paris.

Frothingham, A. 1911. "Medusa, Apollo, and the Great Mother." *AJA* 15:349–77.

Fuchs, W. 1959. *Die Vorbilder der neuattischen Reliefs.* Berlin.

Furtwängler, A. 1900. *Die antiken Gemmen: Geschichte der Steinschneidekunst im klassischen Altertum.* Leipzig and Berlin.

Gadbery, L. 1993. "Roman Wall-Painting at Corinth: New Evidence from East of the Theater." In *The Corinthia in the Roman Period,* ed. T. E. Gregory, 47–64. Ann Arbor, MI.

Gaillard, C. 1982. "La femme et la loi." In *La villa des mystères à Pompéi: Approches, essais d'analyses et de reprise au present,* 95–196. Paris.

Gallistl, B. 1981. "Der Zagreusmythos bei Euripides." *WürzJbb* n. F. 7:235–52.

———. 1995. *Maske und Spiegel: Zur Maskenszene des Pompejaner Mysterienfrieses.* Hildesheim and New York.

Gambetti, C. 1974. *I coperchi di urne con figurazioni femminili nel Museo Archeologico di Volterra.* Milan.

Gandolfi, A. 2003a. "Lo specchio apotropaico." In Campanelli and Pennetta 2003, 158–61, 164.

———. 2003b. "Uno specchio magico che sparisce." In Campanelli and Pennetta 2003, 150–51.

Ganschinietz [Ganszyniec], R. 1921. "Katoptromanteia." *RE* 11:1:27–9.

Garber, M. and N. Vickers, eds. 2003. *The Medusa Reader.* New York and London.

García y Bellido, A. 1949. *Esculturas romanas de España y Portugal.* Madrid.

Garton, C. 1972. *Personal Aspects of the Roman Theatre.* Toronto.

Gasparri, C., ed. 1994. *Le gemme Farnese.* Naples.

Gauer, W. 1995. "Athena und Marsyas." In *Modus in rebus: Gedenkschrift für Wolfgang Schindler,* ed. D. Rössler and V. Stürmer, 50–54. Berlin.

Gazda, E. K., ed. 2000. *The Villa of the Mysteries in Pompeii: Ancient Ritual, Modern Muse.* Ann Arbor, MI and Seattle.

Gerhard, E. 1846. "Geburt und Pflege des Dionysos." *Archäologische Zeitung* 4:218–19.

Germain, S. 1969. *Les mosaïques de Timgad: étude descriptive et analytique*. Paris.

Ghedini, F. 2004. "Achille a Sciro." In Ghedini et al. 2004, 17–26.

Ghedini, F., I. Colpo, and M. Novello, eds. 2004. *Le Imaggini di Filostrato minore: La prospettiva dello storico dell'arte*. Rome.

Giglioli, G. Q. and G. Barbieri. 1925. *Corpus vasorum antiquorum. Italia. Museo Nazionale di Villa Giulia in Roma*. 4 vols. Milan.

Giuliano, A., ed. 1981. *Museo Nazionale Romano: Le sculture 1,2: Catalogo delle sculture esposte nelle ali del Chiostro*. Rome: De Luca.

——, ed. 1984. *Museo Nazionale Romano: Le Sculture 1,7: Catalogo delle sculture esposte nel Giardino dei Cinquecento*. Rome.

Gleason, M. 1995. *Making Men: Sophists and Self-Representation in Ancient Rome*. Princeton, NJ.

Goldhill, S. 2002. "The Erotic Experience of Looking: Cultural Conflict and the Gaze in Empire Culture." In Nussbaum and Sihvola 2002, 374–99.

Goldman, B. 1961. "The Asiatic Ancestry of the Greek Gorgon." *Berytus* 14:1:1–22.

Gonzenbach, V. von. 1975. "Das Göttermosaik in der römischen Villa bei Orbe; Ein Kommentar zu neueren Deutungen." *ZSchwArch* 32:121–8.

Grabes, H. 1982. *The Mutable Glass: Mirror-Imagery in Titles and Texts of the Middle Ages and English Renaissance*. Translated by G. Coller. Cambridge and New York.

Greve, W. 1897–1902. "Narkissos." In Roscher 1884–1937, 3:1:10–21.

Grieco, G. 1979. "La grande frise de la Villa des Mystères et l'initiation dionysiaque." *PP* 189:417–41.

Gross, W. H. 1954. "Clipeata imago und *eikōn enoplos*." In *Convivium: Beiträge zur Altertumswissenschaft: Konrat Ziegle, dem Lehrer und Freunde*, 66–84. Stuttgart.

Guerrini, L. 1963. "Narciso." *EAA* 5:351–2.

Guidorizzi, G. 1991. "Lo specchio e la mente: Un sistema d'intersezioni." In Bettini 1991a, 31–46.

Guimond, L. 1981. "Aktaion." *LIMC* 1:1:454–69.

Gury, F. 1986. "La forge du destin: À propos d'une série de peintures pompéiennes du IVe style." *MÉFRA* 98:427–89.

Haberland, K. 1882. "Der Spiegel in Glauben und Brauch der Völker." *Zeitschrift für Völkerpsychologie und Sprachwissenschaft* 13:325–47.

Hadot, P. 1976. "Le mythe de Narcisse et son interpretation par Plotin." *Nouvelle revue de psychanalyse* 13:81–108.

Hafner, G. 1994. "Der Narkissos des Polyklet: Ein Spiel mit dem Wasser." *Rivista di archeologia* 18:49–56.

Hallett, J. P. and M. B. Skinner, eds. 1997. *Roman Sexualities*. Princeton, NJ.

Halperin, D. M. 1990. *One Hundred Years of Homosexuality and Other Essays on Greek Love*. New York and London.

Halperin, D. M., J. J. Winkler, and F. I. Zeitlin, eds. 1990. *Before Sexuality: The Construction of Erotic Experience in the Ancient Greek World*. Princeton, NJ.

Hamburger, J. 2000. "Speculations on Speculation: Vision and Perception in the Theory and Practice of Mystical Devotions." In *Deutsche Mystik im abendländischen Zusammenhang: Neue erschlossene Texte, neue methodische Ansätze, neue theoretische Konzepte. Kolloquium Kloster Fischingen*, ed. W. Haug and W. Schneider-Lastin, 353–408. Tübingen.

Hardie, P. R. 1985. "Imago mundi: Cosmological and Ideological Aspects of the Shield of Achilles." *JHS* 105:11–31.

——. 1988. "Lucretius and the Delusions of Narcissus." *MD* 20–21:71–89.

Harrison, J. E. 1899. "Delphika: (A) The Erinyes. (B) The Omphalos." *JHS* 19:205–51.

——. 1922. *Prolegomena to the Study of Greek Religion*. 3rd ed. Cambridge.

Hartland, E. S. 1894–6. *The Legend of Perseus: A Study of Tradition in Story, Custom, and Belief*. 3 vols. London. Reprint New York, 1972.

Hartlaub, G. F. 1951. *Zauber des Spiegels: Geschichte und Bedeutung des Spiegels in Kunst*. Munich.

Haskell, F. and N. Penny. 1981. *Taste and the Antique: The Lure of Classical Sculpture, 1500–1900*. New Haven, CT.

Havelock, C. M. 1995. *The Aphrodite of Knidos and Her Successors: A Historical Review of the Female Nude in Greek Art*. Ann Arbor, MI.

Heinemann, F. 1926. "Die Spiegeltheorie der Materie als Korrelat der Logos-Licht-Theorie bei Plotin." *Philologus* 81:1–17.

Hekler, A. 1937. Római köemlékek kethelyen (Sopron VM)." *ArchErt* 50:76–9.

Helbig, W. 1892. "Sopra un tipo di Narciso anteriore al tempo ellenistico." *RendLinc* 1:790–94.

Henrichs, A. 1978. "Greek Maenadism from Olympias to Messalina." *HSCP* 82:121–60.

———. 1984. "Loss of Self, Suffering, Violence: The Modern View of Dionysus from Nietzsche to Girard." *HSCP* 88:205–40.

Herbig, R. 1958. *Neue Beobachtungen am Fries der Mysterien-Villa in Pompeji*. Baden-Baden.

Herrmann, P. 1886–90. "Hermaphroditos." In Roscher 1884–1937, 1:2:2314–42.

Herrmann, W. 1968. "Spiegelbild im Spiegel: Zur Darstellung auf frühlukanischen Vasen." In *Festschrift Gottfried v. Lücken*, ed. K. Zimmermann *(WissZRostock*17), 667–71.

Hertz, N. 1983. "Medusa's Head: Male Hysteria under Political Pressure." *Representations* 4:27–54. Selections reprinted in Garber and Vickers 2003, 173–95.

Holliday, P. J. 2002. *The Origins of Roman Historical Commemoration in the Visual Arts*. Cambridge and New York.

Hölscher, T. 1960. *Victoria romana: Archäologische Untersuchungen zur Geschichte und Wesensart der römischen Siegesgöttin von der Anfängen bis zum Ende des 3. Jhs. n. Chr.* Mainz.

———. 1970. "Die Victoria von Brescia." *AntP* 10:67–79.

———. 2004. *The Language of Images in Roman Art*. Translated by A. Snodgrass and A. Künzl-Snodgrass. New York and Cambridge.

Hopkins, C. 1934. "Assyrian Elements in the Perseus–Gorgon Story." *AJA* 38:341–58.

———. 1961. "The Sunny Side of the Greek Gorgon." *Berytus* 14:1:25–35.

Hörling, E. 1980. "Mythos und pistis: Zur Deutung heidnischer Mythen in der christlichen Weltchronik des Johannes Malalas." Dissertation, Lund University.

Houtzager, J. 1963. *De grote wandschildering in de Villa dei misteri bij Pompeii en haar verhouding tot de monumenten der vroegere kunst*. The Hague.

Howe, T. P. 1954. "The Origin and Function of the Gorgon-Head." *AJA* 58:209–21.

Hugedé, N. 1957. *La métaphore du miroir dans les épîtres de saint Paul aux Corinthiens*. Paris.

Hundsalz, B. 1991. "Neues zum großen Fries der Mysterienvilla." *4. Internationals Kolloquium zur römischen Wandmalerei (Köln, 20–23 September 1989). KölnJb* 24:73–8.

Iaculli, G. 2003. "L'iconografia di Narciso nell'arte classica." In Campanelli and Pennetta 2003, 14–19.

Ideler, J. L. 1841. *Physici et medici Graeci minores*. 2 vols. Berlin.

Immisch, O. 1890–97. "Kureten und Korybanten." In Roscher 1884–1937, 2:1:1587–1628.

Irigaray, L. 1985. *Speculum of the Other Woman*. Translated by G. C. Gill. Ithaca, NY.

Jahn, O. 1868. "Perseus, Herakles, Satyrn auf Vasenbildern und das Satyrdrama." *Philologus* 27:1–27.

Jeanmaire, H. 1951. *Dionysos: Histoire du culte de Bacchus*. Paris.

Jessen, O. 1894–7. "Marsyas." In Roscher 1884–1937, 2:2:2439–60.

———. 1912. "Hermaphroditos." *RE* 8:1:714–21.

Jónsson, E. M. 1995. *Le miroir: Naissance d'un genre littéraire*. Paris.

Jucker, I. 1956. *Der Gestus des Aposkopein: Ein Beitrag zur Gebärdensprache der antiken Kunst*. Zürich.

Junge, M. 1983. *Untersuchungen zur Ikonographie der Erinys in der griechischen Kunst*. Kiel.

Kaltsas, N. 2002. *Sculpture in the National Archaeological Museum, Athens*. Translated by D. Hardy. Los Angeles.

Kampen, N. B. 1996a. "Omphale and the Instability of Gender." In Kampen 1996b, 233–46.

———, ed. 1996b. *Sexuality in Ancient Art*. Cambridge and New York.

Karouzou, S. P. 1951. "Attic Bronze Mirrors." In *Studies Presented to David Moore Robinson on His 70th Birthday*, ed. G. E. Nylonas, 1.565–87. St. Louis.

Kellum, B. 1999. "The Spectacle of the Street." In *The Art of Ancient Spectacle*, ed. B. Bergmann and C. Kondoleon, 283–99. New Haven, CT and London.

Kent, J. P. C. and Painter, K. S., eds. 1977. *Wealth of the Roman World: AD 300–700*. London.

Kerényi, C. 1960. "Man and Mask." In *Papers from the Eranos Yearbooks*, vol. 4: *Spiritual Disciplines*, ed. J. Campbell, 151–67. New York and London.

———. 1964. "Der spiegelnde Spiegel." In *Festschrift für Ad. E. Jensen*, ed. E. Haberland, M. Schuster, and H. Straube, 285–91. Munich.

———. 1977. *Dionysos: Archetypal Image of Indestructible Life*. Translated by R. Manheim. Princeton, NJ.

Kern, O. 1922. *Orphicorum fragmenta*. Berlin.

Kiilerich, B. 1993. *Late Fourth-Century Classicism in the Plastic Arts: Studies in the So-Called Theodosian Renaissance*. Odense.

———. 2001. "Ducks, Dolphins, and Portrait Medallions: Framing the Achilles Mosaic at Pedrosa de la Vega (Palencia)." In *Imperial Art as Christian Art – Christian Art as Imperial Art: Expression and Meaning in Art and Architecture from Constantine to Justinian*, ed. J. R. Brandt and O. Steen, 245–67. Rome.

King, G. G. 1933. "Some Reliefs at Budapest." *AJA* 37:64–76.

Kirk, S. S. 2000. "Nuptial Imagery in the Villa of the Mysteries Frieze: South Italian and Sicilian Precedents." In Gazda 2000, 98–115.

Klein, B. 1988. "Die myronische Athena – Im Weggehen begriffen?" *Boreas* 11:43–7.

Klein, W. 1926. "Pompejanische Bilderstudien III." *ÖJh* 23:71–115.

Kleiner, D. E. E. 1981. "Second-Century Mythological Portraiture: Mars and Venus." *Latomus* 40:512–44.

Klimowsky, E. W. 1972. *Das mann-weibliche Leitbild in der Antike*. Munich.

Knorr, W. 1985. "Archimedes and the Pseudo-Euclidian *Catoptrics*: Early Stages in the Ancient Geometric Theory of Mirrors." *Archives internationals d'histoire des sciences* 35:27–105.

Knox, B. 1994. *Backing into the Future: The Classical Tradition and Its Renewal*. New York.

Koch, G. and H. Sichtermann. 1982. *Römische Sarkophage*. Munich.

Kofman, S. 1985. *The Enigma of Woman: Woman in Freud's Writings*. Translated by C. Porter. Ithaca, NY. Selection reprinted as "A Feminist Rereading of Freud's Medusa" in Garber and Vickers 2003, 165–7.

Koller, H. von. 1973. "Die Apotheose auf zwei römischen Mosaiken, des Planetengöttermosaik von Orbe und das Monnosmosaik von Trier." *ZSchwArch* 30:61–75.

———. 1976. "Narziß oder Hylas? Zum Planetengöttermosaik von Orbe." *ZSchwArch* 33:94–101.

Kondoleon, C., ed. 2000. *Antioch: The Lost Ancient City*. Princeton, NJ.

Konstan, D. and M. Nussbaum, eds. 1990. *Sexuality in Greek and Roman Society*. *Differences* 2 (special issue).

Koortbojian, M. 1995. *Myth, Meaning, and Memory on Roman Sarcophagi*. Berkeley.

Kousser, R. 2001. "Sensual Power: A Warrior Aphrodite in Greco-Roman Art." Dissertation, Institute of Fine Arts.

———. 2005. "Creating the Past: The Vénus de Milo and the Hellenistic Reception of Classical Greece." *AJA* 109:227–50.

Krauskopf, I. and S.-C. Dahlinger. 1988. "Gorgo, Gorgones." *LIMC* 4:1:285–330.

Kuhnert, E. 1903. "Perseus." In Roscher 1884–1937, 3:2:1986–2060.

Künzl, E. 1975. "Eine Silberkanne mit Kentauromachie aus Pompeji." *JbRGZM* 22:62–80.

Lacan, J. 1966. "Le stade du miroir comme formateur de la fonction du Je." In *Écrits*, 93–100. Paris.

Langlotz, E. 1960. *Der triumphierende Perseus*. Cologne.

La Penna, A. 1983. "La parola translucida di Ovidio (sull'episodio di Ermafrodito, *Met*. IV.285–388)." *Vichiana* n.s. 12:235–43.

Larmour, D. H. J., P. A. Miller, and C. Platter, eds. 1998. *Rethinking Sexuality: Foucault and Classical Antiquity*. Princeton, NJ.

Lassus, J. 1965. "Venus Marine." In *La mosaïque gréco-romaine: Paris, 29 août–3 septembre 1963*, 175–91. Paris.

Laurenzi, L. 1960. "Ermafrodito." *EAA* 3:421–4.

Lauter-Bufe, H. 1969. *Zur Stilgeschichte der figürlichen pompejanischen Fresken*. Erlangen.

Leader-Newby, R. 2004. *Silver and Society in Late Antiquity: Functions and Meanings of Silver Plate in the Fourth to Seventh Centuries*. Aldershot.

Leary, T. J. 1990. "That's What Little Girls Are Made of: The Physical Charms of Elegiac Women." *LCM* 15:152–5.

———. 1993. "The Intellectual Accomplishments of the Elegiac Women." *LCM* 18:88–91.

Leclercq-Neveu, B. 1989. "Marsyas, le martyr de l'aulos." *Métis* 4:251–68.

Lehmann, K. 1962. "Ignorance and Search in the Villa of the Mysteries." *JRS* 52:62–8.

Lehmann, P. W. 1953. *Roman Wall Paintings from Boscoreale in the Metropolitan Museum of Art*. Cambridge, MA.

Leitão, D. D. 1998. "Senecan Catoptrics and the Passion of Hostius Quadra (Sen. *Nat.* 1)." *MatTestiCl* 40:127–60.

Lejeune, A. 1948. *Euclide et Ptolémée: Deux stades de l'optique géométrique grecque*. Louvain.

———. 1957. *Recherches sur la catoptrique grecque d'après les sources antiques et médiévales*. Brussels.

Levi, D. 1947. *Antioch Mosaic Pavements*. Princeton, NJ, London, and the Hague.

Lewis, I. M. 1971. *Ecstatic Religion: An Anthropological Study of Spirit Possession and Shamanism*. Harmondsworth.

Lewis, S. 1973. "A Coptic Representation of Thetis at the Forge of Hephaistos." *AJA* 77:309–18.

Lilyquist, C. 1979. *Ancient Egyptian Mirrors from the Earliest Times through the Middle Kingdom*. Munich and Berlin.

Lindberg, D. C. 1976. *Theories of Vision from al-Kindi to Kepler*. Chicago.

Lindner, R. 1997. "Zagreus." *LIMC* 8:1:305–6.

Linforth, I. M. 1941. *The Arts of Orpheus*. Berkeley and Los Angeles.

———. 1946a. "The Corybantic Rites in Plato." *UCPCP* 13:121–62.

———. 1946b. "Telestic Madness in Plato, Phaedrus 244DE." *UCPCP* 13:163–72.

Ling, R. 1991. *Roman Painting*. Cambridge.

Lippold, G. 1951. *Antike Gemäldekopien*. Munich.

Lissarrague, F. 2000. "Image, signe, reflet: Spéculations dionysiaques et funéraires." In Sennequier et al. 2000, 44–8.

Little, A. M. G. 1964. "The Boscoreale Cycle." *AJA* 68:62–6.

———. 1975. "Two Ritual Scenes from Roman Painting." *CronPomp* 1:148–50.

Lloyd-Morgan, G. 1977. "Typology and Chronology of Roman Mirrors." Dissertation, University of Birmingham.

———. 1978. "The Antecedents and Development of the Roman Hand Mirror." In *Papers in Italian Archaeology 1: The Lancaster Seminar: Recent Research in Prehistoric, Classical, and Medieval Archaeology*, ed. H. M. Blake, T. W. Potter, and D. B. Whitehouse, 227–35. Oxford.

———. 1981a. *Description of the Collections in the Rijksmuseum G. M. Kam at Nijmegen: The Roman Mirrors*. Nijmegen.

———. 1981b. "Roman Mirrors and the Third Century." In *The Roman West in the Third Century*, ed. A. King and M. Henig, 145–57. Oxford.

———. 1982. "The Roman Mirror and Its Origins." In de Grummond 1982b, 39–48.

Lochin, C. 1990. "Somnus." [s.v. "Hypnos/Somnus."] *LIMC* 5:1:591–609.

Loeschcke, G. 1894. *Die Enthauptung der Medusa: Ein Beitrag zur Geschichte der Griechischen Malerei*. Bonn.

Longfellow, B. 2000. "Liber and Venus in the Villa of the Mysteries." In Gazda 2000, 116–28.

L'Orange, H. P. 1953. "The Cosmic Clipeus and the Solar Imago Clipeata." In *Studies on the Iconography of Cosmic Kingship in the Ancient World*, 90–102. Oslo and Cambridge, MA.

Macchi, G. and M. Vitale, eds. 1987. *Lo specchio e il doppio: Dallo stagno di Narciso allo schermo televisivo*. Milan.

Macchioro, V. 1920. *Zagreus: Studi sull'orfismo*. Bari.

Macho, T. 2002. "Narziß und der Spiegel: Selbst-repräsentation in der Geschichte der Optik." In Renger 2002, 13–25.

Mack, R. 2002. "Facing Down Medusa (An Aetiology of the Gaze)." *Art History* 25:571–604.

MacKenna, S., ed. and transl. 1991. *Plotinus: The Enneads*. 4th ed. Revised by B. S. Page. London.

Maclagan, R. C. 1902. *Evil Eye in the Western Highlands*. London.

Maiuri, A. 1931. *La Villa dei Misteri*. 2 vols. Rome.

Maloney, C. 1976. *The Evil Eye*. New York.

Mansuelli, G. 1958. "Il ritratto romano nell'Italia settentrionale." *RM* 65:67–99.

Manuwald, B. 1975. "Narcissus bei Konon und Ovid (zu Ovid, *Met.* 3,339–510)." *Hermes* 103:349–72.

Marcattili, F. 2004. "Giacinto." In Ghedini et al. 2004, 141–9.

Marcovich, M., ed. 1986. *Hippolytus: Refutatio omnium haeresium*. New York and Berlin.

Marin, L. 2003. "Caravaggio's 'Head of Medusa': A Theoretical Perspective." Translated by M. Hjort. In Garber and Vickers 2003, 137–60.

Marinatos, S. 1927–8. *"Gorgones kai Gorgoneia."* *ArchEphem* 7–41.

Marmorstein, A. 1932. "The 'Mirror' in Jewish Religious Life." *StMatStorRel* 8:37–41.

Matthies, G. 1912. *Die praenestischen Spiegel: Ein Beitrag zur italischen Kunst- und Kulturgeschichte*. Strassburg.

Mattingly, H. 1950. "The Imperial 'Vota.'" *ProcBritAc* 36:155–95.

Matz, F. 1963. *ΔΙΟΝΥΣΙΑΚΗ ΤΕΛΕΤΗ: Archäologische Untersuchungen zum Dionysoskult in hellenistischer und römischer Zeit*. Mainz and Wiesbaden.

Mau, A. 1890. "Scavi di Pompei." *RM* 5:111–41, 228–84.

———. 1891. "Le quattro pitture pubblicate Bull. 1890 P. 263 segg. N. 5–8." *RM* 6: 71–2.

Maury, A. 1846. "Un miroir magique du XVe ou XVIe siècle." *RA*: 154–70.

Mayer-Prokop, I. 1967. *Die gravierten etruskischen Griffspiegel archäischen Stils*. Heidelberg.

McCann, A. M. 1978. *Roman Sarcophagi in the Metropolitan Museum of Art*. New York.

McCarty, W. 1989. "The Shape of the Mirror: Metaphorical Catoptrics in Classical Literature." *Arethusa* 22:161–95.

Meerloo, J. A. M. 1971. *Intuition and the Evil Eye: The Natural History of a Superstition*. Wassenaar.

Melchior-Bonnet, S. 2001. *The Mirror: A History*. Translated by K. H. Jewett. New York.

Meslin, M. 1980. "Significations rituelles et symboliques du miroir." In *Perennitas: Studi in onore di Angelo Brelich*, 327–41. Rome.

Michel, C. and C. Rolley. 1984. *Vases antiques de métal au Musée de Chalon-sur-Saône*. Dijon.

Mielsch, H. 1975. *Römische Stuckreliefs*. Heidelberg.

Miller, J. 1998. *On Reflection*. London.

Milano capitale dell'impero romano, 286–402 d. C. Milan.

Moller, H. 1987. "The Accelerated Development of Youth: Beard Growth as a Biological Marker." *Comparative Studies in Society and History* 29:748–62.

Moreno, P. 2002. "Iconografia e stile della Vittoria di Brescia." In *Nuove ricerche sul Capitolium di Brescia: scavi, studi e restauri*, ed. F. Rossi, 119–63. Milan.

Mori, G. 1987. "Narciso." In Macchi and Vitale 1987, 115–29.

Mudie Cooke, P. B. 1913. "The Painting of the Villa Item at Pompeii." *JRS* 3:157–74.

Müller, F. G. J. M. 1994a. *The So-Called Peleus and Thetis Sarcophagus in the Villa Albani*. Amsterdam.

———. 1994b. *The Wall Paintings from the Oecus of the Villa of Publius Fannius Synistor in Boscoreale*. Amsterdam.

Myerowitz, M. 1992. "The Domestication of Desire: Ovid's *parva tabella* and the Theater of Love." In Richlin 1992, 131–57.

Napier, A. D. 1986. *Masks, Transformation, and Paradox*. Berkeley.

———. 1992. *Foreign Bodies: Performance, Art, and Symbolic Anthropology*. Berkeley.

Negelein, J. von. 1902. "Bild, Spiegel, und Schatten im Volksglauben." *ARW* 1–37.

Netoliczka, A. von. 1921. "*Katoptron.*" *RE* 11:1:29–45.

Nelson, M. 1999–2000. "Narcissus: Myth and Magic." *CJ* 95:363–89.

Neugebauer, K. A. 1927. *Bronzestatuette des Narkissos von Mechtersheim.* Berlin.

Neumann, G. 1965. *Gesten und Gebärden in der griechischen Kunst.* Berlin.

———. 1986. "Alkibiades." *AA* 103–12.

Nicaise, S. 1991. "'Je meurs de soif auprès de la fontaine.' Narcisse, Écho et la problématique du double chez Ovide." *ÉtCl* 59:67–72.

Nilsson, M. P. 1957. *The Dionysiac Mysteries of the Hellenistic and Roman Age.* Lund.

Ninck, M. 1921. *Die Bedeutung des Wassers im Kult und Leben der alten.* Leipzig.

Nolan, E. P. 1990. *Now through a Glass Darkly: Specular Images of Being and Knowing from Virgil to Chaucer.* Ann Arbor, MI.

Norvin, W., ed. 1913. *Olympiodori philosophi in Platonis Phaedonem commentaria.* Leipzig.

Nouvet, C. 1991. "An Impossible Response: The Disaster of Narcissus." *Yale French Studies* 79:103–34.

Nugent, G. 1990. "This Sex Which Is Not One: De-constructing Ovid's Hermaphrodite." In Konstan and Nussbaum 1990, 160–85.

Nünnerich-Asmus, A., ed. 1993. *Hispania antiqua: Denkmäler der Römerzeit.* Mainz.

Nussbaum, M. C. 2002. "Eros and Ethical Norms: Philosophers Respond to a Cultural Dilemma." In Nussbaum and Sihvola 2002, 55–94.

Nussbaum, M. C. and J. Sihvola, eds. 2002. *The Sleep of Reason: Erotic Experience and Sexual Ethics in Ancient Greece and Rome.* Chicago.

Oberländer, P. 1967. "Griechische Hand-spiegel." Dissertation, University of Hamburg.

Önal, M. 2002. *Mosaics of Zeugma.* Istanbul.

Orlowsky, U. and R. Orlowsky. 1992. *Narziß und Narzißmus im Spiegel von Literatur, bildender Kunst, und Psychoanalyse: Vom Mythos zur leeren Selbstinszenierung.* Munich.

Østergard, J. S. 1996. *Imperial Rome: Catalogue, Ny Carlsberg Glyptotek.* Copenhagen.

Otis, B. 1966. *Ovid as an Epic Poet.* Cambridge.

Otto, W. F. 1981. *Dionysus: Myth and Cult.* Translated by R. D. Palmer. Dallas. Reprint of 1933 edition.

Pailler, J.-M. 1982. "Les oscilla retrouvés: Du recueil des documents à une théorie d'ensemble." *MÉFRA* 94:743–820.

Painter, K. S. 2001. *The Insula of the Menander at Pompeii, Volume IV: The Silver Treasure.* Oxford.

Palol, P. de. 1975. "Los dos mosaicos hispánicos de Aquiles: El de Pedrosa de la Vega y el de Santisteban del Puerto." In Stern and Le Glay 1975, 227–40.

Pansa, G. 1960. "Di uno specchio magico del secolo XV–XVI e della catoptromanzia degli antichi secondo le leggende medievali ed i racconti popolari." *Lares* 26.3–4:129–42.

Papi, R. 2003. "Satiro allo specchio." In Campanelli and Pennetta 2003, 76–7.

Parise Badoni, F. 2001. "Narciso a Pompei nella Casa dei Quattro Stili?" *MÉFRA* 113:787–98.

Parker, H. N. 1997. "The Teratogenic Grid." In Hallett and Skinner 1997, 47–65.

Parlasca, K. 1963. "Das pergamenische Taubenmosaik und der sogenannte Nestor-Becher." *JdI* 78: 256–93.

Peden, R. G. 1985. "The Statues in Apuleius' *Metamorphoses* II.4." *Phoenix* 39:380–83.

Pellizer, E. 1987. "Reflections, Echoes and Amorous Reciprocity: On Reading the Narcissus Story." Translated by D. Crampton. In *Interpretations of Greek Mythology,* ed. J. Bremmer, 107–20. London.

———. 1991. "Narciso e le figure della dualità." In Bettini 1991a, 13–29.

Pendergrast, M. 2003. *Mirror, Mirror: A History of the Human Love Affair with Reflection.* New York.

Pennetta, M. P. 2003. "Magie e divinazioni allo specchio." In Campanelli and Pennetta 2003, 146–9.

Pépin, J. 1970. "Plotin et le miroir de Dionysos." *RIPh* 92:304–20.

Pernice, E. 1938. *Pavimente und figürliche Mosaiken.* Berlin.

Pettazzoni, R. 1921. "Le origini della testa di Medusa." *BdA* ser. 2 1:491–510.

Pfandl, L. 1935. "Der Narzißbegriff: Versuch einer neuen Deutung." *Imago* (Leipzig) 21: 279–310.

Pfister-Roesgen, G. 1975. *Die etruskischer Spiegel des 5 Jahrhunderts v. Chr.* Bern and Frankfurt.

Phay-Vakalis, S. 2001. *Le miroir dans l'art de Manet à Richter.* Paris.

Phillips, K. M. 1968. "Perseus and Andromeda." *AJA* 72: 1–23.

Phinney, E. 1971. "Perseus' Battle with the Gorgons." *TAPA* 102:445–63.

Picard, C. 1941–6. "Le couronnement de Vénus." *MÉFRA* 58:43–108.

Picard, G. C. 1957. *Les trophées romains: Contribution à l'histoire de la religion et de l'art triomphal de Rome.* Paris.

Pirzio Biroli Stefanelli, L. 1991. *L'argento dei romani: Vasellame da tavola e d'apparato.* Rome.

Platt, V. 2002. "Viewing, Desiring, Believing: Confronting the Divine in a Pompeian House." *Art History* 25:87–112.

Pollard, J. 1977. *Birds in Greek Life and Myth.* London.

Pontrandolfo, A. 1987. "Amore e morte allo specchio." In Macchi and Vitale 1987, 54–8.

Porter, J. I., ed. 1999. *Constructions of the Classical Body.* Ann Arbor, MI.

Poulsen, F. 1951. *Catalogue of Ancient Sculpture in the Ny Carlsberg Glyptotek.* Copenhagen.

———. 1997. "Der Spiegel des Narziß: Die Bedeutung sozialer Geschlechterrollen für die Narzißikonographie." In Scagliarini Corlaita 1997, 107–11.

Rafn, B. 1992. "Narcissus." *LIMC* 6:1:703–11.

Rahmanyi, L. Y. 1964. "Mirror-Plaques from a Fifth-Century-A.D. Tomb." *PEJ* 14:50–60.

Rambaldi, S. 1998. "Problemi interpretative di una pittura pompeiana raffigurante il mito di Marsia." *Ocnus* 6:107–16.

Rapp, A. 1884–90. "Erinys." In Roscher 1884–1937, 1:1:1310–36.

Rauch, M. 1999. *Bacchische Themen und Nilbilder auf Campanareliefs.* Rahden.

Rawson, P. B. 1987. *The Myth of Marsyas in the Roman Visual Arts: An Iconographic Study.* Oxford.

Rebuffat-Emmanuel, D. 1974. *Le miroir étrusque d'après la collection du Cabinet des médailles.* Rome.

Regopoulou, P. 1994. *Ho Narkissos: Sta ichnê tês eikonas kai tou mythou.* Athens.

Reinach, S. 1909–12. *Répertoire des reliefs grecs et romains.* 3 vols. Paris.

———. 1912. "Marsyas." *RA*:390–405.

Reitzenstein, R. 1916. *Historia monachorum und historia lausiaca: Eine Studie zur Geschichte des Mönchtums und der frühchristlichen Begriffe Gnostiker und Pneumatiker.* Göttingen.

Renard, M. 1966. "La mosaïque aux divinités planétaires de Boscéaz près d'Orbe." In *Mélanges d'archéologie, d'épigraphie et d'histoire offerts à Jérôme Carcopino,* 803–17. Paris.

Renger, A-B., ed. 1999. *Mythos Narziß. Texte von Ovid bis Jacques Lacan.* Stuttgart and Weimar.

———, ed. 2002. *Narcissus: Ein Mythos von der Antike bis zum Cyberspace.* Weimar.

Richardson, L., Jr. 1955. *The Casa dei Dioscuri and Its Painters.* Rome.

———. 2000. *A Catalog of Identifiable Figure Painters of Ancient Pompeii, Herculaneum, and Stabiae.* Baltimore and London.

Ricciardelli, G. 2000. "Mite e *performance* nelle associazioni dionisiache." In Tortorelli Ghidini et al. 2000, 265–84.

Richlin, A., ed. 1992. *Pornography and Representation in Greece and Rome.* New York and Oxford.

Ridder, A. de. 1897. "Miroirs grecs à reliefs." *MonPiot* 4:77–103.

———. 1919. "Speculum." In Daremberg and Saglio 1877–1919, 4.2:1422–30.

Ridgway, B. 1984. *Roman Copies of Greek Sculpture.* Ann Arbor, MI.

———. 1990. *Hellenistic Sculpture.* 3 vols. Madison, WI.

Ritter Santini, L. 1978. "La favola di Eco: *langue et parole.*" In *Retorica e critica letteraria,* ed. L. Ritter Santini and E. Raimondi, 151–78. Bologna.

Rizzo, G. E. 1918. "Dionysos mystes." *MemNap* 3:39–102.

Robertson, M. 1955. "The Boscoreale Figure-Paintings." *JRS* 45:58–67.

———. 1975. *A History of Greek Art.* Cambridge.

Robinson, M. 1999. "Salmacis and Hermaphroditus: When Two Become One (Ovid, *Met.* 4.285–388)." *CQ* 49:212–23.

Roccos, L. J. 1994. "Perseus." *LIMC* 7:1:332–48.

Rodenwaldt, G. 1909. *Die Komposition der pom-pejanischen Wandegemälde.* Berlin.

Rohde, E. 1925. *Psyche: The Cult of Souls and Belief in Immortality among the Greeks.* 8th ed. 2 vols. Translated by W. B. Hillis. London.

Rohden, H. von and H. Winnefeld. 1911. *Architektonische römische Tonreliefs der Kaiserzeit.* 2 vols. Berlin and Stuttgart.

Róheim, G. 1919. *Spiegelzauber.* Leipzig.

————. 1940. "The Gorgon." *American Imago* 1:61–83.

Ronchaud, L. de. 1887. "Curetes." In Daremberg and Saglio 1877–1919, 1.2:1625–7.

Rorty, R. *Philosophy and the Mirror of Nature.* 1979. Princeton, NJ.

Rosati, G. 1983. *Narciso e Pigmalione: Illusione e spettacolo nelle Metamorfosi di Ovidio.* Florence.

Roscher, W. H., ed. 1884–1937. *Ausführliches Lexikon der griechischen und römischen Mythologie.* 6 vols. Leipzig.

Rostovtzeff, M. 1927. *Mystic Italy.* New York.

Rouget, G. 1985. *Music and Trance: A Theory of the Relations between Music and Possession.* Translated by B. Biebuyck and G. Rouget. Chicago and London.

Rudd, N. 1986. "Echo and Narcissus: Notes on a Seminar on Ovid *Met.* 3.339–510." *EchCl* 30:43–8.

Sande, S. 1981. "The Myth of Marsyas: Pieces of a Sculptural Jigsaw." *MMAJ* 16:55–73.

Santa Maria Scrinari, V. 1972. *Museo Archeologico di Aquileia: Catalogo delle sculture romane.* Rome.

Saunders, C. 1911. "The Introduction of Masks on the Roman Stage." *AJP* 32:58–73.

Sauron, G. 1984. "Nature et signification de la mégalographie dionysiaque de Pompéi." *CRAI* 198:151–74.

————. 1998. *La grande fresque de la Villa des Mystères à Pompéi.* Paris.

Scagliarini Corlaita, D., ed. 1997. *I temi figurativi nella pittura parietale antica (IV sec. a.C.–IV sec. d.C.): Atti del VI Convegno Internazionale sulla Pittura Parietale Antica.* Imola.

Schachter, A. 1986. *Cults of Boiotia, Vol. 2: Herakles to Poseidon.* London.

Schauenburg, K. 1958. "Marsyas." *RM* 65:42–66.

————. 1960. *Perseus in der Kunst des Altertums.* Bonn.

————. 1981. "Andromeda I." *LIMC* 1:1:774–90.

Schefold, K. 1940. "Griechische Spiegel." *Die Antike* 16:11–37.

————. 1957. *Die Wände Pompejis.* Berlin.

————. 1981. *Die Göttersage in der klassischen und hellenistischen Kunst.* Munich.

Schickel, J. 1962. "Narziß: Zu Versen von Ovid." *Antaios* 3:486–96.

Schmidt, E. 1997. "Venus." *LIMC* 8:1:192–230.

Schmidt, M., A. D. Trendall, and A. Cambitoglu. 1976. *Eine Gruppe apulischer Grabvasen in Basel: Studien zu Gehalt und Form der unteritalischen Sepulkralkunst.* Basel.

Schneider-Herrmann, G. 1977. *Apulian Red-Figured Paterae with Flat or Knobbed Handles.* London.

————. 1977–8. "Unterschiedliche Interpretationen süd-italischer Vasenbilder des 4. Jh. v. Chr." *BABesch* 52–3:253–7.

Schuller, M. H. W. 1998. "'Watching the Self': The Mirror of Self-Knowledge in Ancient Literature." Dissertation, Yale University.

Schwarzmaier, A. 1997. *Griechische Klappspiegel: Untersuchungen zu Typologie und Stil.* Berlin.

Scott, J. C. 1990. *Domination and the Arts of Resistance: Hidden Transcripts.* New Haven, CT.

Searle, J. 1980. "*Las Meninas* and the Paradoxes of Pictorial Representation." *Critical Inquiry* 6:477–88.

Sennequier, G., P. Ickowicz, N. Zapata-Aubé, and F. Frontisi-Ducroux. 2000. *Miroirs: Jeux et reflets depuis l'antiquité.* Paris.

Sestieri, P. C. 1939. "Riflessi dell'Orfismo in Etruria." *StEtr* 13:249–59.

Settis, S. 1984. "Images of Meditation, Uncertainty, and Repentance in Ancient Art." Translated by P. Spring. In *Gestures*, ed. J.-C. Schmitt (special issue of *History and Anthropology* 1:1), 193–237.

Sharrock, A. 1996. "Representing Metamorphosis." In Elsner 1996a, 103–30.

————. 2002a. "Gender and Sexuality." In *The Cambridge Companion to Ovid,* ed. P. Hardie, 95–107. Cambridge and New York.

———. 2002b. "Looking at Looking: Can You Resist a Reading?" In Fredrick 2002, 265–95.

Shelton, K. 1981. *The Esquiline Treasure*. London.

Sichtermann, H. 1957. "Zur Achill und Chirongruppe." *RM* 64:98–110.

———. 1986. "Narkissos auf römischen Sarkophagen." In *Studien zur Mythologie und Vasenmalerei: Konrad Schauenburg zum 65. Geburtstag am 16. April 1986*, ed. E. Böhr and W. Martini, 239–42. Mainz.

Sichtermann, H. and G. Koch. 1975. *Griechische Mythen auf römischen Sarkophagen*. Tübingen.

Siebers, T. 1983. *The Mirror of Medusa*. Berkeley.

Simon, E. 1958. *Die Fürstenbilder von Boscoreale: Ein Beitrag zur hellenistischen Wandmalerei*. Baden-Baden.

———. 1961. "Zum Fries der Mysterienvilla bei Pompeji." *JdI* 76:111–72.

———. 1962. "Zagreus: über orphische Motive in Campanareliefs." In *Hommages à Albert Grenier*, 1418–27. Brussels and Berchem.

———. 1986. *Die Konstantinischen Deckengemälde in Trier*. Mainz.

———. 1994. "Phineus II." *LIMC* 7:1:391–2.

Simon, G. 1981. "Derrière le miroir." *Le temps de la réflexion* 2:298–332.

———. 1988. *Le regard, l'être, et l'apparence dans l'optique de l'antiquité*. Paris.

Skinner, V. 1965. "Ovid's 'Narcissus' – An Analysis." *CB* 41:59–61.

Slater, N. W. 1998. "Passion and Petrifaction: The Gaze in Apuleius." *CP* 93:18–48.

Small, J. P. 2003. *The Parallel Worlds of Classical Art and Text*. Cambridge and New York.

Smith, A. M. 1996. *Ptolemy's Theory of Visual Perception: An English Translation of the Optics with Introduction and Commentary*. Philadelphia.

———. 1999. *Ptolemy and the Foundations of Ancient Mathematical Optics: A Source-Based Guided Study*. Philadelphia.

Smith, H. R. W. 1972. *Funerary Symbolism in Apulian Vase-Painting*. Berkeley.

Smith, R. R. R. 1994. "Spear-Won Land at Boscoreale: On the Royal Paintings of a Roman Villa." *JRA* 7:100–128.

Snow, E. 1989. "Theorizing the Male Gaze: Some Problems." *Representations* 25:30–41.

Snyder, J. and T. Cohen. 1980. "Reflexions on *Las Meninas*: Paradox Lost." *Critical Inquiry* 7:429–47.

Sogliano, A. 1930. "Di un particolare nel grandioso dipinto della villa suburbana detta 'dei misteri' presso Pompei." *Historia* (Milan) 4:198–206.

Soles, M. E. C. 1976. "Aphrodite at Corinth: A Study of the Sculptural Types." Dissertation, Yale University.

Sorel, Reynal. 1995. *Orphée et l'orphisme*. Paris.

Sourvinou-Inwood, C. 2004. "Hermaphroditos and Salmakis: The Voice of Halikarnassos." In *The Salmakis Inscription and Hellenistic Halikarnassos*, ed. S. Isager and P. Pedersen, 59–84. Odense.

Spaas, L., ed. 2000. *Echoes of Narcissus*. New York and Oxford.

Spier, J. 1992. *Ancient Gems and Finger Rings: Catalogue of the Collection*. Malibu.

Spinazzola, V. 1953. *Pompei alla luce degli scavi nuovi di via dell'Abbondanza (anni 1910–1923)*. 2 vols. Rome.

Spivak, G. 1993. "Echo." *New Literary History* 24:17–43.

Spivey, N. 1996. *Understanding Greek Sculpture: Ancient Meanings, Modern Readings*. New York.

Stewart, A. 1990. *Greek Sculpture*. 2 vols. New Haven, CT.

———. 1996. "Reflections." In Kampen 1996b, 136–54.

———. 1997. *Art, Desire, and the Body in Ancient Greece*. Cambridge and New York.

Stoichita, V. 1997. *A Short History of the Shadow*. London.

Strong, D. E. 1966. *Greek and Roman Gold and Silver Plate*. London.

Tassinari, S. 1975. *La vaisselle de bronze romaine et provinciale au Musée des Antiquités Nationales, Saint-Germain-en-Laye*. Paris.

Taylor, R. 1997. "Two Pathic Subcultures in Ancient Rome." *Journal of the History of Sexuality* 7.3:319–71.

———. 2005. "Roman Oscilla: An Assessment." *RES: Anthropology and Aesthetics* 48 (autumn) 83–105.

———. Forthcoming. "Death, the Maiden and the Mirror: Ausonius' Water-World." *Arethusa*.

Too, Y. L. 1996. "Statues, Mirrors, Gods: Controlling Images in Apuleius." In Elsner 1996a, 133–52.

Tortorelli Ghidini, M. 2000. "I giocattoli di Dioniso tra mito e rituale." In Tortorelli Ghidini et al. 2000, 255–63.

Tortorelli Ghidini, M., A. Storchi Marino, and A. Visconti, eds. 2000. *Tra Orfeo e Pitagora: Origini e incontri di culture nell'antichità.* Naples.

Toynbee, J. M. C. 1929. "The Villa Item and a Bride's Ordeal." *JRS* 19:67–87.

———. 1964. *Art in Britain under the Romans.* Oxford.

———. 1973. *Animals in Roman Life and Art.* Baltimore and London.

Trendall, A. D. 1967. *The Red-Figured Vases of Lucania, Campania and Sicily.* Oxford.

———. 1978–82. *The Red-Figured Vases of Apulia.* 3 vols. Oxford and New York.

———. 1983. *First Supplement to the Red-Figured Vases of Apulia.* London.

———. 1991. *Second Supplement to the Red-Figured Vases of Apulia.* London.

———. 1987. *The Red-Figured Vases of Paestum.* London.

Trimble, J. 2002. "Greek Myth, Gender, and Social Structure in a Roman House: Two Paintings of Achilles at Pompeii." In *The Ancient Art of Emulation: Studies in Artistic Originality and Tradition from the Present to Classical Antiquity,* ed. E. K. Gazda, 225–48. Ann Arbor, MI.

Trinkl, E. 1997. "Ein Selbstporträt im Alexandermosaik?" *ÖJh* 66: Hauptblatt 101–15.

Tuchmann, J. 1888–9. "La fascination." *Mélusine* 4:278–86.

———. 1890–91. "La fascination." *Mélusine* 5:54–64.

Turcan, R. 1993. "Les petites frises du cubiculum M dans la ville dite de P. Fannius Synistor à Boscoreale (New York, Metropolitan Museum)." *CRAI* 701–22.

Van de Grift, J. 1984. "Tears and Revel: The Allegory of the Berthouville Centaur Skyphi." *AJA* 88:377–88.

Van Hoorn, W. 1972. *As Images Unwind: Ancient and Modern Theories of Visual Perception.* Amsterdam.

Venit, M. S. 2001. "Style, Substance, and the Efficacy of the Image in Tomb Painting of Roman Alexandria." In Barbet 2001, 137–42.

Ver Eecke, P., ed. 1959. *L'Optique et la catoptrique, Euclide.* Paris.

Vernant, J.-P. 1987. "Dans l'oeil du miroir: Méduse." In Macchi and Vitale 1987, 26–32.

———. 1990a. *Figures, idoles, masques.* Paris.

———. 1990b. *La mort dans les yeux: figures de l'Autre en Grèce ancienne.* Paris.

———. 1991a. "Death in the Eyes: Gorgo, Figure of the *Other.*" In Vernant 1991d, 111–38. Selection entitled "Frontality and Monstrosity" reprinted in Garber and Vickers 2003, 222–31.

———. 1991b. "In the Mirror of Medusa." In Vernant 1991d, 141–50. Selection entitled "Frontality and Monstrosity" reprinted in Garber and Vickers 2003, 210–22.

———. 1991c. "Introduzione." In Bettini 1991a, v–viii.

———. 1991d. *Mortals and Immortals: Collected Essays.* Translated by T. Curley and F. Zeitlin. Princeton, NJ.

———. 1991e. "'Psyche': Simulacro del corpo o immagine del divino?" In Bettini 1991a, 3–11.

Versnel, H. S. 1970. *Triumphus: An Inquiry into the Origin, Development, and Meaning of the Roman Triumph.* Leiden.

Vidal-Naquet, P. 1988. "The Shields of the Heroes." In *Myth and Tragedy in Ancient Greece,* ed. J.-P. Vernant and P. Vidal-Naquet, 273–300. Translated by J. Lloyd. New York and Cambridge, MA.

Vinge, L. 1967. *The Narcissus Theme in Western European Literature up to the Early 19th Century.* Lund.

Vogt-Spira, G. 2002. "Der Blick und die Stimme: Ovids Narziß- und Echomythos im Kontext römischer Anthropologie." In Renger 2002, 27–40.

Volbach, F. 1976. *Elfenbeinarbeiten der Spätantike und des frühen Mittelalters.* 3rd ed. Mainz.

Vollkommer, R. 1997. "Victoria." *LIMC* 8:1: 237–69.

Vonder Mühll, F. 1914. "Roscius 16." *RE* ser. 2, 1:1123–5.

Wallis Budge, E. A. 1907. *An Account of the Roman Antiquities Preserved in the Museum at Chesters, Northumberland.* 2nd ed. London.

Walters, H. B. 1921. *Catalogue of the Silver Plate (Greek, Etruscan, and Roman) in the British Museum.* London.

Ward Perkins, J. B. and A. Claridge. 1978. *Pompeii AD 79: Treasures from the National Archaeological Museum, Naples, and the Pompeii Antiquarium.* New York and Boston.

Warner, M. 1985. *Monuments and Maidens: The Allegory of the Female Form.* New York.

Weis, A. 1992. "Marsyas I." *LIMC* 6:1:366–78.

Wesselski, A. 1935. "Narkissos oder das Spiegelbild." *ArOr* 7:37–63, 328–50.

West, M. L. 1983. *The Orphic Poems.* Oxford and New York.

Westerink, L. G., ed. and transl. 1976. *The Greek Commentaries on Plato's Phaedo, Vol. 1: Olympiodorus.* Amsterdam and New York.

Wieseler, F. 1856. *Narkissos: Eine kunstmythologische Abhandlung nebst einem Anhang über die Narcissen und ihre Beziehung im Leben, Mythos und Cultus der Griechen.* Göttingen.

Wiles, D. 1991. *The Masks of Menander: Sign and Meaning in Greek and Roman Performance.* Cambridge and New York.

Wilk, S. 2000. *Medusa: Solving the Mystery of the Gorgon.* Oxford and New York.

Williams, C. A. 1999. *Roman Homosexuality: Ideologies of Masculinity in Classical Antiquity.* New York and Oxford.

Williams, C. K. 1986. "Corinth and the Cult of Aphrodite." In *Corinthiaca: Studies in Honor of Darrell A. Amyx,* ed. M. A. Del Chiaro, 12–24. Columbia, MO.

Wiman, I. M. B. 1990. *Malstria-Malena: Metals and Motifs in Etruscan Mirror Craft.* Göteborg.

Winkes, R. 1969. *Clipeata imago: Studien zu einer römischen Bildnisform.* Bonn.

Winkler, J. J. 1985. *Auctor & Actor: A Narratological Reading of Apuleius'* Golden Ass. Berkeley.

———. 1990. *The Constraints of Desire: The Anthropology of Sex and Gender in Ancient Greece.* New York and London.

Wittgenstein, L. 1958. *Philosophical Investigations.* 2nd ed. Translated by G. E. M. Anscombe. Oxford.

Woodward, J. M. 1937. *Perseus: A Study of Greek Art and Legend.* Cambridge.

Wrede, H. 2001. *Senatorische Sarkophage Roms: Der Beitrag des Senatorenstandes zur römischen Kunst der hohen und späten Kaiserzeit.* Mainz.

Wyke, M. 1994. "Woman in the Mirror: The Rhetoric of Adornment in the Roman World." In *Women in Ancient Societies: An Illusion of the Night,* ed. L. Archer, S. Fischler, and M. Wyke, 134–51. New York.

Zahlhaas, G. 1975. *Römische Reliefspiegel.* Kallmünz.

Zanker, P. 1966. "'Iste ego sum': Der naïve und der bewußte Narziß." *BJb* 166:152–70.

———. 1988. *The Power of Images in the Age of Augustus.* Translated by A. Shapiro. Ann Arbor, MI.

Ziegler, K. 1926. "Das Spiegelmotiv im Gorgomythos." *ArchRW* 24:1–18.

Zimmer, G. 1991. *Frühgriechische Spiegel: Aspekte technischer Neuerungen in der Antike.* Berlin.

———. 1995. *Etruskische Spiegel: Technik und Stil der Zeichnungen.* Berlin.

Zimmerman, C. 1994. *The Pastoral Narcissus: A Study in the First Idyll of Theocritus.* Lanham, MD.

Zintzen, C., ed. 1967. *Vitae Isidori reliquiae.* Hildesheim.

Zouhdi, B. 1970. "Miroirs de verre de l'époque romaine conservés au Musée National de Damas." In *Annales du 5e Congrès de l'Association Internationale pour l'Histoire du Verre,* 59–69. Liège.

Zuccari, A. 1987. "La Vanitas." In Macchi and Vitale 1987, 157–67.

Züchner, W. 1942. *Griechische Klappspiegel.* Berlin.

Zuntz, G. 1965. "On the Dionysiac Fresco in the Villa dei Misteri at Pompeii." *ProcBritAc* 49:177–201.

INDEX